Medium, Me

MW01278244

The book series Recursions: Theories of Media, Materiality, and Cultural Techniques provides a platform for cuttingedge research in the field of media culture studies with a particular focus on the cultural impact of media technology and the materialities of communication. The series aims to be an internationally significant and exciting opening into emerging ideas in media theory ranging from media materialism and hardware-oriented studies to ecology, the post-human, the study of cultural techniques, and recent contributions to media archaeology. The series revolves around key themes:
– The material underpinning of media theory
– New advances in media archaeology and media philosophy
– Studies in cultural techniques

These themes resonate with some of the most interesting debates in international media studies, where non-representational thought, the technicity of knowledge formations and new materialities expressed through biological and technological developments are changing the vocabularies of cultural theory. The series is also interested in the mediatic conditions of such theoretical ideas and developing them as media theory.

Editorial Board
– Jussi Parikka (University of Southampton)
– Anna Tuschling (Ruhr-Universität Bochum)
– Geoffrey Winthrop-Young (University of British Columbia)

Medium, Messenger, Transmission

An Approach to Media Philosophy

Sybille Krämer

Amsterdam University Press

Translated by Anthony Enns.

The translation was made possible by a grant from the Börsenverein des Deutschen Buchandels.

Cover illustration: Giambologna, Mercury (Hermes), 1580. National Museum of Bargello, Florence.

Cover design: Coördesign, Leiden

Lay-out: Crius Group, Hulshout

Amsterdam University Press English-language titles are distributed in the US and Canada by the University of Chicago Press.

ISBN	978 90 8964 741 2 (hardback)
ISBN	978 94 6298 308 3 (paperback)
e-ISBN	978 90 4852 499 0 (pdf)
NUR	670

© S. Krämer / Amsterdam University Press B.V., Amsterdam 2015

All rights reserved. Without limiting the rights under copyright reserved above, no part of this book may be reproduced, stored in or introduced into a retrieval system, or transmitted, in any form or by any means (electronic, mechanical, photocopying, recording or otherwise) without the written permission of both the copyright owner and the author of the book.

Recursions: Editors' Introduction

Recursions: Theories of Media, Materiality and Cultural Techniques is a book series about media theory. But instead of dealing with theory in its most classical sense of *theoria* as something separate from practice that looks at objects and phenomena from a distance, we want to promote a more situated understanding of theory. Theory, too, is a practice and it has an address: it unfolds in specific situations, historical contexts and geographical places. As this book series demonstrates, theory can emerge from historical sources and speculations still closely attached to material details.

We therefore speak of the recursive nature of theory: It is composed of concepts that cut across the social and aesthetic reality of technological culture, and that are picked up and reprocessed by other means, including the many media techniques featured in this book series. The recursive loops of theory and practice fold and define each other. The genealogies of media theory, in turn, unfold in recursive variations that open up new questions, agendas, methodologies, which transform many of the humanities topics into media theory.

The *Recursions* series revolves around the material and hardware understanding of media as well as media archaeology – a body of work that addresses the contingent historical trajectories of modern media technologies as well their technological condition. But we are also interested in addressing the wider field of cultural techniques. The notion of cultural techniques serves to conceptualize how human and nonhuman agencies interact in historical settings as well as to expand the notion of media to include the many techniques and technologies of knowledge and aesthetics. This expansive – and yet theoretically rigorous – sense of understanding media is also of great use when considering the relations to biology and other sciences that deal with life and the living; another field where media studies has been able to operate in ways that fruitfully overlap with social studies of science and technology (STS).

Overall, the themes emerging from the *Recursions* book series resonate with some of the most interesting debates in international media studies, including issues of non-representational thought, the technicity of knowledge formations, and the dimensions of materialities expressed through biological and technological developments that are changing the vocabularies of cultural theory. We are interested in the mediatic conditions of such theoretical ideas and developing them as new forms of media theory.

Over the last twenty years, and following in the footsteps of such media theorists as Marshall McLuhan, Friedrich Kittler, Vilem Flusser and others, a series of scholars working in Germany, the United States, Canada and other countries have turned assumptions concerning communication on their head by shifting the focus of research from communication to media. The strong – and at times polemical – focus on technological aspects (frequently referred to as the 'materialities of communication') has since given way to a more nuanced approach evident in appellations such as 'media archaeology' and 'media ecology'. These scholars have produced an important series of works on such diverse topics as computer games, media of education and individuation, the epistemology of filing cabinets, or the media theories underlying the nascent discipline of anthropology at the end of the nineteenth century, thereby opening up an entirely new field of research which reframes our understanding of media culture and the relationship between media, culture, politics, and society. In other words, these approaches are distinguished by the emphasis on the materiality of media practices as well as the long historical perspectives they offer.

A major part of the influences of recent years of media theory, including fields such as software and platform studies, digital forensics and media ecology, has been a conjunction of German media theory with other European and trans-Atlantic influences. The brand name of 'German media theory' commonly associated with, though not restricted to, the work of Friedrich Kittler – is a helpful label when trying to attempt to identify a lot of the theoretical themes the book series addresses. However, we want to argue for a more international take that takes into account the hyphenated nature of such influences and to continue those in refreshing ways that do not just reproduce existing theory formations. We also want to challenge them, which, once again, refers to the core meaning of recursions: variation with a difference.

Jussi Parikka, Anna Tuschling & Geoffrey Winthrop-Young

Table of Contents

Introduction: The Media Philosophy of Sybille Krämer

Anthony Enns

Canadian media theorist Marshall McLuhan famously argued that the purpose of media studies was to make visible that which normally remains invisible – namely, the effects of media technologies rather than the messages they convey. When he originally proposed this idea in the 1960s McLuhan was widely celebrated as the great prophet of the media age, but in the decades that followed his work gradually fell into disregard. In the 1970s, for example, Raymond Williams claimed that McLuhan's ideas were 'ludicrous'[1] and Hans Magnus Enzensberger dismissed him as a 'charlatan' who was 'incapable of any theoretical construction' and who wrote with 'provocative idiocy'.[2] This tacit dismissal of McLuhan's ideas was largely accepted until the late twentieth century, when there was renewed interest in his work among several German media theorists, such as Friedrich Kittler and Norbert Bolz. Unlike the critics associated with the Birmingham Centre for Contemporary Cultural Studies, who primarily focused on the content of media texts and the interpretive work performed by media audiences, these theorists applied epistemological and philosophical questions to the study of media, which was largely inspired by McLuhan's famous claim that 'the medium is the message'.[3] Kittler even argued that '[w]ithout this formula…media studies itself would not exist as such in isolation or with any methodological clarity'.[4] Kittler's emphasis on the technical aspects of media gradually became fashionable in intellectual circles, and it is now widely known as 'German media theory'. Some of the concepts and ideas that are common to both Canadian and German media theory include their focus on the materiality of communication, the notion of media as prosthetic technologies or 'extensions of man', the concept of media ecology, the impact of media technologies on the formation of subjectivity as well as the military applications of media technologies. Although German media theory has often been criticized for ignoring questions of content and reception and for promoting a kind of technological determinism (as was McLuhan and other critics associated with the Toronto School of Communication Theory), it has also been described as one of Germany's most significant intellectual exports,[5] and despite these criticisms the technical aspects of media have once again become a central issue in the humanities.

Sybille Krämer is rarely mentioned in these discussions, as her work is not widely known outside of Germany and it does not share the technical emphasis that is widely seen as the hallmark of German media theory. Nevertheless, her early work primarily focused on developing a philosophy of technology and theorizing the function of the computer as a medium. Krämer received a Ph.D. in philosophy at the Philipp University of Marburg in 1980, and her doctoral thesis, *Technik, Gesellschaft und Natur: Versuch über ihren Zusammenhang* (*Technology, Society and Nature: An Attempt to Explain their Relationship*), outlined her earliest reflections on technology. Beginning in 1984 she was also part of the 'Mensch und Technik' (Humans and Technology) work group as well as the 'Artificial Intelligence' commission of the Verein Deutscher Ingenieure (Society of German Engineers) in Düsseldorf. In 1988 she published her second book, *Symbolische Maschinen: Die Idee der Formalisierung in geschichtlichem Abriss* (*Symbolic Machines: A Historical Abstract on the Concept of Formalization*), which investigated the use of formalization, calculization, and mechanization in mathematics. Krämer introduced the terms 'symbolic machines' and 'operational scripts' to refer to mathematical equations, as these equations are not readable texts but rather executable processes. If concrete numerals are replaced by letters, for example, it is possible to calculate using signs in a fundamentally more abstract manner. The introduction of algebra thus made it possible to use new signs for new operations, such as the introduction of differential calculus, which made it possible to work with infinitesimally small values. This book effectively expanded Krämer's understanding of technology by arguing that all mathematical equations are essentially mechanical operations. In other words, Krämer did not attempt to provide a history of the computer or even to suggest that the machine should be understood as a manufactured object; rather, she suggested that the concept of the machine was a result of the mediating function of symbols or the process of 'formalization'. *Symbolische Maschinen* thus signaled a shift from the study of technological history to the study of intellectual history and from the concept of technical operations to the concept of symbolic operations.

In 1989 Krämer became professor of theoretical philosophy at the Institute of Philosophy at the Free University of Berlin, and in 1991 she published her habilitation treatise *Berechenbare Vernunft: Kalkül und Rationalismus im 17. Jahrhundert* (*Computable Reason: Calculation and Rationalism in the 17th Century*). This book represented an extension of the argument presented in her previous book by elaborating on the history of the idea of computation, and it similarly focused on operations rather than technologies. *Berechenbare Vernunft* can thus be seen as part of a similar

shift away from the technological a priori that shapes or determines medial processes to the question of 'mediality' itself as a topic of philosophical inquiry. Kramer's divergence from the dominant trends in German media theory at this time was made particularly apparent in her contribution to the 1998 anthology *Medien, Computer, Realität: Wirklichkeitsvorstellungen und Neue Medien* (*Media, Computer, Reality: Perceptions of Reality and New Media*), in which she articulated a very different concept of media: 'We do not hear vibrations in the atmosphere but rather the sound of a bell; we do not read letters but rather a story.'[6] In other words, the medium is supposed to be inaudible and invisible, and it only becomes apparent when it is not functioning properly.

Krämer made a similar argument in her 2001 book, *Sprache, Sprechakt, Kommunikation: Sprachtheoretische Positionen des 20. Jahrhunderts* (*Language, Speech Act, Communication: Theories of Language of the 20th Century*), which focused on the disembodied nature of speech acts:

> Not only is language dematerialized, but also the speakers themselves. Vocality as a trace of the body in speech is not a significant attribute for language, just as the embodiment of speakers is not a constituve phenomenon for their linguisticality.... Just as the vocal, written, gestural, and technical embodiments of language are marginal for language itself, so too do the bodies of speakers – the physical precondition of their speech – remain hidden.[7]

Krämer added, however, that language is always already embodied, and this embodiment takes two different forms. On the one hand, 'language itself provides access to a material exteriority in the form of voice, writing, gesture, etc. And this materiality of language is not marginal, but rather a basic fact'.[8] In other words, language only exists as language through the mediation of an intervening medium, whether it be speech, writing, or gestures, and therefore it is closely linked to the bodies of language users. *Sprache, Sprechakt, Kommunikation* thus not only employed speech acts in order to show that media are never entirely transparent, but it also shifted the discussion of mediality from technical operations to interpersonal communication as well.

This argument has been most fully developed in Krämer's 2008 book *Medium, Bote, Übertragung: Kleine Metaphysik der Medialität* (*Medium, Messenger, Transmission: A Small Metaphysics of Mediality*), which is her first book to be translated into English. Krämer's primary argument is that in order to understand media we must go beyond the technical apparatus and

understand the relations of mediality upon which the apparatus depends. Krämer also argues that all forms of communication are actually acts of transmission and that all media should therefore be understood as transmission media. The confluence of these two ideas results in a philosophy of media that defies much of the conventional wisdom about communication, which is commonly understood as dialogue, understanding, self-expression, etc.

Krämer explains this distinction in her prologue to the book, in which she describes two competing approaches to media philosophy. She refers to the first approach as the 'technical' or 'postal' principle, which is based on the notion that all communication requires an intervening medium, yet communication is only successful when this medium fades into the background and remains unobtrusive. According to the 'postal' principle, in other words, communication is asymmetrical and unidirectional and the medium represents a necessary precondition for the possibility of communication, as it facilitates the connection between the sender and the receiver. This is essentially the technical transmission model of communication developed by Claude Shannon and Warren Weaver,[9] and the phenomenon of 'information entropy' occurs when the medium becomes a 'disruptive third' through the generation of noise or interference. Krämer refers to the second approach as the 'personal' or 'erotic' principle, which is based on the notion of communication as social interaction or dialogue, whose goal is social interaction, understanding, and community. According to the 'erotic' principle, communication is a symmetrical and reciprocal process and the aim of communication is not connection but unification through direct and unmediated access. In other words, communication allows speakers to transform heterogeneity into homogeneity and difference into identity, thereby achieving a kind of 'single voice' or consensus that represents the fusion of separate halves. This is essentially the personal understanding model of communication developed by Jürgen Habermas, and it implies that the presence of any intervening medium constitutes a form of disturbance since the unification of these disjointed fractions depends on the annihilation of the intervening space. These two approaches thus represent two contradictory trends in media theory, and Krämer explicitly argues that 'the concern of this book is...to rehabilitate the postal principle and thus the transmission model of communication', as 'most community-building and culture-founding forms of communication precisely do not follow the standards of dialogical communication'. In short, media are essential tools for bridging distance and difference, and they thus represent a necessary precondition for the possibility of culture and community, yet they also

preserve this distance or difference, as the presence of an intervening medium implies the existence of an intervening space that precludes any possibility of unification. In other words, mediality represents the negotiation of radical alterity rather than the formation of a consensus reality.

Krämer explains this argument by providing a comprehensive overview of various philosophical theories of transmission, including Walter Benjamin's theory of translation as the revelation of an unbridgeable gap between languages, Jean-Luc Nancy's concept of community as founded on a basic divide that constitutes our very essence as communal beings, Michel Serres' notion of communication as an attempt to establish a bridge between worlds that always remain distinct and unbridgeable, Régis Debray's theory that immaterial ideas are only transmissible when they are embodied in material objects, and John Durham Peters' theory of communication as non-reciprocal, non-dialogical dissemination, which is based on a fundamental separation or difference. The idea of communication as dialogue is problematic for each of these thinkers in their own way, and Krämer is able to draw a series of preliminary conclusions from these theories:

(1) A philosophy of mediality can only begin by recognizing that there is an unbridgeable distance between the sender and the receiver – a distance that can never be overcome.
(2) The medium occupies the intervening space between the sender and the receiver, and it is able to facilitate their connection while still maintaining the distance that separates them.
(3) All forms of communication are reducible to acts of (non-reciprocal) transmission between the sender and the receiver, as unification and dialogue remain impossible.
(4) Transmission is an embodied, material process, yet it is frequently understood as disembodied, as the medium is supposed to be invisible through its (noise-free) usage.

Krämer illustrates these ideas using the figure of the messenger as a key metaphor for all medial processes. The figure of the messenger provides an ideal illustration of the function of transmission for three reasons:

(1) As with the classic sender-receiver model of communication, the concept of transmission presupposes the existence of a divide or difference between heterogeneous worlds, and the function of the messenger is to mediate between these worlds while simultaneously preserving the distance that separates them.

(2) The messenger is able to establish this connection between heterogeneous worlds by making something perceptible, thereby embodying the immaterial in a material form. As a representative of his employer, for example, the messenger's body becomes an extension of his employer's body. The messenger thus transforms his employer's absence into a form of presence, which shows how all transmissions function as forms of display.

(3) The embodiment of the message is only made possible through the disembodiment of the messenger, as the messenger must relinquish his own autonomy and agency in order to become invisible and imperceptible. In other words, the messenger disappears behind the content of his message, which makes the process of mediation appear to be direct and unmediated. This idea is most vividly illustrated in the trope of the dying messenger, who expires at the very moment his message is delivered.

According to Krämer, every form of mediality illustrates these aspects of the messenger model. For example, films are not supposed to be perceived as celluloid strips but rather as moving pictures, and the presence of the material strip only becomes apparent when the transmission is disrupted, such as when it jams in the projector. In the same way, the messenger is also supposed to remain transparent in order to facilitate the transmission of his message.

The implications of this theory are fourfold:

(1) All forms of communication are actually forms of transmission, which are always unidirectional and non-dialogical. In other words, communication is a form of dissemination rather than dialogue, and it is directly opposed to the 'personal' principle of communication, which is based on the concept of understanding, dialogue, consensus, etc.

(2) The medium embodies the message through its own disembodiment, and therefore transmission depends on the separation of text and texture, sense and form, signal and noise.

(3) The medium is heteronomous, as it speaks with a voice that is not its own and therefore it is not responsible for the content of the message it transmits. The messenger model is thus directed against hermeneutics and points to a subject-free theory of communication that challenges the notion of media as autonomous agents or as the cause of cultural-historical dynamics (i.e. Kittler's famous dictum that 'media determine our situation'[10]).

(4) The invisibility of the messenger enables its function as a transmitter to be easily replaced by non-human entities, which suggests that the technical transmission model of communication can be used to explain the function of interpersonal communication and vice versa.

Medium, Bote, Übertragung thus moves beyond the history of technology and the study of technical operations and focuses instead on the ways in which the phenomenon of mediality shapes our understanding of the world around us. In other words, mediality is fundamentally productive because it represents the basis of all forms of social and material systems of exchange.

Krämer explains this argument in more detail by examining a diverse range of transmission events, including angelic visitations, the spread of infectious diseases, circulation of money, the translation of languages, psychoanalytic transference, the act of bearing witness, and even the development of cartography. Angels illustrate the concept of mediality because their embodied manifestations facilitate communication with God while at the same time implying the impossibility of direct communication between heaven and earth. The connection between God and humans thus remains unidirectional, and it is only achieved through the process of embodiment, as angels can only communicate with humans in so far as they themselves also assume human form. Viral infections also depend on physical contact between two heterogeneous entities, and they similarly illustrate the unidirectionality of transmission, as they are one-sided and non-reciprocal. Money also represents the transfer of ownership between sender and receiver, which is only possible through the establishment of an equivalent relationship between heterogeneous goods. Money thus enables the desubstantialization of goods, which makes ownership objectifiable. Translators also bridge the differences between languages by making these differences visible, yet they also maintain the divide separating languages by preserving different connotations. Psychoanalysts similarly function as media during the process of transference, as they serve to represent primary attachment figures from their patients' past, thereby enabling the transmission of feelings from their patients' unconscious minds. While analysts make these feelings perceptible to the patient's conscious minds, they must not respond to them emotionally. Psychoanalysis represents a dialogue not between the patient and the analyst (which is implied by the notion of the 'talking cure'), but rather between the patient's unconscious and conscious mind, and the analyst is only able to facilitate the transfer of unconscious emotions by remaining neutral and withdrawn. The act of bearing witness also presupposes a gap between the witnesses, who have

perceived a past event, and their listeners, who were not able to perceive the event for themselves. Like messengers, witnesses are able to make this event perceptible to their listeners through the process of transmission, which depends on their presumed neutrality and impartiality. In other words, witnesses are 'data collection and retrieval instruments', and they are expected to withhold their own opinions and judgments from their testimony. Krämer describes martyrdom as the most extreme form of witnessing, as witnesses are considered to be most trustworthy when they are prepared to die, and the suffering of their bodies thus serves to guarantee the truth of their testimony (much like the dying messenger). Krämer's final case study focuses on the use of maps, which similarly function as media by making perceptible something that is invisible to the eye. Like an incorruptible messenger, maps are also supposed to serve as a transparent window onto the world. In order for maps to facilitate transmission, in other words, users 'must remain blind' to their distortions. Krämer thus concludes that 'cartographic distortion is a condition of possibility of representation' and 'transparency and opacity are two distinguishable dimensions of maps that require and include one another'. Krämer thereby rejects the debate between maps as neutral visualizations of reality and maps as cultural constructions that shape our perceptions of reality by suggesting that there is no point in fighting over the truth of maps; instead, it is more important to understand how maps mediate our perception of the world by obscuring their inherent inaccuracies. More than any of her other case studies, this chapter most clearly illustrates the significance of traces, which reveal that the medium itself is never completely transparent or neutral. By making users aware of the map itself, in other words, cartographic distortions preclude the possibility of transparency, yet the illusion of transparency remains a necessary precondition for the possibility of transmission, as users must perceive the map as an accurate representation of reality in order to be able to orient themselves in space.

According to Krämer, all of these various forms of transmission – angels, viruses, money, translators, psychoanalysts, witnesses, and maps – can be seen as media in the sense that they simultaneously bridge and maintain differences between heterogeneous worlds. The messenger model thus depends on the basic insight that a community of different individuals is founded on the distance that separates them, which precludes the possibility of unification or intersubjectivity, and all attempts at communication are actually acts of transmission, as communication is fundamentally unidirectional, asymmetrical, and non-reciprocal. This theory also implies that the technical transmission model of communication is no longer unique

to mass media; rather, it is an inherent dimension of all forms of human communication – a point that is emphasized throughout Krämer's book, as she repeatedly focuses on interpersonal rather than technical forms of communication. The emphasis of the messenger model thus allows for a media theory based on processes and thirdness rather than the technical apparatus.

In her conclusion, Krämer acknowledges that the figure of the messenger is also fundamentally ambivalent, as 'every messenger acts as a reversible figure: the angel becomes the devil, the mediator becomes the schemer, the circulation of money develops into greed and avarice, etc.' In other words, the danger always exists that the medium might introduce a degree of noise or interference into the act of transmission by making his presence felt instead of remaining neutral and transparent, such as when the devil attempts to manipulate listeners, when the psychoanalyst falls in love with his patient, or when the user of a map becomes aware that it is presenting a distorted image of reality. Ambivalence is therefore inherent in the role of the messenger, and it is reflected in the form of the trace, which exposes the mediating function of the messenger by making his participation perceptible and revealing the possibility that the messenger might also represent a sovereign being with his own individual autonomy and agency.

While Krämer's messenger model may appear somewhat esoteric to readers who are unfamiliar with her previous work – and particularly to English-language media scholars who are more familiar with the technical emphasis of most German media theory – it provides several insights that are potentially valuable for contemporary media studies. In particular, it outlines a general theory of transmission that does not distinguish between technical and interpersonal communication or between technological and human agents. It thus expands our understanding of the concept and function of media as active agents in all systems of social and material exchange, which offers exciting new possibilities for other interdisciplinary approaches to the study of media and communication. Krämer's conflation of technical and interpersonal communication also allows her to avoid the pitfalls of technological determinism, as it does not grant undue power to the technical apparatus, while still recognizing the importance of the materiality of communication or the interface between the medium and the senses. Krämer thus emphasizes the notion that communication is dependent on embodiment, yet at the same time it she also preserves the idea of communication as non-dialogical and non-reciprocal, thus acknowledging the active role of the receiver, who does not necessarily interpret messages

in the way they were intended by the sender (i.e. Stuart Hall's 'encoding-decoding' model of communication).[11] Krämer's messenger model thus offers an alternative to McLuhan-style media theory, which focuses primarily on the impact of media technologies, and the Birmingham School approach to media studies, which focuses primarily on content and reception. Within a German context, one could also say that it carves out an original space in contrast to Kittler's emphasis on the technical aspects of media and Habermas' emphasis on the dialogic aspects of communication.

By reinforcing the function of perception and mediality as opposed to that of technology and content, Krämer's book occupies a key position in contemporary debates concerning the future of media studies in Germany and it represents a significant contribution to a growing body of work that challenges dominant trends in German media theory, such as the work of Hans-Dieter Huber, Dieter Mersch, Matthias Vogel and Lambert Wiesing. The fact that some of these names may be unfamiliar to English-language media scholars clearly shows that we need to expand our understanding of media theory in Germany and the wide range of approaches that this field of study encompasses. This edition will hopefully encourage increased international visibility for these alternative approaches, many of which have not yet been translated into English.

Prologue

Transmission and/or Understanding? On the 'Postal' and 'Erotic' Principles of Communication

Two Preliminaries and a Problem

How can the meaning of media be thought about in such a way that we acquire an understanding of our relationship to both the world and to ourselves? How can a concept of the medium be developed that encompasses our experiences using media? How can we determine what media 'are' in a way that embraces both generally accepted (voice, writing) and newer forms of media (computer, Internet)? How can media be conceptualized in a way that enables not only a reformulation of traditional philosophical questions but also a new conception of philosophy? Assuming first of all that *one* media concept could actually address all of these various questions, wouldn't this concept remain so abstract and general (in a bad sense), wouldn't it turn out so bare and tenuous, that it would say nothing and therefore not provide any answer at all?

As in most cases, it depends on the attempt.[1] And in order to let the cat out of the bag immediately let me state that this attempt will address the question 'What is a medium?' in the context of the idea of the *errand*. The messenger thus represents a primal scene of media transmission. You could even say that the messenger represents the force behind these reflections on media, and my claim is that this relationship – measured against the present state of the debate over media – provides a new perspective on the phenomenon and concept of media.

Isn't this a strange or downright outlandish effort? The messenger appears to be a relic of an epoch when the technical support of long-distance communication was not available, and it became obsolete with the development of the postal service or at the very least with the invention of the radio, the telegraph, and the telephone – not to mention the computer. What could the archaic institution of the messenger offer to modern media theory, whose reflections and explanations must address more advanced media? This provocative impression, which is often evoked by references to the messenger, is further reinforced by two associated preliminaries and an intruding problem:

(i) *First Preliminary*: 'There is always an outside of media.' Messengers are *heteronomous*. The messenger perspective thus challenges attempts to conventionalize media as autonomous sovereign agents or the solitary

causes of cultural-historical dynamics, and it contradicts the conception of media as a foundational a priori in the sense of a 'medial turn'.

(ii) *Second Preliminary*: 'The bulk of our communication is not dialogical.' Messengers are necessary when there is no unmediated interaction between sender and receiver; in other words, when communication *lacks reciprocity* and is precisely not a dialogue. The errand is – to start with – a unidirectional, asymmetrical situation. In the messenger perspective, therefore, reflecting on media means at the same time challenging to a certain extent the fundamental dialogical orientation of the philosophical concept of communication.

(iii) *The Problem*: 'Can transmission be creative?' Messengers transmit what is given to them. They are supposed to pass their messages along across space and time with the least distortion possible, and they should by no means change them. How then can our understanding of the phenomenon of transmission ever take into account the creative impulse, which is commonly associated with communication? Yet even computer-mediated communication is not a matter of data transmission but rather data *processing*, and it thus concerns not the conservation of order but rather its transformation. The rehabilitation of transmission will therefore only be compelling when it incorporates the innovative dimension of transmission and reconstructs the creativity of mediation.

It is therefore no small task to explain and substantiate a media theory of the messenger. This perspective forces us to question previously trusted philosophical assumptions, and it once again problematizes what now seems natural or self-evident.

To reflect on media philosophically therefore does not mean seeing media as more or less a seamless continuation of a philosophical tradition. In order to understand how our reflections on media require a willingness to question our own self-evident and trusted assumptions and thereby see them in a new light, I will now provide an introductory sketch using the *example* of 'communication'.

The Postal and Erotic Concepts of Communication

Hardly any other word has experienced such a rhizome-like diffusion in our everyday language and our disciplinary vocabularies as the word 'communication'. Communication even functions as a central perspectival vanishing point in our conceptual image of ourselves at the end of the twentieth century: practically everything that affects our civilized self-understanding can somehow be structured and described with the help of this word. There is 'communicative action', which complements the goal-directed utilitarian

considerations of instrumental action that constitute an ethos oriented towards self-understanding; there is the description – sometimes even conceptualized as a priori – of language as a medium of communication, which reduces perception, experience, and recognition to the structures of linguisticality; there is the labelling of problems as 'communication prob-lems', the difficulties of which are neutralized and casually associated with the promise of feasibility; there is 'man-machine communication', which signals that the scope and limits of information technologies constitute a key phenomenon of contemporary civilization and which moreover shows that communication is not limited to the interpersonal realm; there is the vision of a globalization that conceptualizes communication as a world-spanning network; and finally we should not forget the laconic assertion that one cannot not communicate.

It would be easy to continue this list. Considering the ubiquity of the word 'communication' and the range of its possible uses, it is no surprise that critics are increasingly critical of this concept. Botho Strauß dismisses the word 'communicate' as the 'non-word of the age' and characterizes it as a 'garbage disposal word'.[2] Uwe Pörksen remains somewhat more objective in his description of 'communication' as an 'amoeba-word' (or also 'plastic word'): it conceals its metaphorical character, enters the everyday after pass-ing through the mathematized sciences and is then used both unhistorically and imprecisely as the minimal code of industrial society: 'Communication' is deployed like a 'Lego brick', which is arbitrarily combinable and practi-cally envelops our entire living space in its word net.[3]

Nevertheless, the imprecision that Pörksen attributes to the word 'com-munication' conceals an obvious tension and divide that is characteristic of the contemporary usage of the word 'communication': in the present discourse the word leads a conceptual double life. It appears in two mutually opposed contexts, which I will refer to as the 'technical transmission model' and the 'personal understanding model' of communication. The *technical transmission model* is elaborated in the communication theory developed by Shannon and Weaver, who studied the technization of information flows, from information transmission to data processing.[4] The output problem in the technical transmission model consists of the spatial and temporal distance between the sender and the receiver. Both the sender and the receiver are considered instances, which could be human beings or objec-tive nature, that form the beginning and end points of a *linear* chain that consists of essential interlinks either in the form of a medium (a channel) or an external disturbance. What happens along this chain is the relaying of signals or data; in other words, the transmission of uninterpreted entities.

The process of data transmission is thus physically specifiable and mathematically operationalizable. The transmission is considered successful when something material is transported from one side (the sender) to the other side (the receiver); there is no such thing as immaterial signals. The basic problem of communication thus consists in keeping signal structures stable in the face of the erosion of this order through external disturbances. The technical connection is successful, in other words, when it keeps the 'disruptive third' away from the transmission event that occurs between the sender and the receiver.

The approach of the *personal understanding model*, whose design is embodied in Jürgen Habermas's communication theory, is entirely different.[5] Here communication is considered an interaction between people, which is dependent on mutual understanding with the help of symbols that convey meaning – preferably a language. Communication thus becomes an expression of human being-in-the-world. The output problem consists in the heterogeneity of people and thus in the question of how intersubjectivity is possible at all under the conditions of individuality. Communication thus represents the basic process that enables coordinated action, which results in the formation of community. It is conceived as a *reciprocal* process of social interaction. Intersubjectivity is made possible through dialogue, which is presented as the primal scene and established norm of communication, and the goal of dialogue is understanding. Unlike the technical approach, the performance of communication consists not only in establishing a connection across distance, but also in fostering agreement and creating a unified society whose goal is precisely to overcome distance and difference. When dialogical communication is successful, those who communicate with one another in a sense become 'one'; if the goal of understanding has been achieved, then it is as if they are speaking with one voice.

While communication-as-understanding is conceived as a symmetrical and reciprocal process, communication-as-transmission is conceived as asymmetrical and unidirectional. Transmission is precisely not dialogical: the goal of technical communication is emission or dissemination, not dialogue.[6] We can thus clearly distinguish between the *personal principle* of understanding and the *postal principle* of transmission.[7]

The postal principle presents communication as the production of *connections* between spatially distant physical instances. On the other hand, the dialogical principle presents communication as the synchronization and *standardization* of formerly divergent conditions among individuals. We could thus say that there is a latent erotic dimension to the telos of this personal perspective (i.e. the merging of people who were separated from

one another).[8] In order to emphasize the differences between these two notions of communication in an intentionally ironic way, we could even refer to them as the 'postal' and 'erotic' concepts of communication.

Both of these concepts presume a distance that can also be described as a qualitative difference: difference constitutes one – if not *the* – universal precondition of communication. According to the postal principle this difference lies between the sender and the receiver, and it is generated through the spatial and temporal distance between them. According to the erotic principle it is the difference between individuals with their heterogeneous and initially impenetrable inner worlds. In each of these cases, however, communication provides an answer to the problem of how to bridge distances. These concepts thus represent different strategies for dealing with distance and difference. The technical concept of communication bridges distance without annihilating it; indeed, it is precisely through and in the successful transmission that the sense of being distant from one another is stabilized and reinforced. The goal of the personal concept of communication, on the other hand, is to overcome and abolish distance and mutual inaccessibility. It thus presumes the existence of difference without endorsing or stabilizing it; instead, it attempts to transform the different into the identical, which is actually divided among the participants and becomes something 'communal'.

When we ask which role media are assigned to play in each of these different approaches, there will obviously be various answers. For the transmission model, media are indispensable; they occupy the position between the sender and the receiver, and without them it would not be possible at all for the sender to 'post' something that would reach the receiver. The medium neither annihilates the distance between the sender and the receiver nor enables any unmediated 'contact' between them; rather, it establishes a connection despite and in the distance that separates them. For the understanding model, on the other hand, media are peripheral and negligible vehicles that provide undistorted and unmediated access to something that they themselves are not, much like transparent window panes. Because the dialogical relationship results in the annihilation of distance and the direct experience of reciprocal understanding, which happens precisely when two individuals in their own inner worlds agree and 'merge', there is no more space for a mediator or a medium.

Just as media are seen as indispensable for the postal aspect of communication because they make mediation itself possible, they are also seen as detrimental to the immediacy of the dialogical. While transmission media are designed to minimize disturbances, media themselves cause

disturbances in dialogical situations. The elusiveness of the voice thus meets the ephemeral status of communication media; and conversely: the more the materiality of the medium is shown to be technical, opaque, and compact, the more the notion of communication understood as dialogue (which is then still possible) appears distorted.

This description of the confrontation between the technical/postal and the personal/erotic approaches to communication is obviously exaggerated. Using names like Shannon and Habermas as a form of shorthand to invoke these theoretical approaches also clearly lacks the reflexive subtlety that would somehow do justice to the ingenuity and the potential compatibility of these approaches. However, this was not the reason for sketching out these radicalized positions for the purposes of a prologue. The opposing models and meanings of communication that have been emphasized in this outline are intended to show why the use of a messenger perspective demands at the same time the surrendering of convictions and attitudes that are commonly taken for granted. From the point of view of a philosophically substantial concept of communication, there is no question that dialogue and mutual understanding are more worthy of description and explanation than the phenomenon of transmission and the one-sided sending of signals. As a theoretical framework for the description and explanation of what happens when people communicate with one another, the postal principle of technical communication appears utterly inadequate. To express this in a more exaggerated way, one might say that the letter carrier cannot possibly provide a figure worthy of explanation for a philosophically sophisticated theory of communication.

The concern of this book is not to elevate the status of the letter carrier, but rather to *rehabilitate the postal principle* and thus the transmission model of communication. In contrast to the privileging of dialogue as the unalterable essence of communication and the privileging of reciprocity as the primary structural principle and emancipatory norm of communication, the following reflections on mediality are inspired by the insight that most community-building and culture-founding forms of communication precisely do *not* follow the standards of dialogical communication. The 'erotic' communication in the speech act of confluent differentiality is indeed *one* possibility, but interpreting it as the ideal or merely the general form of communication constitutes a form of Romanticism.

From Communication to Perception?

And yet this is not a book about communication, as it debates the question of 'What is a medium?' in terms of transmission processes. By introducing

the figure of the messenger as the primal scene of media, it indeed appears that from the very beginning I have set a course for a communication-centric mediation; the unidirectionality and asymmetry of the transmission process, which culminates in the messenger figure, also raise the question of whether media-theoretical mediations concern not the categories of communication and understanding, but rather those of 'making percep-tible' (*Wahrnehmbarmachen*) and 'making appear' (*Erscheinenlassen*). Can the gimmick of the messenger perspective thus lie in a shift from communication to perception? In this light, the non-dialogical – if this can be conceived as an attribute of *perception* – to a certain extent loses its potential for irritation. The conventional view being challenged here is the categorical and categorial separation between 'communication' and 'perception', according to which the definitive foundation of sociality is a communality made possible through communication, not perception. Could a goal of this media reflection thus lie in problematizing not only the philosophical preoccupation with understanding-oriented, reciprocal, 'media-free' communication, but also the marginalization of perception that this preoccupation necessarily implies? Could the 'rehabilitation of the postal principle' thus also rehabilitate the community-building and culture-founding functions of perception and the 'making perceptible'?

Questions upon questions. Before beginning to look for answers, however, I will first reveal my method, which is inspired by a 'metaphysical gesture' that is in need of explanation.

Methodological Considerations

Is a Metaphysics of Mediality Possible?

The following section continues with a look at contemporary reflections on media, albeit limited to the discourses of cultural studies and philosophy.[1]

Media Marginalism and Media Generativism – The Scylla und Charybdis of Media Theory?

The debate over media that was first articulated in the 1960s and continues to flourish today is confusing, multivocal and heterogeneous: there is no consensus in the phenomenal domain, the methodological approach or even the very concept of media. Nevertheless, through the multitude of heterogeneous voices – at least in the cultural studies camp – it is possible to perceive a certain vocal range that could be called the 'bon ton of the media debate'. This 'bon ton' involves reflecting and researching media with an attitude that is committed to a maxim of generativity. Lorenz Engell expressed this maxim with enviable clarity: 'Media are fundamentally generative.'[2]

The meaning is obvious: in contrast to a marginalizing perspective, which treats media as negligible vehicles that add nothing to the messages they convey, this maxim signals a change in perspective that turns towards the media themselves rather than their contents. By shaping their contents, media fundamentally participate in the generation of messages – when not entirely producing them. Marshall McLuhan's provocative thesis 'the medium is the message' radically challenges the assumption that media are transparent and thus a secondary phenomenon that offers the most unimpeded view of the 'actual' objects of humanistic work, like 'sense', 'meaning', 'spirit', 'form', and 'content' – an assumption that had previously been taken for granted by the humanities.[3] The 'culturalization of the humanities', which was so characteristic of the outgoing twentieth century, thus found a support and a material grounding in the medialization of sense, spirit, and content. In the heterogeneous field of media theory a small common denominator is the idea that media not only relay their contents, but are also fundamentally generative.

Doesn't this assumption of the shaping power of media towards their messages represent a necessary *presupposition* for all media theoretical efforts, insofar as these efforts would make themselves meaningless without this assumption? Where then lies the problem with the 'generative maxim'?[4] In order to trace this problem, I will now turn to philosophy.

The media debate reached philosophy late, but the first drafts of a media philosophy are available,[5] the meaning and scope of philosophical media reflections are being debated,[6] the history of media philosophical thought is being written,[7] and the status quo of media philosophical reflections are being analyzed.[8] This inspiring orientation towards questions of media certainly originated at the margins of academic philosophy. Core areas in philosophy, like the philosophy of spirit and language, epistemology, and the theory of science, not to mention ontology and metaphysics, still remain largely unaffected by the issues in media theory. Why is philosophy struggling with these questions?

Perhaps an evident family resemblance can lead the way to a possible answer, which emerges between the 'medial turn' in cultural studies and the 'linguistic turn' in philosophy.[9]

The strategic goal of McLuhan's identification of the medium with the message was to take away the transitory transparency and neutrality of the media and make visible their autonomous opacity and instrumental shaping power. This is precisely the central theme of the 'medial turn'. The discovery of the formational power of media parallels the 'linguistic turn' that took place at least fifty years earlier through the work of Austin, Ryle and Wittgenstein, who determined that linguisticality was a basic condition of our relation to the world. However, the discovery of language as a constitutional condition of experience and cognition presumed precisely that language could *not* (any longer) be interpreted as a medium. This does not at all mean that the mediality of language would have played an explicit role in the philosophy of language. Nevertheless, since the beginning of the modern era philosophical concepts of language also always implicitly reinforced the idea that language represents a verbalization of thoughts, and linguistic relations therefore constitute the – more or less successful – expression of a system that is prior to language – a system based on the structures of the world or human intellect. While philosophy inaugurated the 'linguistic turn' by conceptualizing language and communication no longer as representational instances but rather as productive sites of mind and spirit, rationality and reason, it also challenged the merely derivative status and medial secondarity of language. As a result, language or (as with Peirce) signs or (as with Cassirer) symbolic forms became a constitutional condition of the world and its cognition: in keeping with a strategy of thought that was established since Kant's critical turn, language and sign systems thereby become a condition of possibility for our experience of and relation to the world.

The family resemblance between the medial and linguistic turns should now be clear: in both cases it involves a reflexive figure whose goal

is to reconstruct the opacity and autonomy of transitory and secondary phenomena, thereby showing that something considered derivative and inferior actually has the power to define structures and systems. The generative potential attributed to language and media also involves something demiurgical, for when this creative power is attributed to something it is ennobled as an Archimedean point in our relation to the world, and it is thus thought to be as fundamental as it is unavoidable.[10]

At the same time, however, there is a remarkable contradiction between the 'linguistic' and 'medial' turns. As mentioned earlier, establishing the linguistic a priori meant that language was no longer 'only' a medium. This shift was certainly based on an understanding of the medium as a vehicle and carrier in the sense of a *transitory medium*; however, over the course of the debates concerning media such a concept was gradually rejected in favour of an *instrumental media concept*. As a result, by virtue of this instrumental-generative dimension the media a priori can now actually compete with the linguistic a priori.

It is now necessary to return to Derrida. The radical nature of his deconstructive philosophy reveals itself precisely in the assertion once again – therefore recursively – of the reflexive figure of language criticism as opposed to simply the results of this criticism, insofar as he undermined the primacy of speech in the name of the secondary of writing. This undermining does not lead to the replacement of the writing a priori with the linguistic a priori, however, but rather it results in the baring of dilemmas or aporias: in Derrida's perspective writing becomes a condition of both the possibility and *impossibility* of speech and semiosis.[11] Derrida's interpretation will not be pursued any further here, but it suggests an idea that is more important for our considerations.

If Derrida's reflections on writing are interpreted in an undeniably oversimplistic way as a (recursive) application of media criticism to language criticism, it shows that the traditional transcendental reflexive figure 'condition of the possibility of', which still underlies Kantian epistemology, modern language criticism and implicitly also contemporary media criticism, is not simply transformed but rather *collapsed* in its recursive self-usage. Basically, with the linguistic turn the media critical break proves to be both a breakdown as well as an ultimate justification of the idea of the a priori. It also proves to be a breakdown of the attempt to distinguish, universalize and thus make autonomous *one* phenomenal domain as a prior matrix of our being-in-the-world. When the media critical impulse is brought to bear on the linguistic turn, therefore, it reveals aporias that are distinctive to all a priori processes.

An explanation of this aporetic approach would require a separate study. For the purposes of this book, however, it is easier to postulate on the basis of this diagnosis, thus *heuristically*, that *one* rather obvious method remains completely barred to philosophical reflections on media: the method which posits that an engagement with media is philosophically legitimated by the fact that media are seen as a priori of our experience of the world, which elevates media to an unavoidable condition of the possibility of perception, communication, and cognition. According to this position, there can be nothing 'outside' of media. If it does *not* make sense to think about media in this way – to insert them in the line of succession of the linguistic a priori – then how else can and should a philosophical reflection on media proceed?

The Disappearance of Media in Their Implementation?
In addition to the transcendental program there are also other reflexive figures of philosophical assurance. One of these figures can be called the 'metaphysical gesture'. This gesture does not consist in the Kantian sense in inquiring after the condition of the possibility of something, but rather it consists in the Platonic sense in reflecting on what lies behind a given appearance – namely, what it really is. Kant's ingenuity consisted in show-ing that those accepted a priori forms and concepts are to be sought and found behind appearances, which first enables the coming-to-appearance of something in our own experience. At the same time, however, it was also clear to Kant that the things that determine the world cannot simultane-ously be *in* the world and *from* the world. Plato, on the other hand, was convinced that the ideas that constitute the archetypes of all appearances are real – more real in any case than all material phenomena. The reflexive movement that penetrates the sensible, perceptible surface of a concrete, particular event in order to enter into its depths and expose the concealed entity hiding behind it, which is universal and invisible but nevertheless *real* and therefore effective and at the same time constitutes the 'essence' of this event: this approach provides a philosophical figure of thought that is widely accepted and has not at all gone out of use with the cognitive a priori. It is this figure of thought that will now be addressed.

I thus propose to reflect philosophically on media in a way that does not conceive of media as a condition of the possibility of our relation to the world, but rather grapples with the question of what lies 'behind appear-ances'. To begin, I will pursue this gesture of attending to what lies 'behind' and grapple with media and mediality from this metaphysical perspective. This now appears – at best – to be in need of explanation, and at worst as a

regression back to Platonism, which has long been obsolete. My intuition and intention is nevertheless entirely different: I want to show how applying a Platonic figure of thought to the use of media does not restore Platonism, but rather undermines it. I will now provide a brief summary of what this means.

In their everyday use media enable something to emerge, but this thing is not precisely in the media themselves, but rather in their messages. *In the media event, therefore, the sensible, visible surface is the meaning, while the 'deep structure' constitutes the non-visible medium.* The use of media is thus 'an-aistheticizing', as media remain hidden in their noise-free implementation.[12] Like it or not – or also paradoxically – this is why a metaphysics of mediality leads to a 'physics of media', to take up a term coined by Walter Seitter.[13] But this is premature. First, I must make sense of the argumentative hinge of this 'metaphysical approach', which is the fact that while enabling something to emerge media themselves tend to remain invisible.

We hear not vibrations in the air, but rather the kettle whistling; we see not light waves of the yellow colour spectrum, but rather a canary; we hear not a CD, but rather music; and the cinema screen 'disappears' as soon as the film grips us. The smoother media work, the more they remain below the threshold of our perception. 'Media make something legible, audible, visible, perceivable, while simultaneously erasing itself and its constitutive involvement in this sensuality, thus becoming unperceivable, anesthetic.'[14] At the same time that media bring something forth, they themselves recede into the background; media enable something to be visualized, while simultaneously remaining invisible. And vice versa: only noise, dysfunction and disturbance make the medium itself noticeable.

A medium's success thus depends on its disappearance, and mediation is designed to make what is mediated appear unmediated.[15] The perceptibility of the message, or the appearance of what is mediated, is thus inversely proportional to the imperceptibility of the messenger, or the disappearance of the mediator. This results in the paradoxical idea of an 'unmediated mediacy', an 'immaterial materiality', or an 'absence in presence'. *The implementation of media depends on their withdrawal.*[16] I will call this 'aisthetic self-neutralization'. It is important to note that this neutralization belongs to the *functional* logic of media. It is not an inherent feature of the medium itself, but rather it only takes effect when media are in use.[17] The invisibility of the medium – its aisthetic neutralization – is an attribute of media *performance.*

Even a media theory that is only close to being comprehensive and productive cannot overlook the fact that media remain latent in the

manifestation of their messages. Niklas Luhmann's media theory, which explores the relationship between medium and form, is the most thorough attempt so far to explain why we always see the forms but not the media themselves, but I will not discuss Luhmann here, as he is oriented towards media of communication.[18] Instead, I would like to focus on two positions that are concerned with *media of perception* and that are also important for an understanding of the principle of 'self-neutralization' because of their reflections on the 'invisibility' of media: on the one hand, Aristotle's aisthetic-oriented concept of media, in which the transparency of the medium becomes a *conditio sine qua non* of its function,[19] and on the other hand Fritz Heider's interpretation of the transparency of the medium as a symptom of the 'external conditionality' of media and thus its subordination to an external system.[20]

Aristotle opened the philosophical reflection on mediality insofar as he claimed that all perception was inevitably dependent on media. The eye is a distant sense: whatever touches the eye directly cannot be seen.[21] For Aristotle, sight is dependent on distance in two different ways. On the one hand, spatial distance is necessary for something to be seen. On the other hand, sight also requires the renunciation of interaction: vision cannot be explained as the interaction of the perceiving subject and the perceived object. Lastly, there is also a third: it is not enough that an empty space merely extends between the seer and the seen.[22] Rather, the space in between the subject and the object must actually *be filled*, and this is precisely the task of the medium that mediates between the seer and the seen as a third. Aristotle thus grants the medium a material facticity as well as a functional autarchy. At the same time, however, Aristotle also articulates the sole condition under which media can fulfil their task of enabling perception, which involves 'media diaphana' or *diaphanous* media.[23] Media are indeed bound to materiality, but their transparency is practically required: air, water or crystals are thus the most favourable materials for media of perception. However, this transparency is – as Walter Seitter emphasized[24] – not simply a physical characteristic of the corporeality of media, but rather a functional attribute: it could almost be called a property, which all media of perception to different extents (must) always possess. In the transparency of the medium materiality intersects with the transitory: transparency thus emerges as a *conditio sine qua non* of Aristotle's concept of media. As Thomas Aquinas later notes, the medium is qualified to convey a manifestation only when it does not manifest itself: 'A diaphanous medium must be without color.'[25] *Mediation is dependent on the illusion of immediacy.* To summarize these reflections, transparency

(the diaphanous) as a characteristic of Aristotle's perception medium is an early thematization of the phenomenon of medial self-neutralization.

Although the idea of the transparency of the medium emerges within the context of perception theory, it is then taken up in modern theoretical discussions of signs and symbols and in linguistic theory, or more precisely in reference to the specific nature of language with respect to the figurative modality of signification.[26] Linguistic signs are always already designed not to make their material form apparent but rather to make it recede into the background, so that the sign practically converges with the meaning it conveys. The incarnation of such materiality, whose specialty is making itself 'immaterial', is the voice, in which this disappearance takes the form of sound. Hegel thus notes: 'The word as *sounded* vanishes in *time*.'[27]

I will now jump to the first half of the twentieth century, when Fritz Heider took up the idea of medial transparency and gave it a significant twist in his theory of perception. Heider also defines a 'true medium' as one that can be 'seen through without obstructions'.[28] While Aristotle understood this transparency quite literally, Heider interpreted it as a metaphorical symbol of the non-autarchy or other-directedness of media. Regardless of what media do, this 'external conditionality' always remains significant for their activity: the activity of media involve 'forced vibrations', such that what is visible during the media event constitutes an external system, for which Heider also employed the expression 'false unity'.[29] 'Media processes are only important insofar as they are chained to something important, but they themselves are mostly "nothing".'[30]

It is not necessary to trace here the intricacies of Heider's concept of media. Naturally Heider was aware that media must also have their own system, albeit a system that must be conditioned to allow the highest possible degree of plasticity. Aristotle already conceived of this malleability when he emphasized that the emollience of wax made it possible for the first time to record the form (but not the material) of the signet ring.[31] The special quality of media thus consists in being materially conditioned to separate the material and the form from one another in the course of their operations. Heider conceived of this unconnected multiplicity of elements, which were not firmly established and were thus considered loose or soft, as the physical nature of media. This thought would later be taken up again not only by Niklas Luhmann but also Walter Seitter, who made it the focus of his 'physics of media'. What matters now is that Heider understood the transparency and plasticity of the medium as evidence of its constitutional external conditionality: 'The media event [...] is externally determined.'[32]

Aristotle and Heider's reflections on media, which were motivated by perception theory, can be summarized as follows: a medium always occupies the position of middle and mediator, and it is thus fundamentally non-autonomous. Media are not sovereign, and heteronomy is their defining feature. Aristotle's idea of the 'diaphanous' as distinctive of media of perception and Heider's concept of the 'false unity' of the media event represent two different ways of conceptualizing this heteronomy. To condense this into a catchy formula: *There is always an outside of media.*

Because it is a third placed between two sides, which fills the space between them, the corporeality assigned to media is a 'transitory corporeality'. Media are bodies that can be disembodied; the kind of materiality that appertains to them is the kind that is 'immaterial' during their usage.

On the Difference Between Signs and Media

This transitory nature, which manifests in the functioning materiality of media, nevertheless does not appear to be specific to media. In a long tradition of semiological discourse, signs also present a kind of materiality that 'stands for something else' and thus points beyond itself. Take for instance the most basic meaning of the concept 'sign' as a relation between a perceptible carrier and an imperceptible meaning: in this perspective, the sensibly factual signifier has the task of bringing to mind a mostly insensible signified. While avoiding the semantic simplification that the signifier represents the signified, which Saussure already made obsolete, a syntactic relation still remains dominant: according to Charles Sanders Peirce we can and must start from the premise that every particular, perceptible sign event is identifiable as a sign because and insofar as it is an instantiation of a universal sign type.[33] But when the material sign carrier is only individualizable as the realization of a universal model, then isn't this sign carrier in its material-sensible givenness the incarnation of the heteronomy and other-directedness that Aristotle and Heider attributed to media? Doesn't this indicate that sign carrier, signifier and medium are all one and the same?

Media and material sign carriers are actually conflated quite often. Nevertheless, all that matters here is a definitive difference between sign carrier and medium. This is a pivotal point in my argument. However, to avoid any misunderstanding in advance: the distinction between medium and sign (carrier) in the following cannot be understood as disjoined sorting in the sense of two classes or types of objects. There are not simply signs and in addition also media. Thematizing something as either a sign *or* a medium refers to two *perspectives* that describe the very same thing – for example,

language – in different ways. But how can the difference between these two perspectives be understood?

A sign must be perceptible, but what is perceptible in a sign is secondary, while the meaning of the sign, which is usually assumed to be invisible, absent and perhaps also immaterial, is considered primary. When something is viewed as a medium, however, it behaves in the exact opposite way: what is perceptible is usually the message itself, and the message is also what matters most in the media event. The message is thus considered primary, while the medium itself is secondary; it neutralizes itself, becomes invisible and disappears in its (noise-free) use. *In the semiological perspective, the meaning is 'concealed' behind the sensible; in the mediological perspective, on the other hand, the sensible is 'concealed' behind the meaning.*[34]

This difference reveals a strange inversion in the way the binaries of visibility/invisibility, surface/depth and secondary/primary are allocated in each case. If a metaphysical approach is applied to signs, then a universally trusted formula emerges: behind the sensible ('token') lies the sense ('type'). If a metaphysical approach is applied to media, then this formula is inverted in a significant way: behind the visible message lies the invisible medium. The metaphysics of mediality thus leads to a 'physics of media'.

It should now be clear why the difference between material sign carrier and medium is so pivotal for these theoretical considerations. To put it in an exaggerated way: the procedural logic of signs fulfils the metaphysical expectation to search for meaning over and beyond the sensible, but the functional logic of media reverses this metaphysical expectation by going over and beyond the meaning and confronting the sensibility, materiality, and corporeality of media concealed behind it.

That the visible constitutes the message while the invisible constitutes the medium is nevertheless only 'half the story': it is not the whole story because in this constellation of 'surface versus depth' the medium all too easily assumes the position of a source; it is thus regarded as a generative and hence conditional mechanism, which emphasizes its autonomy. If a metaphysical approach is adopted to seek out the concealed materiality of the medium behind the surface of the meaning, then it *must at the same time be agreed* that the medium possesses a *demiurgical power*, which is always implied by the concept of a 'medium behind'. When the medium is encountered on the reverse side of that which reveals itself as the message, therefore, its 'mode of being' excludes the possibility that the medium is endowed with an autonomous creative power and can be conceived as a quasi-sovereign actor or constitutive conditional relationship.

This line of thought suggests for the first time a good reason for the proposed messenger perspective. Etymologically the word 'medium' de-notes not only means, but also *middle* and *mediator*, yet media theory has (still) hardly explored this dimension. It is precisely this facet that will be addressed here.

The Medium as Middle – The Messenger as 'Dying Messenger'

A brief etymological explanation is now in order.[35] There were originally two significant ways of using the word 'medium'. On the one hand, it was a grammatical form of Greek, which remained neutral with respect to active and passive. It was a *genus verbi* for activities that constituted a mixed form *between* doing and suffering, production and reception or making something happen and something happening to oneself. 'πείδομαι', for example, did not simply mean 'I am persuaded'; rather, in a far more subtle way it signalled grammatically 'I allow myself to be persuaded'. The speaker is thus not simply in the position of object, but also at the same time in the position of subject, which is similar to what happens when people wash their hands. A person is receiver and sender at the same time, while also holding the middle position between receiver and sender.

On the other hand, 'medium' refers to the middle term in a syllogism. The *terminus medius* appears in both premises of a syllogistic deduction and it establishes the correlation between these premises, which in turn makes deductive reasoning on the basis of these premises possible. The conclusion lies in connecting the terms that are not middle terms, but this only happens in the act of effacing the middle term. 'All mammals are warm-blooded; all polar bears are mammals. Therefore, all polar bears are warm-blooded.' By establishing a connection, the *terminus medius* 'mammal' makes itself superfluous. The medium fulfils its function in the process of its own elimination.

These comments on grammar and logic as characteristic sources of the concept of media obviously do not provide an etymology of the concept of media. Nevertheless, the early use of the word casts an interesting light on the concept. Occupying the middle is precisely what the position of the medium represents. This 'middle' can be understood in three ways: spatially as an intermediate position, then functionally as mediation and finally formally as neutralization.[36] And – as evidenced at least by the use of logic – the medium disappears in its successful implementation. Its role consists not in being retained, but rather in being made superfluous. Media cannot be collected.

The idea that the medium becomes superfluous is emphasized most clearly in the legendary figures of dying messengers in myth, religion, and art. In the legend passed down by Plutarch, the runner from Marathon delivers the message of the victory of the Athenians over the Persians – in full armour no less – and then immediately drops dead.[37] The messenger is consumed through his activity. In the transmission of his message, he himself perishes. The motif of the dying messenger can be pursued further to a fresco by Lauretti Tommaso (circa 1530-1602), which shows the statue of Hermes, the messenger of the gods, shattered in pieces at the foot of an altar featuring the crucified Christ.[38] The fresco is called *The Triumph of Christianity*. Its creator thus intended it to be an allegory of the victory of the Christian age over pagan antiquity. In his commentary on the fresco, however, Michel Serres noted: '*Both* Mercury and Christ are at the point of death, their limbs wracked and their bodies torn. Messengers disappear in relation to their message: this is our key to understanding their death agonies, their death and their disaggregation.'[39] The 'life' of the message purchased with the death of the messenger; the messenger sacrificed through the delivery of the message; Is there a connection between being a messenger and being a sacrifice? In any case, the motif of the dying messenger is a radical version of the idea of the eliminatability of the medium, a more moderate version of which was already seen in the aforementioned discussion of syllogisms. The 'becoming invisible' of the carrier is therefore not a phantasm or an idealization: it is fundamentally connected to the messenger function.

This concludes my methodological considerations. The main idea, therefore, is that it is possible to trace the 'disappearance of the medium behind its content' and at the same time reveal the non-sovereignty, the constitutive external conditionality of the medium by understanding what a medium 'is' according to the messenger model. According to the messenger principle, 'foreground' and 'background', the sensible and the insensible, are very clearly allocated: what the messenger brings to the eye and the ear is not simply 'himself', but rather the message he has to convey. In the messenger, who 'speaks with a strange voice', a process emerges that is typical of media events, by which the medium withdraws and neutralizes itself in order to transmit its content.

Introductions

The foregoing preliminary considerations show what the following study intends to accomplish and what it intends to avoid:

(1) The medium will not be theorized as a means or an instrument but rather as a *middle* and a *mediator*. In light of this mediating function, the 'transmission perspective' and the 'postal principle' will be explored by investigating whether 'transmission' is definable in a way that at the same time reveals how media affect and shape what they transmit. The original scope of medial effectiveness will also be reconstructed as a *perceptual relation* and a *letting-appear* (*Erscheinenlassen*), in which the communicative functions of media are rooted and on which they ultimately depend. A philosophical gesture will thus be adopted that is traditionally called a metaphysical perspective insofar as what media let appear can be traced back to something concealed behind it and thus invisible. This process effectively reverses the classical metaphysical gaze, as it involves the 'hidden materiality' of media.

(2) What is to be avoided now appears as a negative image: no media a priori is to be established, and media are thus not to be located within the frame of ultimate justifications. Media are also not to be endowed with a quasi-demiurgical power, thus blazing a trail for a kind of 'media generativism' that at the same time also brings forth what media let appear.

The underlying assumption is that these intentions can be realized by successfully using the messenger model as an inspirational source of media-theoretical reflections. Before we proceed, however, the following chapters will show how various contemporary authors (with the exception of Benjamin) have inspired this media-theoretical project.

Walter Benjamin

> *'Mediation, which is the immediacy of all mental communication, is the*
> *fundamental problem of linguistic theory, and if one chooses to call this immediacy*
> *magic, then the primary problem of language is its magic.'*[1]

The link to Walter Benjamin is more than close. His essay on 'The Work of Art in the Age of Mechanical Reproduction' has become a classic of media theory. This is largely due to the fact that Benjamin is seen as a pioneer in the discovery of a conditional relation between technics and art, technology and perception, media, and the senses. In each case, the way art, perception, and the senses are presented is not only preformed but practically constituted by media, technics, and technology. Because of his artwork essay, Walter Benjamin has been characterized as an early proponent of the media generativistic position. So why include Benjamin when attempting to give a hearing to critical voices that are opposed to a constitution-theoretical understanding of media?

With one exception,[2] the contemporary media debate consistently overlooks a text written by Benjamin in 1916 titled 'On Language as Such and on the Language of Man', in which he introduces the concepts 'communication', 'medium', and 'mediation' in a way that definitely does not support or promote the generativistic tone of the media debate, which all too willingly sees Benjamin as a decisive time keeper. The fact that this early essay on language is almost never interpreted as an insightful media-theoretical source is also due to the author himself: Benjamin wrote these pages less for publication than self-understanding. Benjamin thus produced a cryptically laid out and hermetically held document that he only shared with friends as a sign of his personal esteem.[3] I will now turn to the text itself, although I do not intend to discuss its linguistic content; this has already been done superbly by Winfried Menninghaus[4] and, more recently, Anja Hallacker.[5] Rather, I am looking for traces of a media concept in Benjamin's early work that is shaped by a divergence between the medium and the technical instrument. This media concept will come to light as soon as the non-trivial meaning of the idea that language is a *medium of communication* is understood.

A media theory could not begin in a more unspectacular way: Benjamin explains that communication requires a medium, which he then calls 'language'. In contrast to their traditional meaning, however, these three concepts – 'communication', 'medium', and 'language' – assume an unfamiliar

meaning in Benjamin's text, and this unfamiliar meaning must be partially reconstructed in order to push forward to the essence of the media concept in Benjamin's early work. Here is a hint as to where this essence is to be found: the relationship between these three concepts is conceived in such a way that 'translation' emerges as the core task of mediation.

'Language' as Medium of Communicability: Reconstruction of a Concept

A reconstruction of Benjamin's early understanding of language can be explicated in six steps:

(1) *Language*: Benjamin understands 'language' as a 'tendency [...] toward [...] communication'.[6] He also calls this principle 'communicability'. This is the first conceptual shift: with his use of the concept 'language' Benjamin diverges from the notion of a language spoken by speakers, for '[l]anguages [...] have no speaker'.[7] It thus becomes possible for Benjamin to concede the existence of languages of technology, art, justice, and religion,[8] but at the same time to emphasize that these languages are not verbalized; instead, the legal decisions of justice, the terminology of technicians, the design vocabulary of art, and the reports of revelations in religion represent something that lies itself 'in the subjects concerned – technology, art, justice, or religion'.[9] Moreover, communicability is an attribute that applies not only to cultural spheres – 'symbolic forms' in Ernst Cassirer's sense of the term – but also to animate as well as inanimate nature. For Benjamin, therefore, there are 'languages of things' – he mentions here lamps, mountains, foxes[10] – even if their languages are 'imperfect' and 'dumb'.[11] And lastly there is also the language of God: in the creation story God creates by speaking.

Therefore: 'The existence of language is coextensive [...] with absolutely everything.'[12] And conversely: for Benjamin there is no 'existence' that is 'entirely without relationship to language'.[13] Existence is thus related to language and communicability like the front and back sides of a page. This is possible in that Benjamin bids farewell to three attributes that are commonly associated with the concept of language: language is not to be understood as the use of signs, it is not tied to vocalization, and it also does not depend on conscious awareness.[14] So what is 'language'?

Because language is identified with the principle of communicability and this principle corresponds to everything that somehow constitutes our experiential world, it is necessary to look more closely at how Benjamin understands 'communication'.

(2) *Communication in language versus communication through language*: 'What does language communicate? It communicates the mental being

corresponding to it.'[15] A formulation could hardly sound more conventional, yet what is funny about Benjamin's thought lies less in what communicates – the mental being – than in how it communicates: 'It is fundamental that this mental being communicates itself *in* language and not *through* language.'[16] It comes down to this phrase: to communicate 'in' and not 'through' language. Communicating 'through' language is what is typically understood by the use of spoken language. Benjamin also refers to this as the 'bourgeois conception of language', which he considers invalid and empty[17] and characterizes as follows: 'It holds that the means of communication is the word, its object factual, and its addressee a human being.'[18] Whenever people communicate through language in the conventional sense by someone communicating something to someone else, words are employed as means and instrument. In that case, words make something appear that is itself not linguistic 'nature': 'The word must communicate something (other than itself).'[19] But Benjamin characterizes this as 'the true Fall of the spirit of language',[20] for it assumes that 'the word has an accidental relation to its object, that it is a sign for things (or knowledge of them) agreed by some convention'.[21] In short, 'communicating *through* language' makes language into an arbitrary verbal sign system, which is employed as an instrument of communication. The location where language in this arbitrary sense is communicated *through* is the speaker,[22] yet 'being a speaker' is precisely not a revealing fact for Benjamin's philosophy of language. Against the background of this 'bourgeois' concept of language, therefore, I will now question what Benjamin means by 'communicating *in* language'.

(3) *'Communicating oneself' versus 'communicating something'*: this is a decisive point that reveals how Benjamin's concept of communication differs from our everyday notions. It is already clear that language should not be understood as signs, and it should also not be conceived as means. Benjamin calls such a language, which surpasses its semiotic and instrumental functions, 'expression'; more precisely, language becomes a 'direct expression of that which communicates *itself in it*'.[23] Benjamin thus refers to 'expression' as something that is not communicated through language, but rather something that communicates *itself in* language. For Benjamin, therefore, 'communicating oneself' is more like revealing oneself. From this perspective it is understandable why Benjamin attributes language to things as well as people: they can both express something by revealing something about themselves. The lamp reveals itself by affording light. Unlike the concept of 'communicating something', therefore, the idea of 'communicating oneself' involves a *unidirectional* movement that is not geared towards reciprocity.

But what does 'communicating oneself' mean when it refers to people? Benjamin's cryptic idea is that people do not communicate themselves; rather, what is communicated is language itself: 'All language communicates itself.'[24] In other words, while the lamp expresses and reveals itself by emitting light, people express and reveal themselves by naming. It has already been explained that according to Benjamin a 'mental being' communicates itself in language, but how is this 'mental being' related to 'naming'? At this point I will turn to Benjamin's concept of 'communicability'.

(4) *Communicability*: 'That which in a mental entity is communicable *is* its language. On this "is" [...] everything depends.'[25] If 'mental being' and 'language' coincide, therefore, it is because this mental being itself consists in communic*ability*. That which expresses itself *in* language is not a communication (which is expressed namely *through* language), but rather it is *communicability* itself. Benjamin liked using the suffix *-able* or *-ability*, such as the words 'reproducibility', 'criticizability', 'citability', 'translatability', etc.[26] Samuel Weber associated the use of the suffix *-able* with a particular ontological mode: the communicable is not the same as the communicated or the communication.[27] While the communicated and the communication refer to actual tangible operations, the communicable corresponds to another ontological mode, which is not real but rather virtual. This does not mean that it is simply possible and thus waiting to be realized; rather, by 'virtual' Weber understands that for Benjamin the communicable is an ability that is effective *without mediation*[28] and thus does not depend on intervention from outside.[29] Benjamin actually writes: '[T]his *capacity* for communication is language itself.'[30] Every language thus communicates not something but rather itself. According to Weber, it is precisely the immediacy of this effect that constitutes the mediality of language.[31] I now come to Benjamin's concept of media.

(5) *Medium, Expression*: Allow Benjamin to speak for himself: 'The language of an entity is the medium in which its mental being is communicated.'[32] And: '[A]ll language communicates itself *in* itself; it is in the purest sense the "medium" of the communication. Mediation [...] is the immediacy of all mental communication.'[33] As Benjamin here explicitly associates mediation with immediacy, it is clear that mediation is based precisely on not serving as *means*. Media offer the potential to communicate oneself, but they are not a means of communication. The immediacy of media is only another expression of their non-instrumentalizability for the purposes of communication and semiosis. The medium is not to be understood as a vehicle for transferring content; rather, it makes it possible for something to communicate *itself*. Mediation is thus the ability to express

oneself without the intervention of an external means. That is the basic idea informing Benjamin's early approach to media. Benjamin also describes the immediacy of the medium as 'magical'.[34]

(6) *Magic, Translation*: In light of Benjamin's attempt to keep everything that has to do with instrument, means, or mediation away from the concept of media und thus also from language, it is important to understand his characterization of this immediacy as 'magical': 'Mediation, which is the immediacy of all mental communication, is the fundamental problem of linguistic theory, and if one chooses to call this immediacy magic, then the primary problem of language is its magic.'[35] The medium (and thereby language) thus has its own non-instrumental effect, which Benjamin calls the 'magic of language'. But how can this non-causal effectiveness be understood?

I will reveal the answer up front: the magical effectiveness of language can be reconstructed as its translatability. Just as Benjamin sees the magic of language as the 'primary problem of linguistic theory', so is it 'necessary to found the concept of translation at the deepest level of linguistic theory'.[36] But how can the idea of translatability explain the magical power of language, which must at the same time also explain the process of mediation? And what does it mean to explain the process of mediation as translation?

In order to find an answer to this question, I will stop reconstructing purely conceptual relationships at this point and turn to a narrative dimension in Benjamin's language essay. It involves the biblical story of the Creation and the Fall of Man, which Benjamin interprets as an illuminating linguistic-theoretical resource.

Making Language Mediate: On the Interpretation of Genesis

Benjamin notes that God's creation of nature differs significantly from his creation of people. Nature emerges from the word, but people emerge from the Earth. 'This is, in the whole story of the Creation, the only reference to the material in which the Creator expresses his will, which is doubtless otherwise thought of as creation without mediation.'[37] As compensation for this 'earthly' origin, 'man, who is not created from the word' receives 'the gift o language'.[38] For God, therefore, language 'served *him* as medium of creation',[39] but for people this God-given gift becomes a mere instrument. This reveals something about the role of naming: God creates by naming, yet people name themselves: 'Of all beings, man is the only one who names his own kind, as he is the only one whom God did not name.[40] With the transition from divine to human language, however, the function of naming changes: for people, naming is no longer a medium that causes

the immediate creation of the named, but rather it is 'only' a means of cognition. The human cognitive faculty, which depends on the instrumental use of language, becomes a focal point if you will: it becomes a form of compensation for the loss of a demiurgical potential. Language as cognitive organon represents people's limited ability to create, and it is precisely the original divine creative power that people must renounce.

Benjamin clarifies this idea with his interpretation of the biblical story of the Fall of Man: '[T]he Fall marks the birth of the *human word*, in which name no longer lives intact.'[41] The difference between good and evil, which is now revealed to people, introduces a form of language usage that is no longer based on 'creation through naming', as there is no evil in paradise to refer to by name. Moreover, the human use of language now aims at forming judgements. In the judgement something is communicated *through* language, as the word becomes a sign. Because the word communicates *something* (besides itself) Benjamin – as already mentioned – considers this 'the true Fall of the spirit of language'. If the word communicates something in this superficial sense, Benjamin considers this 'a parody – by the expressly mediate word – of the expressly immediate, creative word of God'.[42] The Fall of Man marks the loss of linguistic immediacy, thus 'making language mediate'.[43] The cognitive judgement thus takes the place of the creating name. It is also the judging word of God that expels people from paradise with a sentence, yet at the same time the linguistic power of forming judgements is left to the people. The world-generating creativity of God thus becomes the world-judging cognitive faculty of people. In cognition, language is no longer 'spontaneous creation', but rather it becomes a kind of *conception*, and this conception is translation. If people give names to things, this naming is based on the silent language of things and thus on how 'the language [of things] is communicated to [man]'.[44] For 'conception and spontaneity together, which are found in this unique union only in the linguistic realm, language has its own word [...] It is the translation of the language of things into that of man.'[45] God thus creates by naming; this is an undisguised, 'pure' form of linguistic magic that is effective without mediation because it brings forth reality. People lost this form of linguistic power, and from that point on they were able to exercise their linguistic creativity (only) as translation.

The Medium as Translation
These reflections now come full circle. A conceptual reconstruction of Benjamin's reflections on language as a medium leads to the concept of 'translation', which Benjamin continued to explicate throughout his life.

My supposition was that because 'translation' constitutes the foundation of Benjamin's theory of language it also outlines his concept of media. Perhaps it has already become apparent in my discussion of Benjamin's interpretation of Genesis how this can be understood.

According to the terms of the biblical narrative, God's language creates but does not translate. Benjamin thus projects onto God the idea of language as a medium of undisguised non-instrumental creative power. That is the origin of the magic of language. Human linguisticality must then be considered, on the one hand, as a *break* with the divine language, but it can also be considered, on the other hand, as a form of its *preservation*.

The *break* is reflected in the linguistic divide between what can be communicated in language and what can be communicated through language. Henceforth, language is always twofold: as unmediated expression and as arbitrary sign, as 'communicating oneself' and as 'communicating something', as a medium of immediacy and an instrument of mediation. The *preservation* is reflected in the compensatory creative power granted to people through language and naming: people do not actually create the world, but they are able to create judgements about the world. This ability is solely due to the fact that human language can be considered a translation of the communicability with which God originally distinguished things by naming and creating them.

For God as well as people, therefore, language is a medium. As language is humanized, however, a decisive metamorphosis in the function of mediality occurs: *when God speaks, he creates; when people speak, they translate.* 'Translation' thus becomes a trace and symptom of the dichotomous condition of being human. The creation of people already distances them from the rest of nature, as they alone emerge from a synthesis of the palpable, corporeal earth and the breath of God-given linguisticality. And this linguisticality is fundamentally ambivalent: language is a medium for people in creation and conception, immediacy and mediation, expression and sign, magic and technology.

It could also be said that God's language creates because it is a 'pure medium'[46] and its performativity is complete. Human language is not a pure medium, but rather a hybrid of medium and instrument; it has become technical, an organon of cognition, and its performativity is only limited.

In light of Benjamin's reflections, therefore, what a medium means for human practices is precisely *mis*understood when the attribute of being an instrument or a sign is falsely included in the concept of media itself. In fact the reverse is true: the meaning and function of 'media' for people can only be defined through the tension, difference, or even dissonance

between media and technical or symbolic means. And the concept of translation reveals how mediality surpasses technical production and symbolic representation.

I will return to the concept of translation later.

Jean-Luc Nancy

'This thought of "sharing" (partition, repartition, part,
participation, separation, communication, discord, cleavage,
devolution, destination) has started to unravel.'[47]

The Ontology of Being-With

Jean-Luc Nancy works on an ontology whose fundamental concept is not Heidegger's 'Dasein' but rather 'Dasein-with' (*Mitdasein*): our existence is being-with-others; we are always only individuals as a collective group. 'Being' is 'singularly plural and plurally singular'.[48] In the context of this attempt to define our existence as 'being-with',[49] the word 'with' acquires a philosophical meaning that allows communality to be understood as 'distant closeness'. The notion of 'being-with-others' as both neighbourly yet distant sheds new light on the concepts of 'sharing' and 'communication': sharing proves to be something that eludes consensus because it presupposes and reinforces the idea of a splitting and separation.[50] And communication functions without reference to heterogeneity and difference, without attributes to be shared with others and indeed also without the person of a mediator. It is not the concept of 'medium' but rather 'mediation' that is important for Nancy. I will now reconstruct a sketch of how this concept inspires a non-instrumental yet nevertheless materialistic notion of mediality. This inspiration becomes clear as soon as it is understood how 'sharing' constitutes the matrix that is 'community' – a matrix that at the same time also turns out to be a 'milieu' in which mediation can take place *without* a mediator.

What does 'communality' even mean after the end of communism? This is a question that Nancy raises and that worries him. He can still only conceive of the human condition as the common condition; however, the sociality of the human mode of Dasein can now no longer be understood as the common bond of shared attributes or an all-encompassing collective agency. Instead, it is necessary to think of community on the basis of a 'common existence'.[51] To begin with, for Nancy *commonality* is *common* and *ordinary*. This is precisely Nancy's characteristic way of thinking about community. It is based on a concept of communication or 'sharing-with' that does not represent the exchange or communication of ideas; rather, it is conceived as the splitting and fragmentation of bodies.

Nancy's explication of our social existence in terms of 'being-with' (*Mitsein*) will thus show how his approach is able to inspire a philosophy of mediality.

On 'Sharing' and 'Communication'

There are three texts in particular that should be consulted: *Corpus*, 'The Compearance: From the Existence of "Communism" to the Community of "Existence"', and *Being Singular Plural*. Nancy's texts are in no way inferior to the cryptic style of Benjamin's essay on linguistic magic. These texts are based not on phenomena but rather linguistic expressions and philosophical concepts, and their purpose is to study words themselves. Nancy described his method of treating and considering hardly communicable words as objects as the *signum* of a poetic process.[52] His philosophy of community could also be characterized as a 'poetry of the common'. His intention to distinguish the ordinary and banal aspects of being-together as the matrix of the societal is in inverse proportion to his unusual and always artistic/ artificial diction, with which he then implements this intention.

I will attempt – as mundanely as possible – to reveal Nancy's philosophy of sharing in a more or less consistent sequence of thoughts, and I will begin by showing what 'sharing' does *not* mean:

(1) *Sharing beyond communication and communal substance*: Nancy observes that '"communicational" ideologies' can profit from the space left behind by the failure of socialism.[53] The ideology of communism has been replaced with the ideology of communication, in which the now-abandoned striving for historical telos, for a target- or goal-oriented notion of human affairs, has devolved into the development of ourselves as communicating members of a communicating community. Only this telos is not one, for 'communication is not an end, at least not in the way we might first mean'.[54] In the context of this critical attitude towards communication it becomes clear that if Nancy locates sharing at the centre of his idea of community, he is not referring to 'the manner which we today designate as "communication"'.[55] But what is sharing beyond communication?

To begin with, it is clear where the common condition is not to be found: it is not a substance, but rather – and this is already no longer entirely so clear – it is 'the lack of a substance which essentially apportions the lack of essence'.[56] Communication thus does not simply produce community, but rather it first registers a lack – the absence of a commonly shared substance: there is for Nancy no communal entity that consists of having or being something in common.

Nancy now maps out – and actually in conflict with Heidegger – three modes of 'commonality': first there is 'common existence', in which 'commonality' is meant in the sense of common or ordinary; then there is 'the common reduction to a common denomination'; and finally the 'the condition of being absolutely *in* common', which forms a collective.[57] Nancy then

eliminates the last two options, insofar as they involve the recognition of our sociality or the specification of our existence as a 'We'. For sharing constantly presupposes a *separation*.

(2) *Sharing as separation and splitting, the materiality and corporeality of the separated*: 'This thought of "sharing" (partition, repartition, part, participation, separation, communication, discord, cleavage, devolution, destination) has started to unravel.'[58] For Nancy, sharing reflects the fact that we originate from a state of dissociation without which association is inconceivable.[59] We are isolated: that is the phenomenon of separation and splitting. And yet we still do not lead our lives as individuals: that is the phenomenon of sharing. Our existence thus takes the form of a co-existence. Nancy consciously plays with the mundane and unpleasant connotations of this word 'co-existence', in which he perceives an oscillation 'between indifference and resignation'[60] that signifies the form of a with-one-another (*Miteinander*) that is imposed rather than sought through extraneous circumstances. 'Co-existence' signals an extremely weak and perhaps even the smallest possible form of a 'We'. With-one-another is a material next-to-one-another: *'partes extra partes'*.[61]

The fact that with-one-another first emerges as a next-to-one-another is rooted in the materiality and corporeality of existence: 'The ontology of being-with can only be "materialist" in the sense that "matter" does not designate a substance or a subject (or an antisubject), but literally designates what is divided of itself, what is only as distinct from itself [...] The ontology of being-with is an ontology of bodies, of every body, whether they are inanimate, animate, sentient, speaking, thinking, having weight, and so on.'[62] With a peculiar indifference that completely undermines Nancy's initial question concerning the givenness of community, the corporeal is described as separated things that exist next to each other and line up piece by piece, regardless of whether they are 'made of stone, wood, plastic, or flesh'.[63] Being-with is thus conceived as a 'being-with-all-things'.[64]

If sharing presumes separation into co-existing parts and if this separation is only possible at all because these parts that exist next to and apart from one another are material bodies, then a conceivable prosaic perspective has been obtained for the 'essence' of sharing. Sharing under conditions of separation means connecting, colliding, and making contact while being-together. This includes the transfer 'from one to another', which is not understood as meaning-carrying translation but rather as literal 'trans-lation'.[65] A distant closeness is thus maintained in the act of sharing. Dialogue loses its emphatic, meaning-saturated orientation towards consensus[66] and gives way to 'phantic, insignificant remarks ("hello,"

"hi," "good"…)'[67] in everyday existence. 'Idle talk' is thus not opposed to the authentic word; meaningless and meaningful words are both forms of maintenance that keep the circulation of sharing flowing.

(3) *Community as the common in its exteriority*: In light of Nancy's reflections, therefore, what kind of communality is being outlined? It is a radically purified form of *communitas*. It is no coincidence that the concept of 'nudity', which appears in many of Nancy's phrases, becomes a main feature of his idea of sociality. Nudity does not refer to particular individuals, but rather to the community itself: our history is 'that of stripping the community bare'.[68] What becomes apparent about the community in this exposure is 'not the revelation of its essence but a stripping down of the "common" in all of its forms (the "in-common" and the "banal"), reduced to itself, despoiled of transcendence or assumption, despoiled as well of immanence'.[69] We discover it in 'the exteriority and its common division'.[70] And: 'what is left for us to hold onto is the moment of "exteriority" as being of almost essential value, so essential that it would no longer be a matter of relating this exteriority to any individual or collective "me" without also unfailingly attaining [*maintenir*] to *exteriority itself and as such* [*l'extériorité elle-même et en tant que telle*]'.[71] This alignment of the common with the external challenges the emphasis on community as something communally internalized. Instead, *common*ality emerges in a purely external sense through various forms of numbers, such as masses, crowds, groups, distances, statistics, and enumerations of all kinds. Common causes and shared concerns do not (any longer) bind people together. Rather, the simple fact of co-existence, the next-to-one-another of different – animate and inanimate – bodies, and the vast multitude, which is the only place where individuals can appear. Nancy outlines – here citing Kant ('unsocial sociability') – a vision of an 'asocial society'.[72] But Nancy does not diagnose or lament this narrow definition of communality as the basis of the social following the failure of communist visions with the intention of being critical of society. On the contrary: it is precisely this basal and banal appearance as the many that necessitates our worldliness, for this co-existing multiplicity is the basic structure of the world in its materiality and corporeality. The '*ego sum*' can thus be conceived as an '*ego cum*'.[73] Moreover, the '*ego sum*' becomes a '*nos sumus*',[74] insofar as we are only individuals as a multitude. However, this means that there is not an ego and an alter ego, there is not the subject and the intersubjective, there is not an individual and a society composed of individuals; rather, there is only co-existence, 'co-ipseity',[75] out of whose dissociation and fragmentation the individual as such can be conceived. The individual emerges through separation, co-existence is a precondition of

existence, being-with necessitates the possibility of Dasein. 'With' becomes a basic constituent of everything that exists. Being is with-one-another.[76] Simultaneity thus becomes the defining tense.[77]

I will now draw a preliminary conclusion: my assumption is that the 'with' in Nancy's philosophy bears a signature that sheds new light on the concept of 'sharing'. Sharing is not oriented towards understanding or dialogically shared communication. Rather, sharing can be conceived as the soundboard of a primordial separation that precedes everything and – in a quasi-transcendental sense – makes it possible that anything exists at all. All sharing originates from this prior separation and at the same time bears witness to it. But how is this related to the other concept whose revisionary light was already anticipated in Nancy's 'philosophy of with': 'mediation'?

(4) *Mediation without mediator*: I will refer here to a passage from *Being Singular Plural*, in which the word 'mediation' (*médiation*) is used several times, albeit in an extremely cryptic way:

(i) At one point being itself is identified as mediation: 'Being is directly and immediately mediated *by itself*; it is itself mediation; it is mediation without any instrument, and it is nondialectic [...] negativity without use.'[78] What does this mean? A preliminary answer is that the concept of 'with', which is the basic constituent of being as being-with, must be understood in a way that precisely does not assume any significant difference between the separated elements or those existing apart. This sounds like a philosophy of identity. Nancy also discusses the 'principle of identity, which instantly multiplies'.[79] There is therefore not the One as distinguished from the Other and between them both the abyss of inequality. Simply because everyone is divided and split and separated does not mean that everyone repels, negates, and remains mutually inaccessible to one another due to differences. Nancy's thinking here is very different from Levinas's notion of the elusiveness of the other. Must we therefore conceive of being-with-one-another not as heterogeneity but rather as homogeneity? Is plurality only one modality of unity? Does Nancy's 'with' simply refer to synchronicity in multiplicity? Can 'with' itself be understood as mediation?

(ii) It is precisely these questions that Nancy poses and also affirms: 'Is mediation itself the "with"? Certainly, it is.'[80] If an instrument of mediation is not necessary, this is because the being-together of many people with-one-another itself already constitutes a – no, *the* – communality. *Sociality takes place in and as a mere 'with'.* It is therefore a mistake to imagine that mediators, media, and instruments are required in order to overcome the primordial separation that dissociates us. The situation is

actually the reverse: it is the separation that makes communality itself possible; community *is* being separated into many.

(iii) What this reveals is a 'mediation without a mediator'.[81] Nancy distinguishes this form of mediation from the Christian prototype of the messenger, or the notion of Christ as a mediator who performs and fulfils his function precisely through the fact that he is different from those between whom he mediates. For Nancy, there is no room whatsoever for a concept of otherness in the plurality of singulars connected by the 'with'. Here we encounter once again the lack of heterogeneity and difference, which consequently leads us to the conclusion that in Nancy's concept of mediation there is nothing at all to mediate in the traditional sense.

(iv) This kind of mediation thus turns out to be a milieu: 'Mediation without a mediator mediates nothing: it is the mid-point [*mi-lieu*], the place of sharing and crossing through [*passage*]; *that is, it is place* tout court *and absolutely.* Not Christ, but only such a mid-point; and this itself would no longer even be the cross, but only the coming across [*croisement*] and the passing through, the intersection and the dispersal [*écartement*].'[82] Nancy's mediation emerges without a medium, and it is precisely for this reason a *milieu*. This is how Nancy's ontology of 'with' offers a new perspective on the concept of mediation.

Mediation as Circulation

I will now attempt a concluding image. Like Benjamin, Nancy locates separation at the centre of sharing. Being separate from one another is thus part of the human condition, which raises the question of how mediation is conceivable under such conditions. Nancy's surprising and rather original answer is that this being-split does not represent a problem at all. It does not denote a lack that needs to be overcome, but rather it constitutes our very essence as communal beings. *We are only individuals as a collective.* We should therefore not see this state of separation as dissonance, dissent, or difference, but rather we should interpret it within the context of a quasi-homogenizing and mass dedifferentiating 'with'. Nancy's use of the term 'with' thus reveals his philosophically unique way of working on and with poetically reified concepts.

In the context of the messenger idea mediation should be seen as something that connects heterogeneous worlds, but for Nancy the word 'mediation' bears the stamp of homogeneity, alignment, and indifference. As a result, his thoughts can be inspiring for the question of how mediation between difference people takes place. This homogeneity is easier to conceive, not to mention banal, because it consists of nothing but its own

actual materiality, corporeality, and exteriority. It is therefore something that is separable – meaning separable from something that is dissected, that is divided with-one-another and that can also be shared.

Nancy thus transforms the question 'What is a medium?' into the question 'Where is a milieu?' And such a 'milieu' can be found wherever a being is constituted as being-with or wherever individuals exist as a plurality yet do not need a mediator, because the milieu of 'with' represents a primordial connection or similarity between the singularities existing with-one-another, which consists of the materiality of their corporeality: 'the juxtaposition of pure exteriorities'.[83] The concept of mediation without mediator can thus be conceived as a thoroughly bodily process, for Nancy treats the intellect as the *punctum*, which is extended and therefore not separable. 'Mediation' must be understood as radically extrinsic, as the back-and-forth of circulation itself.[84]

Michel Serres

> *'The intermediary writes himself out of the picture. He must not present himself or*
> *dazzle, or please...or even appear.'*[85]

From Walter Benjamin and Jean-Luc Nancy I now turn to Michel Serres. This represents a huge leap in terms of disciplinary approaches. While Benjamin's (earlier) work is influenced by metaphysics, linguistic mysticism and even revelation theology and while Jean-Luc Nancy dares to surpass Heidegger's '*Daseinanalysis*' with an innovative new ontological concept of '*Mitsein*', Serres is modestly oriented towards mathematics, structural linguistics, and the history of science. And yet there is a point at which the ideas of these authors intersect or converge: for all three of them, sharing and communication are connected to the same process, which Benjamin calls 'translation', which Nancy calls 'mediation without mediator', and which Serres calls 'transmission'. In order to explain this point of intersection, I want to reveal why and in what way transmission is so fundamental for Michel Serres. I will do this in four steps that outline varying perspectives on Serres's concept of transmission based on texts that correspond to the different phases of his work.

An Epistemological Concept of Transmission

In 1961, during the peak of structuralism, Serres wrote two texts that attempted to legitimate the structuralist approach philosophically and situate it in the context of intellectual history. Serres thus begins historically: since the nineteenth century at the latest, after the classical period, which had been oriented towards order, science, and reason, had given way to the Romantic period, culture was no longer associated with rationality, but rather with symbolism. The distinguishing characteristic of human existence was no longer understanding but rather sense. The meaning that previously corresponded to the question of truth had shifted to the question of sense. 'Since that time every methodological or critical question involves the concept of sense.'[86] The language that expressed this sense was not organized in words and letters, but rather in ideograms, synthetic paintings, and overloaded images.[87] And the archetype, which Romanticism derived from mythology, became the preferred way of ideogrammatically articulating the symbolic: Zarathustra, Ariadne, Apollo, Dionysus, Oedipus, Electra, etc. represented this cultural content.[88] Symbolic analysis thus meant 'the projection of a compactness of sense onto a unique compact archetype,

which in turn is situated in a historical origin that is as distant as possible (the most archaic)'.[89] The archetype thus embodied both the origin and the essence of the Romantic conception of the symbolic. In the early twentieth century, however, this symbolism underwent a decisive transmutation, which – in a way – is linked once again to the classic principles of rationality. The preferred form of articulating the symbolic analysis of culture is now no longer *archetypes* but rather *structures*.[90] While the archetype is overloaded with sense, the structure-oriented approach looks to 'empty the form entirely of its sense' and 'consider it solely in terms of form'.[91] The archetype is a form that is saturated with sense, while the structure is a form that is entirely purged of sense. The ideography of the archetype is thus superseded by the 'abstract language of structural analysis', and the application of structural analysis becomes a secret code, which reveals that 'one best comes to grips with problems of sense when one empties the form of its sense'.[92] Algebra is the discipline that both defines and practices the idea of structure: 'Their analyses are genuinely structural.'[93] What matters most at this point is that it is in this algebraic form that the idea of structure first assumes a shape that allows it to be transferred as a methodological concept in mathematics and science to cultural analysis – just as Lévi-Strauss did for anthropology and Dumézil did for the history of religion.

But how does sense return once again to form? In structural analysis, sense becomes comprehensible as a *translation* of formal language into a concrete model. This translation creates the connection between an abstract configuration of signs and its meaning. Such models always exist in abundance. 'Structure is then the formal analogue of all the concrete models that it organizes.'[94] Sense becomes apperceptible as the realization of a structure. For Serres, this relationship between abstract structure and concrete model, between an algebraic form and its meaningful configuration and interpretation, is the methodological basis of any science of cultural phenomena. Transmission thereby fuels the process that provides the nucleus of a structuralist approach: 'It is now clear what transmission means. A methodological concept that is precisely defined and successfully deployed in one particular field of knowledge [...] is also applied in other fields.'[95] Serres is thus concerned with the 'epistemological meaning of transmission'.

To recap briefly: in cultural analysis, access to sense is only possible through form (structure), because sense can only be reconstructed as realized form. So the analysis of cultural phenomena – from the structuralist perspective at least – is absolutely dependent on the method of transmitting structures. What applies to cultural phenomena ontologically, so to

speak, is thus revealed methodologically through cultural analysis. There is no sense without transmission. In this perspective, the structuralist program championed by Serres proves to be an epistemological version of the insight that sensory processes are systematically dependent on modes of transmission, the characteristic function of which is precisely to *dispense* sense. But why is sense dependent on transmission? This is immediately understandable when it comes to distance communication. For Serres, however, the dependence of sense on transmission is not solely restricted to telecommunications. Rather, it involves a far more fundamental issue, which even applies to intimate conversation. I will thus consider Serres's concept of communication in greater detail.

Communication: No Form without Interference
Communication requires symbolic-technical processes, regardless of whether they are 'natural', as in the case of language, or artificial, as in the case of writing, print, and telephone: without information channels there is no communication.[96] Yet something unique is revealed in their use. Information channels are realized in a more or less fixed form, as they are designed to allow for the decoding or recognition of information, which is conventionalized through the more or less binding definitions prescribed for their use. However, the recognition of information only constitutes one aspect of the communication process. Information channels also convey accidental features, which become visible and operative as the trace of the special conditions of their creation. Regardless of whether this is due to the individual psyche or the regional culture, or whether it is due to ineptitude or passion, the conventionalized form is constantly being deformed through the individual conditions of its production. Communication pathologies of all kinds modify the channels of information. In writing this could consist of falsely placed dashes or orthographic mistakes, in speech this could consist of dialects or stammering, in film this could consist of flickering or lack of synchronization, etc. In all of these modifications, the accidental has left its mark on the necessary and the unique has left its mark on the conventional. In other words, the communicative form is only revealed in conjunction with noise, which for Serres 'is *essential* to communication' and cannot be eliminated.[97] 'Following scientific tradition, let us call *noise* the set of these phenomena of interference that become obstacles to communication.'[98] Every communication is therefore two different things: an 'essential form' and an 'accidental noise'.[99] If noise is inherent to communication, however, dialogue can be interpreted as a game in which the sender and the receiver are opposed to a third party who personifies noise. Serres calls this third

party 'the *demon*'.[100] Every communication thus wears away at the channel's resistance to the accidental or what is mere trace.

At this point Michel Serres presents an analogy. In an effort to separate the communicated from noise, the sender and the receiver behave in a way that is definitely familiar to all mathematicians and logicians: even the symbols used, which originate individually, always bear the traces of their unique and thus contingent origin, yet mathematicians and logicians handle these symbols in a way that is specifically designed to remove this accidental individuality. They are no longer concerned with concrete, empirical symbols but rather with a class of objects (in Tarski's sense) or a symbol *type*, whose realization is considered to be a token symbol situated in space-time. The mathematical use of symbols is thus based on the exclusion of the empirical aspects of symbols as well as the underlying cause of these empirical aspects, as 'no graph is strictly of the same form as any other'.[101] This constitutes precisely 'the first movement of mathematization, of formalization', which is also the basis of structuralism.

It thus became apparent to Serres that there was a close resemblance between communication in general and mathematization in particular: 'The condition of the apprehension of the abstract form' is at the same time 'the condition of the success of communication'.[102] Just as communication attempted to exclude noise in order to make mutual understanding at all possible, mathematics attempted to abstract the sensual and empirical aspects of the symbol event so that it could refer to a universal symbol type.

There are many critical objections to this view of communication. It fundamentally fails to recognize how in each case the contingent trace of the symbol in our lifeworld is significant for that which is communicated. From the perspective of performativity, the concrete, singular execution of the communication act can be thematized as a source of meaning. Nevertheless, Serres's structuralist view of communication reveals a dimension – and this is the point – that is illuminating. In the context of this approach, communication requires the 'separation' of meaning and interference: the necessary aspects of the symbol event must be distinguished from its accidental aspects, and its general features must be distinguished from its singular features. In this respect, formal processes, which become a special practice in mathematics and logic and thereby experience a radical stylization, constitute a dimension of *every* use of symbols that cannot be eliminated. The structuralist approach to symbols is even what makes it possible at all to separate symbol and noise, content and interference. Structures are transmitted, but in the course of their transmission these structures are inevitably influenced; they erode. In light of this inevitability,

the strategy of transmission consists in minimizing the erosion of order. 'Transmission' is thus an operation that stabilizes and preserves the demarcation line between form and deformation. It involves not merely preserving an internal order against external interference, but rather more subtly maintaining the border between order and disorder (which is a dimension of order itself) in the 'transmission substrate'. I will now draw a tentative conclusion, which will admittedly become clearer in the following section: the medium is the device that makes transmission possible by enabling distinctions between structure and interference, meaning and noise, form and deformation. And this is successful insofar as media themselves are designed to recede and become invisible at the very moment their messages are revealed. This disappearance of the transmission event behind the transmitted, or the disappearance of the communicator behind what is communicated, is pivotal to a later work by Serres, to which I now turn.

The Disappearance of the Messengers

It involves the 1993 text *La légende des anges*, in which the post-structuralist Serres actually incorporates the considerations of the structuralist Serres but also modifies and transcends them in significant ways. *Angels: A Modern Myth* is not an academic text, but rather it is a work of literature and philosophy as well as a showroom for artistic and technical images: it is written as a dialogue between a female doctor at an airport hospital and a manager working for Air France, and at the same time it is also arranged as a 'dialogue' between image and text. This dialogue concerns angels, which, as (mostly) invisible messengers, become allegories and symbols of transmission, exchange, and communication between distant worlds. For Serres, the angel represents the archetype for a universe of communication in which it is not enough to simply bridge distances; rather, transmission must succeed between worlds that are entirely different from one another. Serres suggests that the modern information society, with its technical networks, can be considered an objectification of this transmission archetype: the ancient god Hermes and the Christian angel live on in global computer networks.

Serres originally distinguished between a symbolic analysis of culture that assumes a Romantic attitude based on sensually overloaded archetypes and one that assumes a classical attitude based on sensually purged structures.[103] His 1993 text can be interpreted as a synthesis of both these approaches, as it examines the structures of transmission that define our age using of all things the archetype of the angel, which can be considered the incarnation of 'transmissions of every kind'.[104] Serres challenges the reader to learn 'why it was that, in talking of angels, we had a wonderful

paradigm for talking about men and things', and he goes on: 'certain sche-mas stay with us'.[105] The figure of the angel can be understood as the code, key, and symbol of a model. What constitutes the weave of this model? In other words: how does the angel model help to explicate the concept of transmission? It comes down to four points:

(1) *Angels do not create, but rather transmit*: 'The act of transmission in itself cannot create!'[106] Serres thus distinguishes clearly between transmission and production, though they are – albeit temporarily – closely connected. Transmission must be conceived here as a process whose goal is incarnation. A paradigmatic example is the Annunciation, perhaps the most frequently painted Christian scene in Western culture: the angel's mission is fulfilled and 'the end of the reign of angels sounds'[107] as soon as God's word becomes flesh in Mary's body.[108] 'Angels [...] transmit [...] When these messengers finally fall silent, the Word becomes flesh. The true messages are human flesh itself. Meaning is the body.'[109] For Serres, therefore, the goal of transmission is materialization or reification: to 'create' is to 'make meaning with flesh, or make flesh with the Word'.[110] For Serres, creation is synonymous with incarnation in a double sense, as something immaterial materializes and is incorporated into something else. And although it is not corporeal, transmis-sion through angels is what makes this incarnation possible in the first place. Transmission increases productivity without itself being productive.

(2) *Angels are invisible, for the meaning of the message depends on the disappearance of the messenger.*[111] The messenger 'must also disappear, or write himself out of the picture, in order that the recipient hear the words of the person who sent the message, and not the messenger'.[112] If the goal of creation is incarnation, then transmission is based on a kind of disembodi-ment: 'The body of the messenger appears or vanishes. The intermediary writes himself out of the picture. He must not present himself, or dazzle, or please...or even appear. That's why we don't see angels.'[113] But isn't the invisibility of the messenger somewhat paradoxical? The angel must appear in order to become a messenger for someone, yet it also disappears? What is it that appears when the angel speaks? Serres recalls the sixth chapter of the Book of Judges: when Gideon addresses the angel of the lord, the angel does not respond but rather God himself speaks to him.[114] What appears is not the transmitter, therefore, but rather that which is transmitted on behalf of someone else, for the 'first duties of the transporter' are to 'withdraw' and 'step aside'.[115] The embodiment of the message is only made possible through the disembodiment of the messenger. The disappearance of the messenger in the media function is thus also seamlessly interwoven with the topos of the dying messenger.[116]

(3) *The cherubim – a special class of angels – function as 'exchangers' between two worlds.* Serres's allegory not only applies to the kind of transmission that bridges spatial distances. Even more essential is the fact that it involves mediation between extremely different kinds of worlds. It thus privileges the work of the 'exchangers' or distributors. In the realm of angels they appear as the human-animal hybrids of the cherubim: 'Angels transport messages [...] but cherubim are amphibious and embody a connection between two worlds.'[117] And: 'These days, unless we have these amphibious keys [...] how can we hope to make anything function at all? [...] [S]emi-conductors, inverters, transformers, commutators, rectifiers, transistors, silicon chips, microprocessors.'[118] The 'interchanger provides a key for us to pass between two worlds', as they combine a variety of mediators.[119] Unlike the 'messenger-angels', the cherubim do not connect stations, but rather entire networks.[120] They can do this because they have 'two bodies',[121] and therefore they participate in the worlds between which they communicate and mediate in an entirely material sense as hybrids.

(4) *Ethics of mediality, 'deontology of the messenger'*: the messenger's principle function of disappearing for the benefit of the message is based on a deontology of the mediator or a kind of 'law' of transmission.[122] 'If the transmitter does his job properly, he disappears. A true transmission is characterized by elimination, a false one by presence.'[123] A transmission goes astray as soon as the transmitter obscures the message, comes to the fore and becomes the meaning of the message itself,[124] thus arrogating an authority to itself that it actually only 'represents'.[125] For 'if the messenger gets pleasure, the transmission becomes obstructed'.[126] When the moderator is admired, it threatens to derail communication and transmission. This is how the 'misuse' of the transmission function is registered, which provides a criterion for the ethics of withdrawal.

The Reverse Side of the Exchange: The Parasite
At this point I want to go back to another text by Serres: *La Parasite*, which was published in 1980. Everything developed up to now suggests that mediators, which ensure that something 'flows' between two different worlds, are the hinges of a connection that is informed by the 'logic' of reciprocity. Reciprocity, equivalence, balance, and equilibrium seem to be the attributes that fulfil the exchange function of the mediator. However, reality looks – for Serres – completely different. The global flow of information ends in disparity, inequality, imbalance, and disequilibrium. This is also how Serres basically formulates the reciprocal, two-dimensional exchange between systems, people, and worlds: for him, the figure of the angel is inconceivable

without its counterpart in the parasite: 'The parasite is a creature which feeds on another, but gives nothing in return. There's no exchange [...] there's no reciprocity in the relationship, which is one-dimensional.'[127] According to Serres's understanding of the term, the parasite does not simply constitute the opposite of exchange, but rather it is an ineliminable dimension of exchange. Just as there is no structure without disorder, there is no exchange with the parasite. The angel and the parasite not only complement each other; rather, to be more precise, it is necessary to recognize that one-sidedness and non-reciprocity are inherent to two-sidedness and reciprocity and even constitute their reverse side.

The parasite is therefore not a peripheral figure, but rather it lies at the very core of 'intersubjectivity' and can be conceived as sociality. According to Serres, the 'parasitic relationship' is 'the atomic form of our relations'.[128] And it appears whenever there is an exchange between disparate worlds. Parasitism 'switches the changes between what is not equivalent'[129] by making them equivalent. Parasitism 'is thus the most general equivaluator'.[130] I will return to this idea in a later chapter about money as a medium.

Is it blasphemous to view the angel of the Annunciation, as soon as it fulfilled its task of implanting the divine in Mary's body, as establishing and embodying a parasitic relationship between God and Mary? And does this mean that the communication instituted by angels is not as abysmally one-sided as the word of God?

In any case, parasitism constitutes the reverse side of exchange. According to Serres, this ambivalence is fundamental to all transmissions. There is no reciprocity without the implantation of one-sidedness. If this one-sidedness is dismissed, reciprocity becomes an illusion. Social relations are parasitic.

Régis Debray: Mediological Materialism[131]

'All indications are that the human miracle consists in making meaning material.'[132]
'Only bodies can deliver the message.'[133]

The notion that communication constitutes the foundation of society and culture has become a truism of contemporary analysis. Nevertheless, Debray's mediology argues that transmission rather than communication must be recognized as the true force shaping society and culture. Unlike communication, transmission does not depend on the 'illusion of immediacy', but rather it obviously requires media and mediatized bodies.[134] Reflecting on transmission can also shed light on communication, though the opposite is not true.

Culture and the Art of Transmission

According to Régis Debray, the origin of culture emerges from the spirit of transmission. The 'art of transmission' and the 'making of culture' thus become synonymous. But how is this plausible?

To begin with a religious image: the immediacy of our relationship to the world was lost with the 'exile from paradise'. Mediation has been our fate ever since.[135] However, mediation is essentially a transmission process, and for Debray 'transmission' means not simply transportation, but rather the transformation of what is transmitted. That which is transmitted does not simply precede transmission, but rather it is simultaneously created in the act of transmission. In order to understand cultural productivity, the process of instrumentally producing something is less important than the process of mediating between something. But how can this 'mediation' be described and understood? For Debray, the answer to this question is 'mediology'. This term avoids a technicistic reduction of the medial as well as its hypostatization into an autonomous agent or even its absolutization into a methodological a priori. This is not the place for an extensive theoretical and critical discussion of mediology. What matters most is how the assumption of a convergence of culture and transmission is plausible and what role Debray's materialistic approach plays in the description of 'mediation'. This 'mediological materialism', which becomes a wellspring of ideas, can also be groundbreaking for my project of rehabilitating transmission.

How is it that Christianity can refer to statements made by Jesus of Nazareth 2000 years ago? How is it that the music of Johann Sebastian Bach can still be heard today and his musical ideas can still influence us?

The ready availability of a cultural inheritance is so self-evident to us that we are hardly conscious of the complexity of the transmission methods necessary for this succession to take place. Human beings are entities who not only leave traces behind as a result of their activity, but who also record, archive, circulate, and thereby transform traces.[136] The trace, in which the material and the immaterial intersect, is interesting here because for Debray meanings and ideas are only transmissible by virtue of their materialization: the miracle and enduring fascination of human existence does not consist in its ability to 'mentalize' but rather to 'materialize'.[137] Ideas can only be removed from their authors and made to survive because they are embodied in manageable, transferable, and circulatable objects: the dynamics of thought are thus inseparable from the physics of the trace.[138]

Debray conceives of the materiality of the trace as the interaction between organized matter and materialized organization.[139] And instances of transmission crystallize in this interaction. The religion and theology of Christianity is impossible without the organization of the church, just as Bach's music is inseparable from the networks of music distribution and the ingenuity of his performers. Materiality is the joining of objects, which incarnate ideas, and organization, which materializes them, and this union is inconceivable without the *activity* of mediators. Mediological materialism thus focuses not only works and objects, but rather on the activity of transmission.[140]

Materialization: The Reversal of Perspective
What does it mean to understand transmission as mediation? The first step is to understand Debray's idea of transmission as materialization.

Culture is usually associated with the domain of the symbolic. Whenever we behave as if phenomena 'have' a meaning for us, we experience our world as a world of culture. According to the logic of this symbolically constituted relationship to the world, things and objects are considered to be surfaces whose deep structures constantly need to be revealed. When something functions as a sign for something else, it possesses only a transitory materiality and its opaque objectivity is left behind in favour of something nonsensual that is simply represented in the sign. The emergence of 'cultural matter', which simultaneously evokes a tendency towards immateriality and abstraction, thus results in a process of disembodiment that is opposed to the sensual. The usual cultural-semiological approach thus points from the material towards the non-material.

Debray's primary concern is the reversal of this direction. Is it not true that our ability to materialize and concretize the immaterial and the

abstract is much more basic than our competence with immaterializa-
tion and abstraction? What is most important for cultural creativity is not
simply the ability to distil ideas and meanings, but rather to *embody* the
ideal and the meaningful and thus make possible a somatization of the
senses, a concretization of the abstract, an incarnation of the intellect.
The mediological perspective leads from the idea to its objectification and
reification: Debray thus begins where traditional symbolic-hermeneutical
analysis ends. The result of this reversal of perspective is an altered view of
the ideal. In the traditional semiological approach the ideal exists *behind*
the material; the material signifier functions as a sign that stands for the
signified – and thereby becomes transparent – but it is not the signified.
However, when the material is conceived as materialization, then *the ideal
exists not beyond but rather in the material*. The concept of materialization
thus shows that the corporeal and the intellectual are no longer disjointed;
rather, the intellectual exists in the form of the corporeal.

What Debray achieves with this approach is that he does not need to pit
matter against ideas, as Kittler does with his strained media-technological
approach, but rather he is able to trace the interconnection of both. Wherever
culture is found there is obviously *both* and – if you will – the traditional,
hermeneutic-semiological dematerialization, which proceeds from the
tangible to the intangible, is thereby put in its relatively proper place. The
funny thing about this mediological reversal, which consists in transform-
ing things and objects into ideas, is precisely that it thematizes a movement
that lies at the heart of any transmission and even constitutes its very logic.
To transmit something means *to embody the immaterial*.[141]

A misunderstanding of this incorporation approach immediately sug-
gests itself: must it not be accepted that ideas precede their materialization,
so when one speaks of the 'materialization of an idea' the primacy of the
ideal is thereby nevertheless restored? This question leads to a conceptual
hinge of the mediological concept of transmission. The ingenuity as well as
the difficulty of this concept lies in the fact that the immaterial is actually
created by the mechanism of its embodiment: '*The object transmitted does
not preexist the process of its transmission*.'[142]

How is this possible? Debray provides the answer to this question with
his concept of the dual character of materiality: it is technological and
sociological, material and organizational, medial and institutional, in short:
'organized matter' and 'materialized organization'.[143]

The Christian religion always serves as a reference point for Debray:
the idea of the 'resurrection of Jesus' can be explained psychologically
out of the disciples' sorrow over his irretrievable loss. However, the fact

to be explained is not whether such a resurrection actually took place, but rather how such a belief could be preserved for centuries in Christian congregations. This cannot be explained without taking into account the networks of Christianity, in whose chain of transmission Paul became a key figure. Paul never met Jesus personally, yet he saw the resurrected Jesus on the road to Damascus. What he saw thus embodied what he believed, and Paul subsequently became an apostle or mediator. He was subjected to a radical metamorphosis that transformed him from the Jewish Saul into the Christian Paul, and this metamorphosis in turn led to the conversion of others. As a convert and missionary he established Christianity as a church and became part of a chain that continuously reproduces embodiments over time, which naturally includes texts, relics, and practices as incarnations of Christian ideas. In this sense, it is the institution of the church that first made 'Christ' out of Jesus of Nazareth.[144]

Mediation

So what does it mean to be a 'mediator'? I will begin with a distinction that is pivotal for Debray: it does not involve 'media' but rather 'mediations'. Debray's concept of media already incorporates a systematic perspectives insofar as the term 'medium' refers to the interaction between (i) symbolization procedures, like words, writing, and images, (ii) communication codes, like English or German, (iii) inscription materials and storage devices, like papyrus, magnetic tape, and monitors, and (iv) recording dispositifs as dissemination networks like the printing press, television, and informatics.[145] Nevertheless, this is only one side of the 'program' of mediological circulation, for media are a necessary but not sufficient condition for such circulation.[146] The other side consists of the environment or milieu. Only the causal circularity between medium and milieu can become a source of cultural dynamics. Only this socio-technical complex of medium and milieu constitutes the historical object of mediology, which avoids an over-emphasis on the medium as well as an underestimation of the milieu.[147] The distinction between medium and milieu thus makes sense precisely because it focuses on the *intersection* of both sides, which can only become culturally productive through this interaction. What applies to mediology in general also pertains to the mediator in particular. The mediator must be conceived as a figure at the intersection between the material and the immaterial.

A further distinction becomes relevant here: for Debray, the mediator is precisely not a messenger, but rather it displaces and replaces the messenger.[148] How so? Debray recalls Michel Serres's commentary on Lauretti

Tommaso's *The Triumph of Christianity*[149]: the crucified Christ, the mediator between God and humankind, is 'enthroned' over the smashed statue of Hermes, the messenger of the gods. For Debray, this fresco becomes a symbol of his concept of 'transmission through embodiment': the Christian mediator is not an ethereal figure, but rather it is radically subject to the forces of gravity; Christ has no wings to fly away from the cross. Embodiment therefore does not mean glory, but rather affliction, suffering, and expulsion. In Christian mediation it is literally conceived as incarnation, which represents a condensed symbol of a universal law of mediation: it is bodies, not spirits, that transmit messages.[150]

However, there is yet another aspect that goes together with the gravitational force of embodiment. According to Christian mediology, the mediator disappears behind its message. Consider, for example, the angel of the Annunciation. It conveys the impression of immediacy, it strives to leave no traces of the transmission behind, and it thus aims for a traceless, ethereal transparency.[151] The more essential the materiality of transmission is, the more the mediator strives for immateriality.[152]

The materialization of transmission thus corresponds to the immaterialization of the transmitter. But therein lies a problem. If the good mediator is the one that makes itself invisible in the transmission event, and if this striving for transparency is a function of all mediators, then the possibility of obstruction is also inherent in this functional principle. Mediators may no longer be prepared to stand aside. What does it mean if the angel proves to be a demon? This risk is inherent in every mediation.[153] Demonology is therefore only the flip side of angelology.

I will return to the figure of the angel later, but for now it should be clear that 'perverseness', misuse, and interference are always inherent to the process of transmission precisely because it is corporeal.

John Durham Peters

> 'Communication as a person-to-person activity became thinkable only in the
> shadow of mediated communication. Mass communication came first.'[154]

A study of communication could hardly begin in a more provocative way: the key to understanding 'communication' is not conversation, dialogue, or two-way communication between people, but rather mass communication or the non-reciprocal dissemination of a message to countless anonymous recipients, who can – but are not required to – receive this message in their own way. This is the basic thesis of John Durham Peters's *Speaking into the Air*.[155] This notion would be perfectly appropriate for a study devoted to the phenomenon of mass communication, but for a text that wants to treat the 'problem of communication' from a more general, philosophical, and historically sweeping perspective such a privileging of distance communication is unusual and intellectually provocative. It is provocative because it challenges our usual image of communication, which ennobles dialogue as the unconditional model of successful communication and intersubjective connection. For Peters, however, distance communication does not represent a particular type of communication, but rather an alternative to the dialogue model that is of equal value. Moreover, it reveals that the opposite of dialogue is already implicit in dialogue itself in the form of dissemination. This is revealed when people become aware of how much they (must) remain foreign to one another in their own inner worlds. In personal encounters they do not meet people they can freely understand or even identify, but rather these people are and always remain other. This approach, which is inspired by the constitutive inaccessibility of the communicants to one another, thus leads to an ethical appeal: we should not expect the people with whom we communicate to adapt to the matrix of our own understanding, but rather we should respect their otherness and thereby encounter them with love. The problem of communicative understanding thus proves to be a political or ethical problem rather than a semantic problem.[156] If a metaphor is permitted here, it could be said that John Durham Peters is the 'Levinas of communication theory'. In the following, however, I will not focus on this ethical dimension but rather on the theoretical foundations of this relativization of dialogue and rehabilitation of dissemination.

A Key Scene

There is a key scene from which this reconstruction can proceed[157]: in a lecture circa 1873 James Clerk Maxwell demonstrated the phenomenon of 'action at a distance'.[158] By pressing two lenses on top of one another, shining a light through them, and then projecting the resulting light effects on a screen, Maxwell was able to demonstrate that there was an optical interference between the lenses, but a distance between both lenses remained – even when the lenses could no longer be separated from one another – and he concluded that it was impossible to eliminate the distance between the lenses (this distance could even be calculated using light rings and their colours). Maxwell thus demonstrated a reciprocal action without physical contact.

For Peters, this experiment serves as a theoretical metaphor for communication in two ways: either it qualifies as a positive confirmation that a communicative interrelation can dispense with physical touch and interaction, which implies that what actually interacts can only be found in the soul, mind, understanding, or senses (what is exchanged through communication is something 'spiritual', cleansed of bodily filth), or – in opposition to this spiritualistic pathos – the experiment demonstrates that the phenomenon of making contact or even touching is illusory due to the limitations of our senses, which are not able (or willing) to recognize the distance – in a corporeal as well as intellectual sense. If that is the case, however, then the problem of communication does not begin when communicating across spatial distances: 'The problem of communication becomes [...] one of making contact with the person sitting next to you.'[159] It is thus clear which interpretation Peters wants to follow: regardless of the degree of mediation, communication always involves distances, especially in the close proximity of personal conversation. In other words, the problem of communication is rooted in the unbridgeable divide between the self and the other.

But how is communication nevertheless possible under these conditions? Peters's answer is that it is necessary to recognize the illusory dimensions of the idea of reciprocal dialogue and at the same time acknowledge that non-reciprocal, non-dialogical dissemination – understood as sending, scattering, sowing – provides a model of communication that should taken seriously. I will now attempt to recap what this means in three steps.

Dialogue and Dissemination

Isn't there something tyrannical about the celebration of dialogue, especially when its goal is to promote the concept of reciprocal speech acts between communicants who are unified through their physical co-presence? Doesn't the emphasis on dialogue result in the stigmatization and misunderstanding

of the culture-endowing meaning of countless practices that are based on the use of language but are far from dyadic and reciprocal?[160] Doesn't our cultural life depend as much on non-reciprocal forms of action and ritual performance as on the reciprocity of dialogue? 'Reciprocity can be violent as well as fair', Peters notes laconically.[161] Imagine if life and social relations were only guided by reciprocity: wouldn't this result in and amount to nothing more than a monotonous cycle of 'quid pro quo'?[162] Isn't it even characteristic of mortal beings that we are not able to return everything we have received?

This 'blow to non-reciprocity'[163] constitutes the conceptual framework through which Peters explains the difference between dialogue and dissemination, and he refers to two people as symbols of this difference: Socrates and Jesus. They are both martyrs and moreover models for the Western self-conception of morality, but above all they represent alternative modes of communication.

Based on an analysis of Plato's *Phaedrus*, Peters claims that for Socrates speech is a kind of erotic encounter: it is specifically directed towards a particular individual recipient, and it attempts to establish an intellectual union: a shared insight, a common grasp of language and a reciprocal understanding thus constitute only the flipside of a mutual desire.[164] This makes dialogue an intimate as well as a unique event. It is therefore only logical that the interference of a medium like writing threatens, if not completely precludes, the intimacy and eros of the dialogical when it exceeds its function as a mnemonic device and has communicative aspirations instead. The discursive approach of Jesus of Nazareth, as it is passed down in the gospels, appears to be so entirely different that it is practically the antithesis of Socratic dialogue. Jesus is engaged in dissemination: the sending of a text that is no longer selectively directed to particular individual receivers. Jesus describes the mode of his speeches through a parable[165]: the sower casts seeds, a few of which fall on good, fertile soil and a few of which dry up on infertile soil. The speaker no longer has control over the effects of his speech, but rather the responsibility now lies with the receivers. He who has ears to hear, hears, and he who does not have them, fails to hear.

Socrates's 'fertile coupling' thus stands in opposition to Jesus's 'spilled seed'.[166] Plato's esoteric mode of reciprocal communication, which is always only aimed at selected addressees and places the responsibility for the speech on the speaker, entirely contradicts Jesus's exoteric mode of asymmetrical public speech, in which reciprocity is suspended and the effectiveness of the speech ultimately depends on the recipients' own activity.

Peters is not concerned with the historical accuracy of his interpretation of this binary configuration; rather, he wants to present another perspective

on 'broadcasting', or the transmission of a message, using 'sowing' as a model: 'There is [...] no indignity or paradox in one-way communication.'[167] By addressing a uniform message to a diversified, anonymous audience, dissemination effectively suspends dialogicity, which Peters presents as a productive, culture-endowing dimension of human communication. It is productive because it provides an answer to the 'morally intractable condition of plurality': we can live together with people whose personal perspectives remain hidden and are never identical to our own.[168]

The Insight Potential of Media

The Socratic model of individualized two-way speech reflected a desire for communication based on disembodied, immaterial, intellectual contact, which has become an enduring part of the history of communication in the Western world. Speech, bodies, media are thus demoted to the rank of mere vehicles, and moreover they fall under suspicion as the root cause of all communication problems: if people could penetrate the corporeal and see directly into the inner world of the other, then communication would be truly unambiguous. Peters refers to this dream of a bodiless union in the spirit as the 'spiritualist tradition', and he shows how this idea can be found in the philosophically demanding considerations of Augustine and Locke, the Romanticizations of 'animal magnetism' and mesmerism in the nineteenth century, and the visions of 'telepathic' contact and influence from psyche to psyche, which were bolstered by the discovery of electricity.

The paradox of the spiritualist tradition is that the media it exposed made this 'disembodiment' possible in the first place, and this in turn constitutes the phantasm of the tradition. The media actually achieve this in a way that demonstrates and reveals the disseminative, non-reciprocal pull against the dialogical. For Peters, the dialogical ideal of two-way speech in the living presence of the interlocutors is always already interrupted and subverted through a telos of asymmetrical references, whether in the form of communication with God, with the dead, with the absent, with animals or artificial creatures, which in our culture is no less practically effective. In addition to literature and philosophy, which repeatedly express and reflect on the problems of dialogical communication, it is the development of media that reveals the degree to which dialogue itself is already based on a suspension of the dialogical. *Technical media do not simply distort communication, but rather they shed light upon it.* This insight potential, which is inherent to the development of media, consists in revealing and bringing to light the problems that are implicit in the dialogical. Media make manifest and apparent the often latent configurations that are part of any communication. I will explain what this means using two

examples: the telephone, which enables the extrapolation of dialogue across spatial distances, and the radio, which technically radicalizes dissemination.

Telephone

Is a telephone conversation a dialogue? Even though the genesis of the telephone was not originally point-to-point communication, but rather the 'party line',[169] it is taken for granted today that the telephone is an obvious extension of conversation in situations of bodily absence. Unlike radio or television, which are directed towards a dispersed public, the telephone – at least since the technical substitution of switchboard operators[170] – offers an intimate connection between the caller and the receiver that is confidential and inaccessible to the public.[171]

Isn't the interaction of telephone voices in a state of personal absence thus an incarnation of the spiritualist vision of bodiless communication? It certainly is, but at the same time it also embodies the disruptions that reveal the non-dialogical aspects of dialogue. Telephoning without a partner who agrees to be phoned is undeniably impossible, yet in the process of telephoning the 'one-dimensionality' of this communicative two-sidedness becomes very evident: 'Two one-sided conversations that couple only in virtual space: This is the nature of speech on telephone.'[172] The activity is one-sided and depends on the caller, who disturbs the receiver's situation and environment without displaying the kind of consideration that Socrates claimed was necessary for a successful conversation.[173] The receiver's freedom and autarchy lies 'only' in the possibility of hanging up. But how liberating is this act if the phone rings again? How nerve-shattering is the resignation to pick up the phone? For Peters this tyranny, which always neglects the individuality of the other, becomes in a sublime way the compulsion to talk and talk back, but it can also escalate to terror when the call does not communicate a voice but rather only silence. Is there anything more uncanny or frightening than a call that does not transport words but rather only breath?

The dialogical presumes that personality can be individuated, but this individuation constitutes precisely the obstacle of communication 'without bodies'. The telephone apparatus suspends – at least potentially – the identifiability of the speakers and requires culturally varying practices of personal identification. This easing of personal accountability makes the telephone – despite its interactive dimension – more like writing.[174] And just as the monological character of writing already poses the question of range and limits, so too does telephone communication become a metaphor for the question: 'Is communication anything but overlapping monologues?'[175]

Radio

The ontology of the radio signal is curious: no matter where we are, we are always surrounded by streams of strange voices that remain inaudible as long as we do not have a 'receiver', or technically aided 'ears', to hear. And if we have a receiver, it always combines the flashes of pure voices and sounds transmitted by senders – in the case of analog radio at least – with the decentring noise of the invisible worlds around us, the murmuring of the universe; in short, a 'celestial caterwauling'.[176] Hardly any medium provides an experience that can seem as ethereal as that of a wireless epiphany of voices with the aid of electromagnetic waves.

The radio is thus logically a public medium that transmits to everyone, although its omnipresence was originally perceived as a defect and an obstacle. It appeared to be a problem that 'radio telephone messages can never be secret'.[177] As with phonographs, the invention of radio was originally guided by the technical extrapolation of dialogue between individuals, and the potential of dissemination was only gradually discovered.[178] This discovery is related to the realization that there is a difference between a mediator ('common carrier') and a radio transmitter: while the transporter of a message remains blind to its content but accurately reaches its intended addressees, the transmitter remains indifferent towards the receivers but bears responsibility for what is transmitted.[179] Peters recalls the agricultural origins of the word 'broadcasting': the scattering of seeds.[180] The relationship between the listener and the radio is equally as loose. Radio is known as the classic 'background medium' because concentrated attention is not necessary at all. Isn't the radio announcer to a certain extent in the situation of speaking with the dead? Doesn't the radio studio – Peters asks – resemble the scenario of idealistic philosophy: 'communicating deaf and blind through impermeable walls'?[181] The desire to compensate for the distance between the radio transmitter and the audience and the impossibility of interaction thus becomes the driving impulse of radio communication. How can a connection be established with absent listeners? A wide range of new discursive strategies were developed, which enabled intimacy, authenticity, and contact across distances, thereby transforming the anonymity of a disinterested audience into a community of participating listeners: 'Radio audiences were distinctly "consociate" rather than "congregate" assemblies: united in imagination, not in location.'[182] One of the main ways of positioning radio between 'dead' and 'alive' and transforming listeners into witnesses became the live broadcasts, which brought temporality and contingency back to radio communication and transformed the audience into a community of living ear-witnesses to an actual event.[183] Adorno feared and condemned this possibility. His resistance

to radio as a fetishizing and retarding medium of mass communication is actually historically understandable in the context of fascism as a 'community of listeners',[184] yet Adorno does not do justice to the medium itself.[185] Robert Merton comes much closer to understanding the culture-endowing potential of radio,[186] as he recognizes that listening to live broadcasts can be a ritual act that produces a social body for which individual interaction is *no longer* necessary.[187] Adorno's critique can be attributed to the unbroken ideal image of individualizing dialogue, which he sees as being corrupted by radio. In order to return to the key scene of Maxwell's experiment with the two lenses that interact without contact: Adorno only sees that mass communication cannot bridge the distances between individuals, while Merton recognizes that communal actions are possible across distances.[188] However, this means that relationships and communities are formed not only through the reciprocity of dialogical speech, but also through disseminative speech. It also suggests that the bonding force of speech might already begin much more fundamentally with the 'salutation'.

Dialogue as Dissemination

Peters deprivileges dialogue as the ideal form of communication. A conversation that takes place in the close proximity of an interacting encounter is no less affected by the problems of communication than communication across distances: '[F]ace-to-face talk is as laced with gaps as distant communication.'[189] Couldn't dialogue thus be seen as two people 'taking turns broadcasting at each other'?[190] Dialogue and dissemination then become indistinguishable.[191] In the context of this disseminative infiltration of dialogue, the listener or receiver is structurally more important. This is the point of the emphasis on dissemination for communication theory: it is no longer the speaker but rather the listener who is 'boss'. For Peters, the increased significance of the recipient made Peirce's semiotic theory unmistakably clear: no communication from one person to another can ever be definitive,[192] as it is always complemented by the listener.[193] However, this listener does not share the inner world of the speaker. Communication is therefore less like an encounter between '*cogitos*' and more like a dance. Contact is occasionally possible, but trust is also necessary.[194] The aim is not to achieve harmonious mental states but rather to successfully coordinate behaviour, as everything that can be known about other people is conveyed through words, gestures, and actions, which endow people with a certain public significance. Communication is based on showing.

The Messenger Model

An Initial Summary

The texts by Benjamin, Nancy, Serres, Debray, and Peters are all extremely different. It may seem peculiar to invoke these authors as 'introductions' to the theme of mediality when only the last one actually discusses concrete media, yet this is quite deliberate. I want to debate the question of 'What is a medium?' from the very beginning in the context of mediality. '*Mediality*' does not refer to media that are distinct from each other, like sound, text, and image, but rather its aim is to describe an elementary dimension of human life and culture.[1]

Consider, therefore, the following question: Is there a vanishing point at which all five authors meet, regardless of the fact that their approaches are all so divergent? This point of convergence actually stands out. It is their mutual consideration of the way in which the relationship of the self to the other and to the world is fundamentally mediated through transmission processes, and because these processes tend to be invisible their mediation appears to be 'immediate'.

This idea can be divided into a series of distinct but related statements:

(1) The starting point for a reflection on mediality is the assumption of a difference between the communicants, which can be understood qualitatively as their diverseness or quantitatively as their distance from each other.

(2) Media do not transform this difference into identity by simply replacing diversity with agreement, but rather they make communal existence possible while maintaining this difference.

(3) The primary function of media is transmission. Media do not directly produce anything; they do not possess any demiurgical power. Methodologically it makes more sense to describe them as middle, mediator, and milieu rather than an instrument or a medium.

(4) The conditions of transmission constitute the source of culture.

(5) Transmission is an external, corporeal, and material process that can be conceived as a kind of embodiment while at the same time it is also associated with a 'disembodiment' – namely, the way in which media 'become invisible' in their (interference-free) usage.

(6) Non-reciprocity is a structural feature of communication under conditions of difference.

Traces of this web of ideas can be found among each of the authors:

For *Walter Benjamin* the Fall of Man was a symbol of the origin of differ-ence between people, which was revealed in the form of gender differences. Not only was it possible to distinguish between good and evil, but they were also split, which was conducive to mediatization. While the divine word possessed a demiurgical power, as God created by naming, human words lost this creative power and language became a medium of denotation and recognition. It is therefore this loss of genuine creative power that reduced media for the first time to mere instruments and sensory organs and made them congeneric to the technical and symbolic: The performativity of divine language did not distinguish between the technical and the semiotic, as the act of naming directly brought something into existence. A reflection of the original creativity of the medial can emerge (once again) only when the human is hypostatized precisely not as a demiurge and media are stripped of their instrumental character in the sense of their technical and/or semiotic functionality and transmission is readily appreciated as a genuine form of productivity. I will later investigate Benjamin's own version of transmission, namely translation, in more detail. It is sufficient here to clarify that Benjamin, more than anyone else, was a forward thinker concerning technical media, as his early writings on the philosophy of language blazed a trail to a non-instrumentalized concept of media.

For *Jean-Luc Nancy*, unlike Benjamin, there is no longer any memory of a condition prior to 'difference'. Humans only exist as individuals together with others, and they are therefore always already divided into singular exteriori-ties that are situated at a distance from each other. Difference is nevertheless 'defused' for Nancy, as it has become a next-to-one-another, which can be revealed thus far as being with-one-another, as it involves circulation and exchange between co-existing people. 'Communicating' is therefore necessary, but in an entirely unspectacular sense. It refers not to the sharing of com-mon beliefs or identical meanings, but rather to an external sharing of places that become a milieu in the sense of an intermediate space that enables the separation of individuals while at the same time connecting them. Mediation can thus be conceived as a virtual connection or an external and corporeal co-existence that does not (any longer) unify the collective into a whole.

As with Nancy, *Michel Serres* also sees connection as a basic process – im-aginarily modelled in the figure of Hermes and the angel – that is essential to medial transmission. For Serres, however, the multiplicity into which societies are divided loses the homogeneity that Nancy still maintained and becomes heterogeneous instead. A trace of this heterogeneous starting point is preserved and becomes apparent in the fact that the community-forming

moment of transmission presupposes that order must be maintained against interference from outside, against the accidental, and against the influence of third parties. Serres describes the power of transmission to immunize against external influences as the inner mechanism of our use of symbols, which applies equally to a mathematician's theoretical practice as well as a community's ability to establish a connection by excluding third parties. The figure of the third nevertheless returns in the form of the parasite, which becomes an actor in an unequal exchange and thus a one-sided connection: the streams of global transmissions do not correspond to the model of reciprocal exchange, but rather they lead to inequality and imbalance. Media – precisely because their performance is based on transmission and mediation – do not simply facilitate encounters with non-reciprocal situations, but rather they literally give rise to non-reciprocity itself. This marks a radical departure from the assumption that mediation is based on or results in the communal sharing of something.

For *Régis Debray,* culture is also based on a spatial and temporal difference, which poses the question of how the formation of tradition is possible at all. Transmission is also central to his work, as his mediological materialism posits the fundamental exteriority and materiality of transmission processes. Transmission is conceived as an act of embodiment or the formation of traces, as its power enables the spatial transmission and temporal preservation of the spiritual and the ideal. This materialization of the ideal is also understood as an act of production, as the object does not precede its transmission. Transportation is always at the same time understood as a form of transformation, and transmission is always also understood as a form of transubstantiation. Debray's materiality is therefore not opposed to the ideal, but rather it is the only possible way of realizing the ideal, as it involves circulating ideas across space and time. Circulation and communication converge.

The idea of communication as dialogue thus becomes problematic for each of these thinkers in their own way: Benjamin challenges the view that the decisive factor in communication consists of the fact that people communicate something *through* language; Nancy does not identify the sharing of something with-one-another as part of the traditional notion of communication as agreement; Serres sees non-reciprocity as the basic condition of the social; Debray subordinates communication to transmission from the very beginning, insofar as transmission can illuminate what communication means, but the reverse is not true.

The terrain is thus prepared for John Durham Peters's thesis that one-sided dissemination, the sending of messages, does not constitute a

subvariety of communication, but rather it is equally as worthy as dialogical 'near communication'. Moreover, the distancing unfamiliarity between the communicants is already a constituent element of dialogue itself. The point is that the disseminative structure of interpersonal communication valorizes the listener: It is the receivers, the recipients, and not simply the speakers who carry the responsibility for uttered speech to fall on fertile soil. In addition, communication is no longer conceived as the confluence of mental states, but rather it is accepted as a kind of dance where contact is only temporary.

The Messenger as a Topos

The messenger appears to be an extremely archaic figure; a relic of an epoch when non-personal communication was not yet available. The figure of the messenger may appear misplaced and obsolete in a systematic media-theoretical study written in an age of split-second connections through worldwide data networks. Nevertheless, I want to employ the messenger hereafter as a reflection figure,[2] and I present the following analogy to explain its methodological significance: The idea of the errand functions as the 'zero point' in a coordinate system in which different modalities of transmission can be listed from many different fields, like religion, medicine, economics, linguistics, psychoanalysis, and law. Within this coordinate system – it is assumed – it then becomes clear how media can be understood from their position in the middle as mediators. But to start with it is first necessary to explicate this 'zero point', which I would like to call the 'messenger model'.[3]

In a distant echo of the deductive sciences it could also be said that the messenger perspective alters our 'axiom system' insofar as the 'primal scene' of communication is no longer interactive, voice-based dialogue in close proximity to the body, but rather communication between parties who are separated from each other in time and space. Benjamin, Nancy, and Serres have already suggested that communication presupposes separation, division, and difference between the communicants. Debray and Peters have also called attention to the fact that due to this distance transmission proves to be an elementary dimension of communication itself.

I therefore take as my starting point the idea that the mediality of communication will become clearer in the 'laboratory conditions' of communication in absentia. At the same time, however, referring back to the messenger involves more than simply a media-theoretical thought

experiment that focuses on an extreme case in order to better understand its significance under normal conditions. My assumption is that reflecting on messenger-mediated 'absence communication' will also change our understanding of 'presence communication'. The messenger idea only becomes interesting when it is assumed that being distant from one another – in either an internal or external sense – constitutes a fundamental aspect of *all* communication.

Dimensions of the 'Messenger Model'

So what does the messenger do? He mediates between heterogeneous worlds by transmitting messages. This fact is extremely straightforward, but it is more revealing to distinguish between the five dimensions of the 'messenger model': *distance, heteronomy, thirdness, materiality*, and finally *indifference*.

(1) *Distance as Heterogeneity*: Whenever communication is described using the messenger perspective, it always involves communication that is informed and shaped by distance. This distance is not at all limited to spatial distance, but rather it also encompasses other forms of diversity that make communicants entirely foreign and incomprehensible to one another, such as their different histories, singular experiences, varying opinions, different bodies of knowledge, and practical orientations. Communication – if you recall Benjamin and Nancy – presupposes separation and division. People are always with one another at the same time that they are apart from one another and thus individuals.

Emmanuel Levinas emphatically thematized this irresolvable distance from one another as the basis of all communication. According to Levinas, the fact that communicants are identified as ego and *alter* ego is already proof of the egocentricity of understanding, which is inscribed in Western self-consciousness insofar as it is oriented towards understanding others using the model of Odysseus's voyage, which is a return to the self.[4] For Levinas, on the other hand, a conversation represents an encounter that does not treat the being of the other as an egological projection of one's own consciousness; rather, it is able to recognize and maintain the otherness of others. And it is no surprise that this refusal to minimize the strangeness and mystery of others culminates in a concept, namely the 'trace', that bears a subtle resemblance to the idea of the messenger. I will later address the 'involuntary messenger of the trace'. What matters here is that distance is inherent to any communication.

The messenger bridges distances but does not eliminate them; mediation and separation are intertwined in the figure of the messenger. Doesn't this

ambiguity – the simultaneous overcoming and preservation of distance – resonate in the German word '*Ent-fernung*'?[5]

Distance, heterogeneity, difference between communicants thus marks the starting point of my discussion of the errand. I will thereby forego a metatheoretical consideration of the philosophically provocative question of whether it is possible to talk about the meaning of 'difference' at all, insofar as this precedes all different ways of speaking. My reflection on the errand is intended to address *not the question of what heterogeneity and difference are, but rather 'only' how to deal with them.*

From the perspective of 'distance communication' the messenger is situated in an intermediate space between heterogeneous worlds (systems, fields, etc.). His operative function is to be a mediator between these worlds; in light of this operative function he represents the nucleus of a media theory. But how does this mediation take place? To start with, the messenger speaks – but with a *foreign* voice.

(2) *Heteronomy as Speaking with a Foreign Voice*: This is one of the provocative – and at the same time essential – aspects of the messenger model: the messenger is heteronomous, which is understood here in opposition to 'autonomous'.[6] He is not self-activating, he is subordinate to a 'foreign law', and he acts on behalf of another: he has a mission. The messenger is 'guided by outside forces'.

Whenever messengers are thematized, one is confronted with the difference between vertical/sacred transmission and horizontal/secular transmission. An example of vertical transmission is Hermes, who delivers the messages of the gods to mortals. It is advantageous for this task that he is the protective deity of streets and businesses, that he combines scholarship and trickery, and also that he is not averse to thievery. He thus maintains his close proximity to the all-too-human, which is essential because he must translate the divine messages in a way that will be accessible to the people.[7] As Schniewind noted, the biblical words '*angelos*' (messenger) and '*angelia*' (annunciation and message) are not derived from the language of religion, mysticism, or philosophy, but rather from the language of public life.[8] Bernhard Siegert also pointed out that the angel as messenger of God (*angeloi*) is etymologically derived from the '*angaréion*', the attendants of the Persian relay post system.[9] The mythical and religious connections between God and man are etymologically drawn from the prose of a postal principle.

Other vertical messengers include poets, the 'interpreters of the gods', and rhapsodists, the 'interpreters of the poets', whose task is to bear witness. It is precisely this task – bearing witness to a knowledge acquired

through divine inspiration rather than effort, for which the messenger is not responsible – that reduces poets to 'unconscious' mediators in the sense of Plato's Socratic dialogue,[10] and the criticism of these poets thus becomes the genuine task of philosophy: the overcoming of *angelia* through logos represents the origin of a philosophical discourse oriented towards truth. In this context, the messenger becomes an inauthentic speaker.

It is also evident in the horizontal dimension of mediation that the messenger serves as a proxy for foreigners, as in the case of ambassadors, *nuntius*, and *legatus*.[11] Many aspects of the messenger function originate here. Isn't the messenger at the same time also an extension of the body of his employer, who is not only represented by the messenger but rather also made present in time and space? Aren't messengers always also visualizations of an authority in absentia insofar as whoever can be represented as if they were present in their representative is sovereign?[12]

Indeed, messengers are always also part of a 'telecommunications of power' insofar as they not only communicate but also secure territory through their dissemination of the word.[13] The Old High German word '*biotan*' and the Middle High German word '*bieten*', from which the word '*Bote*' (messenger) is derived, take on the connotations of order, command, and prohibition and emerge as both 'decree' and 'interdiction'.

In an entirely different way, the nature of being-sent becomes apparent in the smooth transition between the messenger and impersonal transmission technologies like the letter: it is no accident that in Middle High German the words '*Bote*' (messenger) and '*Brief*' (letter) can be substituted for each other.[14]

The institution of the messenger thus encompasses a variety of differentiations, from the medial extension of the body of the employer to the borrowed authority of the personal representative to the simple act of delivery as well as the privileged interpretation of the messages, and all of these roles are tied to a common assumption: the activity of the messenger does not arise from self-conscious spontaneity, but rather it is subordinate to foreign directives; his 'sovereignty' can simply explore the space of heteronomy. *There is therefore always an outside of media.*

(3) *Thirdness as Nucleus of Sociality*: The messenger establishes a relation. The messenger makes a social relation possible between people who are distant from one another insofar as he is not only sent but rather also directed to someone to whom he has something to 'offer'. It is no accident that the concept of 'relation' refers etymologically to reporting ('*relatio*' in Latin and '*Bericht*' in Middle High German). The messenger's intermediary position between the addresser and the addressee gives rise to an

elementary 'communication community'. The messenger is essential for the formation of this community, but he does not appear as its *subject*. We are accustomed to thematizing intersubjective relationships in dual or dyadic structures: speaker and listener (Searle, Habermas), sender and receiver (Shannon), ego and alter ego (Parsons, Luhmann), producer and recipient, master and slave (Hegel), me and you (Buber). From the standpoint of these binary-oriented theories of intersubjectivity, the emergence of a third appears to be disturbing, parasitic, and alienating. But, as Joachim Fischer asks, aren't 'dyadic figures also latent triangles' so that a third figure is also combined with the binarity of the one and the other?[15] Our personal pronouns (I, you, he/she, we, they) testify to how deeply engrained the third is in our everyday practices. The social sciences and social theories focus on the third as a figure of analysis between alterity and plurality. Doesn't this transition to the third represent the point at which interactions (can) transform into *institutions*?[16]

This reveals a wide and colourful spectrum of trinities, which includes spectators, translators, mediators, judges, scapegoats, parasites, arbitrators, traitors, etc. Most importantly, the messenger also emerges in this series of triadic actors. And it is Joachim Fischer who first drew serious attention to the messenger in the course of a general social theory of the third, from which he developed a social theory of the medium: insofar as the messenger is conceived as a figuration of the third, the 'social potential of the medium' is foregrounded as opposed to its 'technical potential'.[17]

The fragility of the messenger institution is also embedded in this sociality of the messenger from the very beginning, which makes it predestined to be an unstable figure.[18] Because the communicants are inaccessible to each other, the relevant question becomes whether the messenger will maintain his heteronomous status and the neutrality it implies or whether he will 'go wild' as the sovereign and manipulator of 'his' messages by omitting, distorting, or inventing. As a figuration of the third, the medium is always also an interruption and thus a *breaking point*: it can breed ill blood, sow the seeds of discord, contrive intrigues, play people off against each other, betray, and agitate. Mediation is thus symbolically and diabolically two-faced: it can be a symbolic act (throwing together) as well as a diabolical intrusion (dividing apart). *The diabolical misdeed is always inscribed as an option in the function of the third and the messenger.*

(4) *Materiality as Embodiment*: The purpose of the messenger is to eliminate distance through his own movement, a movement whose meaning consists not in bearing correspondences but rather in producing them. Historically, the verb 'to correspond', in the sense of 'agreement', refers

to the noun 'correspondence' as reporting or exchanging letters. There is a peculiarly tense relationship between the mobility of the messenger and the expected identity and stability of the messages entrusted to him. The messenger is supposed to not only convey the message, but also at the same time preserve it from potential interference over the course of space and time. The message is only mobile in the sense that it is externally embodied in a material carrier, but its internal contents are supposed to be kept as immobile as possible. Is this the birth of the separation of signifier and signified from the spirit of the errand? This is what a message always is: regardless of its origin, it must always be separable and transportable. Linguistic statements congeal into physiognomic texture; meaning materializes in the sensuality of the body. Speech becomes something 'external' to the messenger. The statement crystallizes as a recitation, an *imitatio soni.*

The message belongs to a continuum of materiality that also encompasses the corporeality of the messenger. The message is entrusted to and incorporated into his mimesis or 'physical memory'.[19] Incorporation and excorporation thus intersect in the messenger. To safeguard the message it was customary not only to insure its authentic reproduction but also to authenticate the messenger's body through signs or tokens.[20] To return once again to the embodiment of the employer: the *nuntius* was considered to be 'the body of the ruler suspended over his borders'.[21] Through the delivery of his message the messenger also represented at the same time the coming-to-appearance of his employer, a kind of profane epiphany.[22] And it is no surprise – as Horst Wenzel notes[23] – that the immunity of the messenger was constantly at risk, as it was not uncommon for the messenger to be rewarded or punished depending on 'his' message.

As a part of a continuum of materiality, the messenger therefore moves in an intermediate space that is an 'extension of the senses'.[24] In other words, the exterior space of the senses is the messenger's base of operations. *The phenomenon of the separation of sense and sensuality, text and texture, and form and content take on a palpable form in the figure of the messenger.*

(5) *Indifference as Self-Neutralization*: When messages are sent, they usually involve important communications. Messages are emotionally moving, they are surprising, they bring their receivers happiness or sorrow. Yet *the messenger behaves indifferently towards the content of his message.* He remains apathetic with regard to what he says. After all, he is a sign carrier precisely because he ignores and is exempt from the meaning of the signs he carries. He is able to remember signifiers so well because he is allowed to forget what they signify.

The messenger occupies the middle, which means that he is not biased. The neutrality of the middle is the basis of the mediator's position.[25] This indifferent position becomes evident in the messenger's tendency to withdraw or recede, thereby foregrounding his message. The embodiment of a foreign voice is only possible by surrendering one's own voice through a form of selflessness that is inscribed in the functional logic of the messenger and for that matter also constitutes the ethos of his office: *the visualization of the foreign through self-neutralization*. What is different or surprising about a message only takes shape against the background of the messenger's own indifference. Remember: the disappearance of the medium in the syllogism and the motif of the dying messenger both refer etymologically to this self-withdrawal, on which the mediality of the messenger office is based. It is also a prerequisite for the magical real presence of the absent employer, who can become operative through the messenger.

Is it necessary to emphasize that this 'symbolic withdrawal' of the medium also enables its 'diabolical inversion'?

There are therefore five important attributes of the messenger model: (1) He connects heterogeneous worlds and allows them to 'flow' into one another. (2) He is not self-determined but rather heteronomous and thus speaks with a foreign voice. (3) He embodies the figure of a third and thus enables the formation of sociality. (4) He is embedded in a continuum of materiality, operates in an intermediate space that represents an extension of the senses, and thus draws on the separation between text and texture, sense and form. (5) He is a self-neutralizing entity that makes something else appear through his own withdrawal.

The messenger model thus appears to be a contrasting foil if not a 'counter model' to the general understanding of 'communication' – consider, for example, the aspects that have to do with heteronomy, the extension of the senses, and self-neutralization. It can hardly be denied that the 'good' messenger is discursively powerless.[26] I will now attempt to delve into this provocative aspect.

On the Discursive Powerlessness of the Messenger

Almost all of the facets that we have extracted from the speech of the messenger conform to an image of language use that contradicts the meaning of 'communication' and 'linguisticality' in philosophical discourse. When considered philosophically, the messenger represents a repulsive figure: He speaks not on his own behalf but rather on the behalf of foreigners. He does not think and mean what he says. He is not allowed to produce what

he says himself; he is not even permitted to understand what he says. The messenger is not responsible for the content of what he is assigned to say.

Already this list – and it could surely be expanded – shows in an obvious way that the figure of the messenger counteracts everything that we usually associate with speech from a theoretically ambitious perspective. The self-image of philosophy involves the practice and encouragement of a kind of speech that fundamentally overcomes and disavows the kind of communication practiced by the messenger. I will recall two paradigmatic deliberations on this issue from the beginning of ancient philosophy and modern philosophy.

The beginnings of classical philosophy in Greece were accompanied by the replacement of the concept of *'angelia'* (message) with the concepts of 'logos', 'idea', and 'nous'.[27] Poets and rhapsodists were disparaged in Plato's *Ion* as part of a general discrediting of those who 'only' function as messengers, for poets were considered to be the interpreters of the gods and rhapsodists were considered to be the interpreters of the poets.[28] Plato describes the kind of connection created by poetic mediation using the symbol of the magnet, whose powerful influence holds magnetized iron rings together. Whenever divine messages are delivered, their mediators remain dependent and ignorant. Philosophy can therefore only find its own form of speech, based on autonomous thought and knowledge, by critiquing and overcoming the messenger model of communication.

I will now shift to modern philosophy. In his *Discours de la Méthode* Descartes reflects on the difference between humans and machines, which also represents the difference between humans and animals because for Descartes animals are living machines. Humans and machines are different through language and reason, which also distinguish humans from animals. However, there are birds that speak without thinking. Descartes writes: 'For we observe that magpies and parrots can utter words like ourselves, and are yet unable to speak as we do, that is, so as to show that they understand what they say.'[29] Doesn't the speech of the messenger resemble the automaton-like speech of Descartes's speaking birds? This is undoubtedly true and Bernhard Siegert, who calls attention to this connection, cites Azzo's *Summae Institutionum*: 'A *nuncius* occupies the position of a letter; and he is just like the magpie [...], and he is the voice of the ruler who sends him, and he repeats the words of the ruler.'[30]

It is therefore apparent that the messenger is not in command of his speech, and it is not surprising that in his function as a transmitter he can also be easily replaced with non-human entities. Neutrality and indifference are inherent to the impersonal transmission event, and this is not only

invoked in the topos of the dying messenger but also culminates in the fact that messengers can be easily substituted by symbolic and technical information carriers. There is hardly anything as transmissible as the messenger function of transmission. The messenger is a person who fulfils his role by acting as if he is not a person. Messengers embody tasks that can often be accomplished just as well by the circulation and functionality of *things*. It could also be said that the messenger function is 'ontologically neutral': it can be performed personally, semiotically, or technically, and it usually involves the interaction of all three of these components.

Transmissions

Angels: Communication through Hybrid Forms

In religion, myth, legend, and above all in the arts there is an imaginary space populated with messengers: It is the world of angels, of placeless mediators between heaven and earth. The study of angels ('angelology") is an epiphenomenon of monotheism: Judaism, Christianity, and Islam have added a more or less extensive army of angels to the statuary isolation of their God; the constitutional invisibility, unrepresentability, and remoteness of God is therefore supplemented with the offer of something holy that is visible, representable, and close, which takes on an allegorical form in angels. Angels are not simply there, but rather they are active, as Augustine notes: *'angelus enim officii nomen est, non natura'*.[2] 'Angel' is therefore the name of an office, a function. The Greek word *'angelos'*, the Hebrew word *'malakh'*, the Arabic word *'malak'*, and the Persian word *'fereshteh'* all denote 'ambassadors'.[3] The primary duty of angels is thus to serve as holy messengers. In addition – as Siegert points out – the Greek word *'angeloi'* is derived from the *'angaréion'*, the attendants of the Persian relay post system.[4] As Horst Wenzel notes laconically, 'The establishment of the postal system preceded the heavenly messenger.'[5] In the word 'angel', therefore, a predictor becomes a name, which is the process of allegorical formation par excellence. The following considerations focus on the angel as an allegory for the office of the messenger and question whether this form can shed an interesting light on the mediality of the 'messenger's errand'.

An Archaic Vision of the Information Society and a Nebulous Form of Mediology?

I will begin with a perspective that is already familiar through Michel Serres's work: In a world that revolves around the axis of the information-technical exchange of messages, angels can serve as a model for a network that does not consist of things or living entities but rather of channels for the transmission of messages. 'Each angel is a bearer of one or more relationships; today they exist in myriad forms, and every day we invent billions of new ones. However we lack a philosophy of such relations [...] The angels are unceasingly drawing up the maps of our new universe.'[6] Angels create relations precisely because their transmission activities establish an intermediary space situated between the realms of the divine and the

human, and they connect these worlds by literally opening a channel between them.[7]

Michel Serres's standpoint also resembles that of sociologist Helmut Wilke, who sees angels as the legendary anticipation of a method of transmitting messages of any kind to any place, which has since passed to the megamachines of information processing.[8] For the first time data can be sent from any point on the globe to any other point: The invisible hand of the market described by Adam Smith thus returns once again in the form of the invisible hand of communications machines and networks.[9] A utopian society is emerging, for which the principle of location has become irrelevant, and this society is approaching – according to Wilke at least – our visions of angels.[10]

Nevertheless, 'space' is not 'place'. And if location is not an issue for angels, then neither is the spatiality of a world in between, which they create through their errands.

The analogy between this imaginary space and the contemporary globally expanded space made possible by information transmission machines makes evident the messenger angel's ability to be able to establish connections and correspondences between distant parties by not being tied to any particular place. The texture of the border-crossing network of pathways formed by the angels' errands is thus grounded in the very meaning of 'space', which is not based on the principle of location: Angels are homeless and placeless.

Régis Debray goes the furthest in exploring the information-technical aspects of angelology, as he believes it represents a media theory *avant la lettre*, a still nebulous stage of a mediology.[11] The angels, 'the Almighty's petty telegraphers',[12] reveal three principles that are fundamental to his mediological approach: the structure of the mediatizing third between the sender and the receiver of a message, the hierarchical organization of this world in between, as well as the diabolical inversion of transmission into an obstruction. Debray also refers to an ideological problem: The ethnological analysis of 'foreign myths' – like the work of Lévi-Strauss or Malinowski – is considered very prestigious, yet the ethnology of our own European mytho-religious beliefs, to which the angels significantly belong, is (still) hardly acceptable and thus avoided.[13]

I am therefore turning to the theme of angels because they represent the imaginary embodiment of the messenger and the activity of transmission more than any other phenomenon, yet I am only concerned with angels as fiction and idea, as permanent residents of symbolic worlds and enduring figures in our collective imagination. There are no angels, but there is a

multitude of religious as well as artistic representations and conceptions of angels, which are the subject of the following considerations.

What Do Angels Do?

Is there anything more distant and different from one another than God and man? What truly distinguishes heaven from earth is not only distance per se, but rather the divide between two worlds that are apparently conceived to be as different from one another as possible. The divine is related to the human like the unconditional to the conditional, the ineffable to the effable, the invisible to the visible, the absolute to the relative, the infinite to the finite. The monotheistic God is the incarnation of everything that eludes visibility and therefore also representability. It is thus no surprise that the empty distance separating God and man is filled with messengers and mediators who offer their own solutions to the problem of how the invisible nevertheless manifests itself and how the infinite can be effective in the finite world. I will now look more closely at this 'solution process':

The purpose of an angel's existence is to be a messenger; angels are sent from God, and they are destined to transport divine messages.[14] Angels are dependent; they do not act on their own impulses. They are instantiations of a task. Angels act in the name of a foreign authority. This is why they are preferably called 'Angels of the Lord' in the gospels. The Old and New Testaments are thus 'ultimately less interested in the being of the messenger than the appropriate alignment of the message'.[15]

The power of this message is borrowed from or delegated by the 'almighty'. Angels do not create anything, they do not leave anything behind, they have no success and also no history[16]: The hands of angels remain empty. Their existence is fulfilled in the act of speaking on behalf of someone else. In this capacity they can nevertheless participate in the primordial 'creating' performativity of the divine word, which recalls Benjamin: the angel's annunciation coincides with Mary's conception. Moreover, it is also the angels' duty to bear witness; they bear witness to God in the presence of humans so that God manifests through them.[17] Angels represent the trace of God in human reality.

They populate a world in between; they are only present to humans in the moment of their proclamation; their appearance as messengers of God is always characterized by their disappearance and withdrawal: 'The first duties of the transporter are: eclipse, stepping aside, flight and withdrawal.'[18] This placelessness and the ability to withdraw predestine angels to be border crossers who can mediate between positions without themselves taking or having a home. And it is entirely consistent that these border crossers

should assist humans precisely during the borderline situations of their lives. In the New Testament angels tend to appear in situations of flight into exile, birth and death.

On the Angels Themselves

The angel is a virtually crystalline 'materialization' of the concept of the neutral, dependent, border-crossing messenger who fulfils his task and thereby makes himself obsolete. These facets of the mediator and transmitter are familiar enough through the messenger model, but how does the transmission of divine messages through angels reveal *new* aspects of the mediality of a transmission event? I will concentrate on four such aspects: (1) embodiment, (2) hybridization, (3) demonic inversion, and (4) hierarchical multiplicity.

(1) *Embodiment*: Angels are considered 'fundamentally immaterial',[19] yet this immateriality obscures the important fact that their corporeality – and here I am in agreement with Petra Gehring[20] – is a *conditio sine qua non* of their position as messengers. This corporeality undoubtedly has paradoxical features: It is the embodiment of 'incorporeality', an ethereal 'spiritual physicality' that tends to dissolve into light or air. Nevertheless, this special form of corporeality could be considered the most suitable way of materializing the messenger function. Angels substitute the incorporeality and invisibility of God, which implies the impossibility of direct communication with humans, for human-like corporeality and visibility: 'Because angels are transmitters, they must communicate according to human standards. They must be physically and verbally active [...] Without bodies they would not be angels at all, but rather like God himself.'[21] The corporeality of angels is the incarnation of their ability to be seen and heard. The body of an angel has no weight of its own; it is – in a way – 'an impossible body'.[22]

In his philosophical reflections on the figure of the mediator, Christoph Hubig emphasized that a mediating instance can be understood in two ways: the 'forms of the mediator' are either conceptualized as *'impersonal* instances of mediation' or they are represented 'in the form of a messenger of the gods, of the savior, of the redeemer, which is shown in the world religions as a *personal* instance of mediation'. Hubig continues: 'This last-mentioned approach represents the essence of every theology of incarnation.'[23] This idea of embodiment also applies to the in-between world of the angels: it is no accident that Christ is also equated with angels as Christos Angelos.[24]

The theological doctrine of God's incarnation in Jesus himself now constitutes an ongoing dilemma for the theo-christological interpretation. 'The Word became flesh' (John 1:14): This appears to be a mystery, a paradox that bears witness to the fact that faith rather than reason is the medium

that brings one closer to God. And enlightened-philosophical proponents of Christianity like Lessing have also consequently avoided the concept of 'incarnation' as much as possible.[25] Luther even refers to Jesus as a mediator in the course of the Reformation, and Zwingli emphasizes that this position requires Christ to adopt characteristics of *both* of the spheres to be mediated. This brings me to a fundamental attribute: the hybridity of angels.

(2) *Hybridity*: Jesus is a mortal human, and thus flesh, as well as immortal God, and thus spirit. When these dimensions blend together they do not become unrecognizable; rather, the uniqueness of these qualities is retained.[26] Christ does not represent the synthesis of two worlds, which gives rise to a third, 'higher' world; rather, the resistant features of these opposing worlds continue to persist in parallel to one another, which is precisely how a connection is established. What emerges is an in-between world where – in the words of H.J. Hamann – 'Christ is the speech of God'.[27]

This incarnation, which achieves its paradigmatic religious form in the figure of Christ, also holds true for the angels. Angels are hybrid entities. This is meant, first of all, in an entirely 'profane' sense. Angels are – not unlike Hermes – winged creatures, which carries a 'fundamental mythic significance' and implies a 'similar origin for birds and angels'.[28] Massimo Cacciari notes: '*Mehr Vogel* [...] is the title given by Klee to one of his drawings on the theme of the angel: more bird [...] than Angel.'[29] In the prosaic words of Thomas Macho: 'Angels are intermediate beings, and they appear as a blending of birds and humans [...] archaic aviation pioneers; they can ascend to heaven and hover over land and sea. After subtracting metaphysics and the scholastic art of speculation, all that remains are feathers and wings.'[30] Their airworthiness predestines the angels to eliminate spatial distance in a literal sense.

Yet the wings of angels represent only the profane side of the sacred hybridization that constitutes their 'mode of existence'. Their immortality and weightless mobility exist in parallel with their human-like corporeality and their ability to speak. Angels participate in the divine *and* human spheres: 'The world of angels unites *on the same plane* that which is irreconcilably distant and opposed.'[31] The fact that opposing forces can join together in one form is crucial to understanding the 'mechanisms' of angelic transmission. Communication via holy messengers is possible only insofar as they share something with both of the worlds to be mediated. The most interesting aspect of the angels' function as messengers is thus the fact that they *transmit messages through hybridizing embodiment*.

Angels allow the divine 'to emerge from the shadows of distance' and manifest itself as something close to human, and they are able to do this

because as hybrid creatures they combine the attributes of the divine and the human in a subtle conflation of incorporation and excorporation.[32]

(3) *Demonic Inversion*: In their hybridity, angels literally occupy the *middle*. They are mediators insofar as they are *intermediary members*. And they fall as soon as this middle position is no longer readily available. The demonic suspension of the mediator's position is condensed in the image of the 'fallen angel': the closer the angel is to God the more likely it is that he also wants to be like God,[33] yet those who aspire to be equal to God are hurled to Earth. Lucifer's diabolical fall bears witness to the fact that forsaking the hybrid world situated between God and humans also entails a repudiation of the angel's messenger function. While the Hebrew Bible does not recognize 'Satan' as a fallen angel, Satan, Beelzebub, or Belial has a central importance for the followers of Jesus.[34] And it is no accident that it is precisely corporeality that becomes the gateway of the demonic fallen angel: According to St. Teresa of Ávila, the soul can only be influenced through the body; angels possess such a body, but not God.[35] At the same time the relativization of the absolute in the perceivable corporeality of angels also gives rise to the phenomenon of the lapse, of ambivalence. 'Evil' emerges as an inversion of 'good'. What Satan is ultimately left with – from a modern perspective – is no longer the transmission of divine messages, but rather the purchasing of souls through the exchange of services in a demonic pact. This is also a form of transmission, incidentally, which will become more revealing when money is seen as a medium of exchange.

(4) *Hierarchical Multiplicity*: Angels only exist in a multitude, and this multiplicity exhibits a sense of order that is reminiscent of the military: Angels constitute the army of God. This is not the military aspect that interests me here, although the idea of the 'angel with the sword' (not only the archangel Michael as the general of God[36]) consistently grounds and complements that of the messenger angel.[37] Rather, what is more significant is the gradation of the intermediary world according to the proximity and distance to the senders or receivers of holy messages. Such a hierarchization of the world between God and humans was first described by Dionysius the Areopagite around 500 A.D. For Dionysius the hierarchy of angels is an answer to the unrepresentability of God. Dionysius proposes that a highly structured universe of intermediary beings stretches between the Seraphim, the symbols of light and fire that stand next to God, and the guardian angels, which are close to humans. This can explain one thing: the talk of a 'third' that occupies the middle position between opposing forces is only a shorthand way of saying that an abundance of gradations

are operative between dichotomous extremes, which does not leave this in-between space empty, but rather marks it as a transitional space.

The notion that the in-between world of the angels makes an abundance of modularizations visible by virtue of what is distant from one another and yet nonetheless affects one another and is connected to one another leads to one last consideration: The angel as the embodiment of an 'ontology of distance'.[38]

The 'Ontology of Distance' and the 'Representation of Unrepresentability': Interpretations of Angelology

How can distance be overcome *and* preserved at the same time? How can distance be transformed into proximity when it cannot provide the immediacy of contact or a bridge between distant points and it thus remains 'insurmountable'? This is the problem of monotheistic religions and angelology is an attempt to solve or at least offer some compensation for this problem. Andrei Pleşu and Massimo Cacciari have interpreted this problem in two different ways using an onto-epistemological approach and an aesthetic or image-theoretical approach.

Pleşu revised the problem: The point is not that people are unable to maintain a relationship across distances, but rather the contrary: The mostly familiar view of what lies in the distance, which is transcendent, utopian, absolute, and unavailable, directly obscures the view of what lies close by. It is not the distant, 'it is the near that becomes inaccessible to us. Every celestial metaphysics has its morbid counterpart in the suppression of the feeling of closeness'.[39] This 'crisis of proximity' – and this is Pleşu's epistemological trick – thus depends on rigid dichotomies. However, if angels transform the 'abyss between God and humans into an information space'[40] and if the solution to the problem of distance consists precisely in filling the hollow space, the emptiness of this abyss, with mediating figures, then this generates a cognitive-epistemological resonance phenomenon: being-in-the-world must be understood not simply as a static dichotomy, but rather as modulations; people must overcome their 'polarizing instinct' and their 'obsession with binary simplifications'[41] in the context of this image of a Jacob's ladder that is made possible by the hierarchy of angels, which establishes gradations between things that are distant from one another. This constitutes the 'technics of overcoming' distance, which is crystallized out of angelology, because it takes the distance apart and 'transforms it into a series of proximities'.[42] This also implies an anthropological directive: humans should conceive of themselves not simply as dualistic but rather as a triadic composition of will, intellect, and emotion. This restores the

realm of the imaginary to the border between interior and exterior instead of reducing it to mind-body dualism.[43]

This space of imagined messengers is the space of visualized images, and it is at this point that Massimo Cacciari now comes into play.

Cacciari also understands his reflections on angels as a confrontation with the issue of an irreducible distance, but he nevertheless treats this – with reference to Walter Benjamin[44] – as a 'problem of representation' and thus an aesthetic problem.[45] If the graduating modularization of the in-between space is the one form that establishes the proximity of a distance, then *forming an image* of the distance brings about another modality. The inconceivability and unrepresentability of God finds its paradoxical echo in the diverse images of angels, all of which are epiphanies of a withdrawn God who establishes contact without exposing or revealing himself.[46] However, the angel thus becomes 'the exact image of the problem of the image',[47] for an image is always different from and more than a symbol: Images also contain something magical in the form of a real effect of the depicted; they are at the same time both distinguishable and indistinguishable from that which they represent. They are the living presence of a distance, the projection of the absent in the present. For this reason, 'every *true* image is never only a simple representation'; rather, it is one with its own state of being-distant – '*it is one with absence*'.[48] Like Pleşu, Cacciari also addresses the imagination.[49] By revealing this imaginative dimension the angel rescues perception from 'merely being perception' and it thus becomes apparent that every perceived object is always also a '*fictum*'.[50]

People therefore do not see angels, but rather they always only see images of angels. By referring to the question of how it is possible to represent that which cannot be seen, Sigrid Weigel emphasizes how paintings of angels embody 'the moment of visualization' and they thus serve as a 'means for reflection on painting itself'.[51]

Cacciari and Pleşu also call attention to a further dimension of the iconicity of angels, which is their mirror function.[52] In the discourse about angels since time immemorial they have been characterized again and again as mirrors.[53] 'The world of angels – *mundus imaginalis* – resembles a mirror between the world of God and the world of humans, which reflects both worlds and unexpectedly brings them into contact.'[54] Mirror images are precisely not subordinate to the regime of (arbitrary) semiotics; in other words, they are not symbols. Mirrors always reveal the 'trace of a presence' caused by synchronous action, but they are never the presence itself. Furthermore, mirror images are – in an optical sense – virtual images. They

move what is reflected to an illusory place. If an angel mirrors God in the world of humans, for example, then God appears in a place where he is not. The presence of a divine absence emerges in the image of the angel as the proximity of a distance.

The virtuality based on their mirror-like iconicity and the information-technical virtualization anticipated by their relentless activity as messengers thus intersect in the figuration of the angel.

What Does Transmission through Hybridization Mean? A Conclusion

Where are these reflections on the imaginary figure of the angel leading if they are construed as a media theory *avant la lettre*? I want to emphasize five ideas:

(1) The problem of communication does not consist in overcoming distance, but rather in the *otherness* of the worlds between which a connection is to be established. Given the differences between almighty God and mortal human beings, this connection is then (largely) unidirectional.

(2) The art and technique of this connection – and this is the central idea – lies in *hybridity*, or the notion that contact between the heterogeneous can be established when the 'contact organ' is composed of attributes of both of the worlds to be mediated. It is precisely the juxtaposition and simultaneity of these opposing characteristics that allows the angel to function as a mediator.

(3) Such hybridity can only be achieved through *embodiment*. While reflections on angels tend to emphasize their immateriality, they can only communicate with humans insofar as they themselves also have bodies. The transmission of God's word is impossible without embodiment.

(4) The neutrality associated with messengers and their position in the middle and in between are always also vulnerable and subject to change. Lucifer, the messenger who develops a life of his own by denouncing his heteronomy and his intermediate position, is therefore only the reverse side of heavenly message transmission. The *fallen angel* is a structural element of the mediator's position.

(5) Angels are more than 'God's cute telegraphs': They bring the distance of the monotheistic God closer, they make his absence present and they make his invisibility visible. Angels do not simply reveal something imperceptible; rather, they reveal the *imperceptibility* of something that is nevertheless operative in the presence of his non-presence. Angels are therefore not only the messengers of God, but also *traces* of God.

Viruses: Contagion through Transcription

An elementary process of transmission is painfully familiar: contagious
diseases from the flu to AIDS are based on infection. 'Infection' ('*inficere*'
is Latin for 'contamination') is part of the vocabulary of pathophysiology.
Like few other medical terms, the 'logic of infection' is rooted deep in the
everyday fears and hysterias of globalized societies.[55] Moreover, infection
has also been metaphorically adapted to explain cultural – for example,
aesthetic – phenomena.[56] It is obvious why the phenomenon of infection is
particularly interesting here: it concerns a process of transmission through
which the pathogenic agent finds its way from one organism to another.
Could the observation of infection provide insights into the 'nature' of
transmission that would be significant for media theory? The following
considerations are based on this assumption.

On the Classification of Infectious Transmission

Infection is 'transmission through contact' and thus a 'physical model
of influence'.[57] An organism is contaminated and thus changed through
contact. Microorganisms spread disease by inhabiting a body, reproduc-
ing themselves, and then migrating to other bodies. From the perspective
of the infected bodies, the pathogenic agents come from outside. They
bridge the distance between the 'source of the infection', from which they
originate, and their future 'host', which then becomes another 'source of
the infection'. Contagious diseases require a physical exchange between
the organisms as well as between the organism and the environment.
They therefore represent a genuine physical process: there is no infection
without material changes. Moreover, infection always involves a multitude
of bodies: to observe one infected body separately is to interrupt a chain
of events and abstractly single out one particular link in this chain. From
the perspective of transmission, infectious transmissions do not actually
have any beginning.

The medical 'nature' of contagious diseases has only recently been un-
derstood. An insight into the *transmission* character of infection has been
hindered by the almost unbroken acceptance of humoral pathology from
antiquity to the modern era: according to humoral pathology sicknesses
appeared to be caused by an imbalance or unhealthy mixture of bodily
fluids. Humoral pathology cannot explain how something from outside
is transmitted into the body. It was not until the 1840s that the Göttingen
anatomist Jakob Henle postulated the existence of a '*contagium anima-
tum*' or pathogen that caused infectious diseases.[58] In 1876 Robert Koch

succeeded in isolating, observing, and cultivating a bacillus that not only accompanied sickness, but was also its cause.[59] The study of bacteriology was eventually founded, which paved the way for an understanding of infection as a contact and transmission event. An important milestone along the way was Louis Pasteur's insight concerning immunization, which was achieved with great difficulty: An organism *is* not immune, but rather it *becomes* immune by receiving and being exposed to the disease-causing pathogen in a weaker form. If a body is immunized by surviving an illness or receiving a vaccination, it no longer serves as part of the chain of infectious transmission. Nevertheless – and this shows just how much the theory of immunization is connected to the insight concerning the physical character of transmission – the difference between activated and inactivated vaccines is crucial: Vaccines with activated, living pathogens not only prevent an outbreak of the sickness, but also halt the spread of the infection; vaccines with inactivated pathogens, on the other hand, make it very easy for the relevant bacillus or virus to be passed on. In this case – using the terminology of information transmission – a body is actually no longer a receiver, but rather an emissary of an infection.

Which insights about the 'nature' of transmission processes – understood in the literal sense – are revealed using the example of infection? Which kind of picture is obtained when 'transmission' is explicated using the model of infectious diseases?

(1) *Embodiment*: To start with, it is represented as a physiological event in which a natural substance and thus a material substrate is always transmitted. *Something* must be transmitted, a bacterium, a virus, a parasite: in other words, a 'somatic entity'. The infected body is not only the 'receiver', but also the 'host', and he has an elementary economic relationship to the pathogen implanted in him, as it reproduces 'at his own expense'.

Nevertheless, I want to focus on the transmission event itself more than economics. The pathogen comes from outside and infiltrates into the interior: a kind of 'invasion' or hostile conquest takes place. Infections always get 'under the skin'. A dimension of *violence* is inherent to infectious transmission; this kind of transmission leaves victims in its wake. I will later return to this violent aspect of transmission. The relationship between exterior and interior applies to the macro and micro levels: At the macro level, it occurs between bodies; at the micro level, it occurs between pathogens and cells. Yet 'from the outside inwards' is always only a stage that follows immediately after 'from the inside outwards'. The dual process of inclusion and exclusion constitutes the 'chain reaction' of infection. Every component of this chain is at the same time both a receiver and a sender of the pathogen.

(2) *Transmitting Medium*: Transmission is impossible without a transmitting medium. The function of the transmitter depends on the perspective from which the infectious event is observed: From the perspective of the pathogen, air, bodily fluids, skin, or simply food and water serve as means of transportation. For a parasite, entire organisms could also fulfil the function of a 'transport host'. When the sickness is regarded as the thing to be transmitted rather than microorganisms, then a bacterium or a virus plays the role of the transmitter.

In any case, infections cover great distances. They are events that consume space, possibly through rampant epidemics. These means of transportation and transmitters of medical infection represent an elementary form of 'media'. It is nevertheless necessary to remain aware that the question of which transmitting medium is in force can only be answered in relation to the question of what is the object to be transmitted. What constitutes a medium in the course of infection is *relative to and dependent on the position of the observer*. It is nevertheless clear that an infectious transmission is impossible without a (transmitting) medium.

(3) *Milieu*: The invasion of the pathogen into the healthy organism is contingent on certain conditions. It is therefore necessary to put the inevitability of infection in perspective: Infection is by no means a deterministic process. A body can be insusceptible to an infectious disease through its own natural defences or an acquired immunity. Both of these forms of resistance reveal important aspects of infectious transmission. The fact that physical resistance can hinder an infection shows that the presence of a pathogen and its transmitter is actually necessary but not sufficient for an infection. In order to be able to misuse an organism as a host, a pathogen always needs a *milieu*. This 'milieu' depends on whether the skin is unharmed, the acid protection layer is adequate, bacterial flora is intact, the organism is sufficiently nourished and hygiene conditions are observed. In short: whether the milieu is favourable or unfavourable varies according to the pathogen, but infectious transmission always requires and depends on a milieu. The degree to which an organism is plagued by an infection is thus out of the question.

(4) *Immunity*: While the body's natural defences call attention to the significance of the milieu, immunity points to some exceptional features of the relationship between the pathogen and the 'host'. Immunization occurs precisely when the body experiences a sickness and develops the appropriate antibodies: In order to invade the host body, the pathogen must always occupy 'foreign' territory, which differs from itself. A divide between the '*self*' and the '*foreign*',[60] an asymmetry and heterogeneity, creates the

conditions under it is possible to speak about infectious transmission in the first place. The art of vaccination consists precisely in making the pathogen feel 'at home' in a body such that the generic divide between the infected and the non-infected organism collapses, it is no longer possible to distinguish between them pathogenically, and transmission is thus precluded. Is it trivial to state that there is no infection without a difference between a body with a pathogen and a body without a pathogen? In any case, this statement is obvious when one realizes that infectious transmission means not only that a pathogen is transmitted from A to B, but also that there must be a substantial difference between A and B, whose 'pull' first sets into motion the motor function of the infection process.

Viruses: Biological and Technical

The language of medical infection has been used to describe an astonishingly wide range and abundance of non-medical facts. Furthermore, the ubiquity of the vocabulary of infection outside of the medical and scientific disciplines is if nothing else thanks to the attention of that special form of infection associated with viruses. The concept of the 'virus' has been identified as a leading metaphor for contemporary culture,[61] a 'collective symbol',[62] and an exemplary stereotype that has the power to relate various specialist discourses, through which science differentiates and fragments itself, and to cement itself firmly in everyday common knowledge. So what does 'virus' mean?

Viruses do not live; they do not subsist and grow. Viruses reproduce, but their reproduction is not automatic. Viruses are a complex of macromolecules that consist of genetic material, DNA (deoxyribonucleic acid) or RNA (ribonucleic acid), and protein molecules, which surround the virus gene. In order to reproduce they require suitable host cells.[63] This peculiar method of reproduction, which does not have its own metabolism but rather exploits an existing mechanism of self-reproduction from a 'host' external to itself, is the basis of the virus principle. Without their host viruses are simply lifeless structures, like chemical compounds, but through their contact with cells or living entities 'they are awakened' and develop resourceful reproductive strategies.[64]

The form of reproduction specific to viruses requires a virus to infiltrate a system that has not yet been infected and use its reproduction mechanism, and thus its genetic structure, as a medium for its own reproduction; as a result, the newly formed viruses must then look for new hosts. Viruses are highly specialized parasites. By infiltrating a foreign cell, the biological virus uses the cell's own processes of replication, transcription, and translation for the reproduction of its own genetic material. The genetic material of

the intermediate host of a virus is thus transliterated into the DNA/RNA of the virus, and different viruses employ different methods of 'encoding' their genes onto the genes of their host cells. The crucial insight here is that transmission through viruses can be understood as an act of a transcription.

This cellular activity reveals the substantial basis of the family resemblance between biological and technical viruses, as machines also 'infect' one another. There are actually many similarities between the cellular mechanism of replication, which as 'molecular machinery' relies on reading, processing, and relaying information, and the mechanism of a self-reproducing machine or automaton, as modelled in the program of the Turing machine, which transcribes and reads. Indeed, there are so many similarities that there are currently attempts to construct 'biological calculators' that can be implemented in an organism and function like an immune system by identifying and exterminating diseased cells – a vision of a 'vaccination', therefore, that works with technical rather than biological pathogens.[65]

The concept of a 'computer virus' seems to stretch the medical terminology to a metaphorical extreme, yet computer viruses and biological viruses have so much in common that it is possible to refer to two versions of a 'virus principle',[66] which suggests that this concept can be understood in an absolutely literal sense.

A computer virus is a part of a program that encodes itself in a 'host program' on another computer. When the user activates the infected program, the virus can disrupt or even destroy digital 'materials', like data, hard drives, diskettes, and programs. In the process of infiltrating the other computer, the virus also simultaneously replicates itself. The infected program thus becomes a medium through which the virus is able to copy itself onto more files and computers. Computer viruses that spread in an epidemic manner are known as macro viruses. They are relayed not through programs but rather through frequently exchanged documents, preferably as email attachments. Computer viruses can also be distinguished from 'computer worms', which Florian Rötzer compares by analogy to viruses like *bacteria*.[67] Computer worms are self-contained, self-reproducing programs that automatically spread through networks by detecting security flaws, using them to infiltrate systems, and then, for example, multiplying the address files in an email program.

Computer virus problems increase in proportion to the amount of networking. Just as an infection between people requires their interaction, if not immediate contact, so too does an infection between machines require interaction. Machine interaction only refers to the exchange of data and

programs, but this is also true of biological infection when viewed on a cellular rather than a personal level, as a biological virus also transcribes the DNA of a cell and 'exchanges' information in the literal sense of the word.

Productive Dimensions of Parasitism

The previous description of infectious diseases emphasized that the invasion of the pathogen represents a violent exertion of influence, which constitutes the basis of this form of transmission. However, there is more to parasites – in the broadest sense – than simply sickness and death for people or malfunction and destruction for machines. Without a doubt, parasites live off of others; they are freeloaders. Parasites are thus often seen as failures and vermin, but it is possible to reverse this emphasis.[68] Before the word 'parasite' experienced a shift in meaning and became synonymous with freeloader, the ancient word '*parasitos*' referred etymologically to the prestigious attendants invited by priests to holy banquets held in honour of the gods.[69] The word '*parasitos*' thus originally referred to a ritual functionary, but it already experienced a negative reinterpretation in ancient times and in the nineteenth century it was taken over – in the sense of an occupation – by the natural sciences.[70] From a biological viewpoint, parasitism always establishes a (precarious) balance, as the parasite depletes the host's energy while at the same time it is also interested in preserving the vital functions on which it lives. The host ensures the parasite's survival. They both adapt in a kind of co-evolution. The parasitic lifestyle is one of the most successful in the animal world. Are there any systems at all without parasites? Nevertheless, asymmetrical symbiosis is simply a basic phenomenon in the development of the living. It gradually leads to the development of well-adapted species and the disappearance of poorly adapted species. In short: evolution would be unthinkable without parasites. The parasite 'produces small oscillations of the system, small differences'.[71]

It was Michel Serres who drew the radical conclusion that the border between parasitic and non-parasitic life was fluid. For him, the parasitic relationship evolved into a community-endowing elementary form of intersubjectivity par excellence; the parasitic is interpreted as the 'atomic form of our relations'.[72] For him, the essence of parasitism is not the one-sided damage to the host, but 'simply' the disproportionate ratio of giving and taking. If 'to parasite means to eat next to',[73] then the humour of this statement lies in the fact that people are always parasites as they are integrated in an irreversible chain of one-sided giving and taking. Due to the unidirectionality of this chain it is not actually exchangeable, but it is balanced by the

multidirectional diversity in which people become either parasites or their hosts. For Serres, therefore, the 'logic' of the parasite constitutes the basis of all social relationships, and the essence of this 'logic' is non-reciprocity.

Something clearly emerges in the figure of the parasite that is also significant for medical and technical infection. On the one hand, there is the *one-sidedness of transmission*, which requires the existence of a difference between two bodies, organisms, or programs; the direction of the transmission is thereby unambiguous and irreversible, and it thus proceeds asymmetrical and not reciprocally. On the other hand, it is significant that parasitic transmission involves not only a destructive but also a *constructive potential* that promotes cooperation and symbiosis.[74]

It is no accident that computer worms exploit security flaws in operating systems and thereby at the same time call attention to those flaws, which are all too easily overlooked in the course of an operating system's practical use. Computer worms thus encourage the 'healing' – or should I say 'immunization' – of operating systems. In order to turn to a decidedly 'metaphorical'[75] use of the vocabulary of infection, the interrelationship of infection and immunization now provides a key term – namely, the *social contamination* caused by violence between the groups of a 'social body'.

The Epidemic of Violence and the Sacred Victim
Violence infects; violence violates. With its coerciveness and its potential for destruction, there is hardly any other behaviour that so strongly resembles a disease whose subversive power comes from the circulation of transmissions than violence, which obeys a logic of revenge. Infection produces sacrifices. René Girard interprets the holy institution of the sacrifice as a strategy of immunization directed against the epidemic spread of reciprocal acts of revenge in archaic societies, which do not (yet) have legal institutions.[76] And in an ingenious essay Dirk Setton shows how, with the help of the terms of infection, Girard's cultural anthropology of the sacrifice, which is motivated by religious theory, as well as Levinas's philosophy of the incomprehensible singularity of the other, which is motivated by ethics, each reveal violence as the sublime common cause of problems that are then overcome in some way or other through religion and ethics: 'The problem of infectious violence lies at the heart of religion and ethics.'[77] In the following I will only take up Girard's religious considerations, which primarily interpret the sacrifice as an immunizing instance in situations of infectious violence.[78]

The holy sacrifice is usually interpreted as an act of mediation between humans and god, and it thus becomes a social activity that is more or less inconsequential in the space of the imaginary. In contrast to this notion,

Girard wants to show that sacrifice fulfils real interpersonal functions. This first becomes evident when the sacrifice is seen as a form of mediation not between humans and god but rather between the members and groups of social communities.

The starting point is the observation that in archaic societies violence and disease are both identified with the impure or the infected, so they are both to be approached with ritual efforts.[79] Under archaic conditions, violence triggers a chain reaction of reciprocal acts of revenge. An act of violence against a member of a family or clan prompts a reciprocal act by this group against members of the other family or clan. Violence thus activates a 'logic of infection' and acquires a 'viral power'[80] within the social body, which can only be averted through strategies of immunization. The institution of law and the monopoly of violence associated with it can actually be interpreted as disrupting the continuous chain of reciprocal violence insofar as the judge's verdict constitutes the last form of revenge, which cannot be transmitted any further. Girard's premise is that societies without legal institutions attempt to stop the epidemic spread of violence through the rite of sacrifice. From this perspective, law and holy sacrifice prove to be equally pragmatic and functional.[81]

What is most interesting about Girard's theory is not only the epidemic character of violence, the chain reaction of circulating violations in the social body of a society whose logic of infection weakens and undermines the community, or its resolution through the immunizing strategy of sacrifice. It is even more significant that Girard explains the immunizing function of sacrifice by describing it as the *mediator of a transmission event.* The potential for violence is transmitted to the sacrifice – in an absolutely literal sense – and it can then be allayed and overcome in and through the sacrifice. The special status of the sacrificed thus becomes significant; like the neutrality of the messenger, it is caught between competing groups enmeshed in the reciprocal use of force. In a sense, the sacrifice[82] is 'in-nocent' and indifferent; above all, however, it must be free of the reciprocal obligations and responsibilities of the members of a social body (i.e. the responsibility to exact revenge), and it is thus outside the social order. It is the scapegoat. Prisoners of war, slaves, foreigners, unmarried youth, but principally animals were thus especially predestined to assume the role of the cathartic sacrifice.[83]

The sacrificed becomes a 'neutral' medium, which absorbs and embodies the community's potential for violence; the sacrifice 'is a substitute for all the members of the community, offered up by the members themselves'.[84] Communal killing or the collectivity of murder appeases and spares the

reciprocally injured and dead.[85] From this perspective, the sacrifice is no longer considered an exercise of violence against an individual, but rather as an act of violence against the scapegoat it constitutes at the same time a protective barrier against violence within the community. Girard thus interprets sacrificing as a process of immunization.

In a virtual reversal of perspective, I will now turn to another field in which the vocabulary of infection can be applied: the aesthetic experience. The issue here is that the intellectual immunization inherent to theatre as a symbolic, representational institution is always also subverted by the theatrical performance, insofar as a kind of bodily infection emerges precisely in the here and now of the presentation.

Infection as a Form of Aesthetic Experience

With the concept of catharsis, a medical term was employed early on to attempt to describe and theoretically explain the effect of theatre on spectators. 'Catharsis' means bodily purification for the purpose of healing. Erika Fischer-Lichte shows that it also makes perfect sense to use the concept of infection, which like catharsis refers to the transformation of a body (albeit in the opposite direction, from health to sickness), to express a modality of theatrical experience.[86] Moreover, the 'logic of infection' of this theatrical experience is appropriate for expressing in a significant way the relationship between artists and spectators as it pertains to the development of performance art since the 1960s. I will now illustrate the basic intention of Fischer-Lichte's aestheticization of the concept of infection.

Infection occurs between bodies. It is therefore above all the dimension of *corporeality* in the experience of art, which is thematized in the idea of aesthetic infection: 'The concept of infection conceives and describes aesthetic experience in the theater as a primarily somatic process.'[87] The theatrical performance depends on the physical co-presence of actors and spectators in a shared space: the prerequisite for an infection is thus definitely fulfilled. However, unlike medical infection, which requires actual contact and the exchange of organismic material, theatrical infection only happens through the gaze of the spectator: 'The infection takes place in the act of watching, it is the act of watching.'[88] The spectator only changes through looking: a kind of 'white magic' takes place in his gaze, in contrast to the 'black magic' of the evil eye. The fact that the somatic character of infection takes on almost magical properties here illustrates how much the terminology of infection sees itself as a counter project to a hermeneutically-oriented understanding of visual perception. The spectator is not (any longer) considered to be a distanced or even indifferent

observer who reflects upon what he perceives. The somaticity of infection aims to subvert the reduction of watching to a mental process. Moreover, a pre-rational, pre-reflexive relationship between the actors and spectators also unfolds. The spectator's gaze is not directed towards the role and figure of the actor, or his *semiotic* body, but rather it is directed towards his *phenomenal* body. The infection of the spectator consists in the fact that 'powers released in the body of the actor are perceived by the spectator's gaze and are thereby able to influence and transform the spectator's body'.[89]

Insofar as the concept of infection is based on the physiological effects on the spectator, it is no surprise that after this concept was codified in the seventeenth and eighteenth centuries the vocabulary of infection was then replaced by a notion of art reception with the proclamation of the autonomy of art in the nineteenth century, which was geared towards empathy and thus a spiritual-mental process.[90] Infection took on the negative connotations of 'weakness' and 'contamination', and it was not revisited again until the twentieth century when Antonin Artaud compared the theatre to the infectious effect of the plague, as it similarly provokes a crisis in the spectator.[91] For Artaud, the theatre can heal people in the Western world, who are ill with logocentrism and individualism, as it activates a 'kind of counter infection'.[92] The arts since the 1960s have absorbed the corporeality and materiality-oriented impulse of the historical avant-garde: action painting, body art, performance art, or scenic music not only bring the corporeality of the actors into play, but at the same time they also target the corporeality of the spectators themselves.[93] When artists injure themselves during a performance, when they overexert themselves to the point of physical exhaustion, when they display sick and frail bodies, when they make the intimacy of their nakedness public, these all lead to bodily reactions in the spectators themselves, to physiological, energetic, affective, and also motoric states. This physical involvement – among artists as well as spectators – reflects an understanding of aesthetic experience as a somatic process, which lends a new actuality to the concept of aesthetic infection: It thus seems 'sensible and worthwhile to theorize the concept of infection, which until now has been applied metaphorically in the discourse of aesthetics, in the same way that the concept of catharsis has been theorized over the course of many centuries. For it appears in many respects to be the more important concept today.'[94]

Transcription and Mimesis

Take a step back from the panorama that has been presented thus far, which includes medical, technical, social, and aesthetic forms of infection. By discussing infection in terms of biological and technical viruses, it has

been revealed that 'transcription' is the central mechanism of transmission. The power of transcribing is precisely that it levels a systemic difference, the difference between self and other, which is the driving force that sets an infectious transmission in motion in the first place.

Could this equalization of difference through transcription also be reconstructed as a *mimetic* potential?

René Girard actually emphasized that the rite of sacrifice turns everyone involved into 'doubles' whose attitudes converge as they are linked together and communitized through the shared guilt of collective sacrificial murder.[95] The act of sacrificing establishes a mimesis between the sacrificers, and the sacrifice thus becomes a mediator between them. For Girard, as Gunter Gebauer and Christoph Wulf point out, 'mimetic mediation' is actually an anthropological fact and a 'general principle of society'.[96] Moreover, mimesis is an effective although historically transitory principle of art that nevertheless inevitably entails an anti-mimetic critique and must then give way to a semiotic paradigm (Girard explains this using the example of Romantic literature).

The relationship between mimesis and semiosis is connected to the concept of theatrical infection. From the semiotic perspective, the actor plays and represents a role while the spectator observes the stage event from a reflexive distance: This made the theatre into a paradigmatic model of the symbolic culture of representation, which seems precisely to overpower the mimetic as a mode of action and interaction. From the somatic perspective, however, the theatrical infection grips spectators in a way that is beyond distance, reflection, and control, and it is always also interwoven with the idea that the actor is not only a symbolic body, but also a phenomenal body. Doesn't this suggest that the vocabulary of infection undermines the logic of representation insofar as it features a mimetic dimension? Does mimesis thus constitute an anthropologically fundamental form of transmission, which is embedded much deeper in the representational processes of semiosis than is commonly acknowledged?

So What Does 'Transmission through Infection' Mean? A Conclusion
(1) *Somaticity:* One characteristic of transmission that occurs as infection is the explicit corporeality of this process. From a biological – as well as technical – perspective, this means that a pathogen is only transmissible through contact and that the infection then results in a transformation of the infected body. The use of the concept of infection in non-biological contexts is thus always also a counter-project to mentalistic, rationalistic, or 'disembodied' concepts of influence.

(2) *Heterogeneity:* Transmission occurs between systems that vary enormously, regardless of whether this is described as a difference between self and other, healthy and sick, host and parasite, actor and spectator, or rival clans/families. Strategies of immunization depend precisely on the possibility of levelling and erasing this heterogeneity in favour of homogeneity. If the divide created by a difference disappears, then there is also no infection (any longer).

(3) *Non-Reciprocity and Unidirectionality*: Although both sides must be in contact in order for transmission to occur, infectious transmission is not an interrelationship, but rather it is one-sided. Thus there is also an interval through which a body can first become the receiver and (then) the sender of a pathogen.

(4) *Transcription*: The primary device used in the particular kind of infection that occurs through viruses is transcription. It is the unique mechanism of transmission that makes viral activities so instructive. Although somaticity constitutes the fundamental characteristic of disease transmission, the physiology of transmission through viruses is linked to information processing, which is reflected in concepts like 'transcription', 'coding', 'reading', and 'translating'. At the same time transcribing is also related to mimesis. Does mimesis constitute the source of an interconnection between the symbolic and the phenomenal, the mind and the body? Does it constitute a strategy that equalizes the divergent without abandoning divergence?

(5) *Violence*: Violence is inherent to infectious transmission in many respects: (a) pathogens are invasive. They have an elementary power with nearly compelling effects. This also means that something happens to the infected; he performs a passive role insofar as the event is largely beyond his control. This 'compulsion' is particularly significant when it is emphasized that the concept of 'infection' refers to a non-mental, non-reflexive process. (b) This violence is mirrored once again in the violence of the counter-measures used to resist them. Immunization thus represents the controlled implementation of a disease. Above all, however, the isolation and exclusion of quarantine is an element that is experienced as violence by the parties affected.

Money: The Transmission of Property through Desubstantiation

There is hardly any transmission process as familiar as buying and selling. A business transaction in which goods are passed from one person to another is an activity that creates and confirms the overall picture of our social union like hardly any other aspect of our daily behaviour. These transactions are possible because of money.

For philosophy, money is an object that is all too profane and therefore – at least theoretically – mostly avoided. As much as philosophers are concerned with the communicative exchange of words and signs, they neglect to reflect on the exchange of goods and values. And yet there are surprising family resemblances between the circulation of signs and goods, as language and money, as well as intellect and economic rationality, definitely have something in common. Most recently, Hartmut Winkler's study *Diskursökonomie* explored the structural similarities between the exchange of signs and goods, which thus introduced a new perspective for the theory of media as mediator of circulation.[97] And Eske Bockelmann's work *Im Takt des Geldes* examined the capacity for abstraction that exists in the equivalent relationship between, on the one hand, the value function of money, which is detached from its concrete content, and, on the other hand, the commodity form of goods, which possesses all concrete contents.[98] In his groundbreaking study *Signifying Nothing: The Semiotics of Zero*, Brian Rotman has undertaken a comprehensive semiotic reconstruction of money by analyzing its function as meta-sign.[99] Finally, Siegfried Blasche's 'Zur Philosophie des Geldes' worked out the performativity of money as well as its performance conditions by analogy to the performativity of speech acts.[100] However, I am less interested in the symbolic nature of money, and I will also focus only marginally on the performance of the social institution of the monetary system. I am more concerned with the question of whether the functional principle of money contains any insights that would be enlightening for media theory. But what does it mean to analyze money as a medium?

What Is Money?
What is the answer to this elementary question: What is money? One answer – which is nevertheless only provisional here – can be found in the monetary functions of money or the uses to which it is put. This reveals at least three dimensions: money is a means and mediator of economic exchange, it is an instrument of measurement, and lastly it is a store of value. Money transmits value, measures value, and stores value. Admittedly this

is an overly simplified hypothesis that must later be revised, but from the perspective of usage it is at least clear that the mediator function of money is indisputable. So what does it mean if the exchange of goods takes place through the medium of money?

People desire things that they lack but others possess. In societies based on the division of labour this applies to many things. There are three obvious ways of obtaining the desired object: it can be stolen, given as a gift, or purchased. Theft leaves behind a form of guilt, as does the one-sidedness of a gift.[101] Paying the required price, however, absolves people of any further responsibility. Buying and selling always entail *at the same time* both giving and taking. Through the intervention of money, what is received is considered to be equivalent to what is given in exchange, and reciprocity is thus maintained.

The fact that people want what others have results in a conflict-laden asymmetry of interests, and the mediator function of money consists precisely in preventing this collision. The use of money enables people to induce others to do what they want in a way that – unlike the use of violence or love – saves time and energy[102]: 'Money reduces transaction costs.'[103] Money successfully mediates between those who are opposed by designating and assessing commonality in difference. Above all, it embodies and reifies this commonality – the quantifiable value – thus making it manageable. Money is the standard that enables the similarity of the different, the homogeneity in the heterogeneous, to assume an objectifiable form. Money is, in the literal sense of the word, *unifying*, it synthesizes.[104] I will now emphasize more clearly three facets of money-mediated exchange: (1) its sociality, (2) its abstractness and indifference, and (3) its materiality and structural properties.

On the Sociality of Money

(1) *Mediator between people, not things.* The fact that we purchase goods with money or sell them for money fosters the impression that an exchange of things has taken place according to their inherent value. Contrary to the appearance of a transaction of things or services, however, money remains fundamentally a mediator between *people*. What money transmits is not simply a thing, but rather the *ownership* of a thing. Ownership is exclusive: if I legally own something, then others are excluded from this relationship. By enabling the transmission of property, money is a social medium. It mediates between people in that it enables the exchange of things in a way that is free of conflict.[105]

The national economist Hajo Riese goes further into the social interpretation of the function of money. For Riese, money is based not on acts

of *exchange*, but rather on *obligations*: money is only a means of payment because it is 'the ultimate medium of contractual fulfillment'.[106] For Riese, the monetary system is not based on the exchange of goods, which is also possible in non-monetary forms, but rather credit,[107] and thus the relationship between creditors and debtors.[108] The beginning of the monetary economy thus lies in an authorized institution of money creation. This institutional foundation of the monetary system contains two dimensions that help to illuminate its sociality: the religious origin of money and its performativity.

(2) *The sacred origin of money.* Ernst Curtius already clarified the religious character of Greek coins – the earliest form of minted money – in 1870, at a time when this was already assumed but not yet proven. Greek coin designs mostly featured gods, but this was not the profane result of the fact a deity constituted the city coat of arms and thus belonged on coins 'by order of the state'. Rather, Greek temples were the oldest financial institutions and their priests were the first capitalists: the priests gave advances to congregations and private individuals, participated in profitable business enterprises, supported overseas settlements, and intervened monetarily in wars.[109] Moreover, a number of cults were linked to practices whose own dynamics required the minting of money, such as temple prostitution and the ecclesiastical organization of contests, etc.[110] Hellenic coins were thus originally used as temple money and it was not until later that they passed from the hands of the priesthood to those of the state.[111]

However, the connection between religion and money is also systematically instructive in other ways: The power of money to enable the peaceful transfer of goods from those who have them to others who do not derives from the sacrificial character of payment. The desired object is only acquired through a renunciation. Acquisitions mediated by money function as acts of self-denial. This is precisely the same functional logic that motivated the practice of holy sacrifice. The connection between sacrifice and money is actually quite prominent, and it is also established etymologically through such words as '*pecunia*' (from the Latin '*pecus*', which referred to 'sacrificial cattle'), '*obolus*' (from the Greek '*obolos*', which referred to 'sacrificial skewers'), and '*moneta*' (from Juno Moneta, the Roman goddess of fertility and coinage), or in the sacrificial animal, which was the most common motif of early coins.[112]

In *The Philosophy of Money*, Georg Simmel identified sacrifice as the basis of any exchange: '[T]he content of the sacrifice or renunciation that is interposed between man and the object of his demand is, at the same time, the object of someone else's demand. The one has to give up the possession

or enjoyment that the other wants in order to persuade the latter to give up what he owns and what the former wants.'[113] The price of a commodity is therefore the price of the sacrifice that is required for its acquisition. The fact that money mediates reciprocal exchanges opens up the meaning of sacrifice, which in everyday language is considered to be a one-sided, asymmetrical act for which nothing is to be given in return.[114] The idea that people must give something away in order to be able to take, that they can enjoy something when they are prepared to pay the price for it, illustrates how exchange differs from stealing or giving a gift. It also constitutes the money economy's own rationality. Money weighs and specifies the degree of sacrifice necessary to acquire something; it makes giving and taking calculable and billable.

(3) *The performativity of money.* The origin of money in the temple and the priesthood already shows that money is an institutional fact; moreover, the reduction of money to the giving and taking of credit suggests that money is always associated with a 'promise of value' and thus also with 'trust'. In the words of Hartmut Winkler: money is an institution that is not based on reference, truth, or substance, but rather on performance.[115] For Siegfried Blasche, the 'crucial philosophical insight' is that 'money – like other institutions – is the result of speech acts'.[116] And the performative nature[117] of money means precisely that its validity has nothing to do with 'conditions of truth', but rather it is based on trust and approval.[118] There is only money insofar as something is accepted as money: Money exists because it is valid.[119] Moreover, an object only becomes money when it is enthroned as money by a central institution.[120] In modern societies, the central bank controls the creation of money and keeps money scarce. By virtue of this institutional authorization, the mediator function of money can then actually be based on the beliefs and expectations of those who use it rather than a reference to actual goods for which it can be exchanged.

I will now look more closely at this liberation of the value of money from its capacity to be a commodity or its ability to be exchanged for 'valuable' goods.

Generality, Indifference, Abstractness
If money makes giving and taking billable, if it represents the homogeneous in the heterogeneous, if it relates different things to one another and makes them equivalent, this is because there is a fundamental distance between money and the things whose circulation it mediates. Money becomes a medium for the exchange of goods insofar as it remains separate from other goods. This otherness of money is evidenced by the fact that people are able

to neither produce nor consume money: Self-produced money is not money, but rather counterfeit money; and if Uncle Scrooge's consumption consists in the 'enjoyment' of the mountain of cash in his money bin (I will return to the issue of greed later), he has precisely alienated it from its mediating function. The economic encompasses production, consumption, and circulation: And money is a 'material' that genuinely belongs in the sphere of circulation (and distribution). When 'natural' commodities set the standard against which the value of the exchanged object was determined according to size, number, and weight – like barley, which was used in Mesopotamia around 2700 B.C., or more often metals like copper, tin, bronze, silver, or gold, which were remarkably useful for tools and jewellery – these were at best only *early forms* of money. In a conceptually narrow sense, coins furnished with images and numbers were the first examples of actual *money* because in these coins the complete metamorphosis of the use value of a thing into its exchange value acquired a concrete form. If the market economy's penetration into a society tends to put a price on everything and thus subordinates everything to the regime of exchange value, does the 'materiality' of money represent a 'pure' and ideal form of value that objectifies this transformation of use value?[121]

Money, as is well known, has passed through various stages of development, from coins to paper currency and finally to electronic money, which is only understood as sight deposits received and credited to accounts. And no less well-known is the tendency towards the successive separation of the real value and the face value of money: While material value and face value temporarily coincide in coins and while paper currency at least depends on the suggestion of financial coverage through gold reserves, the value of money actually consists in its legally determined institutionalization as a state-approved symbol of economic value.[122]

As a common equalizer, money functions as a 'machine of decontextualization'[123] and a mechanism of dematerialization. Money establishes equivalence not only in the sense of equality, but also in the sense of *indifference*.[124] Money does not reveal its history and it remains entirely available for future use. Money is free of indexical traces. Money is indifferent towards people and things and it can thus also be transmuted into everything purchasable. In the words of Goethe: 'This metal can be transformed into anything.' Money becomes the incarnation of a form of value that makes concrete qualities and substantial differences comparable by levelling qualitative differences. It is also possible to speak of a 'self-neutralization' of money, which is a key to understanding its medial character.[125] Money must have differentiated itself as indifferent and without content as opposed to commodities, which are determined according to their content. Value and money are conceived

as 'a pure unity that consists of itself and is determined by itself; it can refer to any conceivable contents while still remaining detached from them'.[126] The 'quality' of money consists only in its quantity.[127] In money the abstract form of value not only prevails over the concrete natural form, but rather this abstraction also manifests itself: Something invisible is literally and materially objectified and becomes empirically real.[128]

However, as Bockelmann demonstrates, it was not until the sixteenth century (in central Europe), when market conditions took hold to such a degree that money actually became a universal and abstract unity, that nearly all goods were subjected to a standard measurement of value.[129] As Richard Sylla points out, money first led to the rise of large national economies in Holland, England, the USA, and Japan in the form of a developed financial system and a functioning financial market.[130]

I previously asked how money was different from the rest of the world of goods, and I can now once again offer an answer: Concrete goods have a value that is inherently and indelibly connected to their materiality, but money represents this value in a way that is detached from any concrete materiality. *Money embodies the disembodiment of value; it desubstantializes values.* It is the objectification of an abstraction. Money is 'the substance that embodies abstract economic value'.[131]

To posit different things as equivalent through exchange and to subsume the diversity of the objects exchanged into a unifying form is a practice that involves an intellectual if not theoretical performance of the first rank. The abstract and the general usually meet as a result of intellectual processes, but in money abstraction becomes an element of a practical performance. There is a striking family resemblance between the form of money and the form of thought, and it is therefore no surprise that some people assume there is a genuine connection between economics and intellect, between the abstraction of money and formalization. Nietzsche already considered this possibility: 'Making prices, assessing values, thinking out equivalents, exchanging – all this preoccupied the primal thoughts of man to such an extent that in a certain sense it constituted *thinking* itself.'[132] Alfred Sohn-Rethel pursued the analogy of money and intellect to the greatest possible extent: For him, the transcendental subject, and thus the philosophy of a universally valid and necessary a priori, is historically based on the commodity form: 'The abstractness of exchange is reflected in money and its representation is separate from all other commodities.'[133] Exchange, abstraction, and thought assist each other. It is no accident that the introduction of the coin form of money around 680 B.C. in ancient Greece was accompanied by the genesis of an abstract, logical form of thought.[134] Sohn-Rethel interprets

this parallelism as a relationship of dependence: The abstraction of form is due not to thought, but rather to the social traffic of the money economy.

Structural Properties

Money's potential for desubstantiation is therefore due to the fact that it consists of an independent kind of substance that is unlike all other substances. At the same time, however, the development of the money economy is undoubtedly accompanied by a dematerialization and virtualization of money, whose 'manageable substance' is increasingly displaced by debited money. How can this tension between the 'corporeality' and 'disembodiment' of money be understood more precisely? It is at least clear here that the identification of money and immateriality is not sufficient. Walter Seitter – like Sohn-Rethel before him – disagrees with the widespread notion of the immateriality of money: 'Money is certainly not immaterial.'[135] But how is it possible to understand the 'dematerialized materiality' of money, which concretely embodies the disembodiment of value?

First, it must be taken into consideration that the physicality of coin and paper money 'appears in the form of pieces'.[136] As Seitter argues, these 'pieces' can be understood as solid and stabile objects of a manageable size, which are suitable for forming units that can be dissected or combined.[137] Pieces are therefore manageable, which means that they also wear out. Coins become worn out, paper money becomes crumpled and ripped, yet the issuing institution always takes back 'used' money and exchanges it for 'high value' money. This phenomenon shows that the notion of money as solid objects or pieces has its limitations.

Money is discrete and mobile, and it thus ideally fulfils Niklas Luhmann's expectations of media as quantities of loosely connected units. However, money shares this discreteness not only with solid objects, but also with speech sounds, letters, and above all with numbers insofar as they also constitute countable quantities of units. The notion of money as pieces can thus be interpreted as a pioneering form of the digital. Bernhard Vief has theoretically explored the parallels between the discreteness of money and the digitality of the binary alphabet, which functions as 'token money' in the universe of signs.[138]

What is most significant here is that money is a 'material' that is designed to be countable. Pieces of money are distinct from other kinds of material in that they are not subject to *physical* changes over time, even when they are pulled from circulation.[139]

It is no accident that money is always furnished with writing and images and always symbolically marked with numerical values. This unmistakably

shows that the materiality of money does not reside in the material form of its physical givenness but rather in the performativity of its social value. Because the natural form of money wears itself out, the continuity of its value can only be guaranteed *in practice* through the financial institution's promise to replace worn-out money for free. The fact that the use of money does not decrease its value is a property that distinguishes money from 'ordinary' things – even stamps – but links it to linguistic signs. The 'materiality of language' also does not wear itself out. The reason for this is the (virtually) unlimited reproducibility of speech sounds. This is possible because it involves reproduction without an original. However, there is also a fundamental difference between money and language, which leads back to the exceptional nature of money: it is possible to produce linguistic utterances, but not money. As Walter Seitter says, money 'always comes from an other, a distinguished Other'.[140] Seitter also describes this extrinsic origin as the 'heterogony and heteronomy' of money.[141] By virtue of this constitutive heteronomy money is scarce and everyone always has too little of it.

The dematerialization hypothesis falls short, therefore, not because the materiality of money consists in its physical materiality, but rather because it is based on the performative character of money. Money is a 'social material' whose material substance complies with the conditions of its desubstantializing function.

Greed and Miserliness

My insistence on the indifferentiality and neutrality of money as a medium of circulation remains incomplete if it does not take into account that the logic of the money function always undermines this indifferentiality. Money can become an end in itself through greed, the goal of which is to increase money, and miserliness, the goal of which is to conserve money.[142] In this polarization of 'excess consumption' and 'obsessive denial', money is in each case estranged from its role as mediator.[143] Dieter Thomä characterized greed and miserliness as two modalities of avarice: maximized earnings, on the one hand, and minimized expenses, on the other hand.[144] In excess consumption money is spent in order to be equally as quickly replenished, and it must then be spent again; money thus becomes the promise of 'living it up' with an unlimited amount of goods, for which more money is always needed. Conversely, the goal of miserliness is to accumulate money, and the phenomenal features of these hoards of money often provide a physical and archaic sense of satisfaction. Consider, for example, the comic character Uncle Scrooge, who embodies the most extreme denial of the circulation function of money. Uncle Scrooge bathes in money every morning, he swims

in the expanse of cash in his enormous money bin or burrows through it like a mole, yet despite this tremendous fortune he eats dry bread and drinks tap water. He keeps his 'number one dime' – the first coin he earned himself – until a glass cover. The abrogation of the mediator role of money is thus part of this very role, which is true of almost all media.

What Does 'Transmission through Desubstantialization' Mean? A Conclusion

(1) Money not only enables the exchange of goods, but rather it establishes rationalizable relations between people. Money peacefully equalizes situations of inequality (someone wants what someone else owns) by transmitting property such that taking and giving can be calculated. People only receive something when they are prepared to give something in return. The social logic of money is rooted in this reciprocity. Human relations become *billable*.

(2) Money establishes a relationship of equivalence between two things that are distinct and unequal. Money is the medium that homogenizes the heterogeneous through desubstantialization. 'Desubstantialization' means that the substrate of money is a non-commodity, which is devoid of all content and emptied of all substance. Against the background of this indifference with regard to materiality and the qualitative, money represents quantitative relations: its quality consists in a *quantifiability that is unaffected by content*. In this capacity it is a medium that represents value and enables the social exchange of material.

(3) Money's historical tendency towards dematerialization – from especially valuable precious metals to mere credit and electronic money – represents the material manifestation of what money ideally embodies: complete *indifference towards matters of difference* and the abstraction of all content. As with every medium, negations and reversals of the mediator role are part of this role itself: greed and miserliness constitute the poles of an approach that strips money of its medial character.

(4) Nevertheless, the desubstantialization, dematerialization, and virtualization of money should not be misunderstood as immateriality. Rather, the materiality of money can be conceived in a non-material way: it consists in its practical medial function. The main feature of this function is the performativity of money. Something is money because it is used as money. The value that money embodies is based not on its materiality or its reference to a process of material exchange, but rather on the authority of the financial institution that creates it; *trust and trustworthiness* thus lie at the heart of monetary transactions.

Translation: Language Transmission as Complementation

Martin Heidegger explained the meaning of 'translation'[145] as a leap to another language that always remains foreign to the translator.[146] In other words, translation is an event that is shaped by the distance between languages and the irrevocable foreignness of the text, which belongs to another language and another tradition. For Heidegger, therefore, translating is not appropriating a foreign work so that its information is transmitted into one's own language. If this were the case then language would simply remain a vehicle that transports the meaning incorporated into texts using dictionaries as guides and tools. However, the translator does not bring information out of a foreign language into a familiar one, but rather he moves – with a leap that is also always precarious – from his own language to a new context that is foreign to him. By defining translation as the act of *crossing over*, Heidegger makes it clear that translation should not be misunderstood as *transmission*.

No theory of translation that is to be taken seriously can ignore the fact that languages are fundamentally different and therefore there is always something foreign between them. This is symbolized in the myth of the tower of Babel. Quine and Derrida's reflections on translation – despite the fact that they come off as quite different – can also be read as echoing Heidegger's difference-oriented interpretation of translation. Quine's idea of radical translation generalizes the ethnological situation of the field linguist who investigates a language on the basis of concrete situations and their immediate context, which are completely unfamiliar to him and whose meaning is therefore not based on practice through use, habit, and repetition.[147] Derrida interprets the myth of Babel as a deconstructive act of God, who introduces rupture and difference between people and their languages while at the same time facilitating the genesis of sense and meaning by virtue of this differentiality.[148]

For Heidegger, Quine, and Derrida, therefore, the radical difference between languages is an unavoidable fact that sets the standard and the limit for every attempt at translation.

There is only one language thinker who acknowledges the existence of an irreducible linguistic difference 'after Babel' and also agrees with Heidegger's disavowal of the instrumental concept of language reduced to the symbolic, but who nevertheless uses not division but rather *kinship* between languages – though not based on similarity – as the basis of his theory of translation. This thinker is Walter Benjamin, who actually interprets translation as a kind of 'transmission event'. According to Benjamin,

a virtually 'true' and 'pure language' looms in the vanishing point of real linguistic diversity, and this 'pure language' finally emerges in the act of translation. This language does not actually exist for Benjamin, but rather it is only a quasi-'messianic' vanishing point that all translations point towards.

For Benjamin, translation is the 'removal from one language into another'.[149] However, this does not mean that translation simply transmits sense and meaning from one language to another. As already mentioned, for Benjamin translation expresses the 'essence' and 'nature' of our linguisticality; 'to be a language' is therefore 'to be translatable'. This is the basis of the *medial character* of language, which is precisely why Benjamin's concept of translation is significant here. For Benjamin, translatability and mediality are the two sides of our linguisticality, which – if this image were not so static and thus inappropriate – are related to each other like the front and back sides of a page.

For Heidegger, translation remains a leap because there is no medium that enables the transfer of one language to another. For Benjamin, however, translation is a constant transformation, and thus the transfer of one language to another occurs 'through a continuum of transformations'.[150]

To reconstruct Benjamin's theory of translation it is also necessary at the same time to reconstruct his understanding of linguistic mediality. Against this backdrop, Benjamin's reflections on translation also provide an answer to the question of how the transmission function of media makes them productive. I will now illuminate the relationship between translatability and mediality in five steps.

Benjamin's Affinity for the Reproductive
In familiar traditions of thought, language is considered productive precisely because and insofar as it is a *medium*, whether for the cognitive representation of facts or understanding between people. The idea that speech possesses a genuine creative power and that language is therefore a site of production, the original source of our cognitive and communicative creativity, is linked to the assumption that language can be used as an instrument of knowledge and communication.

In contrast, Benjamin displays – even in his early work – a persistent affinity for the reproductive dimension of language and thus for phenomena that are usually considered secondary and derivative, like 'translation', 'critique', or 'mimesis'.[151] By turning precisely to these linguistic practices, which are always associated with the repetition of and reference to something that has already been said, Benjamin attempts to sketch a profile of language

that subverts the instrumentality of language or the anthropogenic shaping of language as a medium of expression and communication. Translation shows that languages should *not* be conceived as a means of expression. If languages are not means, but rather media – as already mentioned, Benjamin's concept of media is based on this opposition between 'means' and 'medium' – then this also implies that they are not media that refer to either objects or other subjects. This is precisely what is ordinarily assumed: The referentiality of a language is based on its (cognitive) reference to the extra-linguistic world or its (pragmatic) reference to communication partners. *For Benjamin, however, the constitutive relation of reference is from one language to another.* Media are therefore languages insofar as they refer to other languages. The first decisive step towards understanding Benjamin's theory of translation is to conceive of the relationality of languages as *interlinguistic*. Language is only language insofar as it communicates with another language. For Benjamin, Wittgenstein's 'private language argument' assumes the form of a 'plurality of languages argument': There can be no language that only exists for itself. Regardless of whether or not a language is actually empirically translated, its translat*ability* is inscribed in every language, and this is precisely what makes it a language. Benjamin's concentration on the sphere of linguistic reproduction is only logical: It is nowhere more apparent 'what a language is' than in its ability to refer to other languages.

It is important to note one additional fact concerning this interlinguistic referentiality; perhaps it appears trivial and will be easily overlooked: 'To translate' always means to translate *languages* and not texts. I will return to this later, but the next step involves dismissing yet another familiar attitude concerning the concept of 'language'.

From the Metaphysics of Language to the Transcendental Character of Translation

In his 1916 essay on language Benjamin already goes far beyond a concept of language as a discursive utterance associated with voice or writing: 'The existence of language [...] is coextensive not only with all the areas of human mental expression in which language is always in one sense or another inherent, but with absolutely everything. There is no event or thing in either animate or inanimate nature that does not in some way partake of language, for it is in the nature of each one to communicate its mental contents.'[152] At the same time, however, Benjamin also emphasizes that there are different languages, such as those of 'technology', 'art', 'justice', and 'religion'.[153] He is referring not to particular specialized terminologies here, but rather to the

way in which characteristic 'mental beings' are communicated for these domains. Something exists in the world that can communicate itself, but that participates in language in some form or another.

What can be achieved with such a metaphysical if not mystical absolutization of language? Benjamin's theory of translation provides one answer. If the differences that are relevant for our world and its linguistic diversity 'are those of media that are distinguished as it were by their density – that is, gradually'[54] – then translatability constitutes the universal register, in which all relationships and differences can be registered. To make language into the 'material' out of which the world is formed means that the order of the world is based on translatability and translation is an elementary expression of a relationship between the diverse. For Benjamin, the fact that *all* of the material dimensions of existence are projected as kinds of languages means that Plato's fundamental distinction between an original and its reflection, which implies that the imitated and reproduced are ontologically secondary and derivative, no longer applies.[55] The interpretation of language and translatability as the basic constituents of the world guarantees that transfer, transmission, and translation will no longer be considered subordinate, but rather they will be conceived as the – fundamental – form of production. It actually all comes down to the concept of form. Benjamin emphasizes that 'translation is a form', which does not mean that a work is really translated, but rather that it 'accepts and even calls for translation – in accordance with the meaning of this form'.[56]

Werner Hamacher's insightful attempt to define translatability as the 'categorical imperative of language', as a challenge that corresponds to Kant's moral law, interprets translatability as a transcendental aspect of language.[57] For Benjamin, translatability is actually a 'law of language', according to which every language transcends itself in its aspiration to be transferred into another language. In contrast to Kant's a prioricity, however, the a priori of translatability in Benjamin's work is to be understood as thoroughly historical. I will now attempt to explain that this means.

The Situation of the Translator: Exteriority

As already mentioned, Benjamin interprets the Fall of Man from a linguistic-theological perspective as a break whose line of demarcation was marked by the fact that language was no longer exclusively employed as a medium, but rather – first and foremost – as an arbitrary means. God created by naming, and the 'language of names' was thus a 'pure' medium, but the Fall of Man resulted in the grammaticalization, semiotization, and instrumentalization of language; from then on, language served as a pragmatic means

of denotation, identification, expression, and communication. Benjamin also describes this instrumental conception of language as the 'bourgeois conception of language'.

A translator who understands his activity as an act of 'mediation', through which the assertions of a work are transposed into another language such that the meaning of the translation resembles that of the original, is neglecting his task: He is a bad translator.[158] In contrast, the 'true translator' remains mindful of the 'fall of language': For him, translation is 'a somewhat provisional way of coming to terms with the foreignness of languages. An instant and final rather than a temporary and provisional solution to this foreignness remains out of the reach of mankind.'[159] At the same time, however, the translator attempts to reverse the historical tendency that culminates in the Babylonian confusion of languages and the bourgeois instrumentalization of language in the sense that 'its goal is undeniably a final, conclusive, decisive stage of all linguist creation'.[160] On the one hand, the irrevocable foreignness between languages must be acknowledged; on the other hand, translation takes place in the vanishing point of a 'paradisiacal' stage of language. How can the 'true translator' do justice to both of these aspects? Benjamin's answer is that he does not use language as a means, but rather he approaches it as a medium. This is the heart of Benjamin's theory of translation, but what does it mean to approach language as a *medium*?

In the act of translation, the translator purges languages of their function as means and restores their immediacy, which was lost through the Fall of Man. This does not happen by transferring the information content intended by the author of a foreign-language text into the translator's native language. When it is assumed that a language communicates something, then it is working indirectly rather than directly. Language is only immediate and direct when it communicates *itself* rather than something else. In order to enable this 'self-communication', the translator must be able to ignore precisely the intention of a text, its 'meaning' in the usual sense.

The translator does this by disregarding the relationship between content and form that is unique to the original text. While content and language actually form a 'certain unity' in the original text, like 'a fruit and its skin, the language of the translation envelopes its content like a royal robe with ample folds'.[161] Benjamin expresses this idea more drastically elsewhere: 'the reproduction of the sense ceases to be decisive'[162]; the translation must 'liberate the language imprisoned in a work'.[163] With this disengagement from meaning and content, the translator radically sets himself apart from language and assumes a position outside of language. Benjamin compares

the poet and the translator and insists on a fundamental distinction between them: Unlike poetry, which is situated 'in the center of the language forest', translation does not enter this forest of language, but rather remains outside of it.[164] By virtue of this exteriority – and here Benjamin uses a strange image – the translator 'calls into it without entering, aiming at that single spot where the echo is able to give, in its own language, the reverberation of the work in the alien one'.[165] This cryptic image is easier to understand when it is made clear that in his translation essay Benjamin also describes the echo and reverberation produced by the translator as 'true' and 'pure language'.[166]

This 'pure language' is direct and thus functions as a medium; it is the language that was lost with the Fall of Man: 'to regain pure language [...] is the tremendous and only capacity of translation'.[167] The point of this 'regaining' is that something is restored *that did not actually exist prior to the restoration*. Benjamin's linguistic-theological interpretation of the Genesis chapter, which identifies 'pure language' with God's creative language of names, implies that such language was never available to concrete histori- cally situated people. This sheds a characteristically paradoxical light on the translator: The productivity of translation consists in revealing a 'pure language' that does not de facto exist. How does this work? At this point I will now turn to the technique of translation.

On the Technique of Translation: Literality

Because translation does not involve transmitting the meaning and content of the original, the translator focuses on the word rather than the sentence as a unit of meaning.[168] Words – not utterances or messages – constitute the 'primary element of translation'. This represents a preliminary step 'back' to the immediacy of language that Benjamin associates with the non- grammaticality of an (originally divine) 'language of names'. At the same time, however, Benjamin also states that the words of different languages never coincide absolutely. At this point Benjamin introduces an important idea, which provides the key to his theory of translation. Benjamin distin- guishes between 'meaning', which could also be called 'word-meaning', and 'connotations'. According to Benjamin, words like '*Brot*' and '*pain*' have the same meaning, but they each invoke entirely different connotations. These connotations are embedded in history, culture, and everyday practices in German- and French-speaking areas.

The translator thus focuses on connotations, which are incorporated into the original but always remains foreign in the translator's native language. The translator is able to express this foreignness through the literalness of a word-for-word transmission: Literality thus becomes the

ideal method of translation. It is no accident that Benjamin refers here to Hölderlin's translations of Sophocles, which for him represent 'monstrous examples of such literalness' because they embody the translator's radical refusal to preserve the meaning of the original, which is precisely what the 'unrestrained license of bad translators' aspires to do. In Hölderlin's translations of Sophocles, 'meaning plunges from abyss to abyss', which evokes the danger that the translator can be enclosed in silence. Hölderlin's translations of Sophocles were his last work, but this danger of the radicalized literality of a translation can be entirely averted: Benjamin offers the example of the interlinear translation of Holy Scripture, which no longer attempts to mediate a meaning, but rather enables the appearance of 'true language', which is direct and thus a medium, through its meaning-alienating literalness. A text proves to be translatable precisely in its literalness and without the mediation of meaning.[169] This representation of 'true, pure language' is therefore what all translations amount to: By remaining faithful to the word, the translator loosens and suspends the original meaning of the message, and the translation now means something different than the original text: It thus reveals the true language, which was concealed in the original but is brought to light in the 'transparent'[170] translation.

But again: How is it possible to understand this 'true language', which the translation reveals but nevertheless does not actually exist?

The Vanishing Point of Translation: The 'True Language' and the Complementarity of Languages

This 'true language' has nothing in common with a discursive sign system. It cannot be understood as a self-contained or demarcated object. It is something that only exists in the *movement of translation*.[171] The 'true language' is the medium in which individual languages grow in that they are transplanted and 'live on' in the translation.[172]

A translation that focuses on words expresses the diversity of 'connotations', which make languages incongruent with each other. By transferring one 'connotation' into another 'connotation', while still remaining mindful of their fundamental incongruence, the translator effectively complements or completes one language through another. The 'connotations' are then 'recognizable as fragments of a greater language, just as fragments are part of a vessel'.[173]

Translation is therefore not about *replacement*, which obeys the semiotic logic of *aliquid stat pro aliquo* and in which what resembles one another can take the place of one another; rather, it is about *completion*. This

complementarity is precisely what translation establishes and achieves. It is the fundamental relation between languages, which shows that languages are related to one another. A relationship – Benjamin emphasizes – does not presume any similarity: Languages and their 'connotations' are as different as puzzle pieces, which nevertheless fit together. The goal of the true translator is to trace these connotations 'lovingly and in detail incorporate' them.[174] The fragment of a particular 'connotation' complements the fragment of another 'connotation', which points to something 'higher' that is nevertheless only prospectively constituted by this reference. The pure language only exists in individual languages as trace and reference, as 'intensive – that is, anticipative, intimating – realization'.[175]

With this reference to something more complex than the individual languages themselves could possibly be, translation becomes 'unsuited to its content, overpowering and alien. This disjunction prevents translation and at the same time makes it superfluous.'[176] The translation does not transmit a meaning, but rather it irretrievably transplants the original in another place: This is also why a translation of a translation cannot restore the original text. This 'relocation' is also at the same time a defamiliarization of one's own native language: Benjamin approvingly cites Rudolf Pannwitz, who complains that 'our translations [...] proceed from the wrong premise. They want to turn Hindi, Greek, English into German instead of turning German into Hindi, Greek, English.'[177] Only when the translation reveals the foreignness and diversity between languages can these differences also be revealed as complementary and thus integratable. The 'true language' only becomes apparent to the translator by virtue of his position *between* the languages.

The task of the translator thus consists in transferring the original text into the translation in such a way that its brokenness becomes a trace of the absent 'pure language'.

Translation as Complementarity: A Conclusion
So what does this complex theory of translation and its linguistic mysticism reveal about the significance of messenger, transmission, and medium?

(1) Unlike the poet, there is nothing demiurgical about the translator. He does not create original texts, but rather he represents the complementary relationship between languages. His sphere or *métier* is therefore not production, but rather *reproduction*.

(2) The translator can represent the relations between languages insofar as he consistently occupies a position of *exteriority*. His standpoint with respect to language – also unlike the poet – is 'external'. The translator

is not situated in language, but rather *between* languages. This makes the translator a kind of messenger figure.

(3) From this external position the translator is able to loosen the relationship between content and form that is unique to the original text. By separating them from one another, the translator's activity no longer needs to focus on the linguistic transformation of the meaning and information content of a text. The 'joke' of his position is therefore that his concern with language *surpasses its function as communication*. From this perspective it becomes apparent that language is not an instrument, but rather a medium. In its mediality language is always also a 'language of names', and literalness is therefore the ideal method of translation.

(4) The translator no longer focuses on the similarities or even equivalencies between different languages, but rather on the *differences* in their 'connotations', which constitutes the translation's basic point of reference. The good translator does not correct or cover up these differences, but rather attempts to bring them out in the translation.

(5) The translator defamiliarizes the native language, but at the same time he can also show that the foreign language and the defamiliarized native language complement each other. *Completion* is thus a fundamental principle for translation. The translator becomes a mediator between languages, as he recognizes their diversity and brokenness but nevertheless integrates them by making them visible as fragments – like puzzle pieces – of 'pure language'. By making the differences between languages transparent and nevertheless fitting them together, the translator reveals that all concrete languages jointly participate in a messianic-like 'pure language'. This revelation can only occur through the process of translation.[78]

(6) Because these fragments of different languages complete each other, they point to a linguistic totality that does not actually exist but is potentially visualized through translation. 'Pure language' has been gone and forgotten since the Fall of Man, but a good translation can be considered a *trace* of this 'pure language' insofar as it signals its absence and makes its potential givenness a measure of the work of translation itself. The trace of this 'pure language' is therefore not found in concrete languages, but rather in the activity between languages first produced by the good translator.

(7) The translatability of languages is intertwined with their mediality, as languages become media when they establish the *milieu* for an assemblage of the diverse.

Psychoanalysis: Transmission through Affective Resonance[179]

'The present is only intelligible in the light of the past.' That is a truism, but within the framework of psychoanalysis the orientation of the present towards the past takes on a surprising and also serious life of its own. It could be expressed as follows: The present can be scarred by something in the past that is forgotten or repressed. The practice of psychoanalysis focuses on people whose lives in this sense were not only formed but also *de*formed by their experiences – mostly in childhood. Psychoanalytic transference is the process of bringing these deformations to light so they can thus also be traced and 'corrected'. A special relationship between the patient and the analyst emerges through transference, as the patient's acquired affective patterns, which mostly remain unconscious, are projected onto the doctor such that the relationship to the doctor becomes a substitute for the patient's primary, mostly early childhood object relations. The point here is that the psychoanalytic dialogue not only opens up the possibility of reviving and acting out frozen 'inner' patterns of experience by exteriorizing and transferring them onto the doctor, but rather it also contains the possibility of remembering the original context of these affective patterns; in this way, psychoanalysis is also able to relieve the patient of the burdensome implications of past experience.[180] *The repetition of past experience becomes an act in which the repeated is therefore recreated and reshaped.* The goal of psychoanalysis is more than simply to 'raise' the unconscious to consciousness through verbalization and memory: Its goal is to transform a cliché-ridden pattern of feeling, and transference is the process by which a mutation of the repeated takes place.[181] The analyst is thus the mediator and medium of transference.

The Psychoanalyst: 'Neutral Medium' or Actor?
That is – in a few brief strokes – the basic idea of psychoanalytic transference, which is incidentally also furnished with a particular 'manner of speaking that is impregnated by the past and also mechanistic', whose justification and relativization will be the aim of the following.

The psychoanalytic concept of transference is interesting because it promises to reveal new aspects of the phenomenon of medial mediation. Paradoxically, however, the notion that the analyst is a medium and a mediator in the transmission event is precisely *repressed* or represented as a problem to be *overcome* in psychoanalytic literature. There is an obvious turning point in the meta-psychological discourse of psychoanalysis, which emphasizes precisely the non-mechanical, intersubjective, interactive

character of the transmission event: Psychoanalytic transference can become what Sigmund Freud intended it to be – not a disruption of analysis, but rather its most valuable tool – only when the idea of the therapist as a neutral, impersonal, affectless mediator is replaced by the idea of the analyst as a participating, interacting person, when the past experience of the patient encounters the here and now of an emotional, intersubjective relationship with the doctor, and when the analyst not only mirrors the projections of the patient but also encounters the patient as an incommensurable Other and thus becomes a sounding board for the patient.

While this shift from a mechanically-oriented explanation of transference to an intersubjective, social-constructivist approach is interpreted in the literature as *surmounting the neutral mediator function* of the analyst, I will show conversely that this 'interactivity perspective' provides a groundbreaking answer to the question of how medial passivity can *at the same time* be conceived as a genuine form of activity. The doctor is a medium of transmission, but he alters the transmission event, which thus remains more than simply a repetition of the past. The goal of the following considerations is to work out this active potential as something that does not defeat or suspend but rather embodies the psychoanalyst's position as mediator.

The Genesis of Psychoanalysis Out of the Spirit of Exorcism and Hypnosis

Psychoanalysis was not the first to discover that the relationship between someone who is spiritually or psychologically ill and his healer is a kind of transmission event. In the framework of the pathology of 'possession', which was practically ubiquitous in the nineteenth century, the exorcist would address the 'evil spirit' inhabiting the invalid not in his own but rather in the name of a higher being, which eventually resulted in the spirit's expulsion.[182] At the same time, however, the exorcist would also talk with the invalid himself, whom he encouraged and bolstered.[183] This dual character of exorcizing communication, which addressed both the spirit that parasitically possessed the invalid as well as the real person of the invalid, is remarkable as these 'two voices' anticipate the dualism of psychoanalytic transference, which is related to both the 'past unconscious' (the 'child within the adult'[184]) and the 'present unconscious' ('the dominant conflict in the here-and-now'[185]) of the patient.

This brief reference to exorcism as an early form of 'spiritual healing' already outlines an interesting constellation: The medium – the exorcist who is commissioned by a higher being to relay communication with the invisible, disease-causing spirit – functions at the same time as a non-medium

insofar as he personally engages the patient in actual communication as an interacting partner. The healer stands apart from the patient in that he talks to spirits – both good and evil – but he also gets close to the patient in that he refers to him as a concrete person: 'The structure of the exorcistic technique creates both closeness and distance between the therapist and the patient, which remains a function of every psychotherapeutic technique to this day.'[86]

The relationship between the hypnotizer and the hypnotized can also be considered a precursor to psychoanalytic treatment. For early mesmerists the hypnotic relationship was defined by the concept of 'rapport', which Freud described as a 'prototype of transference'. The 'rapport' established by the hypnotic relationship also incorporates elements of 'réciprocité magnétique'.[87] In this sense it was already clear early on that hypnotizability is dependent on a reciprocally affective relationship between the hypnotherapist and the hypnotized subject, a relationship that extends far beyond the scope of the mesmeric session.

Janet explored this 'hypnotic' relationship between therapist and patient in depth at the end of the nineteenth century.[88] In the second phase of this therapy, the patient developed a 'somnambulistic passion' for his hypnotizer, which was a combination of love, jealousy, fear, and respect.[89] This love could be erotic, childish, or motherly, but it hardly had any effect on the hypnotherapist. The principle of transference and countertransference therefore already informed the analysis of the hypnotic relationship and, for Janet at least, it was also reflected in the therapeutic technique.

After the turn of the century, however, this understanding of affective reciprocity as the condition of possibility for the hypnotic treatment of diseases was replaced by a non-reciprocal concept of hypnosis, in which the hypnotherapist once again assumed the position of a neutral mediator and hypnosis became first and foremost the one-sided performance of the hypnotized.[90]

In his analysis of Anna O., a patient suffering from hysteria, Sigmund Freud's colleague Dr. Joseph Breuer experienced the impossibility of actually maintaining such a neutral position: In the course of analysis Anna O. fell in love with Breuer and openly revealed her sexual desire for the analyst, whereupon Breuer abruptly 'took flight'. He terminated the analysis, stopped treating her, and refused to treat any other hysterical patients. In the commenting literature this reaction was assessed in such a way that Breuer could not even admit to himself how much he in turn also desired his patient. He could only give an indirect signal of his own libidinal confusion: The following day he took his wife to Venice for a second

honeymoon!¹⁹¹ Sigmund Freud was an observer and witness of Breuer's analysis of Anna O. Is it an accident that Freud's first thoughts concerning the psychological transference from patient to doctor and the irrefutable phenomenon of countertransference from doctor to patient occurred at the same time as Breuer's reactions to Anna O.? In any case, Peters concludes that 'the history of psychoanalysis thus begins clearly with an uncontrolled transference-countertransference relationship'.¹⁹²

Before turning to Freud's views on transference, it is necessary to try once again to attempt to understand more precisely the 'initial spark' that motivated Breuer's elaboration of Freud's psychoanalytic technique.

Breuer's work as a neurologist was part of the tradition of hypnotic suggestion, which offered an alternative to electrotherapy and was remarkably successful in the last decades of the nineteenth century. Breuer observed that Anna O. could escape her psychological state of confusion as soon as she was able to verbalize her psychological conditions. Breuer subsequently asked his patient, under hypnosis, to describe what moved her internally. As soon as Anna O. was able to remember the offending and hurtful feelings and experiences that had previously been repressed, which resulted in her hysterical 'symptoms', she was then able to release these repressed feelings and her neurotic symptoms disappeared: The 'cathartic method' of the abreaction of the repressed was thus born.

Freud adopted this cathartic method from Breuer, although he found an alternative to hypnosis in the psychoanalytic technique of free association, whereby patients are induced to speak and the analyst then deciphers and interprets their verbal communication as an expression of repressed impulses, ideas, and feelings.

This search for a suggestive technique that employed speech rather than hypnosis represented the birth of the 'psychoanalytic cure', and it was also the context in which Freud first came across the phenomenon of transference.

But once again: What was the 'initial spark' of Breuer's psychoanalytic method? The simplest answer is the following: He discovered that through the verbalization of painful feelings in the past these feelings can once again be experienced, acted out, and thus also consciously remembered, which results in a release from the unconscious symptoms of repressed suffering. Yet there is also a more subtle answer, which is related to Freud's experience of the relationship between Breuer and Anna O. Freud is an uninvolved observer of this event, which he undoubtedly knew to interpret as a transmission event – and actually on both sides. The word 'transference' first appears in the theoretical section he wrote for *Studies on Hysteria*,

which he published together with Breuer.[193] However, at the same time Freud observed that Breuer, who was entangled in a thoroughly two-sided 'emotional rapport' with his patient, was not able to recognize or controllably avoid this situation.[194] As a result, this relationship reflected the same duplicity of distance and engagement that already informed the exorcistic and hypnotic precursors of psychoanalysis. Freud then developed a concept of psychoanalysis in which, on the one hand, the doctor assumed a strict, ascetic, and so to speak 'uninvolved' observer position, but which, on the other hand, also acknowledged that the patient-doctor relationship was reciprocal and inevitably libidinal. The idea of psychic transference, which Freud develops into a fundamental theorem of his metapsychology and as the core process of the psychoanalytic technique, constitutes – and this is my primary hypothesis – the theoretical and technical foundation for the double role that is attributed to and demanded from the analyst in psychoanalysis: to be able to be both a neutral medium *and* an affective sounding board at the same time. But how can the concept of transference fulfil this function?

On Transference as Theory and Technique: A Hypothesis
From an objective perspective, psychoanalytic therapy involves a person who seeks help from an analyst to cope with problems that limit and cloud his life and experience. Not only does a 'working bond' develop between then, but this bond also arises in an extremely intimate situation: They regularly meet each other entirely alone and – usually – over a long period of time. The patient begins to reveal his innermost and hardly acknowledged emotions to the analyst. The physician listens and also appears to belong entirely to the patient: His attention to the patient is undivided. The analyst makes every effort to establish a trusting relationship, which allows for the most embarrassing feelings and most intimate confessions to be put into words without shame. The physician understands his patient – probably more than anyone else. Do we ever experience conversations in our everyday lives that are so intimate, impulsive, and intense, particularly for neurotic patients?

The physician becomes a libidinal object for the patient, mostly desired, sometimes also feared and repelled – but always with a certain inescapability, not to mention inevitability. But what is it like from the reverse perspective? What does the patient represent for the analyst? Is he not a libidinal object?[195]

In his commentary on Breuer's abrupt escape from Anna O's desire, Freud notes that Breuer did not understand the 'impersonal nature' of 'his patient's transference on to her physician', which was 'never absent'[196];

furthermore, Breuer could not admit to himself that he was also preoccupied with his relationship to his patient. Freud's concept of transference thus lays the groundwork for this necessary depersonalization of the emotional relationship between physician and patient.[197] The idea of transference makes the physician aware of the emotions that the patient shares with him, but at the same time it also reveals that these emotions are not to be taken personally, as they are not directed at the analyst as a concrete, real individual, but rather only as a symbol of previous attachment figures. Freud described transference as follows: 'This new fact, which we thus recognize so unwillingly, is known by us as *transference*. We mean a transference of feelings on to the person of the doctor, since we do not believe that the situation in the treatment could justify the development of such feelings. We suspect, on the contrary, that the whole readiness for these feelings is derived from elsewhere [...] and, upon the opportunity offered by the analytic treatment, are transferred on to the person of the doctor.'[198] 'What are transferences? They are new editions or facsimiles of the impulses and phantasies which are aroused and made conscious during the progress of the analysis; but they have this peculiarity, which is characteristic for their species, that they replace some earlier person by the person of the physician. To put it another way: a whole series of psychological experiences are revived, not as belonging to the past, but as applying to the person of the physician at the present moment.'[199] While the transference 'seemed in every case to constitute the greatest threat to the treatment', it also 'becomes its best tool, by whose help the most secret compartments of mental life can be opened'.[200] By virtue of transference, rigidified emotional conflicts from the past are actualized as symptoms and in their libidinal orientation towards the physician they take on a new meaning.[201] If the physician does not succeed in deciphering this meaning, tracing the patient's positive and negative feelings of love, hate, anger, and fear back to their infantile origins, and thus 'pointing out to the patient that his feelings [...] are repeating something that happened to him earlier',[202] then this repetitive acting out can be transformed into conscious memory so that the neurotic symptoms are reduced.[203]

Nevertheless, this is not the whole 'story' concerning Freud's observations of Breuer, for where there is transference from patient to physician there are also emotions that flow in the opposite direction.[204] 'Other innovations in technique relate to the physician himself. We have become aware of the "counter-transference", which arises in him as a result of the patient's influence on his unconscious feelings, and we are almost inclined to insist that he shall recognize this counter-transference in himself and overcome it.'[205]

I will now attempt to sort through the aspects that are essential for understanding 'transference':

(1) *Affection*: Transference involves the transmission of feelings and therefore mental conditions or attitudes.

(2) *Orientation towards the past*: These feelings are not new, but rather they originate from the patient's past.[206] They are acquired emotional patterns – Freud also refers to them as 'stereotype plates'.[207]

(3) *Unconsciousness*: These past feelings are not simply remembered, but rather they are revived and re-experienced through the patient's relationship to the physician.[208] They are affective schemata rooted in the 'unconscious', which are then acted out.

(4) *Symbolism/Irreality*: The transferential nature of these emotional clichés implies that they are directed towards the analyst as a '*substitute*' for past object relations; the analyst becomes a symbol and a representative of primary attachment figures from the past, with whom the patient was involved in conflict-laden emotional relationships. These feelings, which are now projected onto the physician, are – for Freud at least – 'not founded on a real relationship'.[209]

(5) *Interpretation instead of experience*: While the patient experiences these feelings, it is the analyst's task not to respond to them emotionally but rather to *interpret* them. In order to interpret them effectively, the physician must be consciously aware of the illusory character and thus the inappropriateness of the 'transference feelings' directed towards him.

(6) *Countertransference*: Although his role is that of an interpreter, the analyst not only interprets but rather also *experiences*: He also always responds to the patient emotionally and unconsciously. He is not only an observer and an instrument of transference, but rather he himself enters into a transference relationship with the patient.

By viewing the intimacy of the psychoanalytic dialogue from an 'objective perspective' and then comparing these observations to Freud's explanations of the concept of transference, it is revealed that the psychoanalytic constellation has two meanings: (i) The patient should be able to act out long-forgotten and above all repressed emotions in the here and now of the analytic dialogue. Yet at the same time it is clear that this does not simply involve repetition, but rather repetition under *altered* conditions, which (should) open up the possibility that the reproduced emotions are at the same time altered through their repetition in that they are articulated, remembered, and thus made conscious. Transference is a process not only of regression, but also of progression. (ii) The psychoanalytic dialogue is emotionally intimate and intense (for both the patient and the physician,

as the concept of 'countertransference' implies), yet it takes place within a particular context where things are only spoken but never acted upon. Thomas Szasz thus characterized the analytic situation as a paradox: 'It stimulates, and at the same time frustrates, the development of an intense human relationship [...] The analytic situation requires that each participant have strong experiences, and yet not act on them.'[210] I am proposing that transference (in conjunction with countertransference) can be interpreted as a process that enables this ambivalence.[211]

The above-mentioned considerations can be consolidated into a hypothesis that contains two parts: (1) As a *theory*, the concept of transference/countertransference explains and justifies the double role of the physician: namely, his function within the psychoanalytic constellation as both a neutral medium and an engaged participant. (2) As a *technique* and a *process*, transference introduces the possibility of circumventing the paradoxical tension between neutrality and intimacy or between impersonal abstinence and personal engagement.

Transference as a Two-Way Process

First, I want to clarify what it means to describe the physician as a *neutral medium* within the context of the concept of transference. Transference actually constitutes a 'liminal realm'; it is a bridge and a mediator between the patient's past and the present. It generates a separate world between mental illness and mental health, between the 'real' and the merely 'symbolic' relationship of the patient to the physician. Freud himself used the expression 'liminal realm' to describe transference, and he emphasized that it is this feature that enables the 'transition' from illness to life.[212] This localization of transference in an *in-between space* also enables the physician to occupy a double role:

(1) On the one hand, he is a projection surface for the patient's repressed conflicts, and the more he is able to bring out these infantile conflicts and focus them on himself like a concave mirror, the more he succeeds in withdrawing as an individual, real, present person – in becoming a blank space, if you will, which can then be 'filled' by the patient. From the patient's perspective, the analyst actually takes the place of infantile object relations and becomes a supplement to the patient's past attachment figures. The analyst is thus an 'embodied carrier' or 'material signifier' with a merely symbolic and impersonal meaning. He becomes a stage on which the dramas experienced by the patient can be re-enacted. In order to focus the wishes and conflicts of the neurotic patient onto himself, the physician must act as a neutral medium.

(2) However, at the same time Freud also conceded the phenomenon of countertransference: Remaining within the same language game – namely that of transferability – he recognized with the concept of countertransference that the physician is not only a passive projection surface for the patient's 'inner child', but rather the physician in turn also externalizes and to a certain extent acts out his own unconscious emotions. The physician thus suspends his neutral status: He is no longer a non-responsive medium, but rather he becomes a reacting and interacting sounding board.

Freud thus conceived of transference as a *two-sided* process, as the rudimentary form of an interactive event. From the physician's neutral (media) perspective it appears that illusory, distorted, and inappropriate feelings are constantly being directed at the 'wrong person' in the form of the physician, but from the patient's perspective they can be real, 'true' feelings, which are directed towards the physician as an individual person and not only as a substitute for infantile attachment figures.[213] Freud wondered whether the infatuations that manifest during analysis should be considered real, as he explained: 'We have no right to dispute that the state of being in love which makes its appearance in the course of analytic treatment has the character of a "genuine" love.'[214] Concerning the relationship of the analyst to the patient, on the other hand, Freud wrote in a letter to Oskar Pfister on June 5, 1910: 'In general I agree with Stekel that the patient should be kept in a state of abstinence or unhappy love, which is naturally not entirely possible. The more the physician allows the patient to find love, the more he develops the patient's complexes.'[215]

Although Freud originally recognized it 'only' in terms of countertransference, he claimed that insight is available or at least prepared in the *real* and not only the symbolic, in the *interactive* and not only the reflecting-receiving relationship between physician and patient.

You will recall that with Breuer Freud witnessed how the emotional involvement of the analyst can undermine and threaten analysis if these emotions are not consciously processed and controlled. When it 'goes off the tracks', countertransference can be disastrous for therapy. Because he recognized the double role of the physician as medium and actor, as an intellectual organ of perception and an affective sounding board, it seems only logical that Freud's concept of transference was designed to ensure theoretically as well as practically that the physician's function as a medium during analysis remains the organizing centre of the psychoanalytic process.

This was ensured theoretically in that according to the Freudian approach all transference feelings, whether originating from the patient or the physician, are in a sense misguided and therefore 'inappropriate',

'illusory', and 'distorted' insofar as they remain quasi-mechanical repetition procedures and constraining structures. Freud thus describes transference as both a 'false connection'[216] and a 'new edition'.[217] From a pragmatic point of view, this emphasis on the reality distorting, repetitive, and regressive character of transference – which has incidentally been discredited by many psychoanalytic authors as an egological, solipsistic, and psychic-technical dimension in Freud's approach – proves to be a tool or 'safeguard' that serves to prevent the internal dynamics of the paradoxical tension between intimacy and technicity, affectivity and recognition from threatening the implementation of psychoanalysis. To know that he is not the receiver, but rather the mediator of the intensive feelings directed towards him helps the physician to maintain a sense of distance with regard to the seductive involvements or repulsive entanglements involved in these emotions.

This was ensured practically in that the spatial constellation of the psychoanalytic dialogue as shaped by Freud provided for the staging of a depersonalization if not 'anonymization' of the analyst: The analyst sits behind the patient and thus remains beyond his field of vision, while the patient in turn lies on the couch.[218] 'Like an infant, the patient cannot be active' and is 'restricted to his couch/crib'.[219] These rules of the analytic dialogue situation evoke associations with early childhood relationships. Precisely because Freud presumes that the transference of infantile attachment figures onto the analyst serves as a positive, indispensable aid, he requires and establishes a set-up for the dialogue situation, in which the physician positions himself as mediator and ambassador of the patient's past. This can already be seen in his seating arrangement, as the analyst literally 'withdraws' and the patient speaks into the blank space of his projections.

The concept of transference thus does not simply discredit the interactive productivity and mutual affectivity of the psychoanalytic dialogue, but rather it guarantees that the emotional contact of the physician does not undermine his role as the analyst. This shows that the 'mechanics' of the transference process, which are notoriously rooted in the past of the patient, at least implicitly point to the reciprocally binding forces and emotions that come into effect in the presence of the therapeutic situation. The precepts of transference ensure that the physician, insofar as he reacts emotionally to the patient, at the same time knows that his patient in turn assumes the role of a medium and becomes a projection surface, on which the unconscious emotions of the analyst are 'registered'. In countertransference the physician subverts his own neutral position as mediator only in order to reconstitute it in the patient; he mutates from mediator to agent in order at the same

time to turn the acting (out) patient into the 'ambassador' and 'mirror' of the physicians' emotions. If the analyst is both a de-individualized mediator *and* an affected individual he can 'play' his role as an individual person precisely because he transfers his depersonalized mediator function to the patient. This contradicts the unidirectionality and asymmetry underlying the notion that the patient 'sends' neurotic signals, which the analyst then 'receives' and interprets, insofar as these positions prove to be interchangeable in the here and now of psychoanalysis. However, in the psychoanalytic constellation there is always a divide between the position of a non-acting, neutral medium and the position of an engaged, acting non-medium.

A Conjecture: Is the Psychoanalytic Dialogue Beyond Dialogue?
The foregoing discussion prompts the following conjecture: Freud describes transference as the core event of the psychoanalytic dialogue, and according to Freud this transference constitutes an irresolvable asymmetry between the speaker who acts (out) and the speaker who is 'only' a medium; furthermore, Freud concedes that these roles are indeed *interchangeable*, but they are not *abolishable*: Doesn't this suggest that the psychoanalytic dialogue – if Freud is actually taken seriously – *cannot* be understood according to the model of a *dialogue*? I am using the word 'dialogue' here in the elementary sense of a symmetrical two-way conversation, in which the participants are on equal terms. I thus propose the following conjecture: *Wherever transference takes place, there is also no dialogue (in the 'strict' sense of the word)*.

When interpreted in a literal sense, this statement may seem trivial. Based on the fact that it concerns psychoanalytic *dialogue*, however, the conjecture of a non-dialogism is quite remarkable. You will recall that Freud's 'discovery' of psychoanalysis was the result of his efforts to replace suggestion, for example, through hypnosis, with talk and nothing but talk. Yet now it has been established that by making transference the core event in the psychoanalytic dialogue Freud precisely revoked the psychoanalytic dialogue's status as 'a dialogue'. Nothing illustrates this denial more clearly than the rules governing the seating arrangements during psychoanalytic sessions, which impose conditions on speech that are constitutively unequal.

At this point it is useful to cast a side glance at Jacques Lacan, who assumes a fundamental bipolarity in speech: Depending on whether the speaker employs the '*moi*' of an egological self-relation or the '*Je*' of a desire oriented towards the other, speech is either a declaration or a remark, it is either a representation or an evocation, it either refers to something that is objectively accurate or to an existential truth. Indeed, we always speak

with these two voices – not only in psychoanalytic dialogue – and for Lacan it is the task of the analyst to make the mostly submerged or repressed voice of the '*Je*' talk.[220] To return to Freud's idea of transference, the more the analyst becomes the medium of transference for the patient, the more he succeeds in making this repressed voice talk, because in this way the desire of the patient towards the other can focus on the analyst without any inhibitions or distractions. From Lacan's perspective, the 'dialogism' that Freud withheld from the psychoanalytic 'talking cure' precisely opens up the way for a form of speech oriented towards desire. I will now turn to this dialogism; and for this purpose it will help to look at newer developments in transference theory, which must nevertheless be read 'against the grain'.

A Dialogical Revision of Freudian Transference Theory?

In the metatheory of psychoanalysis there has been a change regarding the theorization of the concept of transference. In conscious opposition to the theory that was just developed, this change involves the designation and reconstruction of 'transference' as precisely a *dialogical process*. Transference is *no* longer conceived as more than (1) a monolinear, one-sided process that (2) revives past emotional clichés in an almost mechanical way, which (3) distorts the present by referring to the 'wrong' objects at the 'wrong' time and which (4) receives no response from the analyst but is simply observed, interpreted, and recognized by the analyst from his position as a neutral medium, such that (5) with analyst's help the patient's unconscious, repressed past is translated into conscious memory and the patient is thus able to free himself from the neurotic symptoms of confrontational experiences from childhood.

I will now recap how the quasi-mechanical concept of transference, allegedly laid out by Freud, has been corrected.

(1) *Reciprocity instead of one-sidedness*: The heart of the dialogical revision is the recognition of the reciprocity of transference. Balint observed already in 1949 that Freud had created a one-body-psychology, a quasi-physics of the psychic apparatus, such that his metapsychology precisely neglected the intersubjective character of the psychoanalytic situation.[221] Transference is now considered the form of a relationship between people that is based on two-sidedness and reciprocity.[222]

(2) *Intersubjectivity*: What is always brought to light as 'important' in the psychoanalytic dialogue is not simply the repetition of a meaning that was buried in the subconscious in the past. Nor is it an action that arises from the quasi-solipsistic isolation of the patient. Rather, it is an activity that is due to the reciprocal interactivity of the analytic dialogue: The meaning

of transference is therefore always an intersubjective phenomenon. It is not the past of the patient that is to be interpreted in light of transference; rather, it is the existing relationship between the physician and the patient in the present. The unconscious of the patient thus does not itself exist as an absolute fact – according to Paul Ricoeur at least – but rather it only exists relative to the 'dialogical' process of therapy: It is the analyst's act of witnessing that constitutes the patient's subconscious in the first place.[223]

(3) *Relation to reality*: Instead of the inappropriate, illusory, and distorted character of transference feelings it is emphasized instead that what occurs during the process of transference represents to a certain extent a thoroughly realistic and appropriate reaction of the patient to the here and now of the therapeutic situation. This effectively eliminates the demarcation line separating the patient's 'deceptive' form of transference and the physician's 'realistic' insights into the 'true nature' of this transference.

(4) *Beyond the analyst as medium of perception*: Contrary to an intellectually constraining view of the analyst who remains in the position of the observer and performs the functions of recognition and interpretation, it is emphasized instead that the physician is emotionally involved in the transference event and must be in order to be able to establish a connection between the unconscious of the patient and his own unconscious. Wyss thus observes that the therapist's sphere of experience is constitutive for mutual understanding.[224] Racker emphasizes the fundamentally libidinal character of transference: For him, love becomes the very condition of possibility for a successful psychoanalysis.[225] Weiß also agrees with this concept, as he sees transference 'above all as a manifestation of love'.[226] What is required is not recognition and hermeneutics, but rather a 'scenic understanding' that – as Lorenzer emphasizes – is only possible insofar as the analyst actively participates in what the patient performs in his language game.[227] The physician is therefore precisely not a medium; he does not function as a reflecting mirror or as an empty screen for neurotic projections.[228] His self-withdrawing anonymization and depersonalization also remains an illusion.

(5) The healing effect of psychoanalysis does not simply consist in clothing a forgotten past in words and thus being able to bring back memories. Rather, if the analyst recognizes and accepts the patient's feelings without fulfilling their imaginary claim, then the patient is confronted with his own desire in a new way: The 'object' of his desire no longer remains a plaything of his own projections. Rather, through the reciprocal action of acceptance and accommodation in the analyst's real relationship to the patient, on the one hand, and the analyst's otherness and hiddenness with regard to

the patient's imaginary claims, on the other hand, the analyst becomes a focal point for a new kind of 'relationship experience' for the patient. The solidified clichés of traumatic experiences can thus liquefy and finally also disappear. *The experience of a new kind of relationship, not merely recognition or memory, heals the patient.*

Allow me to try once again to explain in a different way the logic of the revision of the classical concept of transference that was just sketched out: The classical concept of transference assumes that an inappropriate, conflict-laden, and deformed emotional pattern acquired in the past is transferred to the present, where it can then be deciphered and treated. An interactive and post-classical concept of transference, on the other hand, assumes that an emotional constellation acquired in the past is transformed over the course of transference, insofar as the patient can have a self-altering relationship to the physician: The patient's emotional clichés are thus subject to a *mutation and transmutation*. According to the classical perspective, therefore, the physician serves as a recording medium and an observing perceptual organ that helps the patient to 'translate' an unconscious potential for conflict into verbalizing memory; the physician thus mediates between the patient's past and present. According to the post-classical perspective the physician is an interactive partner who always also has an emotional and not only interpretive relationship to the patient; together they are able to establish a new kind of relationship, which is real rather than illusory, and through this relationship the patient is able to free himself from his neurotic symptoms. This reconstruction of an 'interactive turning point' in the theory of transference emphasizes the differences between these approaches, and it presents a paradoxical situation for this media-theoretical project: Freud's concept of transference is groundbreaking insofar as the analyst represents a mediating figure that is able to cast a new perspective on media in relation to transmission. However, the interactive concept of transference fundamentally challenges precisely the *medial* status of the analyst. The reason for this is the supposition that the relationship between the patient and the physician represents an entirely interactive and communicative relationship, which thus gives rise to a collectively 'shared' reality in the here and now of the analytic situation. For Freud the physician plays a double role: he is a more or less neutral medium in transference and at the same time an emotionally involved person in countertransference. In the post-Freudian theory of transference, however, this difference disappears and the boundaries between transference and countertransference are blurred.

My method now consists in drawing together aspects of the classical and the post-classical theories, as the question arises: Would it not be possible to

combine what Freud constructed as a kind of exclusive relationship between the analyst as, on the one hand, an observing, reflecting, and interpreting medium and, on the other hand, an emotional person acting out his own subconscious feelings? Doesn't this difference help to explain the productivity of transference, which includes the mutation and metamorphosis of what is transferred and thus reflects one of the central concerns of post-classical theory?

In order to connect both elements it is necessary to 'de-discursify' the communicative interaction between the patient and the analyst. The reciprocity, two-sidedness, interactivity, and intersubjectivity that post-classical theory rightfully emphasizes actually exists, but they precisely do *not* correspond to the universally pragmatic model of communication taken from speech act theory, which is based on the assumption of the formal-rational equality of conversation partners. In order to give an idea of this 'de-discursified interaction' I will now go back to the considerations of René Spitz, who examined pre-linguistic 'dialogue' in the interactions between mothers and children.

'Dialogue' as Circular Affective Resonance

René Spitz researched the early forms of dialogue that occur in childhood interactions before the child is capable of speech. For Spitz, a depth psychologist, this orientation towards early childhood interaction was not an end in itself; rather, he assumed that there were analogies between the analytic situation and early childhood relationships to primary caregivers.[229] This notion implies that the structures of *extra-linguistic interaction* and their 'criteria for success' also reveal the structures of psychoanalytic dialogue and their 'options for success'. Furthermore, it reflects the insight that although psychoanalysis understands itself as a pure 'talking cure' its 'asymmetrical nature' fundamentally distinguishes it from the model of communication taken from speech act theory and it is therefore more than just 'talk'.

Spitz introduces the concept of 'dialogue' to describe early pre-verbal action sequences, and by replacing the usual psychoanalytic concept of the 'object relation' of the patient to the analyst with the term 'dialogue' he also becomes a proponent of the tendency towards the 'dialogization' of psychoanalysis. At the same time, however, there are also indications that this kind of dialogue is involved in psycho-sexual development and it is thus instrumentalized through the manner in which the child's wishes relate to the animate and inanimate object world. The dialogical character of the interaction between mother and child is not conceptualized according to

the model of linguistic understanding; rather, it constitutes a matrix for all human communication phenomena and identity processes and thus also for psychoanalytic dialogue.

Here is what this 'dialogic interaction, which precedes language', looks like: Spitz identifies three stages that occur within the first 18 months, up to the point when the child acquires his mother tongue: (i) An 'objectless stage' during which the I and the not-I remain inseparable, although at the end of the second month human beings occupy a position above all other things, as they are consistently smiled at.[230] (ii) A stage when others are perceived as distinct from the self and the child – obviously experiencing the 'fear of separation' at eight months, which constitutes a counterpart to the 'smiling response' of the earlier stage – is able to distinguish between strangers and people who are familiar.[231] (iii) And finally the training of the first 'semantic gestures' – especially head shaking to indicate 'no' – which the child experiences and adopts through his interaction with and emulation of others, such that his self is constituted by the behaviour of others, the non-self: 'The "no" thus becomes the identifying stamp of social relations on a human level.'[232]

I cannot pursue the details of this fascinating reconstruction of the evolution of communication in the preliminary stages of linguisticality. What matters here is that the development of these early forms of dialogicity is tied to the active interplay between mother and child, and it is crucially shaped by the facilitation or inhibition of this interaction. According to Spitz, what emerges in the relationship between mother and child in the first months is a 'circular resonance process' that engenders a 'quasi-magical sensibility'.[233] It is a process that is not organized through the medium of signs, but rather it constitutes the very origin of this sign function. And yet it does involve a medium, which is the person who interacts with the child. One could also say that the child needs and uses the mother as a medium for the training of his I in relation to others. But the mother can only be such a medium insofar as she constitutes an emotional sounding board for her child. This early childhood interaction must therefore be understood as a series of reciprocal actions, as an exchange of looks that can pose questions and answers, as physical proximity and contact, as sounds resembling 'twitters of delight' that are exchanged as reciprocal signals of acceptance and resistance.[234] For Spitz the 'essence' of this dialogue lies in the 'expectation that something will happen'.[235] For him, this reciprocity fundamentally distinguishes the living from the dead.[236] But it is a reciprocity that, like the mother-child structure, not only involves but virtually presupposes an asymmetry between the interacting partners. It

is the productive resonance of the emotional sphere that makes an unequal relationship with one another possible. What Spitz means by 'dialogue', therefore, is *the formation of an emotional echo of the I in the not-I*. In this sense, for Spitz and also for Weiß psychoanalytic transference is based on 'dialogic resonance phenomena'.[237]

At this point it makes sense to visualize the actual meaning of 'resonance' (Latin *'resonare'*: resound). In a physical sense, it refers to the resonating of a system whose movement is induced by another system. The reacting system thus has a resonant frequency, which is nevertheless 'amplified' by external stimulation. Niklas Luhmann employs 'resonance' as a term for social transmission, thereby emphasizing that a system can only resonate insofar as it already has its own vibrations; at the same time he also stresses that transmission through resonance is only possible between similar kinds of system zones, when there is therefore a similarity between both systems.[238] Resonance thus requires that there is a fundamental difference as well as a similarity between two systems. It causes the movement of one system to be transmitted to another system, but at the same time the resonant frequency of the affected system is changed and converted by this transmission.

So how might it be possible to connect the notion of the analyst as a medium and the notion of the analyst as an actor, which Freud conceived as separate functions? The 'dialogization' that the post-classical theory of transference has in mind – at the expense of the analyst's medial function – manifests itself as something that is embedded in the way the analyst becomes a medium. The transference of past experiences onto the analyst occurs in such a way that the patient's 'reoccurring' trauma is 'processed' insofar as the analyst becomes a sounding board for the emotions experienced by the patient. The vibrations emanating from the patient are thus not only recorded but also transformed through the analyst's own vibrations. This 'self-oscillation' consists in not only the physician's own emotions, but also the fact that he is removed and is thus capable of observing and interpreting. The double role of being at the same time both an observer and an actor is inscribed in the actions of the analyst. This is the joke of psychoanalytic resonance. The 'echo of the I in the not-I' is precisely for this reason not only an echo, but also a transformation, because the analyst embodies the difference between participating and not participating. The analyst both empathizes *and* observes; he is both similar to *and* at the same time different from the patient. The analyst can become a (non-participating) medium of psychic transference precisely because he enters into a (participating) emotional relationship with the patient.

Transference through 'Affective Resonance': A Conclusion

(1) 'Transference' is a psychoanalytic term that describes the kind of connection that emerges in the psychoanalytic situation. With this concept Freud points to the unconscious repetition of earlier experiences in the current relationship of the patient to the analyst. He concedes that transference is usually accompanied by countertransference on the part of the physician towards the patient, yet it remains important for him that transference functions as a therapeutic 'tool', as the analyst withdraws as a person in order to act as a medium that can become a 'projection surface' for the patient's unconscious. Nevertheless, it is also an undeniable fact for Freud that the analyst is always also emotionally involved with the patient. The activity of the analyst thus embodies two aspects: He is an observer, interpreter, and analyzer and at the same time a participant and an actor. Post-classical theories emphasize that transference not only represents a repetition of the past, but rather it is also shaped by the present of the psychoanalytic situation, and it can therefore be understood as a completely interactive event that occurs between the physician and the patient. However, the insight into the role of the analyst as a medium for transference is largely missing in these theories.

(2) The fundamental question is how the passivity and the activity of the analyst, his function as a medium and his role as an actor, can in each case be understood as two dimensions of the transference event. This implicitly explains how 'repetition' can always also be conceived as an act of 'reshaping'. Nevertheless, questioning this duplicity of transferring and creating is only meaningful so long as one holds onto the Freudian insight that being an analyst also means offering oneself as a medium for the repressed feelings of the patient precisely by remaining 'neutral' and withdrawn.

(3) The key to understanding the creative dimension of the transference event is the phenomenon of affective resonance. Being a sounding board means reacting to a vibration. It is important that this 'physics of vibration' is here only a metaphorical expression for the reciprocity of emotions, or affects, which enable a reciprocity between the unequal. René Spitz explained the resonating ability of the dialogic using the example of pre-verbal mother-child interaction, and he thus at the same time attributed a meaning to the function of language in psychoanalytic dialogue that precisely cannot be compared to a dialogical speech act.

Witnessing: On the Transmission of Perception and Knowledge through Credibility

Is Something 'Known through the Words of Another' a Form of Knowledge?

Whenever we learn a language, whenever we learn when we were born and the identity of our birth mother, whenever we acquire knowledge from earlier times and distant lands, whenever} we are informed of the day's events through news reports, whenever we look for a street or a train station on a city map, whenever we consult a lexicon in order to learn what terms such as 'clay loam soil' mean, whenever we learn anything through spoken or written instructions, then we are acquiring knowledge through the words of others. Is it possible to imagine acquiring any knowledge at all without communicating with others? How much of what we regard as experiential facts are actually experienced rather than 'only' heard or spoken?

To depend on information that is not ascertained by us but rather transmitted to us constitutes the basis of our practical and theoretical orientation towards the world, and this applies to science as well as everyday life. Knowledge acquired through the witnessing of others is a ubiquitous phenomenon.

What is even stranger is that this knowledge is not considered to be knowledge, according to the epistemological standards of philosophy, because knowing something means 'knowing why'. According to the traditional epistemological perspective there are only two possible ways of explaining this 'why': either through direct perception or deductive reasoning (or the memory of direct perception or deductive reasoning in the past). No other sources of knowledge are taken into account except perception and deduction. Western philosophy thus deploys a concept of knowledge that denies the most widespread way of acquiring knowledge the status of 'being knowledge'.[239]

Of course the history of philosophy is more complex than this briefly sketched outline: Since the modern era several philosophers, including Leibniz,[240] Hume,[241] Kant,[242] and above all Thomas Reid,[243] have referred to the meaning and epistemological nature of 'the testimonials of others'. In the last few decades in particular philosophers have revaluated witnessed knowledge, which is seen as legitimate precisely because it cannot be reduced to already recognized forms of knowledge, like perception and deduction. The act of witnessing has also developed into a genuine, irreducible source of knowledge 'that neither requires nor is capable of feeding back

into allegedly more foundational sources'.[244] And this means: 'Testimony is a means of the *creation* of knowledge.'[245]

Within the framework of the debate concerning 'testimony' among primarily Anglo-Saxon philosophers, therefore, knowing through witnessing has been rehabilitated and its status is now seen as equal to traditionally approved forms of knowledge.[246] This perspective was the result of a methodological break with the theory of epistemological individualism in favour of a *social* epistemology, which acknowledges that our knowledge is inescapably dependent on others.[247] I will return to this later.

What is most interesting about this epistemological rehabilitation of knowledge through the words of others is the argument with which it was achieved. In the debate concerning 'testimony' at least, the status of witnessed knowledge was elevated due to the fact that it is actually a form of knowledge that *originates* in and through the act of testifying. Witnessing is thus shown to be the genuine creation of knowledge. Conversely, this also implies that most philosophers reject the status of witnessing as knowledge because they interpret the act of testifying as a form of knowledge that can only be *transmitted* and not created.[248]

This is the central issue: Reflecting on the nature of witnessing means confronting the problem of transmitting knowledge. And it can already be established in advance that the philosophical rehabilitation of witnessing – which is both useful as well as necessary – draws on the latent or also manifest devaluation of what is merely due to 'transmission'. Witnessing is of epistemological interest when and only when it proves to be the new creation of knowledge. In order to be philosophically acceptable, witnessing must be a form of *production*.[249]

This media-theoretical perspective presents the following question: Assuming that a witness 'only' functions as a medium for transmitting perception and knowledge, is it possible to specify the 'creativity' of witnessing in a way that does not negate but rather reconstitutes the *transmission* character of the event? My assumption (of course) is that this is possible, and it is for this reason alone that I am turning to the figure of the witness. The 'creativity of transmission' can be traced by examining the relationship between the witness and the audience for whom the testimony is given, and this social relationship is obviously rooted in 'credibility' and 'trust'. The testimony of a witness can be considered a true statement that 'gives' listeners a knowledge that they previously did not possess only because and insofar as the listeners trust and believe the witness. The witness can function as a medium for transmitting knowledge, which at the same time produces new knowledge (on the

part of the listener), when and only when the listeners consider him to be *credible*. Trust and credibility thus constitute the 'mechanism' of knowledge founded on testimonials. This 'mechanism' is a thoroughly social process, which Thomas Reid saw before anyone else: Reid refers to a 'social operation of mind' related to witnessing, which he associates with the principles of 'credulity' and 'veracity'.[250]

What does 'trust' mean? To trust the other is to be convinced that what the other does is *right*. To regard the other as credible and truthful is to assume that what he says is *true*. Trust, credibility, and truthfulness are only important in situations of insecurity and uncertainty. When something is certain, trust is not necessary. 'Witnessing' is only important when something is not known. It is therefore no surprise that 'being a witness' is a term taken from legal proceedings, especially criminal proceedings. Its etymological origins lie in the legal sphere, and it is there that its defining conceptual contours can also be established.[251]

On the 'Grammar of Witnessing': Reflections on Legal Witnessing

The paradigmatic situation of legal witnessing provides an ideal starting point for understanding what a witness is. Five aspects of legal witnessing are particularly relevant: (i) the creation of evidence, (ii) perception, (iii) speech acts, (iv) the audience, and (v) credibility. These aspects constitute what I am calling the 'grammar of witnessing'.

(i) *The witness creates evidence*: Whenever a legal dispute is to be decided there are contradictory ways of judging an event. The task of the court is to ascertain the facts and render a verdict. Witnesses are people who are deployed in this process as a means of providing evidence (this 'objective' form of expression is important); they 'serve' as 'objects' and 'instruments' for the acquisition of factual knowledge, which underlies the court's ability to reach a verdict. Witnessing thus produces evidence.[252] The witness only appears in situations where something is not known: 'One becomes a witness only when one can no longer rely on knowledge and when testimony [...] must nevertheless relate to a series of occurrences that is in itself not-one' in the conflict between competing accounts of an event.[253] The investigation of the 'truth' is neither an end in itself nor an evaluation of the 'right' version of a story; rather, it is supposed to enable the court to reach a fair verdict. It is not supposed to ascertain simply truth or falsity, but rather guilt or innocence. The evidence that the witness creates can also have serious consequences: it changes people's lives – and sometimes also leads to death. In ancient Jewish legal proceedings the witnesses were required to throw the first stone of execution.[254]

What matters here is that the epistemological uncertainty that is typical of witnessing is associated with legislation.[255] Witnessing thus culminates in an act of 'restoration' in the broadest possible sense as the eradication of an imbalance that includes the socialization of private knowledge as well as justice for the victim and atonement for the perpetrator. If the witness creates evidence and his function is embedded in the 'restoration of a social equilibrium', then his truth claims always have a practical, 'humanizing' dimension.

(ii) *The witness is able to testify by virtue of his perception.* The witness was physically present at an event that occurred in the past; he saw something 'with his own eyes' and thus bears witness to a direct perception, something he experienced himself. This 'principle of immediacy' is highly valued in court proceedings.[256] Reports from others also count as something perceived through witnessing, and hearsay testimony is today[257] – in Germany at least[258] – a legally admissible form of evidence.[259] With hearsay it is not an event that is witnessed but rather the *report* of an event: it is therefore an inferior means of evidence. This was already true for Plato[260] as well as Plautus, who believed that one eyewitness was worth more than ten hearsay witnesses.[261]

By any account, therefore, the perceptual foundation of giving testimony is this: *To have had a perception constitutes the* conditio sine qua non *of witnessing.* Only the 'perceptions of a witness' can be an 'appropriate object of testimonial evidence'.[262] This distinguishes the witness from the expert, who does not report his perceptions but rather makes his expert knowledge available to the court. The witness is sought because he was an observer. He only counts as the *recipient* of an event. His cognitive and evaluative activities, such as his opinions, valuations, or conclusions, are not relevant; they disrupt and cloud the process of testifying and thus they remain definitively excluded from legal proceedings.[263] Anyone capable of perception can be a witness.[264]

The dilemma of witnesses who are at the same time victims is grounded in this recipient and observer status. The ideal witness – in the legal sphere at least – is not involved in the event being witnessed.

(iii) *The witness discursifies what he perceived*: The witness must not only have perceived something, but also reported it. Witnessing is thus based on the transformation of a perception into linguistic testimony.[265] Something seen is transformed into something spoken, and the sensually received is transformed into linguistic sense. The witness must perform a kind of translation or transcription of his private experience into a public statement. This is an extremely fragile process. In order for the witness's

statement to be considered a truth claim, which can then be utilized by the court, it is heavily ritualized and institutionalized – and not only when it takes place under oath. The witness does not simply talk and report, but rather he performs a speech act in an institutional-theoretical sense. In the first place, only those who are called to the witness stand are authorized to bear witness. In other words, *the witness's statement is only considered true because it is spoken in the witness stand.*[266] There are therefore harsh punishments for perjury and false testimony.

(iv) *The activity of the listeners*: The witness must have not only perceived something and spoken about it, but also spoken *to* someone. It is impossible to bear witness without listeners or an audience. The listeners are unaware of the event about which the witness is testifying; otherwise, they would not need the witness. There is therefore a fundamental asymmetry between witness and listener. The event to be cleared up is irrevocably past; no words are capable of repeating it. It is impossible to assess the truth content of the witness's statement by direct 'reality testing'.

Testimony is therefore not a monologue, but rather an interaction be-tween the witness and the listener(s) that consists of questions and answers. In a trial there is a distinction between the 'statement' and the 'questioning' of the witness.[267] The witness's statement evolves as part of a dialogue, as the listeners' questions always also determine, direct, and shape *what* the witness presents with his words and *how* he does this. *The witness's statement is not only a speech act, but also at the same time an act of listening.*

(v) *Credibility*: Mental conditions like perceptions and experiences are not transmissible. As John Durham Peters laconically remarks: 'No transfu-sion of consciousness is possible. Words can be exchanged, experiences cannot.'[268] The possibility of lies is thus inherent in every testimony. No matter what the witness says, it can – in principle – be false testimony. This distinguishes witness statements from 'ordinary traces' or indexical signs, which can be misread and misinterpreted but cannot 'lie'.[269] Given the empirical unverifiability of the truth of witness testimony, the illocutionary force that enables the words spoken by the witness on the witness stand to be considered true is also stretched to its limits. The credibility, truthful-ness, and trustworthiness of witnesses thus become more essential. The witness vouches for his words with his character: *The truth of his sentences is based on the truthfulness of his character.* Only a trustworthy witness is convincing. But trust can always be betrayed – otherwise it would not be trust.

This shows that the concept of witnessing has an ethical dimension.[270] And it is no surprise that the verification of the credibility of witnesses

constitutes an important element of the work of the court.[271] Is the concept of oral testimony[272] rooted in this sense of personal responsibility, which privileges the voice as a (more or less authentic) trace of the person and at the same time ensures that the participants are able to look each other in the eyes?[273] As Niklas Luhmann points out, talking in the presence of others helps to prevent a breach of trust.[274] The listeners' lack of knowledge thus corresponds to the trust they place in the witness, which attributes credibility to him: *the transmission of knowledge is only possible with the help of the social bond of trust.*

There are five conditions that constitute the 'syntax of witnessing': (1) In a situation of uncertainty, where knowledge is lacking, the witness creates evidence in the sense of fact-finding; this, in turn, becomes the basis of the verdict. (2) The witness was ideally a disinterested observer of an event that took place in the past, and the basis of the witness's testimony is his perception of this event. (3) The witness must transform his sensory experience into a verbal statement, and this speech act is considered true precisely because the witness is institutionally authorized. (4) Witnessing is an interaction between the witness and the listeners, as the expectations and questions of the listeners always also influence the content of the testimony. The listeners thus represent a constitutive element of witnessing. (5) The witness's statement is recognized to be true not only because of the witness's institutional authorization, but also because of his trustworthiness.

I call these five structural elements the 'grammar of witnessing'. It does not require tremendous powers of imagination to realize that this 'syntax of witnessing' is related to the concrete practice of witnessing like school grammar is related to everyday speech: We are able to communicate with each other in everyday life without speaking in grammatically correct sentences. It can therefore be assumed that real witnessing (and its dilemmas) differs from the standards of ideal witnessing. I will now look at what causes this deviation.

On the Pragmatism of Witnessing: The Ambivalence of Witnessing

It is easy to identify and label the cause of this deviation: It is the *fallibility* of witnessing as an instrument for producing evidence.[275] The witness is a means of evidence, yet the act of bearing witness is a process that remains extremely prone to error and subject to failure. To express this idea in the style of Giorgio Agamben: The potential of witnessing also contains the failure and impotence of witnessing.[276]

This also applies to the thoroughly institutionalized and socially controlled sphere of the law. The appearance of witnesses in criminal trials

seems so natural that it is hardly ever reflected upon or problematized. However, in his essay 'Witness Evidence on Thin Ice' jurist Bernd Schüne-mann calls attention to the fallibility of witness testimony in a way that is unusually critical for a work of legal scholarship: 'Disinterested witnesses suffer from poor observation, poor information processing, poor informa-tion storage, and poor information reproduction, while interested witnesses often tend to manipulate information reproduction. In the postmodern age, therefore, witness testimony must qualify as the most problematic means of evidence.'[277] Schünemann explains why criminal trials nevertheless do not fall apart due to the fallibility of witnesses by mentioning another fact that further problematizes the demonstrative strength of witness statements: According to Schünemann, these statements are so indeterminate that they can be extensively formed over the course of legal proceedings: Witness statements are already decisively directed and shaped by the hypotheses of the police officers who conduct interrogations.[278] These are also the same officers who – without exception – prepare records of interrogations in writ-ing, and this privileging of writing as opposed to other means of recording further shapes witness statements by reflecting the *interrogators'* priorities and assumptions concerning the event. During the main trials, on the other hand, judges nevertheless tend to overestimate incriminating witnesses and underestimate exonerating witnesses: a 'solidarity effect' between lawyers and judges is thus a regular and empirically verifiable reality.[279]

It is not necessary here to discuss legal assessments. These few refer-ences are already sufficient to show that there is something fundamentally problematic about the witness function.[280]

Social-psychological studies also clearly illustrate the relativization of the evidentiary strength of witnessing.[281] Different people present at the same event will provide different accounts of the event. Identification errors involving people and faces are also the order of the day: From the perspec-tive of the perceivers hair colour, clothing, facial features, body sizes and much more are constantly changing like a chameleon. Although memory is weak, a willingness to eliminate dissonance and incongruity deludes people into making blurry perceptions into detailed statements or transforming the factually indistinct into the fictionally sharp. People would rather obey the logic of a narrative structure than admit the lacunarity and uncertainty of their own experience.

It is hard to deny that the practice of witnessing deviates from the ideal of witnessing.

If the deformation of a form in the act of its implementation, its deviations from a set pattern in the course of its realization, and the failure of a complex

praxis in contrast to its simple program were remarkable for nothing else they could at least call attention to the trivial fact that the concept and the reality are – as always – different. However, if a performative approach is employed then the otherness of praxis with respect to its normative and theoretical standards does not appear simply as a lapse or a deformation, but rather as *an expression of ambivalence and aporia, which are immanent in the thing itself.* In this sense the practice of witnessing, which is shaped by its fallibility, alludes to an aporetic structure that is inherent to the 'grammar of witnessing'. And an explanation of precisely this aporetic structure leads to the core of what it means to say that the witness is a *medium* – or at least this is my hypothesis.

The idea of regarding witnesses as media can be traced back to John Durham Peters. He characterizes witnesses as 'the paradigm case of a medium: the means by which experience is supplied to others who lack the original'.[282] And for Peters the undeniable 'unreality of witnesses' is rooted in the transmission character of witnessing, as the witness must turn a subjective experience into an objective discursive form. The private inner world of experience is thus transformed into a public statement, and something mental is transformed into something that is socially accessible: The discursifiability of experience thus enables the generation of evidence through testimony.

I would like to pursue this observation a little further. It is perhaps obvious, but it is still worth mentioning: People function as witnesses, witnesses are people. There is therefore a tension between the depersonalization of the witness, which is reflected in the notion of the witness as a *medium*, and the credibility and trustworthiness of the witness, which is exclusively embodied in the *person* of the witness himself. The witness is at the same time both a 'thing' and a 'person'; he functions as a 'means to an end', yet he is also an 'end in itself'. *When regarded existentially, the witness is a person; when regarded functionally, the witness is an object and an instrument.* This constitutes the ambivalence of witnessing – from a media-theoretical perspective.

One juridical fact is particularly revealing concerning the status of the witness as thing and object. The 'object quality'[283] of the witness is actually foregrounded in the code of criminal procedure. Due to the importance of ascertaining the truth when there is a breach of the law, the notion of the witness as a *subject* with his own demands and needs for protection recedes into the background.[284] It is thus remarkable that modern court proceedings tend to increasingly promote and strengthen the *subject* position of the witness; this development began with the successive expansion of the right to silence

(such as in the case of questions that concern the past life or intimate life of the witness) and it culminated in the institution of the 'witness advisor', which was first introduced in 1974.[285] According to Bernd Schünemann, the expansion of the legal status of the witness advisor involves the danger that the witness will no longer occupy a position *between* the disputing subjects, but rather the witness himself will be treated 'like a party' in the case; in other words, the witness will be treated like a subject in the lawsuit.[286]

This tension between neutrality and involvement becomes more openly visible in criminal proceedings where the victim is at the same time also the (sole) witness. Yet what culminates and manifests in the situation of the victim-witness is a latent dilemma that is inherent in every act of bearing witness. I will return to the issue of survivor testimony later, but for now let me attempt to characterize this dilemma once again:

(i) Witnesses are always people who have perceived something and thus had an experience that is not accessible to those before whom they bear testimony. Because perception and experience are mental acts, the 'craft' of witnessing does not consist solely in transmitting these private experiences through public, openly accessible speech. Rather, the Archimedian point is that the witness presents a narrative of his experiences as if they had been passively *recorded* rather than (actively) *lived*. The witness must behave as if he is a 'blank slate', a disinterested seismograph, a meticulous recording instrument that registers an event in an entirely literal sense. Strictly speaking, it is neither experience nor knowledge that the witness relays, but rather something much simpler: Data and information that is still on the verge of being 'processed' and 'integrated' into something like experience or knowledge. It then becomes the task of the listeners to synthesize the witness's 'simple' information about an event and give it the coherence of knowledge. It is precisely by acting as a recording device that the witness is able to convey something out of which *new* knowledge can actually emerge for the listeners. However, this presumes that the witness is able to separate the instance of perception from the processing of perceptions, which transforms them into an experience or a form of knowledge. If the witness talks about his experience, he disrupts and undermines his function as a messenger who relays 'acquired data'. To say that the witness is a medium basically means that his personal experiences and synthesized knowledge are not relevant; rather, he is nothing more than an instrument for recording data.

(ii) There is an unbridgeable asymmetry between the 'knowing' witness and the 'unknowing' listeners. The performative strength of the witness's statement, whose truth is supposed to be guaranteed by the fact that this

statement is spoken under certain institutionalized conditions, is thus at the same time bound to the personal credibility and trustworthiness of the witness. The witness must prove to be an objective seismograph while at the same time as a person embodying an integrity that consists in the correspondence between his mental state and his statements, between his private inner world and his publicly accessible external world. Considering the complexity of our psycho-physical existence, this integrity is – if anything – an ideal that is virtually unachievable. More importantly, this trustworthiness is not explicable in words: Saying 'I am trustworthy' does not make someone trustworthy.

The fundamental dilemma of witnessing thus consists in the Janus-faced character of the witness role, which involves and requires being both a medium and a person. Personality and depersonalization are *both* necessary to make the mediality of the witness possible. To say this in the terms of antiquity: One only functions as an end for others by at the same time appearing as an end in oneself.

In order to examine this aporetic structure in greater detail, I will now trace two distinct types of witnessing: the sacred witnessing of martyrs and the profane witnessing of survivors.

Martyrs

In the christological perspective, the concepts μάρτυς ('*martys*'–witness), μαρτυρεῖν ('*martyrein*'–witnessing, being a witness), and μαρτύριον ('*martyrion*'–testimony) successively adopted the meaning of 'martyr' as someone who vouches for the truth of his testimony with his life. Insightful references to the dilemma of witnessing can be found in this metamorphosis from the concept of the witness, who testifies through what he *says*, to the concept of the martyr, who testifies through the suffering of his body.

Let us begin with an observation in Søren Kierkegaard's *Practice in Christianity*. Kierkegaard distinguishes between two kinds of truth: On the one hand, there are truths that are transmittable, and thus teachable and learnable, and the aim of these truths is to produce a form of knowledge that can be verbalized and communicated within a community – in a way, they are therefore a 'public good'.[287] On the other hand, there are non-transmittable truths, which can be neither stated nor taught but rather only *shown*; these truths are not given as a 'result' but rather only as a 'path' that cannot be acquired through others but rather only experienced by the individual. This truth is no longer a quality of statements formulated in a commonly shared language; rather, it is an attribute of the life of the individual: 'And hence, Christianly understood, the truth consists not in

knowing the truth but in being the truth. In spite of the newest philosophy, there is an infinite difference between these two.'[288]

Kierkegaard's distinction between 'knowing a truth' and 'being a truth' can be described as a distinction between a discursifiable and an existential truth. In religious terms, Christian truth can be understood as an existential truth. This involves two implications:

(i) Christ himself is considered to be a figure that attests to an existential truth, which nevertheless remains inaccessible to humans: Christ *is* precisely the truth that he testifies. It is fundamentally impossible for him to answer Pontius Pilate's question 'What is truth?' because a question-answer structure lacks what might be called today the *performative* character of the 'truth of Christ': An answer to Pilate's question would amount to a performative self-contradiction.[289]

(ii) The concept of testifying to the truth of Christianity by 'being a martyr' is thus based on the impossibility of bearing witness to a truth and thus only being able to show it through bodily suffering and one's own death. Indeed, Kierkegaard also concludes that martyrdom, suffering for the sake of one's faith, applies in a sense to all Christians.[290]

Kierkegaard's considerations provide a suitable entryway into the Christian reinterpretation of witnessing insofar as he grasps the clear difference between religious witnessing and epistemic as well as juridical witnessing. While the epistemological and legal view of witnessing are based on the transmittability of experience, the Christological view of witnessing – from Kierkegaard's perspective – assumes that *it is impossible to relay Christian experiences through language*. This is remarkable, for the aporia that a 'witness' precisely cannot witness effectively 'compels' the testimony of the truth to take a different route: If testimony cannot be given in words, it must be given through the body, suffering, and life.

While Kierkegaard conceives of witnessing through words and through suffering as a systematically explicable dichotomy that creates an unbridgeable divide between the legal and the martyrological meaning of testimony, Markus Barth shows how in the New Testament the word '*martys*' was used in at least three different ways, which connects it to the legal-epistemic perspective.[291] His main point is that the 'apostles', who in a literal sense are considered the 'delegates of God', unite the three properties of '*martys*' as their speech, life, and death combine all *three* versions of witnessing.

(i) First, there are *eyewitnesses*.[292] The New Testament thus complies with common legal practice: A witness is someone who was present at a particular event, was able to perceive this event by listening and seeing, and then provides an account of this perception in words. The apostles were

eyewitnesses, as they encountered Jesus after his death and they thus bore witness to the resurrection.[293] This was the original meaning of witnessing: The resurrection was improbable and unusual, but the apostles testified that it was something they actually perceived. The role assigned to the body is particularly significant, as bodily presence constitutes the *sine qua non* of being an eyewitness. This bodily presence involves being able not only to see with one's eyes and to hear with one's ears but also to feel with one's hands, as Jesus invites the disciples to touch him. As Markus Barth notes, the disciples became 'indissolubly' one with the 'incarnation of Jesus Christ' through seeing, hearing, and touching.[294]

(ii) Second, there are *confessional witnesses* and *faith witnesses*, who do not bear witness to an external perception but rather to an internal condition or personal conviction. These witnesses feel called upon to serve as advocates and promoters,[295] and they avow themselves as Christians before Jews and non-Christians.[296] The 'inner world of personal conviction' is a new dimension that separates confessional witnesses from legal witnesses.

It is characteristic of the apostles that they integrate the functions of both eyewitnessing and confessional witnessing: The apostles represent a point of intersection where the testimony of (internal) faith can be traced back to the testimony of (external) facts: 'Which we have heard, which we have seen with our eyes, which we have looked at and our hands have touched – this we proclaim.'[297]

(iii) Third and lastly, there are *witnesses of suffering and death*. As Barth explicitly emphasizes, however, this does not refer to someone who 'earns' an honorary title by suffering, like the early Christian martyrs. While martyrs were witnesses in the conventional sense because they were killed, witnesses of suffering in the biblical sense were killed because they were witnesses.[298] Death is therefore not a prerequisite for but rather a result of being a witness. Socrates is a witness in this sense,[299] as is Jesus himself, who became the 'archetypal' witness of death.[300] The same also applies to the apostles, who died because of their faith.

The apostles were 'delegates', therefore, because they combined all three modalities of witnessing. On the other hand, this leads to an interesting implication: If the apostles are the only people able to bear witness to Jesus as a perceived event and their faith is thus based on and can be traced back to 'having been there', and if the apostles alone personally embody the triad of eyewitness, witness of faith, and witness of suffering, then martyrological witnessing, which is not yet available to the apostles in the New Testament, becomes inevitable, for there can no longer be any sensual and therefore *transmittable* experience of the divine as revealed through the resurrection

of Jesus. But how can the authenticity of the *belief* that Jesus is the son of God be guaranteed if this subjective belief can no longer be 'legitimized' through eyewitnesses? The ability of words to guarantee the truth is thus no longer dependent on the corporeality of eyewitnessing, but rather on martyrdom. For Jesus and the apostles suffering signified an *a posteriori* condition for being a witness, but it subsequently became an a priori condition, which lead to the emergence of 'martyrs' in the conventional sense. The visibility, exteriority, and sensual corporeality of torture and death thus compensated for the invisibility, interiority, and spiritual intellectuality of a faith that is no longer able to bear witness to 'facts'. Words no longer refer to the bodily perception of an event, but rather to the experience of suffering death. The 'dying messenger' similarly bears witness through suffering. In this sense, there is a surviving letter concerning the martyrdom of Bishop Polycarp that was sent from his congregation in Smyrna to a congregation in Phrygia in the second century A.D., and it can be considered the first text to employ a 'fixed martyrological use of language'.[301]

Perhaps it is now clear how the christological and martyrological sense of witnessing sheds light on the concept and problem of witnessing in general. The martyr transcends and surpasses the primal scene of legal witnessing and it reveals an aporetic structure that is inherent to the phenomenon of witnessing itself. To start with, the origins of legal witnessing and faith witnessing are similar: The legal context provides the basis for eyewitness testimony, and the special position of apostolic testimony is a result of this. The materiality and sensitivity of touching and feeling forges a corporeal bond between Jesus and the disciples, who acquire the ability to testify that the 'risen' Jesus is 'the son of God' through their physical, tactile, visual, and auditory connection to him. For the Christians, however, this bond no longer exists. They bear witness not to the *immanence* of their perception, but rather only to the *transcendence* of their faith. The dilemma is obvious: *They must publicly bear witness to something that is not publicly accessible.* This situation reveals the entire problematic of witnessing.

Faith witnessing does not involve a form of (intersubjectively verifiable) *knowledge*, which can be transmitted; rather, it concerns a thoroughly private 'conviction' or belief. This, then, is the fundamental situation of being a Christian. Kierkegaard also points out that words no longer count at all; only life itself is still able to vouch for something. The authenticity and coherence of a Christian's inner conviction can only be witnessed through the authenticity and coherence of his external behaviour. The truth of testimony, or in this case the truth of the testified belief, can therefore only be shown through the truthfulness of the person or his credibility.[302] And the

credibility of the person as a medium for transmitting messages is strongest when he is prepared to be depersonalized through dying and death. It is not simply the person but rather the *behaviour* of the person that authenticates his testimony and the borderline case of this behaviour is self-abandonment in death. Does the martyr embody the topos of the dying messenger?

Survivors

The martyr testifies by *dying*, but the survivor of a catastrophe testifies by *living*. The survivor witness is another extreme form of witnessing, and it reveals dimensions that surpass the classical situation of legal witnessing while at the same time bringing to light dilemmas that apply to witnessing in general. Through the process of coming to terms with the Holocaust and forming a cultural memory of this event, the survivors of concentration camps impressively illustrate these 'fractures of witnessing'.[303] In his edited collection *'Nobody Bears Witness to the Witnesses': The Culture of Remembrance after the Shoah*, Ulrich Baer conceives of the Holocaust as a fundamental historical crisis of witnessing.[304] I will now attempt to explicate the 'fractures of survivor testimony':

(i) *Witnessing on condition of the loss of identity*: The idea that the witness can occupy the role of an external, neutral observer is part of the 'grammar of witnessing', but the survivors of a catastrophe are always victims. The convergence of their victim status and their role as witnesses makes it impossible for them to remain 'neutral' observers. Witnesses are ideally expected to separate their passive perception of a situation from their active processing of this perception into an experience that is informed by opinions, beliefs, and emotions, but this is hardly possible for survivors. The fact that this separation is *fundamentally* illusionary – independent of the victim perspective – shows how survivor witnessing crystallizes a dilemma that defines all forms of witnessing. Incidentally, Renaud Dulong's approach to the question of what constitutes an 'eyewitness' is based on this dilemma of being subject to the paradigm of objective registration yet at the same time not being able to fulfil it – in contrast to recording media like photography and film. Dulong conceives of the 'eyewitness' as something precisely beyond the epistemic observer paradigm, and he thus interprets it as a fundamental ethical constellation and challenge.[305] Survivors are not witnesses in a historiographic sense.[306] In the words of Sigrid Weigel, the survivor witness is to the legal or historiographic witness as a lament is to an accusation.[307]

This context sheds light on an exhortation by the SS to concentration camp inmates, which was recorded by Levi and often cited: 'None of you will

be left to bear witness, but even if someone were to survive, the world will not believe him.'[308] Dori Laub refers to the Holocaust as an 'event without witness'[309] and states that 'what precisely made a Holocaust out of the event is the unique way in which, during its historical occurrence, the event produced not witnesses. Not only, in effect, did the Nazis try to exterminate the physical witnesses of their crime; but the inherently incomprehensible and deceptive psychological structure of the event precluded its own witnessing, even by its very victims.'[310] This lack of witnesses did not simply consist in the fact that the dead could not testify to their deaths and that given the enormity and 'incredibility' of the survivor's experiences their stories would not be accepted as testimony. No, this dilemma involves yet another dimension: There were only victims and perpetrators in concentration camps, and therefore there could be no neutral observers. This means that from the perspective of the perpetrators the inhumane practices experienced by the prisoners contaminated them so extensively that they were deprived of their identity and their humanity and they thus became 'inhuman': The integrity of one's own personhood, which must at the same time have been regarded as the (legal) condition of witnessing, was thus subject to destruction.

Giorgio Agamben has reflected on this more recently by reference to the figure of the 'Muselmann',[311] which embodies precisely this loss of personality. 'Muselmann' is camp slang for a prisoner who has given up and who has been forsaken by his comrades. He is regarded as a mummy or as the living dead. He is no longer consciously alive and cannot differentiate between good and evil or kindness and malice; he cannot even differentiate between life and death, as even the will to survive has faded.[312] The 'living corpse' of the *Muselmann* is no longer a person. At the same time, however, he is also 'the complete witness'.[313] The *Muselmann* thus embodies the fundamental paradox of witnessing the Holocaust: By mutating into a non-human, a victim of the Holocaust is (no longer) able to bear witness according to the 'grammar of witnessing'; at the same time, however, he is also 'the true witness, the absolute witness'.[314] The impossibility of speaking is thus inscribed in the speech of all Holocaust survivors, and the impossibility of witnessing is the Holocaust survivor's cross of ash.

(ii) *Witnessing as Restoration of Identity*: This aporia – bearing witnessing to the impossibility of bearing witness and thus articulating what cannot be articulated – nevertheless makes the recounting of events necessary, important, and meaningful. The meaning of these stories does not lie in what they contribute to the reconstruction of history and the formation of historical knowledge. Rather, the testimony given by survivors is primarily an act that restores their identity and integrity as victims of this event. It is

therefore not surprising that these survivors remained silent immediately following World War II: Some historical distance was needed before it was possible for Holocaust survivors to speak as witnesses. As a result of this distance survivors were able to speak not only as humbled victims of concentration camps, but as respectable and respected contemporaries and thus as people who their have found their way back into life again – insofar as that is possible. Holocaust witnesses thus speak on behalf of the present and not simply the past.

What matters most in these accounts is not the testimony of facts but rather the *performance* of witnessing itself. It is an act that precisely does not obey the logic of a 'demonstrative speech act'.[315] Interviews with survivors resemble psychoanalytic dialogue in many respects: As Geoffrey Hartman emphasizes in his reflections on Holocaust witnessing,[316] traumas are (according to Freud) events that have not been emotionally and intellectually processed and that resist being integrated into experience. Articulating these monstrous events is thus a means of integrating them into one's own biography, becoming consciously aware of oneself as a being who incarnates history in its cruellest form, and also existentially accepting this role for oneself.[317] As Arthur Danto points out, 'to exist historically is to perceive the events one lives through as part of a story later to be told'.[318]

For the survivors of the Holocaust, such a re-humanization through witnessing is only possible if it establishes a kind of 'affective community' with the listeners: Interviews with survivors thus become a collective 'social act'.[319] Like every act of witnessing, the addressee is an integral component of survivor testimony.[320] In the case of survivor testimony, however, the 'trustworthiness' that constitutes the *conditio sine qua non* of a person's capacity to testify is transferred to the listener: It is the interviewer who endows trust in the survivor and his ability to communicate his past experiences.

Is the structure of survivor testimony exceptional because the survivor turns the listener into a medium for his testimony and thus transforms the listener himself into a witness? Does the hope of the Yale Testimony Project consist in 'providing a witness for the witness'?[321] Does the interrelationship of a *double* witnessing – namely, of the survivor as well as the listener – correspond to the interrelationship of dehumanization and rehumanization? Survivor testimony is exceptional because the listener himself is transformed into a kind of medium or 'secondary witness'.[322] As Dori Laub writes: 'Bearing witness to the trauma involves the audience in that this audience functions as an empty surface on which the event is inscribed for the first time.'[323] The impossibility of witnessing caused by the loss of personal integrity is thus compensated through the restitution

of personality in the social act of the interview, in which the interviewer testifies to the survivor's capacity to testify by recognizing and treating the survivor as a person who bears witness.

Social Epistemology

After discussing two extreme forms of existential witnessing – the martyr and the survivor – I want to return finally to the ordinary, everyday dimension of bearing testimony. It concerns the knowledge that we acquire through the words and writings of other people. In contrast to the 'formal testimony' given in a legal context, Coady identifies knowledge acquired through the words of others as informal or 'natural testimony'.[324] We are able to acquire knowledge about things that we could never experience on our own through the first-hand, second-hand, third-hand, etc. accounts presented in books, pictures, television, films, newspapers, maps, and timetables, and we (must) naturally depend on others for this knowledge.

The analysis of assertory speech acts has adequately examined speech acts whose illocutive role is that someone not only says something but at the same time also claims that what he says is true.[325] However, there is a significant difference between ordinary assertions and informal testimony: An assertion involves a truth claim, as the speaker believes that what he says is true, and these claims can be rejected. If a person has good reason to doubt such a claim, he may enter into a discourse concerning the truth or falsity of the assertion and the one who asserted the claim must also be able to provide evidence. When bearing testimony, however, the statement itself is also *at the same time* evidence that what is being said is true – an idea that is embodied in the paradigmatic figure of the legal witness. This kind of performativity enables the emergence of new knowledge through the collective circulation of testimony[326] – and it does not require *belief* in the solidarity of the source of the information. This once again raises the issue of trustworthiness, which is inevitable when discussing testimony. The key element of testimony is not the truth of the statement, but rather the truthfulness of the person. The truth of a statement thus depends on the truthfulness attributed to the people or the reliability attributed to the institutions that inform us. In a way, people 'blindly' accept the truth of a statement insofar as they have confidence in the trustworthiness of the information source.[327] In everyday 'natural testimony', the condition of trustworthiness assumes the prosaic form of 'good informants' and 'useful information sources'.[328] Trustworthiness is therefore always subject to power, politics, and practices: As Steven Shapin was able to show, in the

seventeenth century 'gentlemen' were considered trustworthy witnesses of experiments in the context of the Royal Society.[329]

What matters here is what remained unquestioned in this form of knowledge transmission. Although information sources can (or could) in principle always be critically verified,[330] people generally refrain from doing so because they trust the parents who teach them language, the teachers who educate them, the lexicons they consult, and the news reports they watch on television. It is impossible for people to orient themselves in the world any other way. The notion that people acquire most – if not all – of their knowledge through the testimony of others applies not only to everyday life, but also to science and research itself.

The reductionist position – whose most prominent representative is David Hume[331] – argues that the knowledge acquired through the testimony of others can be substantiated and single-handedly justified through the listener's own perception, memory, or inductive reasoning. According to this position, therefore, the individual's perceptual organs and abilities constitute the basis of testified knowledge. However, this supposition is absurd: In practice it is impossible for people to verify all of their knowledge in this way because testimony usually involves facts and perceptions that are beyond the scope of what listeners are able to find out for themselves.[332]

There is therefore an 'irreducible asynchrony' in all situations that involve bearing testimony[333] – and is this surprising in the context of the messenger model? Nevertheless, there is yet another reason for the necessity and irreducibility of bearing testimony: Perception is not the foundation of knowledge, but rather it is also tied to concepts that enable something to be perceived as something in the first place; furthermore, these concepts are based on language, and it is impossible to acquire language without acts of knowledge through the words of others.[334]

This insight constitutes an epistemological turning point in these reflections on the 'inescapability' of bearing testimony in everyday life as well as scientific practices. It effectively represents a revision of the epistemological individual and a rejection of the idea of 'knowing-it-yourself'.

The individualistically-oriented epistemology of the modern era, in which the heroically isolated and independent subject rigorously verifies and justifies all of his opinions and relies exclusively on perception and logic as sources of information in order to achieve absolute certainty 'in the fight against the windmills of scepticism' – this epistemology stylizes an impossible fictional figure who – in the words of Oliver R. Scholz – more closely resembles 'the Knight of the Sorrowful Countenance'.[335] Testimonial knowledge constitutes the foundation and reservoir of our epistemological

practices and it accounts for the fact that our epistemology is a thoroughly *social epistemology*. People are thus inevitably dependent upon interactions with others not only in their everyday lives, but also in their cognitive activities. This 'interaction' proves to be first and foremost the unidirectional *adoption* of knowledge, which cannot (any longer) be verified and is thus rooted in one's faith in others. The fact that large amounts of knowledge are *transmitted between* individuals and are by no means originally produced by individuals means that sociality has become the innermost core of our knowledge practices and witnessing has become a basic epistemological phenomenon.

Conclusion: Transmission of Knowledge through Trustworthiness
(1) These reflections on witnessing have differentiated between the 'grammar' of witnessing and the 'pragmatic' aspects of witnessing. The 'grammar' of witnessing includes all of the attributes that characterize witnessing as the announcement of the perception of a past event by a non-participating observer speaking before a public that was not able to perceive this event for themselves, and this concept of witnessing culminates in the ideal figure of the legal witness. The 'pragmatic' aspects of witnessing consist of the diverse ways in which witnessing occurs as a process situated in space and time, from the information people receive through the words of others in their everyday lives to more extreme forms of witnessing, like the survivors of a catastrophe. Witnessing is a ubiquitous phenomenon in all cultures, yet the 'pragmatic' aspects of witnessing reveal a dilemma that is inherent to the 'grammar' of witnessing.

(2) The act of witnessing presupposes a divide between the witness and his listeners, who are excluded from the perception of the testified event by an irreducible asynchrony. The witness basically stands alone due to his singular experience. This gap cannot be closed not only because the past experience of the witness can only be – at best – communicated to others rather than shared with them, but also because this experience is not (any longer) verifiable through reality testing. Due to the fact that the witness's testimony is singular and secondary, it is exempt from the process of confirmation and proof. However, not only is the witness's perception fallible, but the discursivity of the witness's statement also introduces the possibility of lying. *Formal* testimony, as presented by legal witness, is therefore an institutionalized performative act, which effectively makes a statement true by virtue of the fact that it is uttered. This distinguishes testimony from ordinary claims, whose truth is not already sealed by the mere performance of being uttered but rather is based on the possibility that

a speaker can also justify what she has said. The special status of witness statements is therefore that they produce evidence but they cannot be justified in the conventional sense.

(3) Given the fallibility of witness statements, their truth potential is grounded in the *trustworthiness* of the witness as a person, in his honesty and integrity. The witness performs a double or 'divided' role: On the one hand, he is supposed to be a neutral, non-participating observer. To put it more radically, he is a 'data collection and retrieval instrument', and he must therefore largely ignore his own reflections, opinions, and judgements. At the same time, however, he must also prove to be a person of integrity who is consistently credible and trustworthy and whose external behaviour corresponds (supposedly) to his inner convictions. There is an inherent dilemma in this concept of the witness as a medium whose task is to transmit and convey perceptions, and this dilemma is characteristic of the figure of the witness: He must act as both a 'thing' and an 'authentic person' at the same time. This dilemma becomes particularly apparent in two of the extreme versions of witnessing: namely, the martyr and the survivor.

(4) *Martyrs*: In the Christian tradition the apostles could still lay claim to being eyewitnesses, as they apparently met the resurrected Jesus 'in person', yet Christians bear witness not to the immanence of such a perception, but only to the transcendence of their faith experience. People are most trustworthy when they are prepared to die, so the guarantee of truth gradually becomes not words, but the suffering body and death. In the process of transmitting his message, therefore, the 'dying messenger' transforms into a martyr.

Survivors: The people killed in a catastrophe can no longer bear witness to it. The dilemma of survivor witnesses, therefore, consists in the fact not only that they are both victims and witnesses, but also that they mark the empty position left behind by the dead. It is precisely because they survived and escaped annihilation that they embody the very impossibility of bearing witness to such a devastating event. When the act of bearing witness becomes at the same time also the act of processing a traumatic experience, the listener assumes a special role that consists in witnessing and vouching for the reintegration of the traumatic experience in the 'unity of the person' of the survivor.

(5) The prosaic form of witnessing lies in the ubiquity of knowledge acquired through the words and writings of others, without which socialization and orientation in a culture would not be possible. The ubiquity of this kind of witnessing, which is not actually formal (i.e. juridical) but rather informal or 'natural' testimony, reveals the social dimension of epistemology,

which cannot be eliminated. The impossibility of verifying the knowledge acquired from others through transmission using one's own perception and reasoning makes epistemological individualism an untenable position. The kind of knowledge produced through witnessing is based on the interaction between the witness and the listeners. It first emerges in the in-between space of this interaction, and it thus depends on two different things: on the one hand it depends on the *transmission of perception and/or knowledge* by the witness, and on the other hand it also depends on the *trust and faith* of the listener. The social epistemology of witnessing always contains an ethical dimension because transmission through witnessing is only possible when the witness is believed and trusted.

So What Does 'Transmission' Mean?

Making Perceptible

Up until now I have been dealing with forms of transmission in widely diverse fields. I have also been dealing with forms of transmission that are not obviously subject to the regime of a medium, like radio or television, as this – albeit entirely random – selection of transmission modalities was designed to trace by analogy the functional logic of the messenger precisely where the mediality of this process was not at all obvious. And the discovery of these forms of transmission was bound up with the hope that their subtlety and diversity could assess and also expand the categorical abundance of the rather simple theoretical model of the messenger.

These forms reflect very different transmission strategies: hybridization, transcription, desubstantiation, complementarity, affective resonance, and finally trustworthiness. Hardly any list could be so diverse, and every attempt to measure these various modalities according to the same coherent theory of transmission unavoidably exercises a kind of conceptual violence with regard to the abundance of phenomena. This danger is real. Nevertheless, I want to venture a generalizing perspective, which asks: Do these diverse transmission processes reflect a coherent set of attributes concerning transmission and mediality?

My answer includes four points, which also play a role in the messenger model but which have become clearer over the course of analyzing concrete forms of transmission: (1) Transmissions presuppose a *difference* that is not reducible to spatial or temporal distance. (2) The role of the mediator is not always to bridge and level this difference, but also to maintain it. Media – as seen in the functional logic of the messenger – thus make it possible to *deal* with difference. (3) The function of the messenger – and this is media-theoretically generalizable – is to *make something perceptible*. Aistheticization thus constitutes the very nucleus of all transmission processes, and transmission can be reconstructed as a form of display. (4) This is possible through a transformation that manifests a difference by neutralizing what is 'singular' in each case. Medial mediation thus creates the impression of *immediacy*.

Difference as Prerequisite for Transmissions

As you will recall, the original meaning of the word 'transmission" was tantamount to 'carry across': A burden is taken up and carried 'across

something',[2] like a bridge. It is a matter of overcoming not simply a distance, but rather a divide or a chasm. This image is quite revealing. Wherever transmissions are present, there must also be ruptures or oppositions, which could also be, in Thomas Mann's words, 'chasms of strangeness'.[3] Transmission thus acquires a fundamental difference-theoretical dimension.

This encourages a reconsideration of the various transmission phenomena discussed thus far: Despite the fact that they were created 'in the image of God', humans project onto God precisely those attributes that are unattainable to them, such as being immortal or omnipotent; as a result, the monotheistic God is as distant and different from humans as conceivably possible. Is it possible to imagine an abyss or schism more radical than the one between infinite god and finite humans?

Or, to move on to contagion: In the transmission of diseases, the practice of immunization through a controlled infection with a pathogen depends precisely on the obliteration of the difference between the self and the other so that the chain of transmissions can be interrupted. And conversely, this 'forced levelling' also shows that a form of difference constitutes the prerequisite for medical infection, as there can be no infection without a difference between the self and the other.

Or consider the intermediary function of money: The role of money first emerges in situations where there is a divide between desire and possession, when someone wants precisely what someone else has. Using the principle that 'one must give in order to be able to take', money also contributes to the (relatively) peaceful equalization of this separation. Furthermore, the heterogeneity of goods is the motor that drives the exchange of goods, and the function of money is to make disparate things commensurable through prices. This heterogeneity applies all the more to the credit function money, which is central to my argument.

In psychoanalysis transference could help rather than disrupt therapy – as Freud originally assumed – precisely because the patient's past, which was shaped by traumatic experiences, and his present, which is shaped by the affective resonance of 'his' analyst, are so clearly different that projecting an 'old' pattern of feeling onto the analyst potentially transforms rather than repeats that pattern.

And in the case of witnessing an irreconcilable difference obviously exists between, on the one hand, the perception and knowledge of the witness with regard to a past event and, on the other hand, the ignorance of the listeners before whom the witness testifies, who do not have access to this event.

In summary: A pronounced difference, an imbalance, a heterogeneity constitutes the 'divide' capable of sparking the maelstrom of a transmission event. The intensity of this difference can undoubtedly be modulated: It might simply be a separation in space and time, but in its most extreme form it is a reciprocal otherness and inaccessibility that can even make individuals afraid of one another. *There is no transmission without differentiality.*

Levelling or Articulation of Difference?
The fascinating question now is what happens to this difference in the course of transmission. As I already pointed out in my discussion of the messenger figure, messengers do not just bridge differences, but rather their acts of transmission also serve to maintain and reinforce these differences. This idea offers a more multifaceted image of transmission.

The same principle can be applied to Benjamin's reflections on translation: Translators could certainly understand the act of translating as the transmission of a text from one language to another. In this perspective, if the meaning of the text seems to remain 'the same' then translatability implies the possibility that linguistic differences can be neutralized: The same thing can be said in different ways both intralingually and interlingually. For Benjamin, however, this is precisely the attitude of the 'bad translator'. The 'good translator' does not depend on the equivalence of meaning; rather, he leaves space for the inherent deviations in the 'ways of thinking' to unfold, which brings the differences between languages to light. Instead of concealing the diversity and incommensurability of languages, therefore, translations make them apparent.

To return to the question of whether difference is levelled or articulated: Following Benjamin's concept of translation, is it possible to assume that transmission can be viewed from both perspectives – as the levelling *and* articulation of difference – although the more revealing philosophical perspective is the one in which transmission does not conceal differences but rather makes them apparent? To accept the normative element of Benjamin's 'good translator': If the question of what constitutes a medium is situated in the context of transmission, does this reveal an 'ethos of the medial' in the form of the demand that media must always manifest the difference in whose 'in-between space' they operate?

Consider the concrete transmissions that have already been discussed: A virus is insidious precisely because it is able to lodge itself in the cells of the host's body and reproduce like the host's own cells by transcribing and participating in the host's mechanisms of cellular reproduction. In the case of viral contagion, therefore, the divide between the self and the other is

subtly and radically suspended without 'instances' coming into play that mark this original difference.

Interestingly, however, such 'instances' occur in the case of personal messenger figures: In the context of this bipolar function, the apparent double role played by both the psychoanalyst and the witness can also be interpreted as bridging and exposing a difference at the same time.

As a 'neutral medium' the psychoanalyst constitutes a projection surface on which unprocessed experiences from the patient's past can be inscribed. This process thus opens up the possibility of *repeating* or re-experiencing problematic feelings from the past in the here and now of the psychoanalytic situation. As a participant, however, the analyst also establishes a personal relationship with his patient and becomes an affective resonant body, which makes it possible for a *change* to emerge from the repetition. A transformation of the patient's mental and emotional life thus takes place, and as a result the past can be forgotten and is no longer repetitively acted out.

Like the psychoanalyst, the witness also performs a double task: He must prove to be an infallible recording device, a disinterested witness, a mere medium of a past event, but at the same time he must also appear as a person who is authentic, credible, and trustworthy. The dilemma of the Holocaust witness sheds light on precisely this situation: It is only after the survivors have once again become respected members of society and have situated themselves as people in this society – if it may be put like this – that they can appear (for the first time) as witnesses of their own depersonalized status as victims of the Nazis. They are only able to bear witness to their disintegrated past from the distance of their reintegrated present.

It is thus clear that *transmissions are a way of dealing with difference*; they make differences manageable. I now want to probe a little deeper, and perhaps also more radically, into the idea that transmissions can equalize and at the same time mark differences between worlds, fields, or systems. Such a transmission strategy is 'ideally' realized precisely when transmission is interpreted as a process of *making something perceptible*.

Making Something Inaccessible Perceptible

This represents a turning point in my reflections. The idea of the messenger depends on the semantic field of communication and language use. And because the idea of transmission as the relaying of communication is tied to the origin of the word 'transmission' as the carrying across of a burden, it is also connected to the semantic field of transportation.

The history of words is irreversible, yet we create our concepts ourselves. As a thought experiment, imagine that it were possible to conceive of

'transmission' in a way that evoked entirely different associations than those of movement, carrying, and thus transport. Imagine that this concept was associated with the possibility of bridging a distance by allowing one side to 'visualize' the other and thus discover something that normally eludes perception because it is either strange or just distant. This thought experiment calls attention to the productive function that lies in the ability of transmission to expose and mark differences. It shows precisely the *visualization potential of the image*, whose power is based on both the opening and closing of the separation between the absence and presence of image content.

Is the connection between the role of the messenger and the act of making something perceptible echoed in these transmission procedures?

I will begin with Benjamin: Perhaps the concept of 'making perceptible' can account for the peculiar sacred turn in Benjamin's theory of translation and language, as the acknowledgment that 'post-Babylonian' linguistic diversity cannot be circumvented does not remain his final word on the matter: Benjamin actually starts from the premise that translations do not reveal identical meanings but rather divergent ways of thinking. However, because individual languages can be translated into one another they turn out to be different yet nevertheless compatible fragments of the 'pure language' that has been lost since the Fall of Man. This 'pure language' does not (any longer) exist, but translation can provide an image and an idea of it by manifesting a fundamental compatibility within the diversity of languages; the activity of the translator thus bears witness to the factual heterogeneity of languages while simultaneously revealing a universal bond that connects all languages in the vanishing point of the *one* 'pure language' that does not (any longer) exist.

Benjamin's theory of translation thus reflects a tension that is inherent to any form of imaging that consists in sensualizing (and symbolizing) something that was previously distant and hidden.[4] This tension was already discussed in the chapter on angels insofar as angels bridge the distance between the divine and the human and through their appearance they bear witness to the fundamental absence of God as well as God's real activities among humans. It is this duplicity that induced Massimo Cacciari to conclude that angels represent the incarnation of the principle of the image, which he interprets as '(being) one with his absence'.[5]

I now turn to the phenomenon of witnessing. The witness's statement – ordinarily – testifies to something the witness perceived himself; his speech is not supposed to make any claims about an event in the sense of *judgements*, but rather he is supposed to convey an image of what he

perceived as precisely as possible; and he presents this testimony in a situation where the perceived event is irrevocably past and hidden because it is (usually) no longer reproducible. The 'image' produced by the witness is thus made from language, and it becomes a substitute for the perception of a past event, which has become impossible to perceive in the present. The verbalized testimony should – ideally – mean the same thing to the jury that the original perception meant to the witness, but this is impossible due to the separation between the witness's private experience in the past and his public verbalization of that experience in the present; the witness perceived something, but the listeners before whom he testifies only receive a linguistic *description* of this perception, which can – intentionally or unintentionally – always be false. This is the origin of the paradox of witnessing, which is rooted in the fact that the witness must act in two different forms: as both a depersonalized recording instrument and at the same time as an authentic trustworthy person. The speech of the witness can thus be understood as the act of making something perceptible for others, yet at the same time it must also mark the impossibility of reproducing a private perception as a perception for others, as this making perceptible 'only' occurs in a linguistic form that opens up the possibility of false testimony.

In specifying transmission as a process of making something perceptible, as 'aistheticization',[6] it is essential not to confuse this with 'aestheticization'. As Martin Seel points out, aesthetic perception is a special mode of perception.[7] It is directed towards the phenomenal individuality of an appearing object or the game of appearances in the simultaneity of that which manifests in the presence of an object.[8] However, transmission processes make something perceptible while simultaneously evoking the absence of what is visualized, just as the messenger who speaks for someone else reveals the absence of the one in whose name he speaks while simultaneously making the 'aura' of this absent person present.

If transmission must be conceived as a process of making something that is sensually *inaccessible* perceptible, then a similarity becomes apparent: Isn't this principle – making something perceptible while simultaneously revealing is hiddenness – connected to my previous discussion of traces? The trace reveals not simply 'something', but rather the 'absence of something'. Wherever a trace is encountered or something is interpreted as a trace, this trace is understood as a material mark that refers to something which is no longer there – otherwise there would be no trace.

Until now I have focused on transmission within the context of the messenger model; is it possible and perhaps also time to conceive of traces

as 'involuntary messengers' so that the meaning of 'transmission' might also be discussed in terms of the formation and interpretation of traces? Is it thus possible that what is strange about the messenger model (i.e. that the messenger is still a passive example of someone who has been commissioned for an assignment) could lose its potential for irritation to a certain extent if it is associated with the concept of the trace? Before pursuing this line of inquiry, I would like to explore a further attribute related to the 'material of transmission': What does it mean to reveal something precisely by withdrawing oneself?

Articulating Difference through Self-Neutralization

The messenger's characteristic gesture, which is based on the heteronomy of the messenger's errand, is *self-neutralization*. It is only by suppressing his own senses and structures that the messenger is able to manifest other senses and structures medially. The medium thus presents its message by withdrawing at the same time. There is an inherent connection between, on the one hand, the 'immediacy' of mediation, which is immanent in the medium itself, and, on the other hand, the suppression of the medium's own logic. I will explain this more concretely:

Money reveals this process of self-neutralization in an exemplary way because its intermediary role is based on desubstantiation. There is only talk of 'money' when the means of circulation is no longer a concrete good, like wheat, pearls, or clams. In the conventional sense money can neither be 'used' nor can it be subject to any *physical* changes at all over time. Due to its mobility and its lack of qualities, which reinforces its 'pure countability' (discreteness), money thus embodies – whether as coins, paper, or electronic money – the function of providing a standard measure of value for relations of economic exchange.[9] Money provides a standard measure for the exchange for goods precisely because of its 'desubstantiated substance' and its 'indifferent non-content', which enable the homogenizing quantification of qualitative differences.

Or consider viral infections. Aren't viruses able to make themselves 'unrecognizable' to the host precisely by transcribing the DNA of the host's cells and reproducing themselves in the host, thus becoming part of the afflicted organism itself? It is also possible to describe the viral transcription of cell DNA metaphorically as follows: Viruses neutralize their otherness by converting to the host's mechanism of cellular reproduction and thereby donning the 'mask' of the host cell.

The interplay of depersonalization and personality is fundamental to the figure of the 'personal messenger'. For Freud – unlike many proponents of the 'interactive turn' in psychoanalysis – the self-withdrawal of the analyst

in the sense of the suppressing of his own personality is precisely a *conditio sine qua non* of psychoanalysis. Various strategies of 'anonymization' – like sitting outside of the patient's field of vision – are supposed to enable the physician to function as a suitable projection surface for the transmissions from the patient. However, the analyst is not supposed to consider himself and behave as a receiver of these transmissions, but rather he is supposed to act as a mediator between the (unprocessed) emotions of the patient's past and his present emotions.

The figure of the witness also presupposes a seismographic potential (which is paradoxical, like all such unrealizable assumptions) in that the witness is an observer of rather than a participant in a past event and he must withhold his own judgement and commentary when describing this event.

And aren't word-for-word translations, which Benjamin prefers because they manifest the differences between languages better than 'creative' adaptations, also a form in which the translator is considered 'good' precisely because he relinquishes his own personal ingenuity?

Various approaches to the self-withdrawal and self-neutralization of the medium have already been thematized – as pointed out earlier[10] – such as Aristotle's 'diaphanous medium',[11] Fritz Heider's 'extra-conditionality' of media,[12] Niklas Luhmann's 'loose coupling' by virtue of which the medium remains invisible in the visibility of the form itself,[13] Dieter Mersch's withdrawal of media in their implementation,[14] and Boris Groys's notion of the medium as a material sign vehicle that remains concealed behind the meaning of the sign and is only seen when the sign function is suspended,[15] not to mention the topos of the 'disappearing messenger'!

This raises the question of what has actually been accomplished by locating the an-aistheticization and self-neutralization of the medium in the *messenger's errand*? What is the 'added value' of reformulating this phenomenon in the context of the messenger model?

To start with, the *definitional core* of my media concept is that the medium must suppress itself in order for something to be visualized. This conditional relationship can be considered the 'basic law' of the performance of media. The interrelationship between 'making something appear' and 'withdrawing oneself' provides a criterion that distinguishes media from related phenomena, such as signs but also technologies. To express this idea in a more ontologically cautious way: This criterion makes it possible to delineate the unique character of the *media perspective* from the perspective of signs and technologies. Moreover, this criterion represents the point at which medial disruptions and derailments are identifiable, as a medium

turns into a non-medium when it discards the neutrality of the mediator position in order to become a 'party' and actor itself. And the media of the arts can for the most part be understood as suspending this 'functional law of mediality', but in the process they also contribute to its illumination.

Nevertheless, the 'added value' of this concept exceeds the functional logic of mediality and the criteriological framework associated with it. It is related to a fundamental metaphysical intuition that the world in which we live is not the same as the world that appears to us. In the Western tradition, this intuition introduced a transcendence that was furnished with the index of an immateriality, which enabled it to elude localization in space and time. Yet regarding the medium as a messenger, who can only perform his task by withdrawing and suppressing himself, opens the possibility of reconstructing the relationship between the visible and the invisible (or: the audible, the palpable, etc.) as a *continuum of materiality*. And once again it is the trace – which I will address in the next chapter – that is particularly significant for this 'grounding' in materiality. First, however, I want to go one step further in answering the question of how the messenger perspective and the an-aistheticizing tendency of the medium provide a new dimension.

The messenger is a figure whose performance depends not on the strengthening, but rather on the weakening of the 'self': In order to reveal the other, the self must thereby withdraw. It is not an 'I', or even a 'you', but rather a 'he, she, it' in their unmitigated exteriority that are (made) present in the messenger's errand. The messenger is the incarnation of the metamorphosis in which an *I becomes an other by transcending the self in the act and as an act of making the other perceptible.* Consider once again the metaphysical impulse to transcend one's immediate existence. Is it possible that this impulse is based not simply on our epistemological relationship to the (visible or invisible) world, but rather – much more – on our ethical relationship to the other? To start with, does the 'double world' that metaphysics understands as its own reflection represent the social realm of experience of our personhood, which does not bear witness to the unalterable identity of the self but rather to the possibility of self-abandonment in order to render the other visible? The messenger perspective thus suggests that transcendence proves to be fundamentally self-transcendence: People do not transcend the visible world so much as the self in that they 'speak with someone else's voice'. It is no coincidence that the word 'person' refers to '*per-sonare*', or speaking through the mask. How significant is the cultural-historical coincidence of theatre and metaphysics in this context?[16]

These thoughts anticipate the epilogue, but I will now turn to the question of how the idea of making something perceptible appertains to traces.

Reading Traces

This chapter will shed new light on the meaning of transmission by reflecting once again on the phenomenon of the trace. I will begin by clarifying the meaning of the term 'trace'.

Traces as 'Messengers from the Past'?

The word 'footprint' (Old High German '*spor*', Middle High German '*spur*')[17] is etymologically significant because it provides a way of intuitively tracking down the conceptual origins of the trace.[18] A footprint is an impression that reveals the presence of someone or something in the past; it crystallizes a movement in time as a spatial configuration. The presence of the trace thus bears witness to the absence of what caused it. While the trace is visible, what produced it remains withdrawn and invisible. In other words, the presence of the trace visualizes the non-presence of what left it behind. The trace embodies not the absent thing itself, but rather its absence.

The trace actually reflects the same quasi-magical 'real presence' that I already discussed as a facet of the efficacy of images, which similarly oscillate between the absence and presence of the pictured object: Because traces are due to the causal nexus of a past event, this event is 'somehow' projected into the present in the form of the trace. The trace thus reveals something that is irreversibly past yet still indirectly apparent at the time when the trace is recorded and interpreted.

Unlike the index, which signifies something *synchronous* even if it is perhaps not visible – like the (functioning) weathercock that demonstrates the direction of the wind – the formation of the trace is based on the fundamental *asynchrony* between the time when it is made and the time when it is read. Smoke is an index of fire, but ashes are its trace. Traces thus require a temporal break, as they always refer to a past event: traces are remnants.

This immediately suggests the question: Is it possible to conceive of traces as 'messengers from the past'? Wouldn't this provide the key to explain the presumably close relationship between messengers and traces, as messengers are understood as conveying *transmissions across space* while traces convey *transmissions across time*? Messengers and traces thus constitute different dimensions of transmission, which is understood in the former case as a spatial process and in the latter case as a temporal process. It would undoubtedly be possible to see it this way, yet this approach is not sufficient. From the very beginning, the basis of all transmission processes was described as the 'in-between' position of the messenger, which refers not only to spatial distances but to 'difference' in general.

Temporal displacements are therefore already implicitly included in the messenger model.

However, there is still a deeper underlying reason why it is insufficient to presume that traces are simply 'messengers from the past' – a reason, moreover, whose explanation suggests that the trace is more like a reversal of the messenger's errand. That is therefore my hypothesis: Messengers and traces are paradigmatic configurations of transmission insofar as they are related to one another figuratively like the front and back sides of a page. As basic versions of transmission, messengers and traces are inseparably connected to each other. Nevertheless, they are connected such that – in keeping with the same metaphor – the 'inscription' that the messenger model leaves behind on the front side of the page is read 'backwards' and is thus inverted from the perspective of the back side – that of the trace. *Reading traces is thus considered the inverse function of the messenger's errand.* This inversion suggests an expansion of the concept of transmission, but this expansion nevertheless reveals at the same time the borders of this concept.

So what does it mean to understand reading traces as an 'inversion of the messenger's errand'?

Reading Traces as an Inversion of the Messenger's Errand

You will recall that the messenger is situated between two divergent hetero-geneous sides and is thus associated with the postal principle. The roles of activity and passivity are clearly distributed: The sender tells the messenger to do something and the addressee receives something. The receiver is seen as the one to whom something is delivered; to express it in the language of telecommunications, he functions here only as an 'information sink'. The messenger operates in the space of meaning deferral, which means precisely that the materiality and the meaning of the message are separate. The messenger's 'business' thus unfolds in a continuum of materiality that serves its purpose when the transmitted message is received, regardless of the meaning that the message has for the receiver. Reception is independent of interpretation. That is why the postal principle is absolved of the burden of meaning – from the perspective of the messenger function at least.

But what happens to the distribution of activity and passivity and the abstraction of meaning when seen from the perspective of the trace? Can it be assumed that the one who left the trace behind plays the active role and the one who records and reads the trace more or less plays the passive role? Moreover, can traces also be localized in the intermediate space of meaning deferral, like messengers? Obviously traces *cannot* be reasonably

described in this way. And there are (at least) two interrelated reasons for this: The lack of motivation on the part of those who cause traces and the creation of traces through the act of reading them.

(1) I will begin with the *lack of motivation*: Traces are not produced, and this fundamentally distinguishes them from all other sign events – as well as from the messenger's errand. Traces are unintentional remains: Only things left behind involuntarily, unintentionally, and uncontrollably can then be read as traces. If something is consciously designed as a trace, then it is not really a trace but rather the staging of a trace. It is not intentionality and conscious awareness that give rise to traces, but rather only the materiality and gravitational force of being; Traces are due to the 'blind force' of bodies acting on each other in the continuum of material worldly relations. This lack of motivation means that leaving traces behind is not a theoretical act: It is an effect, but it is never the intention, purpose, or goal of an action. *Traces are phenomena that must be caused but cannot be intended.* Traces are not ordered or commissioned.

(2) At the same time, the idea of intentionally creating traces does not completely disappear. In the messenger model it is the employer who actively creates, but in the case of traces this role is performed by the one who pursues and identifies them. Traces are thus *constructed*, and this insight shows how they invert the postal principle: Despite the fact that traces lack motivation, it is not absurd to assume that traces have a 'creator'; however, this creator is to be found not where traces are caused, but rather where they are perceived and pursued. In order to understand this idea it is necessary to explain more precisely what it means to 'read traces'.

Traces are read – or at least this is what our language use implies; however, they are not written.[19] The act of *reading* traces must therefore be understood as the act of 'picking up' and 'reading out'. Traces are not simply encountered, but rather they originate in acts of securing and identifying traces, which in some cases are very difficult and elaborate. Strictly speaking, traces originate in the eye of the reader. Through the process of reading traces, *'things' that are the effects of something are transformed into traces for something*. The direction of this process is shaped by the actual context of the search for traces or the interests that guide it. Furthermore, the search for traces is an activity that is only able to expose traces at all through intense engagement with the material that qualifies as a possible trace. Nevertheless, the use of the word 'expose', as well as 'find' and 'discover', is thoroughly ambiguous. When traces can be conventionalized in a kind of 'sign register', such as when ideal examples of tracks are represented in a hunting handbook, then it is possible to speak unproblematically of a

'discovery of traces' on the forest floor. However, this situation becomes much more complicated when the forest floor is half frozen and countless tracks run through one another; it is then a matter of determining how fresh or old the tracks are.

Actually, something only becomes a trace when it occupies a well-defined place in relation to a plausible story that produces a connection between the visible and the invisible. The formation of traces is always due to a disruption of order, which is then integrated into a new narrative order by reconstructing the trace-forming event as a story. And the story that corresponds to this reading – and thus the 'semantic' of the trace – is dependent on the interests of the reader, who is searching for a way to resolve something uncertain or unknown with the help of this practical and theoretical activity. Reading traces thus means 'making things talk', yet things are mute. They only become eloquent – and thus become traces – through the stories told by readers. And there are always many possible stories; traces are thus polysemic. Yet the idea of polysemy itself needs to be defined more precisely.[20] Traces are not strictly speaking ambiguous, but rather the same perceptible mark can be transformed into entirely different traces of something depending on the narrative contexts and the reader's orientation requirements.

Traces thus emerge through the work of interpretation, which is rooted in the actual context of the reader and is compatible with the narrative creation of causal dependencies. It is therefore impossible to separate what a trace is from the meaning associated with it. Traces represent the formation of sense out of non-sense.

Perhaps it is now clear: The concept of the trace as 'involuntary messenger' does not simply refer to traces of the past. Rather, some element of the material continuum, in which we are all embedded, is *transformed* into a medium insofar as something perceptible is regarded as a point of reference in order to reconstruct an event that is no longer perceptible. Causes have effects, but these effects do not have the status of traces. The transformation of an effect into a trace is not an act that can be attributed to those who caused the trace – who seldom have any interest in leaving traces behind; rather, it can only be attributed to those who receive what the trace medium can transmit. *The trace is a 'messenger' that is 'delegated' – metaphorically speaking – by the receiver of the message.*

In the context of the postal principle, this idea can also be expressed as follows: The reader of the trace acts as an addressee of something whose unintentional sender must first be reconstructed.[21] It is precisely because of this role reversal that the trace is an inversion of the messenger concept.

Messenger and Trace, or On the 'Sign' as the Basis of Communication and Cognition

But what has been gained by this inversion? In other words, if the messenger and the trace are viewed as inverse media-theoretical figures that embody the 'front and back sides' of the postal principle, how does a consideration of this inversion expand the messenger perspective?

An answer immediately suggests itself: What the trace opens and adds is an *epistemological* expansion. Even though the transmission event is fundamentally about making something perceptible, the messenger is still an instance of *communication*. But the trace is part of the domain of *cognition*. The acts of identification associated with the reading of traces can provide a sense of guidance and transform uncertainty into certainty; the reading of traces is thus a cultural technique of knowledge production. When viewed from this perspective, reflecting on the trace expands the messenger model precisely by adding a dimension that is marked as a constraint in the transmission aspect of messages: namely, the idea that something new emerges and is discovered through transmission.

Carlo Ginzburg's 'paradigm of signs' established a connection between, on the one hand, the 'wild knowledge' of reading traces as an archaic technique of orientation and, on the other hand, cognition through signs and symptoms as a humanities methodology.[22] Even in the natural sciences – as Jörg Rheinberger already emphatically pointed out[23] – the bulk of the investigations of what are often 'invisible phenomena' are due to the cultural technique of reading traces. Ludwig Jäger showed with his 'transcription'[24] approach that our ability to refer back to what we do as a trace, and thus to be able to maintain a distanced, observing, and reflecting relation to what we voluntarily and involuntarily create, is a if not *the* culture-endowing act. The aspects of this epistemology of the trace have been well examined elsewhere, so I won't go into it here.[25]

A preliminary answer has now been found to the question of what is gained by shifting from the messenger to the trace. Our communication and our episteme are dependent on transmission conditions that are embodied in the figures of the messenger and the trace, which make something perceptible. When seen in the light of this concept of transmission, 'signs' prove to be the root of understanding (communication) *and* cognition.

However, as remarkable and momentous as the cultural and epistemological technique of reading traces is, *this* expansion of the messenger model is not yet enough. For the joke of the inversion of the messenger figure does not lie simply in the fact that it compensates for the deficits of the messenger model and thus expands it such that the act of 'making the

imperceptible perceptible' through transmission is not only fundamental
to communication but also to cognition; even though this expansion is of
considerable value. Rather, in the course of reflecting on traces the idea of
transmission and medial mediation itself can become to a certain extent
problematic and thus its borders can be made apparent. These borders
emerge when the 'reconstruction of the sender through the addressee',
which constitutes the nucleus of reading traces – up until now at least – is
visualized as a 'non-thing', as something virtually impossible. And this
dimension is revealed through Emmanuel Levinas's reflections on the
trace.[26]

Transmission as 'Transition': Mediality beyond Transmission
Levinas also leaves no doubt that traces can function as a kind of sign.
While the mark lies in plain view, something concealed behind it can be
deduced. In the process of interpreting this appearance as a trace, what is
presently veiled can at the same time be unveiled. This is how a detective
examines traces at a crime scene, how a hunter pursues tracks in the wild,
how an archaeologist digs for the remains of past civilizations. Levinas
actually distinguishes between signs and traces in terms of intentionality/
unintentionality, but the trace always '*also* plays the role of a sign; it can be
taken for a sign'.[27] So, as my epistemology of the trace already shows, the
trace is part of the universal referential context of the world, in which every
effect can at the same time be considered a sign of its cause. When seen
from this semiological perspective, the trace represents the possibility that
the past is still available in the present through remains and the future can
already be deduced in the present through signs. When the trace is viewed
as a sign, according to Levinas, the world of the present merges with the
past and the future in a more or less unified order. It is a 'strategy' that
forces everything imperceptible back into the immanence of a discernible
and manageable present, that reveals its transcendental character, and
that integrates it more or less seamlessly into the familiar world. Through
the semiology of the trace, the inaccessible beyond becomes part of the
accessible world.

Yet this epistemological positivity obscures the specific meaning of the
trace, which cannot be reduced to denotation and identification or revealing
and unveiling. The authentic trace actually 'disturbs the order of the world'[28]
insofar as it asserts an irresolvable unfamiliarity, an incomprehensible
otherness, an irreversible pastness, a constitutive withdrawal. And it is this
'disturbing' function of the trace that reveals a mediality beyond transmis-
sion. I will address these points one by one.

First, visualize the philosophical motive that moves Levinas to understand the trace in the context of an ungraspable otherness. Western philosophy assumes that everything external, unfamiliar, transcendent, and otherworldly can be subsumed and absorbed into one's own understanding by virtue of the egological function of consciousness. Odysseus, whose journey is ultimately a return to the self, thus becomes a symbolic figure: 'This experience would still remain a movement of the same, a movement of an I.'[29] This defence against the unfamiliar is an inherent part of human relationships, the fundamental aim of which is (usually) to unveil and understand the other and thus deprive the other of precisely his otherness.[30] By understanding and assimilating the other according to the standards set by one's own consciousness, the 'I' becomes absolute and the other becomes an 'alter ego'.

But is this egological absorption the only possible way? What would it mean if the other actually remained 'absolutely exterior',[31] if the 'I' experienced the other as something entirely external to the self – what Levinas calls a 'heteronomous experience'[32] – or, more precisely, if the 'I' was subjected to this experience of heteronomy? This would initiate a movement that does not return to its own starting point – like Odysseus; it would reveal a transcendence that no longer bends to the immanence of the self's own familiar world.

This emergence of something other than the self occurs when the other is encountered as a trace – an 'authentic trace' that cannot function as a sign for something. Of course the other always remains a decipherable sign that can be deduced through 'hermeneutics and exegesis'. But that is not the extent of its meaning. And this surplus of meaning, which is inherently beyond understanding, revealing, and unveiling, becomes apparent for Levinas in the 'face': 'The phenomenon which is the apparition of the other is also a *face*.'[33] Levinas's concept of the 'face' must be understood as the manifestation of an inaccessible world whose essence cannot be found through the conscious interpretation of an appearance. This approach conceives of the face as an *expression*, but what manifests in the face *cannot* be understood as a sign. It is a sign that no longer refers to anything, and such a sign is precisely that of the 'authentic trace'.

The face does not reveal a hidden world behind the visible surface, which emerges through the act of reading traces. The face is a kind of trace that is beyond our world; it transcends sign-mediated cognition. It is the trace of an absence that does not manifest in the present. 'Such is the signifyingness of a trace.'[34] The face reveals a transcendence that is opposed to the order of immanence insofar as time is experienced in the trace as absolutely

irreversible, as an irreversible past. It is therefore no longer a trace that is 'created' through interpretation, but rather it is a trace of the 'weight of being itself'.[35]

So long as the trace is conceived as an index, it is always still committed to a model of *simultaneity* insofar as a past event becomes part of the present of a trace reader and this present can be successfully overcome through reference to the trace. In Levinas's interpretation however, the inimitability of the trace lies in the irreversible pastness of something; it testifies to a movement that is not (any longer) an Odysseian return and cannot be defined merely as '*passing* toward a past'.[36] Levinas does not say that time is spatialized in the trace or that time is thus inscribed in space, but rather that the spatial itself becomes temporal: 'A trace is the insertion of space in time, the point at which the world inclines toward a past and a time.'[37]

Traces are usually spatial configurations that accommodate our prefer- ence for representing and understanding temporality as spatial order (time frame, arrow of time, point in time...). Yet Levinas radically interprets traces as a temporal phenomenon, to which everything spatial must 'defer': As a result, the irreversible temporality that is encountered in the trace can no longer be converted into a simultaneity.

When the other is encountered as a face – Levinas emphasizes – he moves into the position of a third, which is outside the bipolarity of ap- pearance and essence or 'I' and 'you'. He becomes the 'possibility of that third direction' beyond the game of immanence and transcendence, which immanence always won. He is no longer subordinated to the 'I' and yet also escapes the familiarity of the 'you'. He ('*il*') is the third person and is actually understood as '*ille*' or 'that': Thirdness is encountered in the other as '*illéité*'.[38] This inconceivability of the other permanently disrupts the egotism and autonomy involved in thinking of others as projections of the self. The face disarms the 'I'. Levinas describes it as an 'expulsion' of the 'I' and his consciousness.[39]

Yet for Levinas this 'putting into question of the self' is then transformed into a *receiving* of the other.[40] And this reception of the incomprehensible other must be imagined as a call to be answered by the ego. The 'I' is virtu- ally compelled to answer and the only thing that makes him unique is the fact that no one else can answer in his place. What emerges in the encounter with the inexplicable other is therefore *responsibility* as the nucleus of morality and ethics, which depends on this 'practical turn'. Let it be understood: How this answer turns out, whether it results in solidarity or violence, is not at all certain. That is what makes the situation ethical: It can be 'good' or 'bad' and it is thus characterized by the either-or of a moral

decision. With the '*via negativa*'[41] of the trace it becomes the starting point for exiting the self and entering into personal responsibility for the other. For Levinas, the 'negative epistemology of the trace' is transformed into a 'positive ethics of the trace', which can only be achieved as practical activity and practiced intersubjectivity.

'Authentic Trace' and Presence

How does Levinas's idea of the 'authentic trace' contribute to these reflections on the theory of transmission?

(1) *The authentic trace as opaque medium.* To start with, it is a remarkable coincidence that Levinas's concepts – *summa summarum* and taken literally – are reminiscent of the messenger model, as they involve a *heteronomy*, an *exteriority* that cannot be converted into an interiority, a *thirdness* beyond the relationship of 'I' and 'you', a *passivity* and a *receiving*, the spiriting away of interpretation and meaning, and even the material '*weight of being*', which manifests itself instead of consciousness. The concept of reading traces provides a new perspective that expands the concept of the messenger by altering the distribution pattern of passivity and activity; instead of the sender, it is the interpreting and reconstructing reader and thus the 'receiver' who performs the active role. Although Levinas has good epistemological reasons for emphasizing this interpretative aspect of the trace as a sign, it is not philosophically appropriate for his concept of the trace, as everything there is to say about traces-used-as-signs has (already) been best explored and analyzed in semiotic discourse.

No, Levinas describes the reader of traces – the 'I' who encounters the face as a trace – as someone who receives and is even 'afflicted' but who precisely cannot seek refuge from this passivity in the activity of interpretation. What occurs here is a pole reversal of activity and passivity, if you will, as the ego loses the power of construction and interpretation granted to him as a reader of traces.

What the 'I' encounters in the trace is a form of mediacy that cannot dissolve into immediacy; it is not a transparent medium for another world, from which it bears witness to a message. *The 'authentic trace' is a medium in its opacity*: It is the appearance of the indissolubly unfamiliar, which does not belong to the world of the ego.

Until now the foundation of mediality has been characterized as 'making the imperceptible perceptible', which assumes that there is something beyond the medium that manifests in the medium itself, but this view must now be amended or to a certain extent revised: When the trace becomes an opaque medium for the 'I' rather than a referential sign, the result of its

refusal to 'make something perceptible' is that it elicits a response from the 'I' – no: it compels the 'I' to respond. But this response cannot be an epistemological-interpretative gesture, as Levinas rejects the notion that the medium mediates between the 'I' and a distant world. This response thus proves to be the elementary form of an 'ethical act' insofar as it initiates a relationship to the other – whether sympathetic or antipathetic. The 'authentic trace' of the other thus constitutes a medium, and the opacity of this medium precludes the possibility of semiological interpretation, which becomes the seed of (moral) action. For Levinas the difference between the sign and the trace, which can also be read as the difference between the sign and the medium, manifests as the difference between interpretation and action: Traces compel people to act. Does this relationship between mediality and action echo Benjamin's claim that media have a performative dimension, as the immediacy of the medium reflects an agency that is most clearly expressed in the creative power of the word of God?

(2) *The 'authentic trace' as the embodiment of a presence.* Levinas's considerations assume that by 'using' the trace as a sign for something, the reconstructed past as well as the predicted future are adapted to the regime of the familiar present. For the purpose of formulating a theory of transmission, this can also be understood as follows: The spatial implications of 'carrying across' – the etymological origin of transmission – ensure that references to time are based on simultaneity rather than asynchrony, which is inescapably tied to the idea of time as a continuous succession of events. Simultaneity is a spatially inspired notion of time that negates its irreversibility or its simple pastness.

Interestingly, this corresponds to an aspect of media that Friedrich Kittler saw more incisively than anyone else[42]: It is the fact that all media have an inherent tendency towards time axis manipulation; the reversal of temporal orders is central to media technologies. There is no doubt that the mediality of the trace – inspired by Levinas – is to be understood as a break with this tendency to negate the irreversibility of time. It directly ushers in the irreversibility of time. For Levinas, therefore, 'being other' is actually 'becoming other', as it is contingent on the passage of time, and as a result the concept of 'transmission' is replaced by '*transition*', which is embodied in the pastness of the trace. 'Pastness' should not be understood here as referring to a past event or to someone passing by who leaves behind a footprint that – potentially – allows him to be identified and recognized in the present. Rather, 'pastness' acknowledges the irreversible and ungraspable absence of these past events, which no media technology or interpretation is capable of bringing back.

While 'transmission' depends on and bears witness to the possibility of interrelating different things through simultaneity, the opaque trace is based on irreducible asynchrony. Yet this is precisely why the trace demands a *response.* The opaque mediality encountered in the face as a trace of the other at the same time proves to be the seed of an intersubjectivity that does not integrate the other into the subject's horizon of understanding by transforming him into a sign, but rather allows him to 'stand on his own'. The other is no longer a condensation of descriptions and designations, but rather he is 'beyond representation'. For the first time, the other is truly *present.* The encounter with the other thus embodies a subversion of representation, which enables the *experience of presence.*

To return once again to the beginning of this study: From the outset it emphasized the difference between a medium and a sign – a difference, nevertheless, that should not be understood as disjointed ontological sorting, but rather as a methodological difference in the perspective that can be adopted with respect to one and the same fact. A medium is precisely *not* a material signifier. Indeed, what distinguishes a metaphysical approach, which attempts to unveil a hidden reality 'behind the appearance', is that the medium and the sign deviate from each other.

Material sign carriers must be perceptible, as their appearance to the senses promises an immateriality and transparency of the sensual that allows the meaning of the sign to be deduced (not through the senses). Media, on the other hand, convey meaning by virtue of their ability to conceal their own materiality and make themselves invisible. The relationship between mediacy and immediacy, between 'depth' and 'surface', is therefore transposed for the sign and the medium: The immediacy of the material sign carrier requires penetrating the surface and reaching the meaning of the sign, which is no longer visible but rather only interpretable. The immediacy of medially conveyed meaning, on the other hand, requires leaving the surface behind in order to expose the hidden materiality of the medium in its 'depths'. This materiality has just been explicated in the context of the transmission functions of the messenger.

Yet in the transition to the trace, which is considered an inverted form of the messenger model, a constellation emerges that is similar to the one between the sign and the medium. As a positive technique of orientation and cognition, the trace makes identification possible and thus proves to be semiological. The cause of the trace is therefore determined by the reader who interprets it, and it is only explicable as a narrative connection of transformations in the *continuum of materiality* of interrelated events. *A posteriori*, it could then be said of 'successful' interpretations that the

materiality of the perceptible trace *represents* their no longer perceptible and thus absent cause.

However, the materiality and exteriority of the authentic trace *presents* a presence that cannot be defined by relating it to something ideal or material or to causal relationships at all. And it is precisely for this reason that the authentic trace embodies a presence and (not only) a representation.

Understanding traces as modalities of the messenger serves to refine the distinction between the sign perspective and the media perspective, as this methodological distinction appears once again within the media perspective itself – namely, in the difference between the semiological and authentic trace.

Is it possible to conclude this discussion with a very general observation that signs are to media as representing is to presenting? *Do media therefore create experiences of presence*? Is this the source of their efficacy and fascination? The paradoxical 'joke' of this presence lies in the fact that – and this is precisely what is implied by the non-semiological dimension of the trace – it is the presence of an absence that cannot be converted into a presence but that still 'draws in' and involves the subject. (One example is Levinas's 'response' but another is 'immersion', a tendency inscribed in *all* media that does not begin with the virtual reality of the computer but rather already takes effect in the reading of a book, which grips and transfixes the reader.) *Media produce an immediacy of the mediated.* Does this involvement in something immediately at hand yet at the same time withdrawn constitute the nucleus of cultural practices? Is 'unmediated mediation' the term for this, and isn't this precisely what Benjamin understood by 'medium' (in contrast to 'instrument')?

The telos of the Enlightenment project seemed to be the discovery of symbolic difference, the categorical distinction between signifiers and signifieds, but in the late twentieth century this became problematic to a certain extent due to the discovery of the 'quasi-magical power' of the performative (Searle). 'Performativity' was thereby reconstructed as an attribute of semiotic processes insofar as these processes also perform and carry out what they signify.

It could also be said that in the performative representation changes into presence. From the perspective of the performative, the ingrained borders between 'sign' and 'thing' prove to be permeable. Can it be assumed that from the perspective of *media theory* presence is made possible through transmissions precisely because the imperceptible is made perceptible (as in the messenger's errand)? Can it also be assumed that the perceptible appears as the irreducible and indissoluble presence of an absence (as in the

experience of the trace), which is no longer defined in relation to something imperceptible because medial presence is its *only* form of perceptibility and givenness? The complexity of the interplay between the messenger and the trace consists in the fact that both assumptions can be confirmed.

Test Case

Maps, Charts, Cartography

I have not yet provided an example of a phenomenon that can unproblemati-
cally be identified as a medium or demonstrated how the messenger and
transmission perspective I have developed actually brings to light *new*
aspects of this phenomenon. There are two additional requirements that
would – ideally – be satisfied by such a test case: It should be a medium
that cuts across different times, that is not rooted in only one respectable
tradition, but rather that provides a context in which the changes associated
with the development of information technologies and digitalization can
also be reflected and studied. Furthermore, this medium should embody
its mediumness in such an exemplary way that it is endowed with a certain
metaphorical potential and its mediality condenses or is condensed into
a *dispositif*.[1]

I have chosen to focus on maps and cartography. It is no accident that
'maps' and 'cartography' have been named here at once, for a theoretical
dispute has arisen concerning the 'epistemological nature' of maps that
is quite revealing for my own purpose. The perspective of the messenger
and the trace will hopefully provide a new view of maps, which is distinct
precisely because it introduces a new position in this cartographic dispute.
It should come as no surprise that I want to conceive of this new position
as a 'third' or a mediated position.

Maps are 'foundational texts' of our civilization.[2] Maps drastically
visualize what 'world pictures' or 'worldviews' literally mean and how
fast they change.[3] They have so deeply penetrated everyday life that their
mostly unobtrusive presence is hardly noticed. Whether as weather chart,
city map, subway plan, or road atlas, it is nearly impossible to imagine
movement through space without the intervention of maps. These ex-
amples suggest what is initially meant here by the word 'map': pages[4] or
surfaces that contain graphic markings of relations between places in the
form of a spatial, two-dimensional representation. These places can be
real or fictional, they can refer to every possible form of bodies, territories,
empirical facts or purely epistemic entities. There is hardly anything that
cannot be represented cartographically in the form of spatial relations.
The tremendous diversity of the maps that have survived from differ-
ent times, cultures, practices, and orders of knowledge is also virtually
incalculable.

I will thus focus on a fairly selective view: I am only interested here in the elementary forms of familiar maps that claim to represent a more or less substantial spatial territory in such a way that people are able to *orient their actions* within this territory. These maps are employed to refer to a given 'reality' beyond the map, in which the user of the map is practically embedded. I will not address fictional or thematic maps, as their representational form is always already dependent on the model of geographical maps.[5]

I will now discuss the theoretical dispute concerning cartography, which serves as a starting point.

The Narratives of 'Transparent' and 'Opaque' Maps

This dispute focuses on a difference in the interpretation of maps, which I will call – following Christian Jacob – the difference between 'transparent' and 'opaque' maps.[6]

(1) From a *naturalistic-oriented perspective* the map is considered 'transparent', as it is committed to the general principle of exact representation. Its narrative is thus reconstructed as follows: Like the cinema screen on which a film is projected, the map is a technical and symbolic artefact that disappears 'behind' the information it transmits. The content of this information is an illustration of the actual conditions of an external territory, which is as precise as possible. The goal of mapping is to produce a correct and undistorted relational model of a terrain, which enables the producer of the map to transmit information about a territory to the user. The map is thus a medium that represents and mediates knowledge. What matters most is the content of the map or what the map represents.

There is a clear progression in the precision of maps, as they are dependent on the evolution of measuring techniques and forms of graphic representation, and as they become more precise they also approach ever closer to reality. At the same time there is an important historical break in this progressive narrative, the so-called 'cartographic reformation'[7] in the seventeenth and eighteenth centuries, when map producers abandoned the elaborate and fantastic projections created in their studios and exchanged them for fieldwork in a landscape whose topology was exactly quantifiable.[8] The production of maps was considered no longer an 'art', but rather a 'science'. The map became an incarnation of the purity and neutrality required of exact scientific representation. It evolved into a metaphor, which was the force behind the knowledge claims of science: to know something was to be able to substitute it with a symbolic representation that approximated it exactly.[9]

(2) This approach can be distinguished from the *instrumentalist-constructivist perspective*, which is committed to the narrative of the 'opaque' map.[10] To return once more to the film analogy, which Jacob himself introduces to explain the difference between 'transparent' and 'opaque'.[11] Film can be discussed in terms of the optical, chemical, technical, social, and cultural conditions that make film projections and the institution of the cinema possible. This is the standpoint of the 'opaque' map, as the map itself becomes an object. From this perspective maps do not simply depict a territory, but rather they create it. Mapping techniques obey their own technical, semiotic, and social conditions and conventions, which are in no way congruent with the rules of mathematics and logic. Politics and power are then also part of the conditions of cartographic activity.[12] The key question thus becomes not *what* a map represents but rather *how* it does this. And this 'how' is bound to and shaped by the interests that determine the production as well as the use of maps. Maps are no longer considered a neutral means of representing knowledge, but rather they are seen as instruments and tools that can only be understood in the context of their production and use. This instrumental approach is graduated: It ranges from the description of maps as means of communication and text to the notion of maps as ideological and political instruments of power. In the opaque view maps are considered social constructs; they are anchored in practices that are informed by the worldview of an epoch. In other words, maps are witnesses of time. This post-representational[13] or representation-critical approach to maps is methodologically legitimated as a form of deconstruction, as it applies the deconstruction of textuality, introduced by Foucault's socialization and historicization of epistemes and developed by Derrida, to maps.[14]

This is the basic constellation of approaches to cartography, which can also refer to different philosophical traditions and schools: For example, the supporters of the 'transparent' map *naturalize the artificial*, and they are therefore part of the tradition of British empiricism; the proponents of the 'opaque' map, on the other hand, *culturalize the natural*, and they are therefore inspired by continental philosophy and its critique of discourse.

As this sketch suggests, both sides seem to offer opposed and irreconcilably divergent views of mapping. And this divergence is deep-seated, as it exceeds the limited field of cartography and stems from the epistemological alternative between a 'realistic', naturalistically-oriented interpretation of human cognition and knowledge and a 'constructivist', culturalistically-oriented interpretation. But is the disjunctivity of both positions the only possible view? Would it not be possible to understand both perspectives

not as exclusive but rather as inclusive and thus interrelated approaches to the map?

This is precisely what my suggestion implies. It is based on the assumption that a connection between the 'transparent' and the 'opaque' interpretations can be brought to light if the map is understood in the context of the media-theoretical distinction between the 'messenger' and the 'trace'. While the 'representationalists' refer to maps as if they function as *'messengers'* of the territories they represent and the knowledge of the map producers, the 'anti-representationalists' regard maps as *'traces'* of the conditions that determined their production and use. 'Transparency' and 'opacity' thus prove to be the names of two co-existing ways of reading maps, yet they still 'speak' in two different ways, namely in their visible (explicit, manifest) as well as in their hidden (implicit, latent) dimensions. To refer to what maps *explicitly* show means using them for practical orientation in order to operate on a terrain with their help. The fact that the materiality and autonomy of the map 'make themselves invisible' in order to represent something external to the map itself thus corresponds to our 'natural' way of using heteronomous media, which require self-neutralization and self-withdrawal to function smoothly. To refer to the *implicit* dimension of maps, on the other hand, means focusing on this self-concealing mediality and employing the map as an instrument to undercover the contexts of its production, representation, and use, which are crystallized in the map but are more or less buried; the map thus functions as a cartographic *dispositif.*

Nevertheless, the separation of these two dimensions, which are constitutive for the (modern) map and which are to be understood according to the model of 'message transmission' and 'reading traces', does not tell the whole story concerning the narratives of 'transparent' and 'opaque' maps. Actually, the degree to which both of these dimensions *reciprocally* depend on one another is more intense than the distinction between these two approaches to maps. You will recall the media-theoretical formulation that in the course of using media the message of the medium is visible but the medium itself is invisible. It can also be assumed that in the course of using media the medium itself appears 'only' *as a trace of its message.*[15] In fact, by critiquing the notion of the map as text the narrative of the 'opaque' map reveals not only the distortions,[16] rhetorics, and myths[17] of maps, but also their hidden contents, which are due to the inherent logic of mapping practices as well as their social-political embeddedness and instrumentalization.[18] However, these traces of the unsaid and unseen can only be analyzed as something not-said and not-seen because they are implicitly shown through what is said and seen. This means that the map can be regarded as a trace in the

narrative of opacity only because and insofar as it functions as a messenger in the narrative of transparency.

Let me explain more precisely what it means to understand the message of a map as the function of a trace.

It is first necessary to register a remarkable shift in the positions of both 'competing' approaches. Supporters of the narrative of the 'transparent' map are usually believed to be the ones who remain blind with respect to the practices of producing and using maps insofar as they only treat the map as a representation of knowledge and thus they only pay attention to its representational content. The proponents of the narrative of the 'opaque' map, on the other hand, are understood as the ones who situate maps in terms of their relations of production and use. However, from the perspective of the medium as messenger the transparency of the map appears to be a condition precisely of its *practical* use, while conversely the notion of the map as a trace presupposes an examination of what it implies, in the sense of Husserl's '*epoché*', and thus ignores its practical use as a medium of orientation within a territory. It is almost trivial: The map can only become an object of critical analysis when it is not at the same time deployed to facilitate movements in disorienting spaces; in other words, the map does not appear as a trace until it is no longer used for practical purposes. However, this break with the map's original terms of use still refers to them *ex negativo*. It must be possible to assume how a map is supposed to be used, even if it is not being used.

The narrative of the 'transparent' map is therefore surprisingly informed by a practical approach with respect to the map as a medium, and the narrative of the 'opaque' map is informed by a theoretical approach. So what is this 'practical approach'?

On the Everyday Use of Maps
When someone looks for directions to an address on a city map, determines where to transfer on a subway plan, or uses a road atlas to make a detour around a traffic jam: in all of these situations an uncertainty has been eliminated with the help of a map. The map provides new information, which facilitates goal-directed mobility and practical actions in a territory. The legend of the map very rarely plays a role in the everyday use of maps. The reading of maps is a form of routinized literality and technical competence that becomes familiar through practice. This familiarity is rooted in the acceptance of a correspondence between the map and the territory. Practical experience instructs people as to whether they have read a map 'correctly': When someone notices while hiking in the mountains that the

shorter route shows considerable height differences and the destination will thus be reached faster by taking the longer but flatter route, this person has learned that the 'right' reading of a map means accounting for the routes and contour lines.

In an initially unproblematic way it can be said that reading maps means acquiring knowledge about something other than the nature of maps: The message of the map is thus based on reference. Maps are only useful for orientation when a 'correspondence' can be expected between the existing territory and its cartographic representation. This correspondence can take many forms – from a three-dimensional infinitely diverse surface to a convenient little two-dimensional schematic. All that matters here is the fact of referentiality, which vividly shows that maps age. In an ironic twist,[19] not unlike buying milk, it is necessary to pay attention to the date.[20] The fact that maps can be read incorrectly, as well as the fact that they can actually be 'false' and territories thus have a 'veto power' with respect to maps, shows that the narrative of 'transparency' is woven into the everyday use of maps. And it is this use alone that provides the criteria for evaluating maps: *The purpose of the map is the criterion of the quality of its representation.*

In this elementary form the map actually functions as an ambassador who mediates between the territory and the user or between the knowledge of the map producer and the user's lack of knowledge. And the medium of the map does this better the more it is able to visualize something beyond itself in a transparent, objective, and neutral way. Like all media, therefore, maps are *heteronomous*. In light of this heteronomy, the idea of the 'transparent' map proves to be not an ideologeme but rather a thoroughly practical requirement. It refers to the 'natural' position, which is distinctive of an operational approach to maps. 'Transparency' and 'representationality' are characteristics of the *use* of maps. A map in itself is not a medium, but rather a thing with visual marks on it that is easy to handle or hang on a wall. The map does not become a medium until it is situated in practices that at the same time assume its representational transparency, such as when someone uses the map to orient himself. In the words of Rob Kitchin: 'The map emerges through contingent, relational, context-embedded practices.'[21]

To look more closely at this practice, which first constitutes the map as a medium, it is helpful to consider Michel de Certeau's distinction between 'places' and 'spaces'.[22] For de Certeau 'places' are fixed points that can be determined through relations of coexistence. 'Spaces', on the other hand, emerge through the movements of subjects and their goal-oriented activities. 'Spaces' thus result from 'places', as historical subjects have done something with and at these places.[23] By actually walking on the street

marked on the map, a person transforms – according to de Certeau – a place into a space. The meaning of this difference can also be expressed by means of other terms, such as the concepts of absolute or relative, objective or subjective, geometrical or anthropogenic, mathematical or existential, etc.

These two kinds of spatiality reveal the function of the map as a medium: 'Transparent' maps depict places so that they can be transformed by users into spaces. In other words, the messenger function of the map is to facilitate – in cooperation with a user – the transformation of objective places into subjective spaces. The transmissions performed by the map as a medium thus activate a metamorphosis: The *representation* of places on the map is transformed into the *presence* of walkable spaces for the user. The map mediates this gestalt-switch, whose significance as a cultural technique of civilizing spatial integration cannot be overestimated. To begin to understand the function of maps it is necessary to explain how this transformation of representation into presence is possible.

Indexicality

The clearest indicator that maps are bound to an external territory is their indexicalizability. Whenever someone wants to use a map for guidance he must first know how to locate himself, such as the red arrow on the subway plan stretched across the wall of the station that says 'you are here', the worn and no longer readable position on an enlarged extract from a city plan posted for tourist information, or the pointer on a trail map that indicates the hiker's location.

Indexicalizability is an essential element of every operational approach to maps. It is the connecting link in the transformation of places into spaces. Like the pronoun 'I', the indexical 'here', and the deictic pointer finger, something is being referred to whose meaning changes with each articulation: If a person looks at a map of the territory on which he is currently standing, walking, or driving, he is present in two ways. While reading the map the 'I am here' becomes 'I am there'. This is a remarkable deictic gesture, which points from the body to the map and thus at the same time to the self. Through this indexical identification of his own position the map user becomes part of the map. He identifies a position on the map that not only represents an external territory, but also presents the map user. This transformation is what matters here. While maps transform an objectively described place into a subjectively experienced space, their indexicalizability reveals that the reverse is also a necessary condition of the operative use of maps: The map user must transform his individual location in the world into a generalizable position on the map. By 'locating'

himself on the map in the third person perspective, the map user assumes
the role of an external observer. Determining one's own position with the
help of a map is often a tedious business, which demands a constant balance
between what is seen and what is marked on the map. The institution of
proper names – of streets – also plays a key role.

If indexicalizability as a condition of the operative use of maps requires
that there be a correspondence between the map and the territory, then it
is necessary to explain how this 'message' of the map is to be understood.

The Cartographic Paradox

There is no question that any interpretation of cartography has to respect
one principle: 'The map is not the territory.' The transparency of the
map, which reveals something that is not 'of the nature of maps', cannot
be achieved because the map actually creates a double of an unfamiliar
external reality and it is therefore doubly unfamiliar. There are countless
anecdotes about the anachronism and also the absurdity of a map that
reproduces the landscape on a scale of 1:1 and therefore completely covers
it.[24]

A three-dimensional world, which constitutes the living environment,
and a two-dimensional map, which is part of the living environment of
this world, are each of a different ontological nature and weight. All of the
potential contained in the cultural technique of mapping is based precisely
on the *difference* between a territory and its map. How can this difference
be defined?

Maps are flat. This is something they share with paintings and pho-
tographs, yet there is a notable difference between them: Maps are not
perspective representations. While the flatness of a central perspective
image appears to transform optically into a window, through which the
eye can see a three-dimensional space, the map has precisely no depth
dimension – in the case of normal topographic maps at least. The map is
regarded as the view of a surface and it is precisely for this reason that it
provides an overview. Its ordering principle is the visual graphic marking
of adjacent neighbourhoods with the help of lines, points, shading, colours,
etc. Maps give an 'aerial view'. The world appears primarily in horizontal
outline for people who walk upright. Yet maps *reverse this point of view* and
show the territory vertically in that it is seen from above – even from way,
way above depending on the size of the mapped section.

This standpoint of the Apollonian eye,[25] with which the world is ob-
served 'from outside' in a way that was impossible before the invention
of airplanes, rockets, and satellites, has a profound significance not only

for our worldview, but also for our role as epistemological subjects. I will return to this later.

I want to focus here on the representational-technical aspects of this Apollonian perspective: Maps show territorial surfaces from a perspective that is usually impossible for human eyes. But their representational claim is based precisely on the art of adopting this 'unnatural' perspective. This view from above also applies to globes, spherical models featuring representations of the earth's surface, and it is no coincidence that the production of globes and the design of maps went hand-in-hand in the epoch of the 'cartographic reformation'.

If they both represent surfaces as seen from the perspective of a 'divine eye', what distinguishes the two-dimensional map from the three-dimensional globe? This is a key turning point in my reflections on maps. Three-dimensionality cannot be transmitted onto two-dimensionality without distortion. Can the peel of an orange be spread out flat on a table? Because the map represents the surface of the earth without its curvature, two-dimensional maps cannot depict surfaces, angles, contours, distances, and directions *at the same time* without distortion.[26] This constitutes the *'cartographic paradox'*. To understand this paradox it is necessary to be familiar with several other aspects of the inherent logic of the map as medium: In addition to a font, which is part of its 'language',[27] maps must have (i) a scale, (ii) a grid-like coordinate system for positioning places, and (iii) a method of projection.

(i) The scale indicates the proportions between distances on the earth's surface and the distances represented on the map, therefore 1:100, 1:1000, etc. It ensures not only the manageability and clarity of the map, but also the undeniable difference and structural similarity between a territory and its cartographic representation.

(ii) In the Western tradition latitude and longitude (meridians) have been established as the coordinate system for positioning places on the earth's surface. They are oriented towards the equator and the prime meridian, which stands perpendicular to it. The equator (from the Latin *'aequāre'*, to equalize) is based on the ideal spherical shape of the earth. It is a geometric form created by a plane that goes through the centre of the sphere and stands perpendicular to the rotational axis of the earth. The equator vertically intersects circles of longitude, which lead through the poles. The equator also marks the point of zero degrees latitude, while the prime meridian was designated the point of zero degrees longitude purely out of convention.

These mathematical-geographical relationships will not be enlarged upon here. It is sufficient to note that the arrangement of the earth's surface

according to coordinates of latitude and longitude is a mathematical *con-struct* (whose relationship, by the way, is etymologically due to seafaring on the Mediterranean, whose length runs from east to west and whose width stretches from north to south).[28]

The mathematical poles are also not identical to the magnetic poles, to which compass needles point. Longitudinal and latitudinal lines provide the earth with a 'network' that treats all places equally; regardless of whether they are located on the summits of mountains or in the depths of the ocean, they only distinguishable in terms of their mathematically exact position. It is almost redundant to add that the mathematically exact configuration of this 'network' is a feature of the *representation* of the earth as a globe, but not an attribute of the earth itself. So how can this mathematical arrangement of the earth's surface, which is only geometrically correct on a three-dimensional globe, be transmitted onto a two-dimensional map? This is only possible through methods of projection.

(iii)For a curved surface to be represented on a flat plane it must be projected onto it. All maps claiming to be 'transparent' must embody a method of projection, but there is always a plurality of them.[29] Projecting the surface of a sphere onto a flat plane means changing it – and this is a topological law. The price of the projection, therefore, is that a map cannot preserve both the areas and angles of a globe at the same time. When the surface of a globe is stretched out onto a map, in other words, the map cannot retain both the proportions and the right angles at the points where the longitudinal and latitudinal lines intersect. The kind of distortion that is then preferred depends solely on the pragmatic purpose of a map.

I will now turn to an example: the conformal world map designed by Gerhard Mercator (1512-1594) in 1569. Mercator's map is the prime example used to deconstruct the idea of the 'transparent' map, as it is obviously 'Eurocentric': The distortion increases from the equator to the poles so that northern regions are represented as disproportionately large in relation to equatorial regions. Greenland (2.2 million km²) appears to be the same size as Africa (30.3 million km²) on this map.

So what was Mercator's method of projection?

It is helpful to imagine projecting the surface of a sphere onto a cylinder. The cylinder is 'wrapped' around the globe like a coat, but only touches it at the equator. A light inside the globe casts shadows of the continents onto the surface of the cylinder.[30] If this cylinder is then cut open at a random place and rolled out, it will look approximately like Mercator's world map. In order to retain the angles between the longitudinal and latitudinal lines, Mercator had to stretch the map vertically and thus increase the distance

between latitudinal lines. An image is also helpful here: Imagine that the globe is a balloon stuck inside the cylinder, which (again) only touches the surface of the cylinder at the equator. If the balloon is inflated so that it touches the entire surface of the cylinder – and not only the equator – then the polar regions of the balloon will have to let in more air, as the surface of the balloon has to stretch further at these places in order to come into contact with the cylinder. Because the distance between latitudinal lines increases towards the poles, the surface area will be greatly enlarged in these regions. The price of preserving the angles is thus the distortion of the areas.

I will now return to the accusation that this map is Eurocentric.

Arno Peters developed a map in 1974 that was intended to do justice to the 'countries of the third world' by using an equal-area projection so that every square meter on the earth was represented as true to scale on the map.[31] This resulted in an ideologically heated debate.[32] Of course Peters's projection was also distorted, but in a different way: this time it was not the surface areas, but rather the lengths and angles that were 'falsified'.

I will not delve any deeper here into the artistry or diversity of carto- graphic projections, none of which are able to escape the cartographic paradox that maps are only able to depict something by distorting it. The ideological critique of Mercator's world map nevertheless reveals a constel- lation that was already encountered in the narratives of the 'transparent' and 'opaque' map. Every critique of distortions must *nolens volens* invoke the narrative of the representationality of maps, as this narrative establishes the criterion necessary to diagnose something as a distortion. Peters's map claims to represent the land masses in the equatorial region 'more cor- rectly' than the Mercator projection. Such a claim explicitly presupposes that there is a correspondence between the map and the territory and that this correspondence is the organizing principle of mapping. And the presupposition that maps are supposed to represent an external territory as faithfully as possible overlooks their pragmatic purpose and practical use, which provide the only means of evaluating whether a map is 'good' or 'bad'. Maps are not simply visual representations of something, but rather they are a means of exploring and operating with what is represented. The performance and limits of the Mercator projection can only be determined in the context of its production and use.

Mercator Projection and Navigation
According to the cartographic paradox a certain structure can only be transmitted onto the map 'faithfully' when other structures are thereby

replicated 'unfaithfully'. And the topology and topography do not determine which structures retain their proportions and which ones are distorted, but rather the purpose that the map 'serves'. *Representationality and relativity are not mutually exclusive but rather inclusive.*

Peters's correction of the Mercator projection is 'naïve' because in overlooking the cartographic paradox it also ignores the pragmatic situation of maps. While the Peters projection absolutely makes sense as a means of revealing the 'unconscious' and 'discreet' enlargement of temperate land masses at the expense of equatorial regions on traditional maps, and it is rightly deployed by aid organizations for precisely this function,[33] the meaning of the Mercator map is entirely different. It is less epistemic and therefore decidedly practical. This map served less as a projection of a worldview (which it also naturally is) than as a means of navigation. It first became a medium through its interaction with sailors who needed to orient themselves at sea. Its conformal quality made it possible to find the simplest and safest route to a target destination through so-called loxodromes or straight courses in a constant direction on the sea. Loxodromes are mathematical constructs, like latitudinal and longitudinal lines. They look like helixes on a circular cylinder, as they approach the poles in spiralling coils. What is special about the conformal Mercator map is that these coils appear to be straight on the map, and this enables a ship to proceed on a constant course with a compass. It is only necessary – and actually with the help of the map, which is thus an act of graphic measurement – to take an initial bearing of the course from the home port to the destination port and then to maintain this bearing at sea without constantly adjusting one's direction.

This movement along a cartographically determined line applies not only to nautical but also to aerial navigation. The Mercator projection underlies nearly all nautical and aeronautical charts to this day. This map enables the calculation of spaces without markings or traces, like the sea and the air, which then become 'navigable' and 'traversable'.

Therefore, if a map is viewed as a mediating third between a user and a territory then its mediality evolves solely in the field of activity of a triadic relation between people, maps, and territories. The map links data documenting the structures of a territory to the intentions of the map user ('I am here and want to go there'). Every interpretation that considers maps to be either illustrations or constructions thus falls short.

I will now return once more to the relationship between representation and relativity in order to address the 'inherent logic' of maps, which is at the same time constantly rooted in their terms of use. The next section focuses

on the abstractions and generalizations that are necessarily connected to cartographic representations.

Generalization, Schematization, Stylization

Unlike pictures and photographs maps are not 'consistent' but rather 'disjointed' symbolic systems and they can thus be *highly selective* (measured against the territory they represent): They equalize things that are different, they omit some things and highlight others. For example, it is impossible to use an aerial photograph as a city map due to the vast range of details. Consider a contemporary electronic practice: It is only when the zoomed-in photographic details from 'Google Earth' are superimposed over the corresponding maps from 'Google Maps', and thus the aerial photograph of a city is furnished with a schematic inscription of streets, that a visual representation emerges that actually makes it possible to identify and determine places, distances, and directions. What distinguishes an aerial photograph of a place from a map are processes of generalization, schematization, and stylization.

Maps can be considered a modality of representation that is sui generis. They emerged semiotically from the intersection of language and image. Graphic variables like two-dimensionality, size, brightness, pattern, colours, forms, etc. become conventional signs. With the help of these signs, the individual details of a territory are assigned different kinds of objects that then appear on the map as individual streets, rivers, places, mountains, etc. The map intertwines the graphic-visual with the linguistic-syntactical. Maps visually represent relations that in principle can also be translated into linguistic expressions, such as relations of position like 'A is east of B' or relations of quantity like 'A is larger than B'. Maps thus contain an element of testimony, and what they show can be completely false.[34] Please keep in mind that the territory does not predetermine the criterion of correctness and falsity, but rather the method of projection as well as the purpose and use of the map. To return to the example of representations of distances: Maps signify planimetric distances, horizontal distances in which height differences are levelled. Planimetric distances are always less than real distances, and even less than linear distances, as all of the terrain coordinates are projected onto a horizontal surface and thus – necessarily – distorted.[35]

To return to the issue of generalization: Maps would not be possible without processes of abstraction like selection, simplification, elimination, equalization, straightening, and typesetting. A meandering river becomes a curve; a winding road becomes a line; constantly crisscrossing streets, trains, and rivers become parallel; a constantly changing coastal zone

becomes a stroke; and villages of different sizes and populations become equal points.

Subway cartograms depend on neglecting the real geometry of a city. They depict constellations of places in a way that ensures precisely that the user is able to transform these places into subjective spaces through his own movement: Subway lines are always straight on subway plans and the distance between stations is expanded in the city centre and compressed on the periphery.[36] Readability is more important than topological precision.[37]

The topic of cartographic generalization is virtually inexhaustible, and what has been presented here constitutes nothing more than a fragment. I will now turn to a phenomenon that is related to cartographic generalization but is not limited to it; moreover, it is a phenomenon that continues one of the central media-theoretical propositions of this study: Maps – fundamentally – make the *invisible visible*.

The Visualization of the Invisible

Maps require these practices of abstraction due to their selectivity: Maps can only exist because it is possible to ignore the excessive abundance of what is seen. If mapping is also rooted in the art of abstraction then it can only develop as a strategy of visualization in connection with the ability to concretize, visualize, and embody something that is abstract and thus not simply perceptible. To understand the culture-endowing function and epistemic power of maps it is therefore necessary to conceive of this embodying and concretizing potential as the ability to visualize the non-sensory and to transfer it to the register of perceptibility. There are different kinds of invisibility that thereby come into play.

(i) On the *first* level, it is necessary to undo an oversimplification. Up until now I have referred to the representation of a 'territory' on a map, yet strictly speaking is it not a territory but rather *knowledge* about this territory that is visualized as a map. The map does not depict things, but rather 'epistemic things', to use Jörg Rheinberger's concept.[38] And these knowledge-things must be quantifiable: They must be able to be described as the result of measurement methods (in the field) and they must be regarded as bodies of measurable data that can be inscribed. However, measurement methods are cultural techniques that work with different scales and constantly change with the evolution of knowledge cultures, especially mathematics and technology.

(ii) The concept of visualizing something invisible applies even more to the plotting of purely mathematical constructs, like latitudinal and longitudinal lines, and this is the *second* level. By appearing on maps these

lines not only enable the identifiability of (previously surveyed) places, but above all they also introduce self-positioning. Making these mathematical constructs and epistemic things perceptible opens up the possibility of concretely situating the user in the map. This indexical place is a 'known place': The user does not simply see where he has positioned himself within the map, but rather he must deduce this position.

(iii) Maps make not only mathematical constructs and the determination of indexical positions perceptible, but also political bodies that are almost never encountered in the phenomenal world, and this is the *third* level. In the history of nations, the unified image of the map has quite often suggested a sense of national unity that did not exist politically or administratively. David Guggerli and Daniel Speich show what this means using the example of the first topographic map of Switzerland. Exhibited in 1883, the cartographic representation of the entire confederation, which was first founded as a federal state in 1848, became an identification model with which the public began to transform itself into *one* nation of Swiss people – an idea that had previously been largely a utopian dream.[39] Nevertheless, this national map also sparked conflicts concerning the borders of cantons. Before then 'clear borders' had meant nothing more than a lack of border disputes, but as a result of this map people had to wrestle with the exact locations of political borders.[40] It is no accident that the creation of topographic maps became an official and thus national task in the nineteenth and twentieth centuries. Topographic maps or so-called 'general maps' always depict – like most maps – a constellation of political power. This power largely consists of the 'power of naming', and the example of Switzerland is also instructive here.[41] Because the places depicted on maps are always furnished with proper names, but these places mostly bear different names in the practical life of the population, the erasure of this difference in support of a single name makes it 'quasi-official',[42] and it thus becomes a 'political issue'. The map is granted 'the character of a decree'.[43]

The political function of maps is a well-explored field[44] and does not require any further discussion here. Yet the 'power of naming' clearly shows how maps visualize the invisible: namely, what is visualized on the map is at the same time created and constituted by this act of visualization. Because maps refer to something independent of and prior to the map itself, in a gesture of naturalistic transparency, they have the power to shape this independent and prior thing according to the model of the map. And 'model' here does not mean an after-image, but rather a 'prototype'. It is through the map that a worldview emerges.

(iv) To explain what this means I will now turn to the *fourth* and perhaps most significant level. *Maps depict something that in principle and not only with respect to some abstractions cannot be seen by anyone in this form.*[45] And it is precisely because maps present something that is not accessible to people, who are embedded in the living environment, that a non-human standpoint beyond the living environment must be adopted in the construction of the map. Maps thus represent a 'view from nowhere' or an Apollonian perspective. With maps something enters into our world thanks to our ability to imagine stepping out of it.

Before the moon landing and the development of satellite images, the only way of representing the earth as a planet was in the form of a globe. Planimetric maps inherited this unique function of representing the world from the perspective of an external observer, who is (or seems to be) not part of the world. Because people do not perceive things in sequence, like the experience of listening, but rather in juxtaposition, like the experience of seeing,[46] they are able to compare objects and visualize their proportionality through their proximity to one another. The visualization of simultaneous spatial relations introduces a disposition of perception that is most conducive to the cognitive understanding of the perceived, as observing something simultaneous from a distance offers a perspective that is optimal for cognition and objectivity. Maps that treat this distance even more radically as the position of the 'Apollonian eye', which underlies their principle of construction and representation, constitute a nucleus of crystallization that honours the eye as an organ of perception.

Maps thus present the world in a form that is not actually accessible to the human eye, but for that reason they come even closer to the modern scientific and philosophical position of the human as *subject of cognition*. In other words, maps present the world as seen with an 'intellectual eye'. Yet this 'intellectual eye' depends on the potential of visualization, which is due to the materiality of the map as medium. The form of invisibility that matters here is therefore the position of the modern subject, which is the organizing perspective of planimetric-topographic mapping. The arrangement of a simultaneous overview, which the map communicates, requires a standpoint 'high above'. Unlike the real map user, who positions himself indexically on the map and can then also see his position like an external observer, the Apollonian point of view of the subject of cognition exists not on the map as a perceptible event, but rather – like the central perspective image – as its *'inner organizing principle'*. The invisible form that the map implicitly visualizes is the *methodological function* of the modern subject to be able to adopt the perspective of an external, neutral

observer. Or, to express this in Kantian terms, what the map visualizes is the epistemological fact that the subject is not part of the world, but rather constitutes the transcendental condition of its visibility and cognizability.

This connection between the map's visualization of the invisible and the constitution of the modern idea of the subject is only plausible so long as it is clear that the standpoint of the 'Apollonian eye' is an epistemological abstraction that belongs to the realm of the imaginary, that cannot be based on real experience, and that only develops into an illustrative function within the symbolic world of the map.

But what happens when the imaginary 'Apollonian eye' transforms into a satellite camera and the perspective from 'nowhere' is located as a position in space? The final step in my reflections on maps will thus question how mapping changes as a result of digitalization.

Digital Maps

It is remarkable that with the triumph of the computer the principle of location seemed to become obsolete and space and spatiality seemed to become almost superfluous. Yet in recent years there has been a noticeable expansion of precisely those practices in which the computer is deployed as an instrument of mapping and localized 'georeferencing' information.[47] I want to look more closely at such phenomena of digitalized mapping, which are associated with buzzwords like 'virtual globe' and 'digital earth'.[48] Programs like Google Earth and Google Map[49] not only enable the pleasure of exploring the earth's surface from the perspective of a bird in flight, but also pave the way for the creation of thousands of individual maps, as users are able to feed *local* information into these programs with *global* datasets that contain everything localizable and digitalizable.

Google Earth is a software program that consists of an animated model of the earth's surface. This model was created by digitally combining hundreds of thousands of satellite and aerial photographs taken from different points of view. Using this program it is possible to 'navigate' around the world, or more vividly: to fly over the earth's surface and thereby visit random places. The detail resolution usually amounts to 15 m, but in urban centres it can also be up to 15 cm; cars and people are then already recognizable. Moreover, Google Earth is frequently coupled with three-dimensional terrain and city models. In any case, users are able to zoom in and out of places, always in gliding flight, and the reloading of the image does not disrupt the continual view of the landscape.

People have seen sections of the earth's surface from a bird's perspective before in the form of photographs or through airplane windows; what is new

about Google Earth, however, is its interactivity or the possibility that the user can determine which places he wants to view and explore as a 'virtual visitor'. From its origin, Google Earth is a game for virtual hobby pilots. This feature leads to unexpected and sometimes even bizarre discoveries, like the swastika formation of a US Marine barracks in Coronado, California that was 'uncovered' and brought to the world's attention through Google Earth: The swastika-like arrangement of the building could only be seen from above, and it had never attracted attention before because the building was located in a no-fly zone.[50] The degree to which the virtual pilot perspective of Google Earth had become a publicly recognized common property capable of raising political issues was signalled by the decision of the US Marines to conceal the building from aerial photographs (using plants and solar panels). Google Earth had (until then) made the invisible visible.

What was introduced as a game turned out to be – to say it in jargon – a 'georeferencing information machine'. For this purpose it is only necessary for Google Earth to be connected to locally specified datasets. The Danish biologist Erik Born equipped walruses on Greenland's arctic coast with sensors in order to track their movements through the Arctic Ocean.[51] He was then able to use Google Earth to identify the location and migration of every walrus on his screen. The biologist was also able to superimpose his walrus migration map onto a map created by his geographer colleague, which visualized data concerning the thickness of arctic ice and the direction of arctic currents. The image that then emerged enabled the biologist to obtain new findings about the influence of the melting of the ice on the behaviour of the animal world and thus to discover new causal relationships in times of climate change.[52] Observations of the virtual world of visualized data thus introduce new insights to the real world.

Or, to go from science to the everyday: So-called 'mash ups' are individually created maps that result from combining local data with global services like Google Earth or Google Maps; these maps are then uploaded onto the Internet, where they reproduce explosively.[53] Maps then emerge of everything indexicalizable: the geographical distribution of approximately 12,000 ant species,[54] all of the airliners flying over the USA, the distribution of comics on buildings in Brussels, speed traps in Cologne, or free wireless hotspots in Berlin.[55] People also like to point to the example of emergency relief efforts during catastrophic situations, as viewing destroyed areas from above allows people not only to diagnose the severity of the catastrophe but also to determine which routes are still intact and can be used for supporting measures.[56]

The virtual globe is thus filled with traces of local events and individual preferences.

There is no question that the digitalization of mapping has far-reaching consequences for the creation, distribution, and use of maps and that it fundamentally alters the face of cartography. There appears to be some truth to the speculation that we will witness a revolution in the cultural technique of mapping whose potential for radical change is even greater than that of the 'cartographic reformation' in the early modern period. But I want to look once again at what is new about the use of maps 'via the Internet', which can be subdivided into three dimensions that are nevertheless always integrated in digitalized mapping: operating, exploring, and presenting.

(i) *Operating*: Generalizing maps record the places and structures of a region supra-individually: the subway network of Berlin, the city plan of London, the hiking map of the Ötztal Alps. In order to use a map the individual must be able to locate himself in and indexically inscribe himself onto the map; the individual is then able to acquire new knowledge from the map, which is essential for orienting his movements in space. The work of locating is now automated by GPS and satellite technology, and the individualized maps that these technologies produce depict a territory in a way that is fundamentally based on the standpoint of the user. The conversion of objective spatial relations into subjective and tangible spatiality is now – for the most part – automated by the computer.

(ii) *Exploring*: The possibility of exploring random places on the earth from the perspective of a bird in flight is fascinating, and this activity also offers an unprecedented degree of freedom and playfulness. More importantly, the empirical observation of the world itself becomes virtual, which creates new 'possibilities of observation'. Through the hybridization of different geographically indexicalized datasets (resulting from surveys), new knowledge can be acquired about relations on the 'real earth itself'. Patterns become discernible that can only be seen on the screen in the form of computer-generated visualizations. Visualization thus evolves into a scientific instrument of perception that plays a fundamental role in empirical observations, experiments, and theory.

(iii) *Presenting*: Information can be represented in different ways: linguistically, visually, or through a mixture of both modalities, as in writing, diagrams, and maps. Because 'mash ups' combine global and local data and thus specify and make visible local information in countless ways (properties for sale, company headquarters, clusters of retired people, Italian restaurants, residences of sex offenders, etc.), the map lends itself as a substitute for purely linguistic representations of information. Commercial

directories are no longer written, but rather they are available in the form of digitalized maps that clearly show where companies can be found – near the user's place of residence, for example.

It is not necessary to provide an overly incisive conclusion to see that what digitalization contributes to our approach to maps lies in its visualization, with which the map develops into a ubiquitous format of information acquisition and mediation. The often diagnosed 'topographical turn'[57] thus finds its counterpart in the fact that the significance of maps has not declined but rather grown. Yet an interesting shift in the function of the use of maps becomes apparent with digitalization. I would like to formulate this shift in the form of a hypothesis that can prepare the way for a more comprehensive investigation, which cannot be carried out here: *While the creation and use of overview maps was developed during the 'cartographic reformation' as a cultural technique for practical operations in complex territories, 'cartographic digitalization' transforms mapping into a cultural technique for movement in landscapes of knowledge.* These 'landscapes', however, are no longer accessible at all except through media.

The Messenger Model Considered in Light of the Map: In Lieu of a Conclusion

Up to now I have been focusing on what my basic media-theoretical assumptions reveal about maps. I would now like to reverse this perspective and explore what maps, as a text case, reveal about media theory.

One of the main goals of this study is to avoid the creative-oriented (generative) image of media, which conventionalizes media as more or less autonomous agents of cultural dynamics. The basis of these reflections is the presupposition that the figure of the messenger – in conjunction with the involuntary errand of the trace – constitutes a prototype of what it means to function as a medium. What distinguishes this 'function' is that it is not self-organized. The 'heteronomy' that makes media into instances of being-directed-by-others is a basic idea, if not *the* basic principle of this media theory. But this raises some unavoidable questions:

– If media transmit and mediate something that they themselves have not created, how is it nevertheless possible to trace the creativity that is still 'somehow' immanent in this approach to media? How can the culture-endowing power of media be explained if they are so strongly thematized as foils of transmission and not of creation and transformation? There can be no reasonable doubt that media possess an inherent logic through which they also (pre)form what they transmit and mediate. Is the shaping power of media fundamentally neglected – and does

it therefore remain inexplicable – if the messenger is made into the
ur-scenario of a media theory? Is there a danger of throwing out the
'media-theoretical baby' with the 'generative bathwater'?

– I wanted to avoid both the marginalization and hypostatization of the
 medial, but doesn't the rejection of a generative approach marginalize
 media once again, as the assumption that they are directed by others
 seems to reduce media in relative importance to merely a secondary
 phenomenon? How is the claim that media have an irrefutable function
 in communication, perception, thought, and experience consistent with
 their reduction to 'mere' relations of transmission?

In summary, how can media have a culture-endowing power if their creative
power is denied?

My assumption is that these media-theoretical reflections on maps
suggest an answer to these questions in two ways:

(1) *Media as Mediator and Third: Distributed Activity* – Media occupy
the position of a middle, a mediator, and a third in a triadic relationship
between two heterogeneous fields. Describing media as the 'middle' spa-
tially connotes and (misleadingly) suggests that this constellation should
be understood as a – more or less static – structural relationship. Yet the
map reveals that mediality is less structural than pragmatic: The map *is*
not a medium, but rather it *becomes* a medium when and only as long as
someone actively orients himself in a territory with the help of the map. The
map thus occupies the position of a mediator only when it is being used.
Media only exist in the processuality of their implementation.

The idea that the meaning of something only emerges through its use may
seem banal. Moreover, this use-oriented explanation would seem to lump
media together with signs, which this is something I have tried to avoid from
the beginning. However, the point of establishing use as the foundation of the
map's function as a medium lies elsewhere. When the map is employed as a
medium, this does not simply mean that the map is read and interpreted as a
form of symbolic representation, but rather it means that something outside
of the map is altered through the act of orienting oneself with the map. It
thus depends not on an interpretation, but rather on a *transformation* that
turns an ocean without markings into a straight traversable 'sea lane' or an
unfamiliar city into a walkable space. This transformation is caused not by
the medium per se, but rather by the operative unity of user, map, and terri-
tory. *This functioning 'unity' alone has agency and the attributes of an actor.*

When media are denied any original creative power, therefore, it does
not mean that this ability is then granted instead to those who employ

media. Being subjected to a complex, confusing, and unfamiliar space without a map is adventure, and it leaves people thoroughly powerless. Something like 'agency' only emerges in the practical tripartite connection in which the medium is situated as middle and mediator. The mediatized ability to act must therefore be understood as a 'distributed' potential whose productivity always depends on the collaboration of human and non-human components. This type of distributed activity is not prevented but rather made possible by the heteronomy of media or their ability to incorporate attributes of both of the worlds between which they mediate.

(2) *Media Make the Imperceptible Perceptible: Transparency and Opacity and the Possibility of a Media-Critical Epistemology.* – What could be easier than to suppose that maps reproduce something prior and already extant and they are considered practical failures if they do not reproduce it more or less exactly? Where, if not with maps, does 'imaging' prove to be an essential dimension of our symbolic processes? Nevertheless, even though media are fundamentally based on something prior (remember that 'topographic maps' were chosen as the starting point, which disregards fictional maps) they still make perceptible something that is *invisible* to the eye – in many possible ways.

Making something that eludes the senses perceptible is a creative transformation that obviously depends on the presupposition that the medium is transparent, as it must represent the expanse of the ocean or the branching of subway lines 'in reality', like an incorruptible messenger. But maps depict neither the sea and the land nor subway lines and stations, but rather the spatial and positional *relationships* between them – relationships that can only be seen in the diagram of the map. The map *is* undoubtedly not the territory, but more importantly *it also does not depict it*. Maps can at best reveal something *about* a territory, yet they always do this from an Apollonian or non-human perspective that is not part of the territory itself. Maps incorporate something into our life world that can only be seen from a standpoint outside of this world – something that is therefore not accessible to the senses – and it is precisely for this reason that they possess an explosive potential through which *new* orientation knowledge can be generated.

Cartographic visualization is therefore always also a process of construction. The representational and generative dimensions of media are not exclusive, but rather inclusive.

The 'cartographic paradox' shows that cartographic representations are inherently distorted and that this distortion is not a disruption but rather a condition of possibility of representation. Like the relationship between

'representation' and 'generation', it could also be said that transparency and opacity are two distinguishable dimensions of maps that nevertheless require and include one another. They are related to each other like the messenger aspect and the trace aspect of media.

The difference between transparency and opacity must not be bypassed or even annulled. It is distinctive, it is eminently practical, and it is also the source of a *media-critical epistemology*: To use maps for everyday orientation and self-localization one 'must remain blind' to the inherent distortions in cartographic projection methods.

To critically analyze map projections and their social instrumentalizations, on the other hand, one must render the user's approach inoperative. Like a Husserlian *'epoché'*, a theoretical approach requires dispensing with the practical use of maps.

Thematizing the medium as messenger also reflects my practical approach to media – how analyzing the medium as a trace of its social-historical contextualization and instrumentalization can be the starting point of a media-critical approach. *A critical epistemology of media is inevitably tied to the duplicity of the transparent and opaque dimensions or of the messenger and the trace – a doubling that corresponds to all media in one way or another.* This relationship is epistemologically generalizable: 'realism' and 'constructivism' (or 'instrumentalism') appear to be not competing and exclusive but rather interdependent and reciprocally inclusive epistemological positions.

Epilogue

Worldview Dimensions, Ambivalences, Possible Directions for Further Research

This discussion is (almost) at an end; all that remains is a conclusion, and I want to open this conclusion by raising a concluding and very fundamental question: What is the use of a study that proposes to rehabilitate the model of the messenger and transmission? Surely it is intended to develop a more interesting – if also slightly outmoded – approach to media theory, but isn't the risk of misunderstandings too high a price to pay for this media-theoretical perspective given the obvious heteronomy of the messenger figure and his apparently dependent transmission activity? This risk is further exacerbated by the fact that I have neglected to distinguish conceptually between the activity of a mere *transmitter* and the much more complex activity of a *mediator* (a difference that calls for a follow up to this study, as it is not addressed here). If it was only a matter of accenting a new aspect of this media concept, then the 'dangers' caused by the problems lurking in the messenger model could indeed compromise its potential benefits.

Yet the aim and motivation of this study is not to define a concept of media. If it were, I would have had to engage the diverse landscape of contemporary media theoretical discourse, which has only been mentioned here peripherally, in an entirely different way.[1] If the work of philosophy is considered to be the non-empirical definition of concepts in the form of intersubjectively understandable argumentation – and this is a respectable definition of the work of philosophy that is shared by many people – then this study would indeed be inadequate.

However, the question of what philosophy is and what makes a text philosophical can also be answered differently: Philosophers *reflect*. Of course the sciences and the arts also depend on reflection, so what is distinctive about '*philosophical* reflection'? The double meaning of the word 'reflection' offers a starting point: Before 'reflection' denoted contemplation or linguistically-oriented deliberation it originally referred to an optical phenomenon – the reflection of light from surfaces. This optical-epistemological double meaning of the term 'reflection' is no accident, and it has been extensively examined as a signature of mirror-oriented modern epistemology.[2] All that matters here is that 'reflection' is tied not only to *speaking* but also to *showing*. Philosophical statements do not exclude, overcome, or suspend the act of 'showing'; rather, they always indicate something by making it

appear. It is a kind of showing that renders something visible from the surface of what is said and also what is *not* said. Philosophical reflection can thus be considered a form of reflection that reveals something through the interplay of the spoken and the unspoken. But what does philosophy *show*?

This once again concerns the 'worldview function' of philosophy. Because philosophy involves the definition of concepts – this constitutes the 'surface' of its discursive practice, so to speak – it always also conceptualizes an image of the overall context of our experience, which can hardly be grasped discursively. In the propositionality of their domain-specific statements, coupled with the gaps out of which their network of statements is (literally) woven, philosophical texts always also contain a *view* of our relationship to the self and to the world in general and they reveal this image on closer inspection. What is special about this 'closer inspection' is that it makes the implicit explicit and thus discursified; it can then, in turn, be made into an object of reflection. This is precisely what I want to do now by asking which image 'of the world' and which conception of the self is revealed in this text.

For those who are nevertheless sceptical-minded towards such an 'imaging function' of philosophy – even when it is understood as something thoroughly explicable – and who remain convinced that successful philosophical reflection is only possible through the propositionality of disambiguation and argumentation, the matter can also be expressed differently: The *meaning* of conceptual work lies – in principle – in the possibility of prompting further research and debate. This conclusion can thus be characterized as an attempt to highlight the theoretical consequences of this study and possible directions for further research. I will thus proceed with a two-pronged approach: The first section primarily addresses the worldview and self-image implications of this study, and it also reflects these images in a way that is not 'risk-free'. Whoever would like to be spared this section can proceed immediately to the second section, which addresses possible directions for further theoretical research.

Worldview and Self-Image Implications
The concept of the 'medium' is central to this work, yet individual media analyses – with regard to sensory perceptual media, semiotic information and communication media, or technical distribution, processing, and storage media – do not play a role[3] and general media theories – like those of McLuhan, Baudrillard, Flusser, or Luhmann – are not discussed.[4] It would not be mistaken to justify these omissions by saying that 'individual media ontologies'[5] and reconstructions of 'general media theories'[6] have already been done, but this does not go to the heart of the matter. Rather, the

concentration on the messenger as a figurative model of mediality is to be understood as a *theoretical gesture* that deliberately and definitely originates from the human sphere and is thus oriented towards the personal, but there are two phenomena that bracket the personal aspects of this approach. On the one hand, the 'individual personhood' of the messenger recedes and fades out for the benefit of the voice of the other, which articulates itself in the voice of the messenger. On the other hand, the messenger can be replaced by apparatuses and sign configurations because nothing is as transmissible as the function of transmission.[7]

Therefore it is not simply a matter of presenting the human as a medium in place of technical or semiotic instruments, which are commonly seen as the reservoir of media. Rather, this study focuses on the movement of personality and depersonalization through which people, apparatuses, and sign systems become as permeable to one another as a person who is able to act as (or advocate for) another and speak in their name. 'Heteronomy' then means not simply that the messenger obediently transmits what he hears, but rather that transmission represents a network of culture-endowing activities in which *the suppression of one's own personality appears to be not dissolution and loss, but rather a kind of productivity.* Although the concept of persona (*'per-sonare'*: to sound through the mask) originated in theatrical role-playing, personhood is usually associated with individual identity and autonomy of action. Yet it is necessary for the messenger figure to be able to withdraw and fade out as a person – to be able to depersonalize himself to a certain extent – in order to perform his function.

This leads to the self-image implications of this study, as the decision to focus on the personal messenger model takes the following questions seriously: How can the human understand his own position in the world according to the model of the messenger? How can our self-image not be based on 'authorship' – on our continuing function and our constructive potential? How can we (also) understand our position in the world as that of having a 'mission'? This study can raise such questions, but answering them lies beyond its scope. Nevertheless, what can and also must be pointed out here is that every reflection on the messenger perspective as a dimension of the *conditio humana* has to concede a fundamental ambivalence that is inevitably inscribed in the heteronomy of the messenger. This ambivalence is already indicated by the fact that every messenger acts as a reversible figure: the angel becomes the devil, the mediator becomes the schemer, the circulation of money develops into greed and avarice, etc. This 'lapse' is thus understood as an ambivalence that is inherent in the role of the messenger as a medium that must negotiate between the conflicting priorities

of personality and depersonalization. In order to understand this 'lapse' more precisely, it is helpful to draw on Wolfgang Schirmacher's diagnosis that 'The first law of media is: *The self is the focal point*.'[8] This 'self' does not actually coincide with the modern concept of the subject, but rather it is an ego that develops, in the sense of a progression, from '*homo faber*' to '*homo generator*' to a direct object of its own design – an activity that creates everything, including the self.

This diagnosis of the times, which still sees a remnant of the creative potential that originally configured the modern idea of the subject in the current 'turn to self-care',[9] is quite evident and Schirmacher is not the only one to have recognized it. Undoubtedly my considerations on the culture-theoretical rehabilitation of transmission manifest a decidedly 'a-demiurgical' approach, which perhaps shares with Schirmacher the motive of profiling our image of the human without absolutizing his constructive power. Schirmacher's diagnosis does differ from mine on one crucial point: While I claim that 'self-neutralization' constitutes the basic functional law of media, Schirmacher argues, to the contrary, that the basic law of media is 'self-stylization'. Nevertheless, this controversy is easily resolved by recalling the complementary terms 'transparency' and 'opacity', as something different is meant here in each case: While Schirmacher's 'self-stylization' and 'self-care' refer to the 'what' of media – the content that media, especially the current mass media, transparently communicate – I am referring to the 'how' of media – the mechanism of self-withdrawal that only becomes apparent when the opacity of the medium enables its content to be disregarded.

But if the opposition between 'self-neutralization' and 'self-stylization' is so easily resolved, then why have I referred to Schirmacher's diagnosis? Because it helps to avoid the snares of a simplification that could arise in connection with this study. It is indeed a central concern of this work to raise the *guiding* question of what it means to have a mission that can only be fulfilled when one is ready and able to withdraw oneself. The goal of this study is therefore a long-overdue correction of many varieties of the demiurgical notion of self-understanding, which is still operative today. However, this correction raises another question: What does it mean for our understanding of 'productivity', 'community', and 'culture' if circulation is valued above production,[10] mediation is valued above creation,[11] dissemination is valued above dialogue,[12] and unidirectionality is valued above interactivity? In this context it is important to avoid a simple either/or, for if it is assumed that the demiurge (author) and the messenger (transmitter) constitute two archetypes of our being-in-the-world, then a

messenger-oriented media theory could suggest – by generalizing an image of the world and the self – that the human should be understood *precisely not* as an autonomous author, but *rather as* a heteronomous transmitter and mediator. Such a simplification would do more harm than good to the project outlined here.

(i) The *first method* of working against this simplification involves applying the idea of a 'mediator' and a 'third' to the study itself; it is therefore central to the methodology of this study to avoid opposing dichotomies. Our role in the world is then not simply to have a mission, but rather it is characterized by the always also precarious interplay of creating *and* transmitting, of activity *and* passivity, of autonomy *and* heteronomy, of generation *and* simulation, of self-determination and determination by others,[13] of constructivism *and* realism. The methodological benefit of this study lies in its self-application of the 'idea of the third'[14] as opposed to all of the schematizing binarizations in the 'realm of concepts', and one of the research tasks that remains is to work out the figures that reflect and relate *both* sides of the both/and.[15]

(ii) Yet there is an even more complex way of overcoming the simplification of an either/or in the tension between the figures of the demiurge and the messenger, and this *second method* reveals an ambivalence that is inherent to the messenger model. The self-withdrawal of the medium, as opposed to the message it conveys, has been characterized as the *hidden* mechanism of the medium; this mechanism does not become apparent to the media user because what it makes perceptible is in effect the voice of an other. It is just like Luhmann's medium/form distinction: one always perceives the form but never the medium.[16] But what if this self-withdrawal, self-neutralization, and selflessness become the content and the 'mission' of the medium by enabling the creation of the self to mutate into a hidden mechanism? What if an evidently prevailing heteronomy becomes an *instrument* of a self-concealing and thus perhaps all the more destructive autonomy? It is possible for a suicide bomber to want to appear as the martyr type of messenger, for example, as his attack instrumentalizes his self-effacement and can thus be inaugurated as a medium of martyrdom.[17] Don't all of the *perpetrators* with a 'mission' have perhaps the highest potential for violence and destruction? The topos of the 'dying messenger' offers the most radical image of the human becoming a thing, and this extreme example of self-withdrawal reflects the ambiguity and ambivalence embedded in the messenger function.

Michel Serres's rehabilitation of the parasite[18] as a structural condition of community was intended to show the creative potential that is immanent

in the breaking of reciprocity, and this study is similarly concerned with positivizing the non-reciprocal. Nevertheless, my considerations go beyond such a 'rehabilitation' and 'positivization': If the distinctions and responsibilities that correspond to the human condition are localized in autonomy, then practically all of the dramatics and fallibilities of our being are grounded in it as well. If heteronomy is interpreted for the most part as a *self-renouncing* sovereignty, then it can also be included among the *failures* of autonomy.[19] The rehabilitation of heteronomy as a culturally necessary and culturally creative figuration – in the form of thousands of transmissions from mediator figures – is thus undoubtedly sensible and important for relativizing the absolutism of autonomy. One cannot overlook the fact that the human ability to be 'selfless' and 'determined by others' is also inherently ambiguous, and this ambiguity is in no way inferior to the ambiguity of autonomy. Yet as a result of these considerations it is at least possible to diagnose the crucial point, which is that the potential 'to have a mission' not only constitutes a ground-breaking relativization of the 'generative image of the human' but it also takes on threatening features when the medial mechanism of self-neutralization and selflessness is employed as an instrument of self-empowerment. Is it now possible to better understand why Walter Benjamin allegorically associated the idea of a medium becoming an instrument with the Fall of Man?

Possible Directions for Further Research
(1) *On Productivity* – The messenger is not the origin and the beginning of what he does. He is not a subject in the theoretical sense of constitution or construction. He receives and relays something that he does not create himself. He does not operate in the sphere of production, but rather in the sphere of circulation. He withdraws and is thus able to 'lend' his voice to an other. The use of representational vocabulary seems obsolete today, as concepts like imitation and mimesis or 'similarity' in the tradition of our demiurgical self-understanding have been largely discredited. Yet doesn't 'assuming the role of an other' and 'acting in place of an other' constitute a vital source of creativity that enables people to appear as others and speak in the name of others? Isn't this what the theatre embodies in an exemplary way: that people assume and perform a role whose lines they have *not* written themselves? In the words of Arthur Rimbaud (although with somewhat different intentions): 'I is someone else.'[20]

(2) *On Understanding* – Can anything be more convincing than the idea that communality and intersubjectivity are based on *understanding* the other? If society consists of a plurality of individuals, doesn't this

immediately suggest that the nucleus of all sociality is a union that requires difference in order to find or 'create' identity – whether in the form of an intellectual or physical union? The understanding of the other thus takes place as a unified duality or pairing. Yet individuals mutated into pairs have a tendency to isolate themselves; this is an undeniable aspect of love and quite often of friendship as well. So why should the *binary* constellation or the *dynamic* principle be the distinguishing 'archetype' of successful sociality? The idea of the messenger introduces a third participant into this constellation. The *tertiary* relation[21] then becomes the basis of inter-subjectivity and gives rise to a community-building dynamic that is able to create the supraindividual in the form of institutions.

This tertiary basis of intersubjectivity also sheds new light on understanding: Mutual understanding no longer constitutes the heart of successful sociality. The messenger operates in the domain of meaning deferral, and this applies to understanding people as well as texts. Text and texture are separable, and this dissociation of meaning and materiality enables transmissibility through space and time, across the differences of individuals and epochs. Texture is communally shared, as it alone is mobile and goes from hand to hand. Interpretations, on the other hand, are always (also) individual: They are biased, historical, concept-specific, and therefore deeply embedded in the conditions of their place and time. The intersubjective use of signs would be inconceivable without the stability, not to mention the 'conservation', of a material signature whose semantic 'allocation' has the greatest possible, if not random, variability. The in-between space of deferred meanings thus depends on a 'sign container' that always remains the same, which enables the emergence of new meanings. Formalization[22] also constitutes not only an epistemic but even a culture-endowing power: By emptying signs of their meaning to a certain extent, it enables them at the same time to take on new meanings.[23]

(3) *On Dialogue and/or Dissemination* – If the nucleus of sociality shifts from a dyadic to a tertiary relationship then this also alters the model-building meaning of dialogue, which in the interrelationship of talk and response, of question and answer, is always already implicitly informed by the dual connection of ego and alter ego, of speaker and listener, of identity and alterity. The interplay of the dyadic or the dialogical thus appears to be an elementary condition of successful intersubjectivity – an assumption that is rarely questioned despite the fact that it underlies most theories of communication. Measured against this dialogical figure, the one-dimensionality of communication and transmission processes – and with it the concept of dissemination – appears to be a lost cause. It primarily appears as an

imitation, deformation, and alienation of dialogical interrelationships. In the widespread emphasis on any form of intersubjectivity – especially in connection with new media – it is easily seen as an echo of this hypostatiza-tion of the dialogical. One of the remaining research tasks is to explore what it means to understand dissemination – the concept of 'sowing seeds' or transmitting from 'one-to-many', which takes place beyond intersubjectivity – no longer primarily as something that is unique to mass media, but rather as an inherent dimension of human communication. The first milestones have already been laid by Jacques Derrida[24] und John Durham Peters.[25]

(4) *On Distance* – The question is not whether it is possible to understand the other, but whether it is necessary at all. Inherent in Jean-Luc Nancy's assumption that we are only individuals as many is the idea of a 'weak form' of co-existing or being-with-one-another, which does not require that the subject adapt to the unfamiliar and to otherness but still maintains respect for the individuality of the other. And didn't Emmanuel Levinas's insight concerning the latent tyrannical gesture of the egological absorption of the other enable him to develop the ethos of a response to the voice of the other – and thus the ethos of a responsibility – that is not (any longer) guided by a demand for consensus? If the idea of individuality as an existential form of being is taken seriously, then the idea of speaking with *one* voice is and remains an illusion – and this idea must be taken seriously because otherwise it would be impossible to practice or even conceive of justice, freedom, and responsibility.

The idea of the messenger thus depends – even if it is conceived abstractly so as to avoid the hypostatization of unmediated communication – on the basic insight that a community of different individuals is founded on their capacity for distance. This constitutes one of the most enduring 'binding agents' of communities.

(5) *On Showing, Showing Oneself, and Not Showing Oneself* – 'Showing' has become the central focus of cultural theory and philosophy.[26] Can the exemplary figure of the messenger shed light on the meaning of 'showing' and 'showing oneself'? The act of 'showing', in the conventional sense of 'pointing out', preserves a distance between the person who shows and the thing that is shown, as the person who shows usually does not produce, handle, consume, or even have contact with the thing that is shown.[27] It is a form of reference that is beyond appropriation. The person who shows directs attention away from himself towards something that he himself is not, something that is not coextensive with himself.

While 'showing' is usually understood as an act, 'showing oneself' is un-derstood as an event. It is the medium, or more precisely the medium-in-use,

that reveals how 'showing' and 'showing oneself' are dependent on and intertwined with one another. Through the withdrawal of the medium, the message is able to show *itself*. It is only through the self-neutralization of the messenger's activity, in other words, that the other is able to appear in the sense of 'show itself'. If, as Dieter Mersch states, the act of 'showing something' implies that something must first 'show itself',[28] so every act of 'showing' thus depends on the reflexivity of 'showing oneself', then the medium is a strangely reversible figure: The medium that does 'not show itself' becomes the condition of 'showing something'.

(6) *On Ontological Neutrality* – The successive disengagement of humanities research from people as a fundamental category, which Foucault introduced even though he returned to the topic of 'care of the self' in his last lecture,[29] finds its media-theoretical echo in two developments: On the one hand, there is a euphoria for apparatuses and programs whose technicity specifies what is to be understood as mediality. This euphoria has not yet subsided and it continues to fascinate an entire generation of media theorists, who see these apparatuses and programs as textbook cases of medial functions. On the other hand, there is an echo of the 'overcoming of methodological humanism' in the attention given to the materiality of signs, to signifiers as well as sign vehicles, which then become a source of what counts as a medium. The medium is then identified with the material, perceptible signature of the sign. Media theory thus connects fairly easily to semiotics without having to dispense with the idea that signs are atoms of culture and constituent elements of any cultural theory.

It would undoubtedly go too far to characterize the apparatus and semiotic theories of media as the Scylla and Charybdis of media theory, particularly as the findings of both approaches have laid open the field for this study. Nevertheless, my media-theoretical undertaking can also be interpreted as an attempt to avoid using either (technical) apparatuses or (semiotic) signifiers as media-theoretical 'landing and docking sites'.

It is no coincidence that my series of messenger figures contains not only human forms, like translators, analysts, and witnesses, but also non-human forms, like angels, viruses, and money. It is thus necessary to take the 'ontological neutrality' of the messenger model seriously, as personal and material moments not only interact with one another but can also substitute for one another. Can this 'ontological neutrality' be understood in such a way that 'being a messenger' and 'transmissibility' are viewed as attributes that are not reserved for the sphere of culture – in other words, they are not socially constructed – but rather they also exist in sub-human nature? Consider, for example, the physiology of messengers. It is customary *not* to

apply concepts inspired by cultural practices to natural events. This custom
is based on the recognition of a categorical divide between the explanation
of the human (reasons) and the extrahuman (causes), and this divide can
only be transgressed at the cost of committing a categorical mistake. But
does it compromise the insight into the marvel of our cultural potential to
view the human as a link in a connection that encompasses both nature
and culture and is virtually inconceivable without transmission?

Notes

Prologue
1. Williams, 1974, p. 128.
2. Enzensberger, 1982, p. 67.
3. Kittler, 2010, p. 31.
4. McLuhan, 1964, p. 7.
5. See Winthrop-Young, 2011.
6. Krämer, 1998, p. 74.
7. Krämer, 2001, p. 101.
8. Ibid., p. 270.
9. See Shannon and Weaver, 1964.
10. Kittler, 1999, p. xxxix.
11. Hall, 1980.

Prologue
1. Attempts can fail; nevertheless, these failures can be instructive. In this sense I hope that my considerations will allow answers to the questions posed above to be developed and that these answers will be enlightening and inspiring even if their scope is seen as overly limited or insufficient.
2. Strauß, 2004, p. 41.
3. Pörksen, 1988.
4. Shannon and Weaver, 1963.
5. Habermas, 1984.
6. These considerations are inspired by John Durham Peters's distinction between 'dialogue' and 'dissemination'. Peters, 1999, p. 33 ff.
7. The concept of the 'postal principle', which here follows Derrida, was first employed in Chang, 1996, p. 47: '[T]he dialectic of mediation [...] is itself governed by another more general principle [...] the *postal principle*.' For Derrida, the 'post' becomes a kind of absolute metaphor, the incarnation of trans-mission, the meta-phor, and thus the structural principle of the meta-phor itself. Derrida, 1982, p. 82. For a discussion of postal addressability as the constitution of the subject see also Siegert, 1993 and Winthrop-Young, 2002.
8. The term 'erotic' is clearly being used here in a very elementary and reflexively unassuming sense.

Methodological Considerations
1. Parts of this chapter can also be found in: Krämer, 2004a.
2. See Engell, 2003, p. 54, although Engell does not wish to (mis)understand the generative principle – in view of the historicity of media – in a transcendental sense.
3. The title of the first chapter in: McLuhan, 1964, p. 23-35.
4. See also: Krämer, 2004b, p. 66-83.

5. See also: Mersch, 2002a und Konitzer, 2006.
6. Hartmann, 2000, Münker, Roesler, and Sandbothe, 2003; Sandbothe, 2001; Tholen, 2002; Vogel, 2012; see also 'Philosophie der Medien', *Journal Phänomenologie*, vol. 22 (2004).
7. Lagaay and Lauer, 2004; Mersch, 2006.
8. Ramming, 2001; Filk, Grampp, and Kirchmann, 2004.
9. On this concept: Margreiter, 1999.
10. It is not without irony that the technical approach to media inspired by Friedrich Kittler, who is dedicated to the expulsion of the spirit from the humanities with his fundamentalizing of media technologies into – nevertheless historicized – a priori, participates in precisely the same gesture of inevitability that is so often committed to the philosophical thought that Kittler passionately disavows.
11. See Krämer, 2001, p. 214 ff.
12. Dieter Mersch emphatically pointed to this withdrawal of media: Mersch, 2002a, p. 132 ff.
13. Seitter, 2002.
14. Engell and Vogl, 2000, p. 10.
15. 'In the process of its mediatization, the medium conceals itself, remains unrecognizable, disappears as an instrument behind its effects.' Mersch, 2002a, p. 135.
16. Mersch, 2002a, p. 135 ff.; Engell and Vogl, 2000, p. 10; Groys, 2012, p. 11 ff.
17. Jäger, 2004, p. 59 and p. 65 emphasizes this by describing the transparency of the medium not as a characteristic of the medium, but rather as an 'aggregate state' of communication.
18. See also: Krämer, 1998.
19. Aristotle, 1964; See also: Hoffmann, 2002, p. 30 ff.; Seitter, 2002, p. 33 ff. Seitter was the first to characterize and contrast Aristotle und Heider as classical authors of media theory.
20. Heider, 1927.
21. Aristotle, 1964, p. 265.
22. '[I]f the intervening space were void, not merely would accurate vision be impossible, but nothing would be seen at all.' Aristotle, 1964, p. 107.
23. Aristotle, 1964, p. 106-109, 229 f.
24. Seitter, 2002, p. 34.
25. Thomas Aquinas, 1999, p. 222, qtd. in Hoffmann, 2002, p. 33.
26. See also: Jäger, 2004, p. 50 ff., who calls attention to the fact that Adam Schaff, *Der Mensch, Subjekt und Objekt*, Wien 1973, p. 183 f., speaks of a 'transparency of meaning of the linguistic sign', based on the merging of material form and word meaning, which results in the linguistic signifier no longer being perceptible.
27. Hegel, 1971, § 462, p. 220.
28. Heider, 1927, p. 115.

29. 'All these media processes, which strike our sensory organs and provide us
 with information about things, are false unities. These false unities point to
 other unities, but they themselves are unintelligible.' Ibid., p. 120.

30. Ibid., p. 130.

31. Aristotle, 1964, p. 137.

32. Heider, 1927, p. 116.

33. Peirce, 1931-1935, vol. 4, p. 537.

34. Groys, 2012, p. 13 conceived of this idea as the interplay of expression and
 concealment, which is part of the sign itself: 'Every sign signifies something
 and refers to something. But at the same time, every sign also conceals
 something. And it is not the absence of the signified object that is con-
 cealed, as we hear time and again, but simply a piece of the medial surface
 that is being materially, medially occupied by this sign.'

35. Bahr, 1999, p. 273 ff., and Hartmann, 2000, p. 16 have referred to the etymo-
 logical roots of the concept of media.

36. Spitzer, 1969, p. 203, pointed out a duplicity of spatial middle and functional
 relationship in the Latin concept.

37. Plutarch, 1878, p. 403.

38. Illustrated in: Serres, 1995, p. 80 f.

39. Ibid. (italics added).

Introductions

1. Benjamin, 1996a, p. 64.

2. Weber, 1999.

3. See Menninghaus, 1980, p. 9.

4. Ibid.

5. Hallacker, 2004.

6. Benjamin, 1996a, p. 62.

7. Ibid., p. 63.

8. Ibid., p. 62.

9. Ibid.

10. Ibid., p. 64.

11. Ibid., p. 67.

12. Ibid., p. 62.

13. Ibid.

14. Ibid.

15. Ibid., p. 63.

16. Ibid.

17. Ibid., p. 65.

18. Ibid.

19. Ibid., p. 71.

20. Ibid.

21. Ibid., p. 69.
22. Ibid., p. 65.
23. Ibid., p. 63 (italics added).
24. Ibid.
25. Ibid.
26. Weber, 1999, p. 41.
27. Ibid.
28. Ibid., p. 42.
29. Ibid.
30. Benjamin, 1996a, p. 64.
31. Weber, 1999, p. 42.
32. Benjamin, 1996a, p. 74.
33. Ibid., p. 64; also: 'If mental being is identical with linguistic being, then a thing, by virtue of its mental being, is a medium of communication, and what is communicated in it is – in accordance with its mediating relationship – precisely this medium (language) itself.' Ibid., p. 66.
34. Ibid., p. 64.
35. Ibid.
36. Ibid., p. 69.
37. Ibid., p. 67.
38. Ibid., p. 68.
39. Ibid.
40. Ibid., p. 69.
41. Ibid., p. 71.
42. Ibid.
43. Ibid., p. 72.
44. Ibid., p. 69.
45. Ibid.
46. Ibid., p. 68.
47. Nancy, 1992, p. 374.
48. Nancy, 2000, p. 28.
49. 'Therefore, it is not the case that the "with" is an addition to some prior Being; instead, the "with" is at the heart of Being.' Ibid., p. 30. Also: 'Thinking, absolutely and without reserve, beginning from the "with," as the proper essence of one whose Being is nothing other than with-one-another.' Ibid., p. 34.
50. Translator's note: the German word for sharing, '*Mitteilung*', literally means 'with-separation'.
51. Nancy, 1992, p. 373.
52. Nancy, 2000, p. 87.
53. Nancy, 1992, p. 384.
54. Ibid.
55. Ibid.
56. Ibid., p. 374.
57. Ibid., p. 371-372.

58. Nancy, 1992, p. 374.
59. Ibid., p. 392.
60. Nancy, 2000, p. 43.
61. Ibid., p. 84.
62. Ibid., p. 83-84.
63. Ibid., p. 84. See also: Nancy, 2008, p. 41.
64. Ibid., p. 88 (the original text reads: '*être-avec-toutes-choses*').
65. Ibid., p. 87.
66. '[T]he end [or purpose] of dialogue is not to overcome itself in "consensus".' Ibid., p. 87.
67. Ibid., p. 87 (the original text reads: '*Ces insignifiances "phatiques"*').
68. Nancy, 1992, p. 373.
69. Ibid.
70. Ibid.
71. Nancy, 2000, p. 30.
72. Ibid., p. 43.
73. Ibid., p. 31.
74. Ibid., p. 33.
75. Ibid., p. 44.
76. Ibid., p. 34 (the original text reads: '*à partir de l'avec, en tant que la propriété d'essence d'un l'être qui n'est que l'un avec-l'autre*').
77. Ibid., p. 38.
78. Ibid., p. 94 (the original text reads: '*L'être est [...] soi-même médiation: média-tion sans instrument*').
79. Ibid., p. 35.
80. Ibid., p. 94.
81. Ibid. (the original text reads: '*la médiation sans médiateur*').
82. Ibid., p. 94-95.
83. Ibid., p. 35.
84. Nancy, 1992, p. 385.
85. Serres, 1995, p. 102.
86. Serres, 1968, p. 26.
87. Ibid.
88. Ibid., p. 23.
89. Ibid.
90. 'Just as the nineteenth-century symbolist created archetypes, so too does our symbolist, who has since become a formalist, attempt to create struc-tures.' Ibid., p. 25.
91. Ibid., p. 26-27.
92. Ibid., p. 27.
93. Ibid., p. 28.
94. Ibid., p. 32.
95. Ibid., p. 28.
96. Serres, 1982, p. 65.

97. Ibid., p. 66.
98. Ibid.
99. Ibid.
100. Ibid., p. 67.
101. Ibid., p. 69.
102. Ibid., p. 68.
103. Serres, 1968.
104. Serres, 1995, p. 60.
105. Ibid., p. 185.
106. Ibid., p. 87.
107. Ibid., p. 185.
108. 'The end of the reign of angels sounds with the birth of the Messiah, who makes flesh divine and incarnates love.' Ibid.
109. Ibid., p. 274.
110. Ibid., p. 90.
111. Ibid., p. 102.
112. Ibid., p. 99.
113. Ibid., p. 102.
114. Ibid.
115. Ibid.
116. Ibid., p. 80.
117. Ibid., p. 166.
118. Ibid., p. 168.
119. Ibid., p. 170.
120. Ibid.
121. Ibid., p. 166.
122. Ibid., p. 104.
123. Ibid.
124. 'Which is where we see the difference between good and bad angels: the humble angel disappears in the face of the message; the other becomes visible, in order to derive importance from it.' Ibid., p. 106.
125. Ibid., p. 101.
126. Ibid., p. 102.
127. Mortley, 1991, p. 57.
128. Serres, 2007, p. 8.
129. Ibid., p. 150.
130. Ibid.
131. Debray employs the term *matiérism*: see, for example, Debray, 2000, p. 118.
132. Debray, 2000, p. 73 (the original text reads: '*Tout se passe comme si "le miracle humaine" avait consisté à matérialiser*').
133. Ibid., p. 20. (the original text reads: '*Les agents cruciaux d'une acculturation, ce sont des corps, non des esprits – seuls les premiers peuvent délivrer le message*').
134. Debray, 2000, p. 7.
135. Ibid., p. 47 (the original text reads: '*la médiation sera notre destin*').

136. Debray, 1996, p. 11.

137. Debray, 2000, p. 73.

138. Debray, 1996, p. 11 (the original text reads: *'une dynamique de la pensée n'est pas séparable d'une physique des traces'*).

139. Debray, 2000, p. 10 ff.

140. Debray, 1996, p. 11.

141. Debray, 2000, p. 20.

142. Ibid., p. 18 (the original text reads: *'L'objet de la transmission ne préexiste pas à l'opération de sa transmission'*).

143. Ibid., p. 10.

144. Ibid., p. 18 ff.

145. Debray, 1996, p. 13.

146. Ibid., p. 14 (the original text reads: *'il serait réductionniste, bien sur, de promouvoir le médium, condition nécessaire mais non suffisante d'une revolution médiologique'*).

147. Ibid., p. 16.

148. Ibid., p. 5 (the original text reads: *'Le médiateur remplace le messager'*).

149. Ibid.

150. Debray, 2000, p. 20 (the original text reads: *'Les agents cruciaux d'une acculturation [...] ce sont des corps, non des esprits – seuls les premiers peuvent délivrer le message'*).

151. Ibid., p. 106.

152. Ibid.

153. Ibid., pg. 42 (the original text reads: *'le risque est inherent à la function'*).

154. Peters, 1999, p. 6.

155. Ibid.

156. Ibid., p. 30.

157. Ibid., p. 177 ff.

158. Maxwell, 1890, p. 313 f., qtd. in Peters, 1999, p. 178.

159. Ibid., p. 178.

160. Ibid., p. 34.

161. Ibid., p. 56.

162. Ibid., p. 56.

163. See also: Peters, 1995, p. 41 ff.

164. 'For Socrates the issue is not just the matching of minds, but the coupling of desires.' Peters, 1999, p. 37.

165. See also: Matthew 13, Mark 4, Luke 8.

166. Peters, 1999, p. 49.

167. Ibid., p. 62.

168. Ibid., p. 108.

169. This concept is taken from 'To Stop Telephone-Eavesdropping', *Literary Digest*, vol. 49 (1914), p. 733, qtd. in Peters, 1999, p. 207.

170. See Gold and Koch, 1993.

171. Peters, 1999, p. 195.

172. Ibid., p. 200.
173. Ibid., p. 198.
174. 'Dialogue, despite its reputation for closeness and immediacy, occurs over the telephone in a no-man's-land as exclusive as writing itself.' Ibid., p. 199.
175. Ibid., p. 205.
176. Bliven, 1922, p. 328, qtd. in Peters, 1999., p. 212.
177. Ibid., qtd. in Peters, 1999, p. 206.
178. Peters, 1999, p. 206.
179. 'Broadcasting [...] involves privately controlled transmission and public reception, whereas common carriage involves publicly controlled transmission but private reception.' Ibid., p. 210.
180. Ibid., p. 207.
181. Ibid., p. 214.
182. Ibid., p. 217.
183. On witnesses and ear-witnesses: Peters, 2001.
184. Adorno, 1982, p. 270-299.
185. On Peters's disagreement with Adorno: Peters, 1999, p. 221.
186. Merton, Fiske, and Curtis, 1946.
187. On Peters's connection to Merton: Peters, 1999, p. 222.
188. 'In Maxwell's terms, Merton believed in action at a distance; Adorno believed that all immediacy was laced with infinitesimal gaps.' Ibid., p. 224.
189. Ibid., p. 264.
190. Ibid., p. 264.
191. Ibid., p. 261.
192. 'No communication of one person to another can be entirely definite.' Peirce, 1955, p. 296, qtd. in Peters, 1999, p. 268.
193. Peters, 1999, p. 268.
194. 'Our interaction will never be a meeting of cogitos but at its best may be a dance in which we sometimes touch.' Ibid.

The Messenger Model

1. On the difference between 'medium' and 'mediality', see Krämer, 2003a, p. 81.
2. References to the figure of the messenger and the mediator can be found in Bahr, 1999; Capurro, 2003; Hubig, 1992; and Krippendorf, 1994, although the messenger is not central to these media theories.
3. This parallel between the messenger and the number 'zero' is quite intentional: just as the zero is numerically a neutral 'nothing', as it is (or seems to be) neither positive nor negative but nevertheless becomes the centre of a mathematical coordinate system and even the 'origin' of a range of numbers, which introduces arithmetical transmissibility to geometry, the messenger also appears to be the 'neutral nothing' at the centre of communication. For more on the number zero, see Krämer, 2005.
4. Levinas, 1986, p. 346.

5. Translator's note: the German word for distance, '*Entfernung*', literally means 'distantiation', yet the prefix '*Ent-*' also implies removal.
6. The heteronomy of the messenger is central to the theory of the message outlined in Capurro, 2003.
7. For an explicit reference to Hermes's activities as a translator, see Gadamer, 1974, p. 1062.
8. Schniewind, 1953, p. 57 f.
9. Siegert, 1999, p. 46. See also: Herodotus, 1969, p. 97.
10. Plato, 1937, vol. 1, p. 285f.
11. On the etymology of the word 'messenger' as ambassador (*missus*, *nuntius*, *legatus*, *cursor*), see Wenzel, 1997, p. 87, note 2.
12. Sloterdijk, 1999, p. 667.
13. Ibid., p. 668.
14. Wenzel, 1997, p. 13.
15. Fischer, 2004, p. 80.
16. Ibid., p. 82.
17. Ibid., p. 31.
18. Ibid., p. 35.
19. Wenzel, 1997, p. 86 ff.
20. Ibid., p. 98.
21. Siegert, 1997, p. 49; Wenzel, 1997, p. 92 ff.
22. Siegert, 1997, p. 50.
23. Wenzel, 1997, p. 97.
24. Tholen, 2002, p. 8.
25. 'To a certain extent the messenger must become neutral, as if he were a pure channel.' Sloterdijk, 1999, p. 676.
26. This statement obviously refers to the 'pure form' of the messenger model; it does not represent a judgement concerning empirical-historical forms of transmission. At the same time it is also clear that this 'discursive power-lessness' constitutes the prerequisite for the 'telecommunications of power' embodied in the messenger.
27. See: Capurro, 2003, 105 ff.
28. Plato, 1937, vol. 1, p. 289.
29. Descartes, 1850, p. 98.
30. Siegert, 1997, p. 48.

Transmissions
1. On this concept: Pleşu, 2005, p. 240.
2. Qtd. in ibid., p. 243.
3. Ibid., p. 243.
4. Siegert, 1999, p. 46.
5. Wenzel, 1997, p. 16.
6. Serres, 1995, p. 293.
7. See also: '*Le charme des mondes intermédiares*' in: Pleşu, 2005, p. 17 ff.

8. Wilke, 2001, p. 70.
9. Ibid.
10. Ibid., p. 78.
11. *Et l'angélogie en particulier comme une médiologie à l'état mystique, ou gazeux.'* Debray, 2000, p. 31.
12. Ibid., p. 32 (the original text reads: *'les petits télégraphistes du Très-Haut'*).
13. Ibid., p. 31-32.
14. Luke 1:19: 'I am Gabriel. I stand in the presence of God, and I have been sent to speak to you and to tell you this good news.'
15. Seebaß, 1982, p. 585.
16. Barth, 1950, p. 428, p. 562.
17. Ibid., p. 540.
18. Serres, 1995, p. 102.
19. Ruhs, 1997, p. 110.
20. Gehring, 2004, p. 52 ff.
21. Ibid., p. 52.
22. Ibid., p. 61.
23. Hubig, 1992, p. 50.
24. For a reference that recalls Schelling, see Pleşu, 2005, p. 242.
25. Piepmeier, 1976, p. 375.
26. Zwingli explains that in order for Christ 'to be able to be a mediator' he is at the same time 'entirely God and entirely human', and he then continues: 'Not because the one nature becomes the other or because they both blend together, but rather because they each retain their uniqueness.' Zwingli, 1940-1963, vol. 11, p. 257.
27. Hamann, 1955, p. 213.
28. Macho, 1997, p. 88.
29. Cacciari, 1994, p. 83.
30. Macho, 1997, p. 83.
31. Pleşu, 2005, p. 260.
32. Ibid., p. 240.
33. Debray, 2000, p. 41 ff.
34. On the social history of Satan: Pagels, 1995.
35. Debray, 2000, p. 43.
36. Godwin, 1990, p. 36 ff.
37. Macho, 1997, p. 90 ff.
38. Pleşu, 2005, p. 247.
39. Ibid., p. 238.
40. Ibid., p. 244.
41. Ibid., p. 252.
42. Ibid., p. 247.
43. Ibid., p. 259.
44. 'For Benjamin, the necessity of the angel arises from the problem of representation, as the representation of ideas [...] Artists need angels for their

pictures, but philosophers need angels as well: their words must also be representations and concern representation.' Cacciari, 1986, p. 129.

45. 'The problem of the angel is nothing other than the problem of representation.' Cacciari and Vedova, 1989, p. 12.

46. Ibid., p. 12.

47. Ibid., p. 16.

48. Ibid., p. 20.

49. Translator's note: The inclusion of a hyphen in the German word for imagination (*Ein-Bildung*) also suggests 'forming one'.

50. Cacciari and Vedova, 1989, p. 22.

51. Weigel, 2007a, p. 309-310. For Weigel the images of angels, which manifest what is never seen, become *images of the image*, which opens up a discussion of the concept of the image in painting.

52. Cacciari, 1994, p. 2; Pleşu, 2005, p. 260.

53. See Bandini, 1995, p. 162 f.

54. Pleşu, 2005, p. 260.

55. '*The age of globalization is the age of universal contagion*', Hardt and Negri, 2000, p. 136.

56. Fischer-Lichte, 2005, Schaub, 2005, Suthor, 2005.

57. Schaub and Suthor, 2005, p. 9, emphasizes this aspect of corporeality.

58. Winau, 2005, p. 66 f.

59. Ibid.

60. The process of immunization is based on this identification of something as 'foreign': the inoculated pathogen is recognized as foreign and is met with an immune response.

61. Mayer and Weingart, 2004, p. 10.

62. On this concept: Link, 1988, p. 293.

63. Lüdtke, 2000, p. 159.

64. Doerfler, 2002, p. 3.

65. Lindinger, 2004.

66. Dawkins, 1991.

67. Rötzer, 2003.

68. The most significant contributions to this discussion in the humanities are above all Derrida, 1988, and Serres, 2007.

69. For a reference to the positive use of '*parasitos*', based on a discovery in the temple of Heracles in Cynosarges, see Athenaeus, 1854, vol. 1, p. 370-391. The writing of Athenaeus – a kind of ancient history of morality – is the oldest source for the positive meaning of '*parasitos*'.

70. See: Bokern, 2003.

71. Serres, 2007, p. 192.

72. Ibid., p. 8.

73. Ibid., p. 7.

74. A revealing phenomenon in this regard is 'parasitic architecture'. This practice involves the strategic placement of small 'parasitic' buildings in ailing

host buildings. These small buildings actually use the infrastructures of their host buildings, but rather than simply draining their energy they are supposed to revitalize them and make them more attractive. See: Bokern, 2003.

75. We are ignoring here the methodological problem associated with the difference between the literal and metaphorical meaning of terms. This distinction is more than a little problematic, but in our everyday language it possesses an intuitively obvious meaning.

76. Girard, 1977.

77. Setton, 2005, p. 367.

78. I am focusing only on Girard's discussion of the archaic epoch in which reciprocal acts of revenge were allayed through acts of collective violence towards an 'innocent sacrifice', and I have not included any discussion of the sacrifice's evolution into a guild-ridden, conscience-plagued subject, which is embodied in the figure of Oedipus Rex. Girard, 1977, p. 169 ff.

79. Ibid., p. 30 ff.

80. Setton, 2005, p. 370.

81. Girard, 1977, p. 18.

82. At least up until what Girard diagnoses as the 'crisis of the cult of sacrifice' occurs.

83. Girard actually rejects the idea that animals are particularly appropriate sacrifices, yet Setton, 2005, p. 374, rightly sees an insight in his thoughts on the 'zoomorphism' of the sacrifice: in a way, human sacrifices were also seen and treated as animals.

84. Girard, 1977, p. 8.

85. Setton, 2005, p. 374.

86. Fischer-Lichte, 2005, p. 35 ff.

87. Ibid., p. 40.

88. Ibid., p. 36.

89. Ibid.

90. Ibid., p. 41.

91. Artaud, 1958, p. 15-32.

92. Fischer-Lichte, 2005, p. 43.

93. Ibid., p. 50.

94. Ibid.

95. Girard, 1977, p. 79.

96. Gebauer and Wulf, 1995, p. 235.

97. Winkler, 2004.

98. Bockelmann, 2004.

99. Rotman, 1987.

100. Blasche, 2002; also: Hadreas, 1989.

101. According to Derrida, 1992a, this is why there is no such thing as a gift.

102. For more detail see: Ganßmann, 1995.

103. Ibid., p. 134.

104. Hörisch, 1997, p. 681, speaks of a 'transcendental synthesis'. Bockelmann, 2004, p. 172 ff., also focuses on the synthetic function of money.

105. Müller, 1816, already called attention to this personal dimension very early when he criticized Adam Smith's theory of money by arguing that its most important property was its ability to regulate relationships between people. Qtd. in Blasche, 2002, p. 192 f.

106. Riese, 1995, p. 55.

107. Blasche, 2002, p. 193 also refers to credit as the nucleus of the social function of money.

108. Riese, 1995, p. 54 ff.

109. Curtius, 1978, p. 106.

110. Ibid., p. 107.

111. Ibid., p. 108.

112. See also: Laum, 1924.

113. Simmel, 2004, p. 75.

114. Ibid., p. 78.

115. Winkler, 2004, p. 41.

116. Blasche, 2002, p. 193.

117. See also: Hadreas, 1989.

118. Blasche, 2002, p. 188.

119. Ibid.

120. Riese, 1995, p. 56.

121. See also: Marx, 1906, p. 106-162.

122. The splitting of the nominal and the real is also reflected in the separation between the sums that are transferred in monetary transactions and the money that only circulates in the material form of bills and coins. On the creation of 'sight deposits' see: Raap, 2000, p. 211.

123. Winkler, 2004, p. 42 ff.

124. Hörisch, 1997, p. 681.

125. A 'neutrality postulate' is also promoted in economics: Laidler, 1991; see also: Schelkle and Nitsch, 1995, p. 22 ff.

126. Bockelmann, 2004, p. 224.

127. Simmel, 2004, p. 261.

128. 'Money, in minted form, surely played the essential role of the mediator in the transformation because the abstraction of the real can only emerge in the socially synthesizing property or function of minted money.' Sohn-Rethel, 1990, p. 33.

129. Bockelmann, 2004, p. 213 ff.

130. Sylla, 1993.

131. Simmel, 2004, p. 118.

132. Nietzsche, 1964, p. 79-80.

133. Sohn-Rethel, 1990, p. 31.

134. Ibid., p. 9.

135. Seitter, 2002, p. 185.

136. Ibid., p. 182.
137. Ibid., p. 180 ff.
138. Vief, 1991, p. 140.
139. Sohn-Rethel, 1990, p. 34.
140. Seitter, 2002, p. 188.
141. Ibid.
142. Gabriel, 2003, p. 28.
143. Thomä, 2004, p. 259.
144. Ibid., p. 260.
145. Translator's note: the German word for 'translation' (*übersetzen*) also means 'crossing over' in the sense of ferrying across a river. Heidegger is invoking this double meaning when he describes translation as the act of 'leaping over' to a foreign shore.
146. Two citations will clarify this: 'Such translation is possible only if we transpose ourselves into what speaks from these words. And this transposition can succeed only by a leap, the leap of a single vision which sees what the words […] tell.' Heidegger, 1968, p. 232, and: 'In the case of the translation of the words of Heraclitus […] the act of translating is like crossing over to a foreign shore that lies beyond a wide river. It is easy to get lost there and the journey usually ends with a shipwreck.' Heidegger, 1979, p. 45.
147. Quine, 1960, p. 29 ff.
148. Derrida, 1992b.
149. Benjamin, 1996a, p. 70.
150. Ibid., p. 70.
151. See: Benjamin, 1999. In his late work he then turns to aesthetic reproduction.
152. Benjamin, 1996a, p. 62.
153. Ibid.
154. Ibid., p. 66.
155. Hirsch, 1995, p. 51 ff. called attention to this.
156. Ibid., p. 10.
157. Hamacher, 2003, p. 183.
158. 'For what does a literary work "say"? What does it communicate? It "tells" very little to those who understand it. Its essential quality is not statement or the imparting of information. Yet any translation which intends to perform a transmitting function cannot transmit anything but information – hence, something inessential. This is the hallmark of bad translations.' Benjamin, 1996b, p. 253.
159. Ibid., p. 257.
160. Ibid.
161. Ibid., p. 258.
162. Ibid., p. 259.
163. Ibid., p. 261.
164. Ibid., p. 258.
165. Ibid., p. 258-259.

166. Hallacker, 2004, p. 140-158, instructively worked out Benjamin's theory of translation and 'pure language'.
167. Benjamin, 1996b, p. 261.
168. 'For if the sentence is the wall before the language of the original, literalness is the arcade.' Ibid., p. 260.
169. 'Where the literal quality of the text takes part directly, without any mediating sense, in true language, in the Truth, or in doctrine, this text is unconditionally translatable.' Ibid., p. 262.
170. Ibid., p. 260.
171. Hirsch, 1995, p. 53 already called attention to this.
172. Benjamin, 1996b, p. 254.
173. Ibid., p. 260.
174. Ibid.
175. Ibid., p. 255.
176. Ibid., p. 258.
177. Ibid., p. 261-262.
178. I cannot agree with Paul de Man that 'it is impossible to translate' (de Man, 1985, p. 26). This only applies to a concept of translation as the transmission of meaning.
179. Translator's note: the German word for transmission, '*Übertragung*', can also be translated as 'transference', a psychoanalytic term that refers to the unconscious redirection of feelings. The purpose of this chapter is to explore what psychoanalytic transference reveals about the nature of transmission, so these two terms will be used interchangeably.
180. Although psychoanalysis is implemented as conversation, what the patient performs in transference is considered an acting out and not only talk; see Roth, 1952.
181. This concept can be found in Strachey, 1934.
182. Ellenberger, 1970, p. 53 ff.
183. Peters, 1977, p. 13.
184. Sandler and Sandler, 1984, p. 370.
185. Ibid., p. 390.
186. Peters, 1977, p. 17.
187. Qtd. in ibid., p. 18.
188. Janet, 1897.
189. 'Somnambulistic' in the sense of being 'under the spell of hypnosis'.
190. See also Peters, 1977, p. 21, who refers to Braid's instructions for hypnosis.
191. Jones, 1962, vol. 1, p. 225.
192. Peters, 1977, p. 31.
193. Freud, 1955, vol. 2, p. 302 ff.
194. Freud later commented again on Breuer's decision to stop treating Anna O.: 'I found reason later to suppose that a purely emotional factor, too, had given him an aversion to further work on the elucidation of the neuroses. He had come up against something that is never absent – his patient's

transference on to her physician, and he had not grasped the impersonal nature of the process.' Freud, 1955, vol. 19, p. 280.

195. Szasz, 1963, p. 437.

196. Freud, 1955, vol. 19, p. 280.

197. Szasz, 1963, was the first to develop the idea that the theory and technique of transference (also) represents a 'defense mechanism' for the analyst.

198. Freud, 1955, vol. 16, p. 442.

199. Freud, 1955, vol. 7, p. 116.

200. Freud, 1955, vol. 16, p. 444.

201. Ibid., p. 443.

202. Ibid., p. 443-444.

203. Ibid., p. 444-445.

204. C.G. Jung described this more clearly: 'The transference, however, alters the psychological stature of the doctor, though this is at first imperceptible to him. He too becomes affected, and has as much difficulty in distinguishing between the patient and what has taken possession of him as has the patient himself. This leads both of them to a direct confrontation with the daemonic forces lurking in the darkness.' Jung, 1966, vol. 16, p. 182.

205. Freud, 1955, vol. 11, p. 144-145.

206. Freud employed the publishing terms 'reprints', 'reissues', and finally 'revisions' in order to emphasize the repetitive character of transference feelings and their relation to the past: Freud, 1955, vol. 7, p. 7-122.

207. Freud, 1955, vol. 12, p. 100.

208. 'The part of the patient's emotional life which he can no longer recall to memory is reexperienced by him in his relation to the physician.' Freud, 1955, vol. 11, p. 51.

209. 'In every psycho-analytic treatment of a neurotic patient the strange phenomenon that is known as 'transference' makes its appearance. The patient, that is to say, directs towards the physician a degree of affectionate feeling (mingled, often enough, with hostility) which is based on no real relation between them and which – as is shown by every detail of its emergence – can only be traced back to old wishful phantasies of the patient's which have become unconscious.' Ibid.

210. Szasz, 1963, p. 437.

211. If this is true, then it also implies that transference is not a universal phenomenon that takes place in any relationship.

212. 'The transference thus creates an intermediate region between illness and real life through which the transition from the one to the other is made.' Freud, 1955, vol. 12, p. 154.

213. Sterba, 1936.

214. Freud, 1955, vol. 12, p. 168.

215. Qtd. in Peters, 1977, p. 54. Freud emphasizes this again in a letter: 'I am not the psychoanalytic superman that you have conceived in your imagination, I have also not overcome countertransference.' Qtd. in ibid., p. 55.

216. Freud, 1955, vol. 2, p. 302.

217. Freud, 1955, vol. 7, p. 116.

218. C.G. Jung favoured a face-to-face situation in which both the analyst and the patient sat in an upright position and shared eye contact precisely because he saw transference as a disruptive and demonic event that needed to be deactivated.

219. '[T]he analyst is received as an adult because he sits and is therefore situated on the higher level of parents.' Spitz, 1956, p. 67 f.

220. See: Krämer, 2001, p. 193 ff.

221. Balint, 2001, p. 222.

222. Schelling, 1985, p. 82. Habermas's position (1979) also points in this direction, as he claimed that Freud founded a human science that was seen and practiced as a natural science.

223. The unconscious 'is not absolute but only relative to hermeneutics as method and dialogue'. Ricoeur, 1974, p. 107.

224. Wyss, 1982, p. 101 f.

225. Racker, 1978, p. 43.

226. Weiß, 1988, p. 49, see also: p. 52 ff.

227. Lorenzer, 1983.

228. Bordin, 1974, p. 13.

229. Weiß, 1988, p. 65 ff. links his interaction theory of psychoanalysis directly to Spitz.

230. Spitz, 1956, p. 21.

231. Ibid., p. 48 ff.

232. Spitz, 1978, p. 123.

233. Ibid., p. 42.

234. Spitz, 1972, p. 197.

235. Spitz, 1957, p. 74.

236. 'Life in our sense is created through dialogue.' Spitz, 1976, p. 26.

237. Weiß, 1988, p. 210.

238. For Luhmann resonance between a system and its environment is only possible by virtue of the system's own vibrations; see: Luhmann, 1989, p. 15 ff.

239. For a discussion of the different notion of witness knowledge within Indian philosophy and a critical examination of its 'Western' marginalization, see Matilal and Chakrabarti, 1994.

240. Leibniz, 1949, p. 417.

241. Hume, 1975, p. 109-116.

242. See: Scholz, 2001a.

243. Reid, 1967, p. 194 ff.

244. Scholz, 2004, p. 1322.

245. Lipton, 1998, p. 2 (italics added).

246. For a discussion of the French debate, see Castelli, 1972.

247. These authors include Coady, 1992; Fricker, 1987; Fricker, 1995; Lipton, 1998; Welbourne, 1979; Welbourne, 1986.

248. See: Chauvier, 2005.
249. Translator's note: The German word for creation, '*Erzeugen*', also contains the root word '*zeugen*', which means 'to bear witness'.
250. Reid, 1967, p. 194-196.
251. The Middle High German word '*geziuge*', from which evolved the German word for witness, '*Zeuge*', was a legal term meaning 'to be arraigned'. *Duden*, vol. 6, p. 2936.
252. Coady, 1992, p. 32.
253. Düttmann, 1996, p. 73, qtd. in Weigel, 2000, p. 117.
254. See: Schwemer, 1999, p. 323.
255. The fact that the theoretical question of 'right' information refers to the practical question of guilt, innocence, and judgement is made apparent by the possibility of the right to refuse to give evidence, such as testimony given by close relatives of the accused, as well as witness protection, which the state grants to witnesses for the prosecution when they are faced with anticipated acts of revenge on the part of the accused.
256. For more on this principle – and its undermining – see: Schünemann, 2001, p. 401.
257. In the Constitutio Criminalis Carolina of 1532, the first standardized code of law, hearsay was fundamentally excluded from witness statements: Scholz, 2004, p. 1318.
258. English law treats 'hearsay' with scepticism. See: Coady, 1992, p. 33.
259. Nevertheless, it is not permitted to be the only means of evidence used to arrive at a verdict. See: *Fachlexikon Recht*, 2005, p. 1583.
260. Plato, 1937, vol. 2, p. 206.
261. Plautus, 1913, p. 231, qtd. in Scholz, 2004, p. 1323.
262. Meyer-Goßner, 2004, p. 152.
263. Ibid.
264. It is explicitly noted in all legal commentaries that this also applies to children and the mentally ill.
265. Peters, 2001, p. 709 ff.
266. 'The kind of evidence in question here seems to be ›say-so‹ evidence: we are, that is, invited to accept something or other as true because someone says it is, where the someone in question is supposed to be in a position to speak authoritatively on the matter.' Coady, 1992, p. 27.
267. Strafprozeßordnung §69, Sec. 1. See: Schünemann, 2001, p. 389.
268. Peters, 2001, p. 710.
269. Traces that are misinterpreted are no longer (involuntary) traces in the conventional sense, just as a weathercock rusted in place is no longer an index.
270. For a detailed analysis of the ethical dimension of witnessing see: Schmidt, 2007.
271. Whether a 'court decides that a factual claim is to be deemed true or not' depends on considerations of trustworthiness: Nack, 2001, p. 2.

272. This principle explains why writing (as transcribed oral speech) is the best form of admissible evidence, while videos and photographs are only admissible to a limited extent, if at all.
273. Auslander, 1999, p. 112 ff., develops a media-theoretical analysis of orality in the American legal system.
274. Luhmann, 1968, p. 35.
275. In an entirely different way, the fallibility of testimony is a key element in two recent French studies on witnessing: Derrida, 2005, and Dulong, 1998.
276. Agamben, 2002, p. 145 f.
277. Schünemann, 2001, p. 388.
278. Ibid., p. 391.
279. Ibid., p. 388.
280. See also: Kaube, 2006; Barton, 1995.
281. Ross, Read, and Toglia, 1994.
282. Peters, 2001, p. 709.
283. Schünemann, 2001, p. 394.
284. This is shown most prominently in the reimbursement of expenses and the right to refuse to give evidence. Ibid., p. 395.
285. Ibid., p. 396.
286. This role usually entails the right to access records. Ibid., p. 396.
287. Kierkegaard also identifies this truth as the 'discovery' and the 'dividend' that is passed down within a community, and it therefore does not matter who discovered this truth. Kierkegaard, 1944, p. 205.
288. Ibid., p. 201.
289. 'Wherein then lies the fundamental confusion in Pilate's question?' Kierkegaard continues: 'How then could Christ explain this to Pilate in words, when that which is the truth, Christ's own life, has not opened Pilate's eyes to what truth is? [...] The question is just as foolish, precisely as foolish, as if one were to inquire of a man with whom one was talking, "Dost thou exist?" [...] And what could that man say in reply? He must say, "If one who stands here talking to me cannot feel sure that I exist, my asseveration can be of no avail, for that is something much less than my existence."' Ibid., p. 199 f.
290. Ibid., p. 219 ff.
291. Barth, 1946.
292. Ibid., p. 272-276.
293. Luke 24:48 employs this concept: 'You are witnesses of these things', namely of suffering, the appearance of Christ, and his words. Qtd. in ibid., p. 273.
294. Ibid., p. 275.
295. Ibid., p. 276-283.
296. Matthew 10:18, Mark 13:9, Luke 21:12 f. Qtd. in ibid., p. 276.
297. I John 1:1.
298. See also: Schwemer, 1999, p. 326.
299. Plato, 1937, vol. 1, p. 401 ff.

300. As a loyal and true witness who certifies the authenticity of his spoken testimony through his body and his death: Book of Revelation 1:5; 3:14.
301. Schwemer, 1999, p. 347.
302. Translator's note: the German word for credibility, '*Glaubwürdigkeit*', literally means 'worthy of faith'.
303. This prominently includes the 'Fortunoff Video Archive', now located in the archive of Yale University, which contains 200 recordings of witness interviews, and the Yale Oral Testimony Project, which has recorded 4000 personal reports from survivors and other witnesses of the Holocaust and has more than 30 branches operating in many countries: Hartman, 2000a, p. 100 f.
304. Baer, 2000, particularly the essays by Hartman, Laub, and Caruth.
305. Dulong, 1998.
306. Laub, 1992, p. 59 ff., mentions the case of an Auschwitz inmate who made factual errors when recounting her memories, who forgot her participation in the 'Canada Commando', and who marginalized the Jewish resistance.
307. Weigel, 2000, p. 131.
308. Levi, 1989, p. 11.
309. Also: Laub, 2000.
310. Laub, 1992, p. 80.
311. Agamben, 2002, p. 41 ff.
312. Ibid., p. 41.
313. Ibid., p. 150.
314. Ibid.
315. Weigel, 2000, p. 119.
316. Hartman, 2000b.
317. See also: Hartman, 2000b, p. 38 ff., and Laub, 2000, p. 70 ff.
318. Danto, 2007, p. 343.
319. Hartman, 2000a, p. 86.
320. See also: Weigel, 2000, p. 118.
321. Hartman, 2000a, p. 89. Schmidt, 2007 traces the ethical-social dimension of witnessing back to the problem that given the unverifiability of every witness statement the witness effectively needs a 'guarantor' who vouches for and bears witness to the trustworthiness of the witness.
322. For more on 'secondary witnesses', see: Baer, 2000, p. 101 ff.
323. Laub, 2000, p. 68.
324. Coady, 1992, p. 38.
325. For example: Searle and Vanderveken, 1985, p. 182 ff.
326. Kusch, 2002, p. 67 f.
327. Fricker, 1994 critically grapples with the problem of 'credulity' – the dark shadow that witnessing casts over knowledge.
328. Craig, 1993, p. 43; see also: Gelfert, 2003, p. 133.
329. Shapin, 1994.

330. Wittgenstein nevertheless recalls: 'A child learns there are reliable and unre-
 liable informants much later than it learns facts which are told it.' Wittgen-
 stein, 1969, p. 22.
331. Hume, 1975, p. 109-116.
332. Weigel, 2000, p. 116.
333. Gelfert, 2003, p. 136, also emphatically calls attention to this asynchrony.
334. Coady, 1992, p. 152 ff.; Scholz, 2001b, p. 369.
335. Scholz, 2001b, p. 355.

So What Does 'Transmission' Mean?

1. Grimm and Grimm, 1961, vol. 23, p. 602.
2. Ibid., p. 598.
3. Mann, 1955, p. 83.
4. This is the starting point for Sigrid Weigel's reconstruction of images of
 angels as 'images of images'. See: Weigel, 2007a, p. 309.
5. Cacciari and Vedova, 1989, p. 20.
6. Aisthesis (αἴσθησις) refers to the 'theory of sensory perception' as developed
 by Plato and Aristotle.
7. Seel, 1998, p. 50.
8. Ibid., p. 52 ff.
9. Although for us this standard measure constitutes only *one* of the functions
 of money!
10. See chapter 2.
11. Aristotle, 1964, p. 106 ff.
12. Heider, 1927.
13. Luhmann, 1987.
14. Mersch, 2002a, p. 135 ff.
15. Groys, 2012, p. 11 ff.
16. Lagaay, 2001.
17. Translator's note: '*Spur*' is also the German word for 'trace'.
18. See: Krämer, 2007.
19. On reading traces: Kogge, 2007, p. 186-188.
20. Reichertz, 2007, p. 326 ff.
21. Grube, 2007, p. 231.
22. Ginzburg, 1995.
23. Rheinberger, 1992.
24. Jäger, 2001.
25. Krämer, Kogge, and Grube, 2007.
26. Levinas, 1986, p. 345-359.
27. Ibid., p. 356 (italics added).
28. Ibid., p. 357.
29. Ibid., p. 348.
30. Ibid., p. 346.
31. Ibid., p. 348.

32. Ibid.
33. Ibid., p. 351; also: 'The epiphany of the absolutely other is a face.' Ibid., p. 353.
34. Ibid., p. 355.
35. Ibid., p. 357.
36. Ibid., p. 358.
37. Ibid.
38. Ibid., p. 356.
39. Ibid., p. 353.
40. Ibid.
41. Westerkamp, 2006.
42. Kittler, 1993; see also: Krämer, 2004c.

Test Case

1. *Dispositif* in Foucault's sense of embeddedness in an ensemble of discursive and non-discursive practices. See Foucault, 1978, p. 119 f.
2. Schlögel, 2003, p. 91.
3. Translator's note: The German words '*Weltbild*' and '*Weltanschauung*' literally refer to views of the world but figuratively refer to views or philosophies of life.
4. In the late Middle Ages the German word for map, '*Karte*', referred to a piece of paper.
5. See Ljungberg, 2003.
6. Jacob, 1996, p. 191.
7. See Edney, 1993, p. 56.
8. Brannon, 1989; Rees, 1980; for criticism see Edney, 1993.
9. For more on the map as a metaphor for scientific theories see Azevedo, 1997.
10. This approach is pursued in Cosgrove, 1999; Harley, 1989; Pickels, 1995; Wood, 1992.
11. Jacob, 1996, p. 192.
12. See Guggerli and Speich, 2002; Wood and Fels, 1986.
13. Pickels, 2004, p. 70.
14. Harley, 1989.
15. Long before the elaboration of the messenger perspective this idea was already developed in Krämer, 1998.
16. Monmonier, 1991.
17. Wood and Fels, 1986.
18. Harley, 1988a.
19. Monmonier, 1991, p. 54.
20. Berlin city maps were to a large extent obsolete after German reunification.
21. Kitchin and Dodge, 2007, p. 342.
22. de Certeau, 1988, p. 115-130.
23. Ibid., p. 117.
24. See, for example, Umberto Eco's essay 'On the Impossibility of Drawing a Map of the Empire on a Scale of 1 to 1' (Eco, 1994, p. 95-106) and Lewis Car-

roll's *reductio ad absurdum*: '"Have you used it much?" I enquired. "It has never been spread out, yet," said Mein Herr. The farmers objected: They said it would cover the whole country, and shut out the sunlight! So we now use the country itself, as its own map, and I assure you it does nearly as well.' Carroll, 1893, p. 169, qtd. in Edney, 1993, p. 55.

25. Cosgrove, 2001.
26. Monmonier, 1991, p. 8 ff.; Schlögel, 2003, p. 97 ff.
27. For more on the semiotics of maps, see Bertin, 1967; MacEachren, 1995; Pápay, 2005.
28. Sobel, 2003. Translator's note: The English word 'latitude' is derived from the Latin word '*latitudo*' which means 'width', and the English word 'longitude' is derived from the Latin word '*longitudo*', which means 'length'.
29. For example, there are conformal, equidistant, azimuthal, scale preservation, and equal-area projections.
30. See Ossermann, 1997, p. 28 ff.
31. Peters, 1983. This involved a cylindrical projection with secant parallels in temperate latitudes rather than the tropics and at the equator.
32. See Deutsche Gesellschaft für Kartografie, 1981; Crampton, 1994; Robinson, 1985.
33. See Protestant mission work in Germany: 'Die Welt mit anderen Augen sehen – Die Weltkarte des Bremer Historikers Prof. Dr. Arno Peters' (http://www.emw-d.de/fix/files/peters-proj.pdf).
34. The discussion of forged Soviet maps is often based on the assumption that maps can be transparent, distorted, neutral, and free of ideology: 'Soviets Admit Map Paranoia', in: *Wisconsin State Journal*, vol. 3, September 1988, qtd. in Harley, 1989, p. 9.
35. Monmonier, 1991, p. 33; also Schlögel, 2003, p. 101.
36. It is interesting that subways and buses are labelled 'line 1', 'line 2', etc. This is proof of how strongly the representational conditions of maps condition our understanding of what is represented.
37. 'Legibility overrides geometric fidelity'. Sismondo and Chrisman, 2001, p. 43.
38. Rheinberger, 1992.
39. Guggerli and Speich, 2002, p. 13.
40. Ibid., p. 84.
41. Ibid., p. 76 ff.
42. Ibid., p. 80.
43. Ibid., p. 84.
44. Wood and Fels, 1986; Harley, 1988b.
45. 'Cartography provides a means by which to classify, represent and communicate information about areas that are too large and too complex to be seen directly.' Dodge and Kitchin, 2001, p. 2.
46. Jonas, 1997, p. 259 ff.
47. See the excellent compilation of digitalized maps in Dodge and Kitchin, 2001.

48. Programmatic for Al Gore's speech 'The Digital Earth: Understanding Our Planet in the 21st Century' on January 31, 1998, in Los Angeles (http://www.digitalearth.gov).
49. There are other similar programs like NASA World Wind, Microsoft Virtual Earth, Yahoo Maps, Amazon A9, Googletouring, Googlesightseeing, etc. See Soutschek, 2006.
50. 'US-Marine will "Hakenkreuz" tarnen', *Tagesspiegel*, 28 September 2007.
51. Dworschak, 2006.
52. Butler, 2006b.
53. Butler, 2006a.
54. Ibid.
55. Drösser, 2007.
56. Nourbakhsh et al., 2006.
57. Weigel, 2002.

Epilogue

1. The field of contemporary media theory is 'surveyed' in: Filk, Grampp, and Kirchmann, 2004; Jäger, 2004; Groys, 2012; Hartmann, 2000; Lagaay and Lauer, 2004; Krämer, 2002; Mersch, 2002a; Mersch, 2003; Mersch, 2004; Mersch, 2006; Münker, Roesler, and Sandbothe, 2003; Pias et al., 1999; Ramming, 2001; Sandbothe, 2001; Sandbothe and Nagl, 2005; Tholen, 2002; Vogel, 2012; Winkler, 2004.
2. Rorty, 1979.
3. Such an analysis constitutes the foundation of *Systematische Medienphilosophie*, which was edited by Mike Sandbothe and Ludwig Nagl: see Sandbothe and Nagl, 2005.
4. Alice Lagaay and David Lauer have produced a series of annotated analyses of these theories: see Lagaay and Lauer, 2004; Dieter Mersch has more recently worked on them in a monograph: see Mersch, 2006.
5. Leschke, 2003, p. 73.
6. Ibid., p. 161.
7. See chapter 9.
8. Schirmacher, 1994, p. 77; also: 'Taking care of oneself is now the activity of media'. Ibid., p. 77.
9. It is remarkable in this regard that at the end of his life Foucault himself, to whom the 'death of the subject' is often attributed, returned to the subject from the perspective of subjective self-representation and self-formation. Nevertheless, Foucault based this idea of 'self-care' on classical Greek antiquity, in which self-care was not yet colonized by the principle of self-awareness. It was therefore oriented towards not true knowledge but rather 'true life'. Foucault, 2005.
10. See Winkler, 2004.
11. Gamm, 1998.
12. Peters, 1999.

13. Seel, 1998.
14. The idea of the third is understood here in a thoroughly 'weak' formal sense that consists in accepting a both/and instead of the disjointed either/or.
15. This study has only examined the transparency (representationality) and opacity (constructivity) of maps: see chapter 18.
16. Luhmann, 2000, p. 102 ff.
17. On suicide bombers and the cult of martyrs: see Weigel, 2007b, p. 11 ff.
18. Serres, 2007.
19. Unlike Werner Hamacher's concept of 'heterautonomies'. Hamacher, 2003.
20. Rimbaud, 1966, p. 305 (the original text reads: '*Je est un autre*').
21. Fischer, 2000; Fischer, 2004.
22. Even if this concept mostly evokes a defensive response from humanities scholars!
23. For a discussion of what this means for the evolution of mathematics: see Krämer, 1988; Krämer, 1991.
24. It is no accident that Derrida is confronted with dissemination in the context of his conviction that writing (which is based on absence) rather than speech (which is based on presence) constitutes the 'ineluctable elementary form' of our approach to signs: see Derrida, 1987.
25. Peters, 1999.
26. Mersch, 2001; Mersch, 2002b; Krämer, 2003b; Klein and Jungbluth, 2002; Gfrereis and Lepper, 2007.
27. For instructive debates concerning these considerations: see Figal, 2007.
28. Mersch, 2001, p. 86.
29. Foucault, 2005.

Bibliography

Adorno, Theodor W. (1982). 'On the Fetish-Character in Music and the Regression of Listening', in: *The Essential Frankfurt School Reader*, ed. Andrew Arato and Eike Gebhardt, New York: Continuum, 270-299.

Agamben, Giorgio (2002). *Remnants of Auschwitz: The Witness and the Archive*, trans. Daniel Heller-Roazen, New York: Zone Books.

Aristotle (1964). *On the Soul, Parva Naturalia, On Breath*, trans. W.S. Hett, London: William Heinemann.

Artaud, Antonin (1958). 'The Theater and the Plague', in: *The Theater and Its Double*, trans. Mary Caroline Richards, New York: Grove Press, 15-32.

Athenaeus (1854). *The Deipnosophists*, trans. C.D. Yonge, 3 vols., London: Henry G. Bohn.

Auslander, Philip (1999). *Liveness: Performance in a Mediatized Culture*, London: Routledge.

Azevedo, Jane (1997). *Mapping Reality: An Evolutionary Realist Methodology for the Natural and Social Sciences*, New York: New York University Press.

Baer, Ulrich, ed. (2000). *'Niemand zeugt für den Zeugen': Erinnerungskultur und historische Verantwortung nach der Shoah*, Frankfurt am Main: Suhrkamp.

Bahr, Hans-Dieter (1999). 'Medien-Nachbarwissenschaften I: Philosophie', in: *Medienwissenschaft: Ein Handbuch zur Entwicklung der Medien- und Kommunikationsformen*, Berlin: de Gruyter, 273-281.

Balint, Michael (2001). *Primary Love and Psycho-Analytic Technique*, London: Routledge.

Bandini, Pietro (1995). *Die Rückkehr der Engel: Von Schutzengeln, himmlischen Boten und der guten Kraft, die sie uns bringen*, Bern: Scherz.

Barth, Karl (1950). *Die kirchliche Dogmatik*, vol. 3, Zürich: Theologischer Verlag.

Barth, Markus (1946). *Der Augenzeuge: Eine Untersuchung über die Wahrnehmung des Menschensohnes durch die Apostel*, Zürich: Evangelischer Verlag.

Barton, Stephan (1995). 'Fragwürdigkeiten des Zeugenbeweises: Aussagenpsychologische Erkenntnisse und verfahrensrechtliche Konsequenzen', in: *Redlich aber falsch: Die Fragwürdigkeiten des Zeugenbeweises*, ed. Stephan Barton, Baden-Baden: Nomos, 23-65.

Benjamin, Walter (1996a). 'On Language as Such and on the Language of Man', trans. Edmund Jephcott, in: *Selected Writings*, *Volume 1: 1913-1926*, ed. Marcus Bollock and Michael W. Jennings, Cambridge: Belknap Press, 62-74.

— (1996b). 'The Task of the Translator', in: *Selected Writings*, *Volume 1: 1913-1926*, ed. Marcus Bollock and Michael W. Jennings, Cambridge: Belknap Press, 253-263.

— (1999). 'On the Mimetic Faculty', trans. Edmund Jephcott, in: *Selected Writings, Volume 2, Part 2: 1931-1934*, ed. Michael W. Jennings, Howard Eiland, and Gary Smith, Cambridge: Belknap Press, 720-722.

Bertin, Jacques (1967). *Sémiologie graphique: Les diagrammes – les résaux – les cartes*, Paris: Gauthier-Villars and Mouton.

Blasche, Siegfried (2002). 'Zur Philosophie des Geldes', in: *Kultur, Handlung, Wissenschaft*, ed. Mathias Gutmann, Dirk Hartmann, Michael Weingart, and Walter Zitterbarth, Weilerswist: Velbrück Wissenschaft, 182-200.

Bliven, Bruce (1922). 'The Ether Will Now Oblige', in: *New Republic*, vol. 29, no. 376, 328.

Bockelmann, Eske (2004). *Im Takt des Geldes: Zur Genese modernen Denkens*, Springe: Zu Klampen.

Bokern, Anneke (2003). 'Parasitäre Architekturen', in: *Topos*, vol. 42, 52-57.

Bordin, Edward (1974). *Research Strategies in Psychotherapy*, New York: Wiley.

Brannon, Gary (1989). 'The Artistry and Science of Map-Making', in: *Geographical Magazine*, vol. 61, no. 9, 37-40.

Butler, Declan (2006a). 'Mashups Mix Data into Global Service', in: *Nature*, vol. 439, 6-7.

— (2006b). 'The Web-Wide World', in: *Nature*, vol. 439, 776-778.

Cacciari, Massimo (1986). *Zeit ohne Kronos: Essays*, trans. Reinhard Kacianka, Klagenfurt: Ritter.

— (1994). *The Necessary Angel*, trans. Miguel E. Vatter, Albany: State University of New York Press.

Cacciari, Massimo, and Emilio Vedova (1989). *Vedovas Angeli*, Klagenfurt: Ritter.

Capurro, Rafael (2003). 'Theorie der Botschaft', in: *Ethik im Netz*, Stuttgart: Steiner, 105-122.

Carroll, Lewis (1893). *Sylvie and Bruno Concluded*, London: Macmillan.

Castelli, Enrico (1972). *Le Témoignage*, Aubier: Éditions Montagine.

Chang, Briankle G. (1996). *Deconstructing Communication: Representation, Subject, and Economics of Exchange*, Minneapolis, University of Minnesota Press.

Chauvier, Stephane (2005). 'Le savoir du témoin est-il transmissible', in: *Philosophie*, vol. 88, 28-46.

Coady, C. Anthony J. (1992). *Testimony: A Philosophical Study*, Oxford: Clarendon Press.

Cosgrove, Denis (1999). 'Mapping Meaning', in: *Mappings*, ed. Denis Cosgrove, London: Reaktion Books, 1-23.

— (2001). *Apollo's Eye: A Genealogy of the Globe in the West*, Baltimore: Johns Hopkins University Press.

Craig, Edward (1993). *Was wir wissen können*, Frankfurt am Main: Suhrkamp.

Crampton, Jeremy (1994). 'Cartography's Defining Moment: The Peters Projection Controversy 1974-1990', in: *Cartographica*, vol. 31, no. 4, 16-32.

Curtius, Ernst (1978). 'Über den religiösen Charakter der griechischen Münzen', in: *Museum des Geldes: Über die seltsame Natur des Geldes in Kunst, Wissenschaft und Leben*, ed. Jürgen Harten and Horst Kurnitzky, Düsseldorf: Städtische Kunsthalle, 106-113.

Danto, Arthur C. (2007). *Narration and Knowledge*, New York: Columbia University Press.

Dawkins, Richard (1991). 'Viruses of the Mind', in: *Dennett and His Critics: Demystifying Mind*, ed. Bo Dahlbom, Oxford: Blackwell, 13-27.

Debray, Régis (1996). *Media Manifestos: On the Technological Transmission of Cultural Forms*, trans. Eric Rauth, London: Verso.

— (2000). *Transmitting Culture*, trans. Eric Rauth, New York: Columbia University Press.

de Certeau, Michel (1988). *The Practice of Everyday Life*, trans. Steven Rendall, Berkeley: University of California Press.

de Man, Paul (1985). '"Conclusions": Walter Benjamin's "The Task of the Translator"', in: *Yale French Studies*, vol. 69, 25-46.

Derrida, Jacques (1987). *The Post Card: From Socrates to Freud and Beyond*, trans. Alan Bass, Chicago: University of Chicago Press.

— (1988). 'Signature Event Context', in: *Limited Inc*, trans. Samuel Weber and Jeffrey Mehlman, Evanston: Northwestern University Press, 1-23.

— (1992a). *Given Time I: Counterfeit Money*, trans. Peggy Kamuf, Chicago: University of Chicago Press.

— (1992b). 'From *Des Tours de Babel*', trans. Joseph F. Graham, in: *Theories of Translation: An Anthology of Essays from Dryden to Derrida*, ed. Rainer Schulte and John Biguenet, Chicago: University of Chicago Press, 218-227.

— (2005). *Poétique et politique du témoignage*, Paris: Éditions de L'Herne.

Descartes, René (1850). *Discourse on the Method* of Rightly Conducting Reason, and Seeking Truth in the Sciences, Edinburgh: Sutherland and Knox.

Deutsche Gesellschaft für Kartographie (1981). 'Die sogenannte Peters-Projektion: Eine Stellungnahme', in: *Geographische Rundschau*, vol. 33, 334-335.

Dodge, Martin, and Rob Kitchin (2001). *Atlas of Cyberspace*, Harlow: Pearson.

Doerfler, Walter (2002). *Viren*, Frankfurt am Main: Fischer.

Drösser, Christoph (2007). 'Die neue Heimat', in: *Die Zeit*, September 20, 41-42.

Dulong, Renaud (1998). *Le témoin oculaire: Les conditions sociales de l'attestation personelle*, Paris: EHESS.

Düttmann, Alexander García (1996). *At Odds with Aids: Thinking and Talking about a Virus*, trans. Peter Gilgen and Conrad Scott-Curtis, Stanford: Stanford University Press.

Dworschak, Manfred (2006). 'How Google Earth Is Changing Science', trans. Christopher Sultan, in: *Spiegel Online*, January 8, 2006.

Eco, Umberto (1994). 'On the Impossibility of Drawing a Map of the Empire on a Scale of 1 to 1', in: *How to Travel with a Salmon and Other Essays*, trans. Warren Weaver, New York: Harcourt Brace, 95-106.

Edney, Matthew H. (1993). 'Cartography without Progress: Reinterpreting the Nature and Historical Development of Mapmaking', in: *Cartographica*, vol. 30, no. 2 & 3, 54-68.

Ellenberger, Henri F. (1970). *The Discovery of the Unconscious: The History and Evolution of Dynamic Psychiatry*, New York: Basic Books.

Engell, Lorenz (2003). 'Tasten, Wählen, Denken: Genese und Funktion einer Philosophischen Apparatur', in: *Medienphilosophie: Beiträge zur Klärung eines Begriffs*, ed. Stefan Münker, Alexander Roesler and Mike Sandbothe, Frankfurt: Fischer, 53-77.

Engell, Lorenz, and Joseph Vogl (2000). 'Vorwort', in: *Kursbuch Medienkultur: Die maßgeblichen Theorien von Brecht bis Baudrillard*, ed. Claus Pias, Joseph Vogl, Lorenz Engell, et al., Stuttgart: Deutsche Verlags-Anstalt, 8-11.

Enzensberger, Hans Magnus (1982): 'Constituents of a Theory of the Media', in: *Critical Essays*, ed. Reinhold Grimm and Bruce Armstrong, trans. Stuart Hood, New York: Continuum, 46-76.

Figal, Günter (2007). 'Zeigen und Sichzeigen', in: *Deixis: Vom Denken mit dem Zeigefinger*, ed. Heike Gfrereis and Marcel Lepper, Göttingen: Wallstein, 196-207.

Filk, Christian, Sven Grampp, and Kaz Kirchmann (2004). 'Was ist 'Medienphilosophie' und wer braucht sie womöglich dringender: die Philosophie oder die Medienwissenschaft? Ein kritisches Forschungsreferat', in: *Allgemeine Zeitschrift für Philosophie*, vol. 29, no. 1, 39-68.

Fischer, Joachim (2000). 'Der Dritte: Zur Anthropologie der Intersubjektivität', in: *wir/ihr/sie: Identität und Alterität in Theorie und Methode*, ed. Wolfgang Eßbach, Würzburg: Ergon, 103-138.

— (2004). 'Figuren und Funktionen der Tertiarität: Zur Socialtheorie der Medien', in: *Massenmedien und Alterität*, ed. Joachim Michael and Markus K. Schäffauer, Frankfurt am Main: Vervuert, 78-86.

Fischer-Lichte, Erika (2005). 'Zuschauen als Ansteckung', in: *Ansteckung: Zur Körperlichkeit eines ästhetischen Prinzips*, ed. Mirjam Schaub, Nicola Suthor, and Erika Fischer-Lichte, Munich: Fink, 35-50.

Foucault, Michel (1978). *Dispositive der Macht: Über Sexualität, Wissen und Wahrheit*, Berlin: Merve.

— (2005). *The Hermeneutics of the Subject*, trans. Graham Burchell, New York: Palgrave Macmillan.

Freud, Sigmund (1955). *The Standard Edition of the Complete Psychological Works of Sigmund Freud*, trans. James Strachey, 24 vols., London: Hogarth Press.

Fricker, Elizabeth (1987). 'Epistemology of Testimony', in: *Proceedings of the Aristotelian Society*, supplement 61, 57-106.

— (1994). 'Against Gullibility', in: *Knowing from Words*, ed. Bimal Krishna Matilal and Arindam
 Chakrabarti, Dordrecht: Kluwer.
— (1995). 'Telling and Trusting: Reductionism and Anti-Reductionism in the Epistemology of
 Testimony', in: *Mind*, vol. 104, 392-411.

Gabriel, Gottfried (2003). 'Ästhetik des Geldes', in: *Dialektik*, no. 1, 5-16.
Gadamer, Hans-Georg (1974). 'Hermeneutik', in: *Historisches Wörterbuch der Philosophie*, ed. Joachim
 Ritter, Kalfried Gründer, and Gottfried Gabriel, vol. 3, Darmstadt: Buchgesellschaft, 1061-1073.
Gamm, Gerhard (1998). 'Technik als Medium: Grundlinien einer Philosophie der Technik', in:
 Naturerkenntnis und Natursein, ed. Michael Hauskeller, Christoph Rehmann-Sutter, and
 Gregor Schiemann, Frankfurt am Main: Suhrkamp, 94-106.
Ganßmann, Heiner (1995). 'Geld, Arbeit und Herrschaft', in: *Rätsel Geld: Annäherungen aus
 ökonomischer, soziologischer und historischer Sicht*, ed. Waltraud Schelkle and Manfred
 Nitsch, Marburg: Metropolis, 125-144.
Gebauer, Gunter, and Christoph Wulf (1995). *Mimesis: Culture, Art, Society*, trans. Don Reneau,
 Berkeley: University of California Press.
Gehring, Petra (2004). 'Engelszunge, Engelszungen: Einige Feststellungen zur Physiologie der
 Engel', in: *Engel in der Literatur-, Philosophie- und Kulturgeschichte*, ed. Kurt Röttgers and
 Monika Schmitz-Emans, Essen: Blaue Eule, 52-61.
Gelfert, Axel (2003). 'Zeugnis und Differenz: Über die Epistemologie des Beim-Wort-Nehmens
 und In-Erfahrung-Bringens', in: *Differenzerfahrung und Selbst: Bewusstsein und Wahrneh-
 mung in Literatur und Geschichte des 20. Jahrhunderts*, ed. Bettina von Jagow and Florian
 Steger, Heidelberg: Winter Universitätsverlag, 123-140.
Gfrereis, Heike, and Marcel Lepper, eds. (2007). *Deixis: Vom Denken mit dem Zeigefinger*, Göt-
 tingen: Wallstein.
Ginzburg, Carlo (1995). *Spurensicherung: Die Wissenschaft auf der Suche nach sich selbst*, Berlin:
 Wagenbach.
Girard, René (1977). *Violence and the Sacred*, trans. Patrick Gregory, Baltimore: Johns Hopkins
 University Press.
Godwin, Malcolm (1990). *Angels: An Endangered Species*, New York: Simon and Schuster.
Gold, Helmut, and Annette Koch, eds. (1993). *Fräulein vom Amt*, Munich: Prestel.
Grimm, Jacob, and Wilhelm Grimm (1961). *Deutsches Wörterbuch*, Leipzig: S. Hirzel.
Groys, Boris (2012). *Under Suspicion: A Phenomenology of Media*, trans. Carsten Strathausen,
 New York: Columbia University Press.
Grube, Gernot (2007). '"abfährten" – "arbeiten": Investigative Erkenntnistheorie', in: *Spur:
 Spurenlesen als Orientierungstechnik und Wissenskunst*, ed. Sybille Krämer, Werner Kogge,
 and Gernot Grube, Frankfurt am Main: Suhrkamp, 222-257.
Guggerli, David, and Daniel Speich (2002). *Topografien der Nation: Politik, kartografische Ordnung
 und Landschaft im 19. Jahrhundert*, Zürich: Chronos.

Habermas, Jürgen (1979). *Erkenntnis und Interesse*, Frankfurt am Main: Suhrkamp.
— (1984). *The Theory of Communicative Action*, trans. Thomas McCarthy, Boston: Beacon Press.
Hadreas, Peter (1989). 'Money: A Speech Act Analysis', in: *Journal of Social Philosophy*, vol. 20,
 no. 3, 115-129.
Hall, Stuart (1980): 'Encoding/Decoding', in: *Culture, Media, Language: Working Papers in
 Cultural Studies, 1972-1979*, London: Hutchinson, 128-138.
Hallacker, Anja (2004). *Es spricht der Mensch: Walter Benjamins Suche nach der lingua adamica*,
 Munich: Fink.

Hamacher, Werner (2003). 'Heterautonomien: One 2 Many Multiculturalisms', in: *Gewalt verstehen*, ed. Burkhardt Liebsch and Dagmar Mensink, Berlin: Akademie, 157-201.

Hamann, Johann Georg (1955). *Briefwechsel*, ed. Burkhardt Liebsch and Dagmar Mensink, Berlin: Akademie, 157-201.

Hardt, Michael, and Antonio Negri (2000). *Empire*, Cambridge: Harvard University Press.

Harley, John Brian (1988a). 'Silences and Secrecy: The Hidden Agenda of Cartography in Early Modern Europe', in: *Imago Mundi*, vol. 40, 57-76.

— (1988b). 'Maps, Knowledge, and Power', in: *The Iconography of Landscape: Essays on the Symbolic Representation, Design and Use of Past Environments*, ed. Denis Cosgrove and Stephen Daniels, Cambridge: Cambridge University Press, 289-290.

— (1989). 'Deconstructing the Map', in: *Cartographica*, vol. 26, no. 2, 1-20.

Hartman, Geoffrey H. (2000a). 'Die Wunde lesen: Holocaust-Zeugenschaft, Kunst und Trauma', in: *Zeugnis und Zeugenschaft*, ed. Gary Smith and Rüdiger Zill, Berlin: Akademie-Verlag, 83-110.

— (2000b). 'Intellektuelle Zeugenschaft und die Shoah', in: *'Niemand zeugt für den Zeugen': Erinnerungskultur und historische Verantwortung nach der Shoah*, Frankfurt am Main: Suhrkamp, 31-52.

Hartmann, Frank (2000). *Medienphilosophie*, Wien: Universitätsverlag.

Hegel, Georg Wilhelm Friedrich (1971). *Hegel's Philosophy of Mind*, trans. William Wallace, Oxford: Clarendon Press.

Heidegger, Martin (1968). *What Is Called Thinking?*, trans. J. Glenn Gray and F. Wieck, New York: Harper & Row.

— (1979). *Heraklit*, ed. Manfred S. Frings, Frankfurt am Main: Klostermann.

Heider, Fritz (1927). *Ding und Medium*, Berlin: Weltkreis Verlag.

Herodotus (1969). Book VIII, in: *Herodotus*, trans. A.D. Godley, 4 vols., Cambridge: Harvard University Press, vol. 4, 1-156.

Hirsch, Alfred (1995). *Der Dialog der Sprachen: Studien zum Sprach- und Übersetzungsdenken Walter Benjamins und Jacques Derrida*, Munich: Fink.

Hoffmann, Stefan (2002). *Geschichte des Medienbegriffs*, Hamburg: Felix Meiner.

Hörisch, Jochen (1997). 'Geld', in: *Vom Menschen: Handbuch historische Anthropologie*, ed. Christoph Wolf, Weinheim: Beltz, 679-685.

Hubig, Christoph (1992). 'Die Mittlerfigur aus philosophischer Sicht: Zur Rekonstruktion religiöser Transzendenzüberbrückung', in: *Wissenschaft und Transzendenz*, ed. Günther Abel, Berlin: Universitäts-Bibliothek der TU, 49-56.

Hume, David (1975). *Enquiries Concerning Human Understanding and Concerning the Principles of Morals*, Oxford: Clarendon Press.

Jacob, Christian (1996). 'Towards a Cultural History of Cartography', in: *Imago Mundi*, vol. 48, 191-198.

Jäger, Ludwig (2001). 'Transkriptivität: Zur medialen Logik der kulturellen Semantik', in: *Transkribieren: Medien/Lektüren*, ed. Ludwig Jäger and Georg Stanitzek, Munich: Fink, 19-41.

— (2004). 'Störung und Transparenz: Skizze zur performativen Logik des Medialen', in: Per-formativität und Medialität, ed. Sybille Krämer, Munich: Fink, 35-74.

Janet, Pierre (1897). 'L'influence somnambulique et le besoin de direction', in: *Revue Philos-ophique*, vol. 43, 113-143.

Jonas, Hans (1997). 'Der Adel des Sehens', in: *Kritik des Sehens*, ed. Ralf Konersmann, Stuttgart: Reclam, 247-271.

Jones, Ernest (1962). *The Life and Work of Sigmund Freud*, 3 vols., New York: Basic Books.

Jung, Carl Gustav (1966). *The Collected Works of C.G. Jung*, 20 vols., London: Routledge.

Kaube, Jürgen (2006). 'Die Hälfte aller Augenzeugen irrt sich', in: *Frankfurter Allgemeine Zeitung*, December 29.

Kierkegaard, Søren (1944). *Training in Christianity*, trans. Walter Lowrie, Princeton: Princeton University Press.

Kitchin, Rob, and Martin Dodge (2007). 'Rethinking Maps', in: *Progress in Human Geography*, vol. 31, no. 3, 331-344.

Kittler, Friedrich (1993). 'Real Time Analysis: Time Axis Manipulation', in: *Draculas Vermächtnis: Technische Schriften*, Leipzig: Reclam, 182-207.

Kittler, Friedrich (1999): *Gramophone, Film, Typewriter*, trans. Geoffrey Winthrop-Young and Michael Wutz, Stanford: Stanford University Press.

— (2010): *Optical Media*, trans. Anthony Enns, Cambridge: Polity Press.

Klein, Wolfgang, and Konstanze Jungbluth, eds. (2002). 'Themenheft "Deixis"', in: *Zeitschrift für Literaturwissenschaft und Linguistik*, vol. 125.

Kogge, Werner (2007). 'Spurenlesen als epistemologischer Grundbegriff: Das Beispiel der Molekularbiologie', in: *Spur: Spurenlesen als Orientierungstechnik und Wissenskunst*, ed. Sybille Krämer, Werner Kogge, and Gernot Grube, Frankfurt am Main: Suhrkamp, 182-221.

Konitzer, Werner (2006). *Medienphilosophie*, Munich: Fink.

Krämer, Sybille (1988). *Symbolische Maschinen: Die Idee der Formalisierung in geschichtlichem Abriß*, Darmstadt: Wissenschaftliche Buchgesellschaft.

— (1991). *Berechenbare Vernunft: Kalkül und Rationalismus im 17. Jahrhundert*, Berlin: de Gruyter.

— (1998). 'Form als Vollzug oder: Was gewinnen wir mit Niklas Luhmanns Unterscheidung zwischen Medium und Form?', in: *Rechtshistorisches Journal*, vol. 17, 558-573.

— (2001). *Sprache, Sprechakt, Kommunikation, Sprachtheoretische Positionen des 20. Jahrhunderts*, Frankfurt am Main: Suhrkamp.

---, ed. (2002). *Medien, Computer, Realität: Wirklichkeitsvorstellungen und Neue Medien*, Frankfurt am Main: Suhrkamp.

— (2003a). 'Erfüllen Medien eine Konstitutionsleistung?', in: *Medienphilosophie: Beiträge zur Klärung eines Begriffs*, ed. Stefan Münker, Alexander Roesler, and Mike Sandbothe, Frankfurt: Fischer, 78-90.

— (2003b). 'Sagen und Zeigen: Sechs Perspektiven, in denen das Diskursive und das Ikonische in der Sprache konvergieren', in: *Zeitschrift für Germanistik*, vol. 3, 509-519.

— (2004a). 'Die Heteronomie der Medien: Versuch einer Metaphysik der Medialität im Ausgang einer Reflexion des Boten', in: *Journal Phänomenologie*, vol. 22, 18-38.

— (2004b). 'Kann eine performativ orientierte Medientheorie den "Mediengenerativismus" vermeiden?', in: *Act! Handlungsformen in Kunst und Politik*, ed. Gerhard J. Lischka and Peter Weibel, Bern: Beneteli, 66-83.

— (2004c). 'Friedrich Kittler: Kulturtechniken der Zeitachsenmanipulation', in: *Medientheorien: Eine Philosophische Einführung*, ed. Alice Lagaay and David Lauer, Frankfurt: Campus, 201-224.

— (2005). 'Das Geld und die Null: Die Quantifizierung und die Visualisierung des Unsichtbaren in Kulturtechniken der frühen Neuzeit', in: *Macht Wissen Wahrheit*, ed. Klaus W. Hempfer, Freiburg: Rombach, 79-100.

— (2007). 'Was also ist eine Spur? Und worin besteht ihre epistemologische Rolle?', in: *Spur: Spurenlesen als Orientierungstechnik und Wissenskunst*, ed. Sybille Krämer, Werner Kogge, and Gernot Grube, Frankfurt am Main: Suhrkamp, 11-36.

Krämer, Sybille (1998): 'Das Medium als Spur und als Apparat', in: *Medien, Computer, Realität: Wirklichkeitsvorstellungen und Neue Medien*, ed. Sybille Krämer, Frankfurt am Main: Suhrkamp, 73-94.

— (2001): *Sprache, Sprechakt, Kommunikation: Sprachtheoretische Positionen des 20. Jahrhunderts*, Frankfurt am Main: Suhrkamp.

Krämer, Sybille, Werner Kogge, and Gernot Grube, eds. (2007). *Spur: Spurenlesen als Orientierungstechnik und Wissenskunst*, Frankfurt am Main: Suhrkamp.

Krippendorf, Klaus (1994). 'Der verschwundene Bote: Metaphern und Modelle der Kommunikation', in: *Die Wirklichkeit der Medien: Eine Einführung in die Kommunikationswissenschaft*, ed. Klaus Merten, Siegfried Schmidt, and Siegfried Weischenberg, Opladen: Westdeutscher Verlag, 79-113.

Kusch, Martin (2002). *Knowledge by Agreement: The Programme of Communitarian Epistemology*, Oxford: Oxford University Press.

Lagaay, Alice (2001). *Metaphysics and Performance: Performance, Performativity and the Relation Between Theatre and Philosophy*, Berlin: Logos.

Lagaay, Alice, and David Lauer, eds. (2004). *Medientheorien: Eine philosophische Einführung*, Frankfurt am Main: Campus.

Laidler, David E.W. (1991). *The Golden Age of Quantity Theory: The Development of Neoclassical Monetary Economics, 1870-1914*, Princeton: Princeton University Press.

Laub, Dori (1992). 'An Event without a Witness: Truth, Testimony and Survival', in: *Testimony, Crises of Witnessing in Literature, Psychoanalysis, and History*, ed. Shoshana Felman and Dori Laub, London: Routledge, 75-92.

— (2000). 'Zeugnis ablegen oder: Die Schwierigkeiten des Zuhörens', in: *'Niemand zeugt für den Zeugen': Erinnerungskultur und historische Verantwortung nach der Shoah*, Frankfurt am Main: Suhrkamp, 68-83.

Laum, Bernhard (1924). *Heiliges Geld: Eine historische Untersuchung über den sakralen Ursprung des Geldes*, Tübingen: Mohr.

Leibniz, Gottfried Wilhelm (1949). *New Essays Concerning Human Understanding*, trans. Alfred Gideon Langley, LaSalle: Open Court.

Leschke, Rainer (2003). *Einführung in die Medientheorie*, Munich: Fink.

Levi, Primo (1989). *The Drowned and the Saved*, trans. Raymond Rosenthal, New York: Vintage.

Levinas, Emmanuel (1986). 'The Trace of the Other', in: *Deconstruction in Context: Literature and Philosophy*, ed. Mark C. Taylor, Chicago: University of Chicago Press, 345-359.

Lindinger, Manfred (2004). 'Ein künstliches Immunsystem', in: *Frankfurter Allgemeine Zeitung*, May 5, 2004.

Link, Jürgen (1988). 'Literaturanalyse als Interdiskursanalyse: Am Beispiel des Ursprungs literarischer Symbolik in der Kollektivsymbolik', in: *Diskurstheorien und Literaturwissenschaft*, ed. Jürgen Frohmann and Harro Müller, Frankfurt am Main: Suhrkamp, 284-307.

Lipton, Peter (1998). 'The Epistemology of Testimony', in: *Studies in the History and Philosophy of Science*, vol. 29, 1-31.

Ljungberg, Christina (2003). 'Cartography and Fiction: Spatial Strategies in Late Medieval and Early Modern Fiction', in: *European Journal for Semiotic Studies*, vol. 15, 426-444.

Lorenzer, Alfred (1983). 'Sprache, Lebenspraxis und szenisches Verstehen in der psychoanalytischen Therapie', in: *Psyche*, vol. 37, 97-115.

Lüdtke, Karlheinz (2000). 'Theoriebildung und interdisziplinärer Diskurs – dargestellt am Beispiel der frühen Geschichte der Virusforschung', in: *Wissenschaftsforschung Jahrbuch 1998*, ed. Klaus Fuchs-Kittowski, Hubert Laitko, Heinrich Parthey, and Walter Umstätter, Berlin: Gesellschaft für Wissenschaftsforschung, 153-194.

Luhmann, Niklas (1968). *Vertrauen: Ein Mechanismus der Reduktion sozialer Komplexität*, Stuttgart: Ferdinand Enke.

— (1987). 'The Medium of Art', trans. David Roberts, in: *Thesis Eleven*, vol. 18-19, 101-113.

— (1989). *Ecological Communication*, trans. John Bednarz, Jr., Chicago: University of Chicago Press.

— (2000). *Art as a Social System*, trans. Eva M. Knodt. Stanford: Stanford University Press.

MacEachren, Alan M. (1995). *How Maps Work: Representation, Visualization and Design*, New York: Guilford.

Macho, Thomas (1997). 'Himmlisches Geflügel: Beobachtungen zu einer Motivgeschichte der Engel', in: *Engel, Engel: Legenden der Gegenwart*, ed. Cathrin Pichler, Wien: Springer, 83-100.

Mann, Thomas (1955). *Confessions of Felix Krull, Confidence Man: The Early Years*, trans. Denver Lindley, New York: Knopf.

Margreiter, Reinhard (1999). 'Realität und Medialität: Zur Philosophie des "Medial Turn"', in: *Medien Journal: Zeitschrift für Kommunikationskultur*, vol. 23, no. 1, 9-18.

Marx, Karl (1906). *Capital: A Critique of Political Economy*, trans. Samuel Moore and Edward Averling, New York: Modern Library.

Matilal, Bimal Krishna, and Arindam Chakrabarti, eds. (1994). *Knowing from Words: Western and Indian Philosophical Analysis of Understanding and Testimony*, Dordrecht: Kluwer.

Mayer, Ruth, and Brigitte Weingart, eds. (2004). *Virus! Mutationen einer Metapher*, Bielefeld: Transcript.

Maxwell, James Clerk (1890). 'On Action at a Distance', in: *The Scientific Papers of James Clerk Maxwell*, ed. William D. Niven, Cambridge: Cambridge University Press.

McLuhan, Marshall (1964): *Understanding Media: The Extensions of Man*, Cambridge, MA: MIT Press.

McLuhan, Marshall (1964). *Understanding Media: The Extensions of Man*, New York: McGraw-Hill.

Menninghaus, Winfried (1980). *Walter Benjamins Theorie der Sprachmagie*, Frankfurt am Main: Suhrkamp.

Mersch, Dieter (2001). 'Körper zeigen', in: *Verkörperung*, ed. Erika Fischer-Lichte, Christian Horn, and Matthias Warstat, Tübingen: Francke, 75-89.

— (2002a). 'Wort, Bild, Ton, Zahl: Eine Einleitung in die Medienphilosophie', in: *Kunst und Medium, Gestalt und Diskurs*, vol. 3, ed. Theresa Georgen, Kiel: Muthesius Hochschule, 131-254.

— (2002b). *Ereignis und Aura: Untersuchungen zu einer Ästhetik des Performativen*, Frankfurt am Main: Suhrkamp.

— (2003). 'Technikapriori und Begründungsdefizit: Medienphilosophien zwischen uneingelöstem Anspruch und theoretischer Neufundierung', in: *Philosophische Rundschau*, vol. 50, no. 3, 193-219.

— (2004). 'Medialität und Undarstellbarkeit: Einleitung in eine "negative" Medientheorie', in: *Performativität und Medialität*, ed. Sybille Krämer, Munich: Fink, 75-96.

— (2006). *Medientheorien zur Einführung*, Hamburg: Junius.

Merton, Robert K., Marjorie Fiske, and Alberta Curtis (1946). *Mass Persuasion: The Social Psychology of a War Bond Drive*, New York: Harper.

Meyer-Goßner, Lutz (2004). *Strafprozessordnung*, Munich: Beck.

Monmonier, Mark (1991). *How to Lie with Maps*, Chicago: University of Chicago Press.

Mortley, Raoul (1991). 'Michel Serres', in: *French Philosophers in Conversation*, London: Routledge, 47-60.

Müller, Adam (1816). *Versuche einer neuen Theorie des Geldes mit besonderer Rücksicht auf Großbritannien*, Leipzig: F.A. Brockhaus.

Münker, Stefan, Alexander Roesler, and Mike Sandbothe, eds. (2003). *Medienphilosophie: Beiträge zur Klärung eines Begriffs*, Frankfurt: Fischer.

Nack, Armin (2001). 'Der Zeugenbeweis aus aussagepsychologischer und juristischer Sicht', in: *Strafverteidiger*, no. 1, 1-9.

Nancy, Jean-Luc (1992). 'La Comparution/The Compearance: From the Existence of "Communism" to the Community of "Existence"', trans. Tracy B. Strong, in: *Political Theory*, vol. 20, no. 3, 371-398.

— (2000). *Being Singular Plural*, trans. Robert D. Richardson and Anne E. O'Byrne, Stanford: Stanford University Press.

— (2008). *Corpus*, trans. Richard A. Rand, New York: Fordham University Press.

Nietzsche, Friedrich (1964). 'The Genealogy of Morals', trans. Horace B. Samuel, in: *The Complete Works of Friedrich Nietzsche*, vol. 13, New York: Russell & Russell.

Nourbakhsh, Illah, et al. (2006). 'Mapping Disaster Zones', in: *Nature*, vol. 439, 787-789.

Ossermann, Robert (1997). *Geometrie des Universums: Von der Göttlichen Komödie zu Riemann und Einstein*, Braunschweig: Vieweg.

Pagels, Elaine (1995). *The Origin of Satan*, New York: Random House.

Pápay, Gyula (2005). 'Kartografie', in: *Bildwissenschaft: Disziplinen, Themen, Methoden*, ed. Klaus Sachs-Hombach, Frankfurt am Main: Suhrkamp, 281-295.

Peirce, Charles Sanders (1931-1935). *Collected Papers*, ed. Charles Hartshorne and Paul Weiss, 6 vols., Cambridge: Harvard University Press.

— (1955). 'Critical Common-Sensism', in: *Philosophical Writings of Peirce*, ed. Justus Bucherl, New York: Dover.

Peters, Arno (1983). *The New Cartography*, New York: Friendship Press.

Peters, John Durham (1995). 'Beyond Reciprocity: Public Communication as a Moral Idea', in: *Communication, Culture, and Community: Liber Amicorum James Stappers*, ed. Ed Hollander, Coen van der Linden and Paul Rutten, Houten: Bohn, 41-50.

— (1999). *Speaking into the Air: A History of the Idea of Communication*, Chicago: University of Chicago Press.

— (2001). 'Witnessing', in: *Media, Culture & Society*, vol. 23, no. 6, 707-723.

Peters, Uwe Henrik (1977). *Übertragung – Gegenübertragung: Geschichte und Formen der Beziehungen zwischen Psychotherapeut und Patient*, Munich: Kindler.

Pias, Claus, et al., eds. (1999). *Kursbuch Medienkultur: Die Maßgeblichen Theorien von Brecht bis Baudrillard*, Stuttgart: Deutsche Verlags-Anstalt.

Pickels, John (1995). *Ground Truth: The Social Implications of Geographic Information Systems*, New York: Guilford.

— (2004). *A History of Spaces: Cartographic Reason, Mapping and the Geo-Coded World*, London: Routledge.

Piepmeier, Rainer (1976). 'Incarnation', in: *Historisches Wörterbuch der Philosophie*, ed. Joachim Ritter, Karlfried Gründer, and Gottfried Gabriel, vol. 4, Darmstadt: Wiss. Buchgesellschaft, 368-382.

Plato (1937). *The Dialogues of Plato*, trans. B. Jowett, 2 vols., New York: Random House.

Plautus (1913). 'Truculentus', in: *The Comedies of Plautus*, trans. Henry Thomas Riley, London: G. Bell, vol. 2, 209-254.

Pleşu, Andrei (2005). *Actualité des Anges*, Paris: Buchet/Castel.

Plutarch (1878). 'Whether the Athenians Were More Renowned for Their Warlike Achievements or for Their Learning', in: *Plutarch's Morals*, 5 vols., Boston: Little Brown, vol. 5, 399-411.

Pörksen, Uwe (1995). *Plastic Words: The Tyranny of a Modular Language*, trans. Jutta Mason and David Cayley, University Park: Pennsylvania State University Press.

Quine, William V.O. (1960). *Word and Object*, Cambridge: MIT Press.

Raap, Jürgen (2000). 'Die Entstofflichung des Geldes', in: *Das Schicksal des Geldes – Kunst und Geld – Eine Bilanz zum Jahrtausendwechsel*, ed. Jürgen Raap. Wetzlar: Schulte, 210-213.

Racker, Heinrich (1978). *Übertragung und Gegenübertragung: Studien zur Psychoanalytischen Technik*, Munich: Ernst Reinhardt.

Ramming, Ulrike (2001). 'Medienphilosophie – ein Bericht', in: *Dialektik*, no. 1, 153-170.

Rees, Ronald (1980). 'Historical Links Between Cartography and Art', in: *Geographical Review*, vol. 70, 60-78.

Reichertz, Jo (2007). 'Die Spur des Fahnders oder: Wie Polizisten Spuren finden', in: *Spur: Spurenlesen als Orientierungstechnik und Wissenskunst*, ed. Sybille Krämer, Werner Kogge, and Gernot Grube, Frankfurt am Main: Suhrkamp, 309-332.

Reid, Thomas (1967). 'An Inquiry Into the Human Mind', in: *Philosophical Works*, ed. William Hamilton, Hildesheim: Olms, vol. 1, 95-214.

Rheinberger, Hans-Jörg (1992). *Experiment, Differenz, Schrift: Zur Geschichte epistemischer Dinge*, Marburg: Basilisken.

Ricoeur, Paul (1974). *The Conflict of Interpretations: Essays in Hermeneutics*, ed. Don Ihde, Evanston: Northwestern University Press.

Riese, Hajo (1995). 'Geld: das letzte Rätsel der Nationalökonomie', in: *Rätsel Geld: Annäherungen aus ökonomischer, soziologischer und historischer Sicht*, ed. Waltraud Schelkle and Manfred Nitsch, Marburg: Metropolis, 45-62.

Rimbaud, Arthur (1966). *Complete Works, Selected Letters*, trans. Wallace Fowlie, Chicago: University of Chicago Press.

Robinson, Arthur H. (1985). 'Arno Peters and His New Cartography', in: *American Cartographer*, vol. 12, 103-111.

Rorty, Richard (1979). *Philosophy and the Mirror of Nature*, Princeton: Princeton University Press.

Ross, David F., Don Read, and Michael P. Toglia (1994). *Adult Eyewitness Testimony: Current Trends and Developments*, Cambridge: Cambridge University Press.

Roth, Nathan (1952). 'The Acting Out of Transferences', in: *Psychoanalytic Review*, vol. 34, 69-78.

Rotman, Brian (1987). *Signifying Nothing: The Semiotics of Zero*, New York: St. Martin's Press.

Rötzer, Florian (2003). 'Wettrüsten in der digitalen Lebenswelt', in: *Telepolis*, November 11, 2003.

Ruhs, August (1997). 'Der Engel, ganz Stimme', in: *Engle, Engel: Legenden der Gegenwart*, ed. Cathrin Pichler, Wien: Springer, 109-115.

Sandbothe, Mike (2001). *Pragmatische Medienphilosophie: Grundlegung einer neuen Disziplin im Zeitalter des Internet*, Weilerswist: Velbrück Wissenschaft.

Sandbothe, Mike, and Ludwig Nagl, eds. (2005). *Systematische Medienphilosophie*, Berlin: Akademie.

Sandler, Joseph, and Anne-Marie Sandler (1984). 'The Past Unconscious, the Present Unconscious, and Interpretation of the Transference', in: *Psychoanalytic Inquiry*, vol. 4, 367–399.

Schaub, Mirjam (2005). 'Visuell Hochprozentiges: Übertragung aus dem Geiste der Gegenübertragung in Matthew Barneys Cremaster Cycle', in: *Ansteckung: Zur Körperlichkeit eines ästhetischen Prinzips*, ed. Mirjam Schaub, Nicola Suthor, and Erika Fische-Lichte, Munich: Fink, 211-229.

Schaub, Mirjam, and Nicola Suthor (2005). 'Einleitung', in: *Ansteckung: Zur Körperlichkeit eines ästhetischen Prinzips*, ed. Mirjam Schaub, Nicola Suthor, and Erika Fische-Lichte, Munich: Fink, 9-22.

Schelkle, Waltraud, and Manfred Nitsch, ed. (1995). *Rätsel Geld: Annäherungen aus ökonomischer, soziologischer und historischer Sicht*, ed. Waltraud Schelkle and Manfred Nitsch, Marburg: Metropolis.

Schelling, Walter A. (1985). *Lebensgeschichte und Dialog in der Psychotherapie: Tiefenpsychologie, Anthropologie und Hermeneutik im Gespräch*, Göttingen: Vandenhoeck & Ruprecht.

Schirmacher, Wolfgang (1994). 'Homo Generator: Media and Postmodern Technology', in: *Culture on the Brink: Ideologies of Technology*, ed. Gretchen Bender and Timothy Druckrey, Seattle: Bay Press, 65-82.

Schlögel, Karl (2003). *Im Raume lesen wir die Zeit: Über Zivilisationsgeschichte und Geopolitik*, Munich: Hanser.

Schmidt, Sybille (2007). *Zeugenschaft: Ethische und politische Dimensionen*, M.A. thesis, Department of Philosophy, Freie Universität Berlin.

Schniewind, Julius (1953). 'Angelia', in: *Theologisches Wörterbuch zum Neuen Testament*, ed. Georg Kittle and Gerhard Friedrich, Stuttgart: Kohlhammer, 56-71.

Scholz, Oliver Robert (2001a). 'Autonomie angesichts epistemischer Abhängigkeit: Kant über das Zeugnis anderer', in: *Akten des IX Internationalen Kant-Kongresses*, ed. Volker Gerhardt, Rolf-Peter Horstmann, and Ralph Schumacher, Berlin: de Guyter, vol. 2, 829-839.

— (2001b). 'Das Zeugnis anderer: Prolegomena zu einer sozialen Erkenntnistheorie', in: *Erkenntnistheorie: Positionen zwischen Tradition und Gegenwart*, ed. Thomas Grundmann, Paderborn: Mentis, 354-375.

— (2004). 'Zeuge/Zeugnis', in: *Historisches Wörterbuch der Philosophie*, ed. Joachim Ritter, Kalfried Gründer, and Gottfried Gabriel, Darmstadt: Wiss. Buchgesellschaft, vol. 12, 1317-1324.

Schünemann, Bernd (2001). 'Zeugenbeweis auf dünnem Eis: Von seinen tatsächlichen Schwächen, seinen rechtlichen Gebrechen und seiner notwendigen Reform', in: *Strafverfahrensrecht in Theorie und Praxis*, ed. Albin Eser, Jürgen Goydke, and Kurt R. Maatz, Munich: Beck, 385-407.

Schwemer, Anna Maria (1999). 'Prophet, Zeuge und Märtyrer: Zur Entstehung des Märtzrerbegriffs im frühesten Christentum', in: *Zeitschrift für Theologie und Kirche*, vol. 96, 320-350.

Searle, John R., and Daniel Vanderveken (1985). *Foundations of Illocutionary Logic*, Cambridge: Cambridge University Press.

Seebaß, Horst (1982). 'Engle, II: Altes Testament', in: *Theologische Realenzyklopädie*, Berlin: de Gruyter, vol. 9, 580-615.

Seel, Martin (1998). 'Bestimmen und Bestimmenlassen: Anfänge einer medialen Erkenntnistheorie', in: *Deutsche Zeitschrift für Philosophie*, vol. 46, no. 3, 351-365.

Seitter, Walter (2002). *Physik der Medien: Materialien, Apparate, Präsentierungen*, Weimar: Verlag und Datenbank für Geisteswissenschaft.

Serres, Michel (1968). 'Structure et importation: Des mathématiques aux mythes', in: *Hermes I: La Communication*, Paris: Éditions de Minuit, 21-35.

— (1982). 'Platonic Dialogue', in: *Hermes: Literature, Science, Philosophy*, ed. Josué V. Harari and David F. Bell, Baltimore: Johns Hopkins University Press, 65-70.

— (1995). *Angels: A Modern Myth*, trans. Francis Cowper, Paris: Flammarion.

— (2007). *The Parasite*, trans. Lawrence R. Schehr, Minneapolis: University of Minnesota Press.

Setton, Dick (2005). 'Die Zumutung des Opfers: Immunisierung der Gesellschaft und (Des)Infektion des Subjekts bei Girard und Levinas', in: *Ansteckung: Zur Körperlichkeit eines ästhetischen Prinzips*, ed. Mirjam Schaub, Nicola Suthor, and Erika Fische-Lichte, Munich: Fink, 367-386.

Shannon, Claude E., and Warren Weaver (1963). *The Mathematical Theory of Communication*, Urbana: Illinois State University Press.

Shannon Claude E., and Warren Weaver (1964): *The Mathematical Theory of Communication*, Urbana: University of Illinois Press.

Shapin, Steven (1994). *A Social History of Truth*, Chicago: University of Chicago Press.

Siegert, Bernhard (1997). 'Vögel, Engel und Gesandte: Alteuropas Übertragungsmedien', in: *Gespräche – Boten – Briefe: Körpergedächtnis und Schriftgedächtnis im Mittelalter*, ed. Horst Wenzel, Berlin: Schmidt, 45-62.

— (1999). *Relays: Literature as an Epoch of the Postal System*, trans. Kevin Repp, Stanford: Stanford University Press.

Simmel, Georg (2004). *The Philosophy of Money*, trans. Tom Bottomore and David Frisby, London: Routledge.

Sismondo, Sergio, and Nicholas Chrisman (2001). 'Deflationary Metaphysics and the Natures of Maps', in: *Philosophy of Science*, vol. 68, 38-49.

Sloterdijk, Peter (1999). *Sphären II – Globen*, Frankfurt am Main: Suhrkamp.

Sobel, Dava (2003). *Längengrad*, Berlin: Taschenbuch-Verlag.

Sohn-Rethel, Alfred (1990). *Das Geld, die bare Münze des Apriori*, Berlin: Wagenbach.

Soutschek, Martin (2006). 'Die digitale Erde: Die Vision wird Wirklichkeit', in: *Vermessung Brandenburg*, vol. 11, no. 1, 21-31.

Spitz, René A. (1956). 'Übertragung und Gegenübertragung: Die Psychoanalytische Behandlungs-situation – eine genetische Untersuchung ihres Kräftespiels', in: *Psyche*, vol. 10, 63-81.

— (1957). *Die Entstehung der ersten Objektbeziehungen: Direkte Beobachtungen an Säuglingen während der ersten Lebensjahre*, Stuttgart: Klett.

— (1972). *Vom Säugling zum Kleinkind: Naturgeschichte der Mutter-Kind-Beziehung im ersten Lebensjahr*, Stuttgart: Klett.

— (1976). *Vom Dialog: Studien über den Ursprung der menschlichen Kommunikation und ihrer Rolle in der Persönlichkeits bildung*, Stuttgart: Klett.

— (1978). *Nein und Ja: Die Ursprünge der menschlichen Kommunikation*, Stuttgart: Klett.

Spitzer, Leo (1969). *Essays in Historical Semantics*, New York: Vanni.

Sterba, Richard (1936). 'Zur Theorie der Übertragung', in: *Imago: Zeitschrift für Psychoanalytische Psychologie, ihre Grenzgebiete und Anwendungen*, vol. 22, no. 1, 456-470.

Strachey, James (1934). 'The Nature of the Therapeutic Action of Psychoanalysis', in: *International Journal of Psycho-Analysis*, vol. 15, 127-159.

Strauß, Botho (2004). *Der Untenstehende auf Zehenspitzen*, Munich: Hanser.

Suthor, Nicola (2005). 'M'être – merde: Immunisierung zur Meisterschaft bei Cézanne und Picasso', in: *Ansteckung: Zur Körperlichkeit eines ästhetischen Prinzips*, ed. Mirjam Schaub, Nicola Suthor, and Erika Fische-Lichte, Munich: Fink, 101-131.

Sylla, Richard (1993). *Patterns of European Industrialization: The Nineteenth Century*, London: Routledge.

Szasz, Thomas S. (1963). 'The Concept of Transference', in: *The International Journal of Psycho-Analysis*, vol. 44, 432-443.

Tholen, Georg Christopher (2002). *Die Zäsur der Medien: Kulturphilosophische Konturen*, Frankfurt am Main: Suhrkamp.

Thomä, Dieter (2004). 'Geld, Gier und Moderne: Philosophische Bemerkungen anläßlich der Kalifornien-Romane von Frank Norris', in: *Tugenden und Laster: Gradmesser der Menschlichkeit*, ed. ZDF-Nachtstudio, Frankfurt am Main: Suhrkamp, 254-279.

Thomas Aquinas (1999). *A Commentary on Aristotle's De anima*, trans. Robert Pasnau, New Haven: Yale University Press.

Vief, Bernhard (1991). 'Digitales Geld', in: *Digitaler Schein: Ästhetik der elektronischen Medien*, ed. Florian Rötzer, Frankfurt am Main: Suhrkamp, 117-146.

Vogel, Matthias (2012). *Media of Reason: A Theory of Rationality*, trans. Darrell Arnold, New York: Columbia University Press.

Weber, Stefan, ed. (1999). *Medial Turn: Die Medialisierung der Welt*, Innsbruck/Wien: Studien Verlag.

Weigel, Sigrid (2000). 'Zeugnis und Zeugenschaft, Klage und Anklage: Die Geste des Bezeugens in der Differenz von Identity Politics, juristischem und historiographischem Diskurs', in: *Zeugnis und Zeugenschaft*, ed. Gary Smith and Rüdiger Zill, Berlin: Akademie, 111-135.

— (2002). 'Zum "topographical turn": Kartographie, Topographie und Raumkonzepte in den Kulturwissenschaften', in: *KulturPoetik*, vol. 2, no. 2, 151-165.

— (2007a). 'The Measurement of Angels: Images of Pure Mind as a Matter of Science in the 19th Century', in: *European Review*, vol. 15, no. 3, 297-320.

— (2007b). 'Schauplätze, Figuren, Umformungen: Zu Kontinuitäten und Unterscheidungen von Märtyrerkulturen', in: *Märtyrer-Porträts: Vom Opfertod, Blutzeugen und heiligen Kriegern*, ed. Sigrid Weigel, Munich: Fink, 11-40.

Weiß, Heinz (1988). *Der Andere in der Übertragung: Untersuchung über die analytsiche Situation und die Intersubjektivität in der Psychoanalyse*, Stuttgart-Bad Cannstatt: Frommann-Holzboog.

Welbourne, Michael (1979). 'The Transmission of Knowledge', in: *The Philosophical Quarterly*, vol. 20, 1-9.

— (1986). *The Community of Knowledge*, Aberdeen: Aberdeen University Press.

Wenzel, Horst (1997). *Gespräche – Boten – Briefe: Körpergedächtnis und Schriftgedächtnis im Mittelalter*, Berlin: Schmidt.

Westerkamp, Dirk (2006). *Via Negativa: Sprache und Methode der negativen Theologie*, Munich: Fink.

Wilke, Helmut (2001). *Atopia: Studien zur atopischen Gesellschaft*, Frankfurt am Main: Suhrkamp.

Williams, Raymond (1974): *Television: Technology and Cultural Form,* London: Fontana.

Winau, Rolf (2005). 'Ansteckung – medizinhistorisch', in: *Ansteckung: Zur Körperlichkeit eines ästhetischen Prinzips*, ed. Mirjam Schaub, Nicola Suthor, and Erika Fische-Lichte, Munich: Fink, 61-72.

Winkler, Hartmut (2004). *Diskursökonomie: Versuch über die innere Ökonomie der Medien*, Frankfurt am Main: Suhrkamp.

Winthrop-Young, Geoffrey (2002). 'Going Postal to Deliver Subjects: Remarks on a German Postal Apriori', in: *Angelaki: Journal of the Theoretical Humanities*, vol. 7, no. 3, 143-158.

Winthrop-Young, Geoffrey (2011): *Kittler and the Media*, Cambridge: Polity Press. Wittgenstein, Ludwig (1969). *On Certainty*, ed. G.E.M. Anscombe and G.H. von Wright, trans. Denis Paul and G.E.M. Anscombe, Oxford: Basil Blackwell.

Wood, Denis (1992). *The Power of Maps*, New York: Guilford.

Wood, Denis, and John Fels (1986). 'Designs on Signs: Myth and Meaning in Maps', in: *Cartographica*, vol. 23, no. 3, 54-103.

Wyss, Dieter (1982). *Der Kranke als Partner: Lehrbuch der anthropologisch-integrativen Psychotherapie*, Göttingen: Vandenhoeck & Ruprecht.

Zwingli, Huydrich (1940-1963). *Hauptschriften*, ed. Fritz Blanke, Oskar Farner, and Rudolf Pfister, 13 vols., Zürich: Zwingli-Verlag.

Index of Names

Index of Subjects

16W21657/ T1/ 9789462983083